Time Travel

Time Travel

*Tourism and
the Rise of the Living History Museum in
Mid-Twentieth-Century Canada*

Alan Gordon

UBCPress · Vancouver · Toronto

25 24 23 22 21 20 19 18 17 16 5 4 3 2 1

Printed in Canada on FSC-certified ancient-forest-free paper (100% post-consumer recycled) that is processed chlorine- and acid-free.

Library and Archives Canada Cataloguing in Publication

Gordon, Alan, author
 Time travel : tourism and the rise of the living history museum in mid-twentieth-century Canada / Alan Gordon.

Includes bibliographical references and index.
Issued in print and electronic formats.
ISBN 978-0-7748-3153-6 (hardback). – ISBN 978-0-7748-3155-0 (pdf). –
ISBN 978-0-7748-3156-7 (epub). – ISBN 978-0-7748-3157-4 (mobi)

 1. Historical museums – Canada – History – 20th century. 2. Tourism – Canada – History – 20th century. I. Title.

FC21.G67 2016 971.075 C2015-908765-1
 C2015-908766-X

Canadä

UBC Press gratefully acknowledges the financial support for our publishing program of the Government of Canada (through the Canada Book Fund), the Canada Council for the Arts, and the British Columbia Arts Council.

This book has been published with the help of a grant from the Canadian Federation for the Humanities and Social Sciences, through the Awards to Scholarly Publications Program, using funds provided by the Social Sciences and Humanities Research Council of Canada.

Printed and bound in Canada by Friesens
Set in Galliard and New Baskerville by Artegraphica Design Co. Ltd.
Copy editor: Deborah Kerr
Cover designer: Martyn Schmoll

UBC Press
The University of British Columbia
2029 West Mall
Vancouver, BC V6T 1Z2
www.ubcpress.ca

Contents

Figures

Acknowledgments

THIS BOOK IS THE RESULT of more than a decade of reading, visiting, and talking about living history museums. In all this time, my partner and best friend Adrienne has been my enthusiastic supporter, tolerant sounding board, and strictest critic. This book is for her.

Over the years a number of people have made contributions large and small to the project. Museum directors and curators opened their files to help me understand how living history was done in the past. My thanks are owed specifically to Roger Chaisson, Shanna Dunlop, Ninette Gyrody, Elizabeth Hardin, Sheila Johnson, Tom LeClair, Pauline MacLean, and Tom Reitz. I hope I have left no one out. I am particularly grateful to Sylvia Harnden and Darrell Butler for not just providing access to records, but for taking the time to talk with me at length about living history and give me the benefit of their insights into this complex use of the past.

Portions of this book have appeared at various conferences and invited presentations over the years. Questions and comments at conferences and workshops are a part of academic life to be celebrated and this book has benefitted from many. Some portions are now in print in the *Canadian Historical Review*, the *International Journal of Heritage Studies*, and in James Opp and John Walsh's edited collection *Placing Memory and Remembering Place in Canada*. I am grateful to Jim and John for inviting me to the workshop that led to that publication, as well as to the workshop's participants. Friends and colleagues have made suggestions, answered questions, and pointed out mistakes along the way. For this I thank Russ Johnston, Ken McLaughlin, Michelle Hamilton, Ross Fair, Chris Dummitt, Don Wright, Ben Bradley, and Cecilia Morgan. Mary Tivy shared her knowledge of local museums on numerous occasions. However, I am especially grateful to Mike Dawson, who generously sent me his research notes on British Columbia tourism and helped track down some obscure archival materials.

At Guelph, I am indebted to Stuart McCook, who gave me access to his grandfather's research into western Canadian historic sites and to Kevin James and the Tourism History Working Group. Guelph's History Department is a wonderful, collegial, and supportive place to work, where students and colleagues make the study of the past a collaborative endeavour. Research assistants Beth Robertson, Rebecca O'Reilly, Tom Hooper, Mark Sholdice, and Robyn Graham did important legwork that made writing possible. Faculty, postdocs, and graduate students helped sustain a positive environment. I am particularly grateful to the regular participants in our faculty summer "works in progress" seminars: Karen Racine, Catherine Carstairs, Matthew Hayday, Catharine Wilson, Elizabeth Ewan, Doug McCalla, Richard Reid, Susan Armstrong-Reid, Susan Nance, Tara Abraham, Susannah Ferreira, Renée Worringer, Linda Mahood, and Sofie Lachapelle.

The research behind this book was made possible through a grant from SSHRC in 2005 and its production has benefitted from the continuing support for academic publishing offered through the Awards to Scholarly Publications Program of the Canadian Federation of the Humanities and Social Sciences. I have been privileged to work with fantastic people at UBC Press and I would like to single out Darcy Cullen and Ann Macklem for their advice, suggestions, and support. The anonymous reviews arranged by the press helped guide the unpolished manuscript into this finished product. Of course, any errors or omissions in the research and writing of *Time Travel* are my responsibility alone.

Time Travel

Introduction
Living History Time Machines

ONTARIO ENDURED A COOL and rainy summer in 2009. Average temperatures were more than two degrees below normal, and persistent rain cast a damp pall on many summer plans. As outdoor tourist attractions, living history museums felt the pinch. But in the eastern part of the province, the rhetoric around one tourist attraction was surprisingly heated. Controversial changes to the historical program at Upper Canada Village, a pioneer village recreation near Morrisburg, on the St. Lawrence River some eighty kilometres south of Ottawa, outraged local museum curators, history buffs, and even the president of Ontario's public service union. They were incensed that a museum honouring Canada's settlement past was being turned over to crass commercialization and anachronistic historical messages. Some felt that the museum's direction was more than misguided – it was damaging to Canada's well-being.[1]

That the presentation of history at a heritage tourism attraction ignited such passion should suggest that living history was alive and well in Ontario at the start of the twenty-first century. Nothing could be farther from the truth. In June, the *Ottawa Citizen* reported on the hard times facing Upper Canada Village, a reconstruction of a "typical" eastern Ontario community from about the time of Confederation. Its grass and gardens had been left to grow wild and unkempt. Staff had been fired, and its historic buildings, some rescued from the flooding of the St. Lawrence Seaway half a century earlier, were locked up and off-limits to visitors.[2] The village museum, once a centrepiece of provincial tourism promotion and host to hundreds of thousands of annual visitors, was nearly destitute. The St. Lawrence Parks Commission, the provincial agency responsible for Upper Canada Village, Fort Henry, two tourist parkways, and a number of recreational parks along the north bank of the St. Lawrence River, had responded to diminishing revenues and government pressure to become more self-sufficient by diversifying its mandate.

Perhaps the most controversial of the plans to restore Upper Canada Village to solvency involved hosting a mock medieval fair on the grounds of the nineteenth-century pioneer village. "Surely you joust," the *Ottawa Citizen* mocked in a front-page headline. Dozens of placard-waving protesters turned up at the medieval fair to denounce the commercialization of a heritage site. They invoked concepts of authenticity as they deplored the anachronism. They denounced the museum's management and bluntly questioned its commitment to preserving the heritage of Ontario's pioneer past and of the lost villages whose 1950s flooding had prompted the construction of the museum. And they lamented that a once treasured historical site was "one step closer to being a theme park," a third-rate Disneyland attraction.[3]

Picking up on the theme, letter writer Harry Needham from Kanata told the *Citizen* that historic sites were places for education, not entertainment:

> Living history sites that are successful, such as King's Landing in New Brunswick, the Fortress of Louisbourg in Nova Scotia, Black Creek Pioneer Village in Ontario, Old Sturbridge Village and Plimoth Plantation in Massachusetts and Sovereign Hill in Australia, are successful because they are very good at interpreting and exploiting the special characteristics of each. They do not try to be things they are not; they do not operate out of their historical contexts and they do not turn to tawdry and inappropriate "dog and pony shows."[4]

As sincere as Needham and other protesters might have been, they themselves were in many ways misguided. Their view of living history museums was more idealistic than accurate.

In many ways, Upper Canada Village is a curious historic site. For one thing, it is fantasy, not history. It never existed in the past. Assembled from buildings, some threatened by the widening of the St. Lawrence for shipping and hydroelectric development and others from elsewhere, it was merely "representative" of Ontario's nineteenth-century past. It was intended to be a living monument to Ontario's pioneers, the relocation and restoration of various buildings that illustrated the evolution of a hypothetical St. Lawrence River community from its earliest days until the time of Confederation. Initially, the plan was to use only structures salvaged from the submerged lands. However, it was quickly recognized that such limits would leave many aspects of the past unrepresented, so the search for buildings was extended to other communities in eastern Ontario.[5]

The end result, according to museum staff, was a "typical St. Lawrence valley community" and "a living picture of life in the area between 1784 and 1867," which offered visitors a "first-hand examination of the beginnings of this nation."[6] Yet, although it was intended as an accurate reconstruction of a past way of life, it remained a purely fictional village. Why, one might wonder, would people expect a fictional past to be accurate and authentic? And, from another perspective, what was the problem with replacing one fantasy version of the past with another, even if for just one day?

Tourism's History
The difficulties Upper Canada Village faced in the early twenty-first century did not inspire this book, but they do encapsulate some of the themes and issues that it explores. Living history museums have always walked the fine line between entertainment and education. They were built for competing motives, sometimes complementary and sometimes contra-dictory. Among the most powerful was the economic benefits they could deliver from increasing tourism and providing employment in economic-ally depressed regions of the country. Indeed, although advocates such as Needham insisted that education must supersede entertainment, and despite the best efforts of staff to produce accurate, educational represen-tations of the past, living history museums promoted themselves as com-mercial tourist attractions. Speaking about another Ontario museum, this time in the 1960s, one publicity agent cautioned that people were generally happy when governments spent money on living history museums for educational purposes but bristled at any semblance of commercial promo-tion. He nevertheless vigorously promoted Sainte-Marie among the Hurons across North America, exploiting its commercial potential wherever he could.[7]

The study of commercial tourism's history has been a growing field since the end of the 1990s. It is now rapidly advancing and promoted by its own dedicated scholarly serial, the *Journal of Tourism History*, founded in 2009. Historians recognize in tourism a reflection of the social and political values of past societies. Travel promotions reveal to the world what local societies regard as their most attractive and marketable char-acteristics. Thus, early historians of tourism directed their attention to the work of promoters, boosters, and entrepreneurs, with a particular focus on the rise of "mass tourism." For instance, James Buzard argued that promoters such as Thomas Cook and guidebook publishers such as

Baedeker and Murray seized on the growth of the British and European bourgeoisie as well as infrastructural improvements to peddle packaged experiences as "authentic" engagements with foreign places.[8] Other pioneers of tourism history examined changing travel technologies and commercial operations to trace the expansion of tourism as an industry in the twentieth century.[9] Much of this early work implied that an artificial barrier separated tourists from truly authentic experiences, a phenomenon that increased in scope during the twentieth century as mass tourism expanded the industry's scale. Although more recent authors have shied away from such a simplistic characterization of tourists as ignorant interlopers, the distorting effect of the business of tourism on human understanding remains a constant theme in the literature.

Scholars have long cautioned against commercial tourism's potential to misrepresent history.[10] Commercial imperatives mandate, at least in the minds and ambitions of tourism promoters, a cleansing of the past. This cleansing is often derided as a Disneyfication of history, the creation of a cute cartoon version of life that simplifies highly complex social and political environments. The critique of this process is threefold. First, Disneyfication highlights only the positive elements of the past to make it more appealing. Second, it expunges the dark episodes of our history to make it palatable. And third, this distortion is by its very nature presentist – it judges the past by the values of the present. Rather than taking David Lowenthal's advice to assess past societies on their own terms, much as one might understand a foreign culture, Disneyfication seeks confirmation of current values. Many historians find this notion problematic because it implies that the economic, political, and social conditions of the present are inevitable.

Recently, Ian McKay and Robin Bates have drilled into tourist promotions in mid-twentieth-century Nova Scotia and revealed how tourism reshaped provincial history into a new form of historical consciousness. Tourism/history, the term that McKay and Bates gave to this new consciousness, was a historically specific strategy of history writing. Characteristic of the ideological apparatus of the mid-twentieth century, it reordered the past, consciously catering to the anticipated expectations of real or imagined tourists. It remapped social reality in the province to conform to those conjured expectations, resulting in a sort of historical feedback. But more insidiously, it reshaped the landscape of the province by constructing tourist attractions to highlight the tourist trade's historical

message. Thus, the tourist infrastructure, built to conform to the tourism industry's view of the past, became the empirical evidence of that past.

Tourism/history not only blurred the lines between historical fact and fantasy past, but it also served to muddy the distinctions drawn between insiders and outsiders. McKay and Bates congratulate scholars for recently correcting the old formulations in which international tourism was seen as trampling over local identity and imposing false, quaint cultural forms on hapless locals who were desperately seeking to eke out a living. Yet, for the most part, they reject the idea that consumer choice and cultural pluralism characterize tourism's effect on historical consciousness. Instead, they see the history made to serve tourism as another form of imposition. The provincial state and commercial promoters articulated a particular and selective vision of the past, and negotiated its place in both local identity and tourist expectations.[11]

Promoters and innovators did not see their own work quite so cynically. They often believed in the educational benefits that their projects promised as they sought new ways to bring materials they cared about deeply to an ever more jaded and distracted consumer culture. As much as anyone else, they too lived, worked, and created in circumstances not entirely of their own making. Nevertheless, people have a tendency to imagine the world to suit themselves. Tourism promoters thus constructed an interpretation of the past that conformed to their own interests and their idealized version of history. But the histories they told, as Raphael Samuel once suggested, were Janus-faced: they were both a shrine to an idealized past and a beacon for a post-industrial economic future.[12] At the same time, they helped reshape how the past was presented to tourists and locals in a reformulation of the genre of travel writing.

By the 1820s, professional travel writers were developing the genre of the tourist guidebook. From the late eighteenth century through the nineteenth century, two main forms of travel literature captured the attention of literate Europeans and Americans: travelogues and guidebooks.[13] Travelogues typically recorded in narrative form the experiences of individual travellers and were aimed at middle-class readers.[14] Travel guides or guidebooks were more ephemeral publications produced for commercial gain. They offered practical information on local sites, attractions, and accommodations to help tourists navigate unknown places with confidence. By the late nineteenth century, the format had been popularized by the German publisher Karl Baedeker and in the United Kingdom

by John Murray III.[15] Crucially, guidebooks offered tourists easily comprehensible and "transparent" information that did not "bewilder the reader/traveller or ... introduce the potential for a multiplicity of meanings."[16] Thus, they developed the simplified historical understanding that McKay and Bates observed in twentieth-century Nova Scotia.

In the twentieth century, and particularly after the Second World War, travel writing became a more mainstream pursuit. Once the preserve of personal narratives and boosterism, it began to merge with journalism. Newspapers and magazines began sending reporters to provide allegedly objective coverage of travel "news," and their pages swelled with journalistic reviews and advice on destinations. A new, specialized genre of journalism developed and was nurtured in mainstream newspapers and an increasing number of niche magazines. In the 1930s, travel journalism was primarily the realm of business and economic reporting. Almost immediately after the Second World War, it began to merge with promotional writing in Canadian and American newspapers and magazines. For example, by the mid-1950s the *Montreal Gazette* was publishing a special winter travel section and had hired a travel editor.[17] Like the travel columns and sections of newspapers, popular magazines began to cover tourist destinations. A Philadelphia publisher launched a glossy, illustrated magazine, *Holiday,* in the spring of 1946. *Holiday*'s publication was highly anticipated, and after two years its paid circulation had rocketed to over 800,000 subscribers.[18] *Holiday* helped direct travel writing away from prescriptive guidebooks and toward reporting and news. All the while, it retained its underlying rationale of marketing and boosterism. Eventually, travel writing that dealt with tourist destinations wound its way into mainstream reporting. Often, the researchers at living history museums provided the information that figured in reporters' accounts of their work, and they occasionally wrote the stories that appeared in general interest magazines and in newspaper travel sections. Thus, the past presented at living history museums became a promotional tool, used to entice tourists to visit the museum to learn about the past.

Studying Living History

Scholars have studied public representations of history as enshrined in monuments, parks, commemorative celebrations, and historic sites. In Canada, history museums have received less attention. Particular examples, such as Pierre Chasseur's ephemeral museum in 1820s Quebec City, Montreal's McCord Museum, and the New Brunswick Provincial

Museum, have been the focus of dedicated studies.[19] However, because museums are representations of historical knowledge, the study of their histories presents special challenges. Museums create historical arguments through the positioning and describing of artifacts. As Michelle Hamilton contends, writing about museums thus draws upon the links between anthropology, history, and material culture. Material culture theory suggests that objects can have multiple purposes and meanings, depending on their contexts. In museum displays, they become artifacts. Thus, they are assigned significance, not so much by the cultures that produced them, but by the cultural values of the society that displays them.[20] In Western societies, objects as artifacts acquired a particular significance as evidence. Museums trained people to see scientifically by encouraging learning through the observation of artifacts; an object's materiality provided physical proof of the narratives constructed about it. Early Canadian curators, such as David Boyle and Janet Carnochan, spoke approvingly of the use of artifacts as teaching tools, claiming every object should tell a story.[21] The living history museums of the mid-twentieth century took this proposition farther by recreating the environmental context of artifacts. Moreover, by demonstrating the use of artifacts in their period contexts, they appeared to give them life. Living history museums thus seemed more real and accurate than their traditional counterparts.

Living history museums can be defined as cultural institutions that teach historical lessons by recreating past environments. They are a form of open-air museum – multi-building depictions of "historical" places – that explicitly use interpreters in period costumes to demonstrate past ways of life. They have not attracted specific scholarly interest until fairly recently. Jay Anderson's 1984 book *Time Machines: The World of Living History* was probably the first to seriously examine them. Anderson offered a general overview of the evolution of living history from the 1890s in Sweden to 1960s and 1970s interpretations at American historic parks. However, Anderson's interest was in training public historians. His concern was to investigate and improve the practice of living history in American museums, an approach he more explicitly followed up in a subsequent edited collection. Although some contributors to the collection engaged with the cultural implications of museum displays, Anderson himself steered away from difficult or critical questions regarding the practice of living history, its ideological background, or its implications.[22] A more critical approach appears in Tony Bennett's analysis of Beamish Village in the north of England, concluding that, no matter how people might "read

against the grain," the museum offered a deeply conservative interpreta-
tion of the past.[23] Approaching the topic from the perspective of theatre
studies, Scott Magelssen has dissected how the performance of history at
living history sites constructs historical reality for contemporary visitors.
By focusing on the minute details of what he calls the "superfluous,"
museums engage in strategies for masking gaps in knowledge and rely on
the authority that audiences vest in them as institutions to construct a
three-dimensional "reality."[24]

Scholars who are interested in living history, such as these three, have
tended to look at museums and museum visitors in the present, relying
on site visits, oral testimony, and participant observation to create snap-
shots of historical interpretation. For instance, in a classic work on living
history, Richard Handler and Eric Gable took an explicitly anthropological
approach to the study of one open-air museum. They examined the ways
in which public history is managed and how visitors interpret the history
they see at Colonial Williamsburg.[25] This is not to say that authors have
not rooted their scholarship in historical contexts. Warren Leon and
Margaret Piatt surveyed the twentieth-century development of American
living history museums in 1989. However, their real focus remained firmly
on what were then present-day depictions of history, and they concluded
by recommending best practices and improvements in historical inter-
pretation.[26] Similarly, and more recently, Carla Corbin traces the develop-
ment of local fairs to contextualize her examination of contemporary,
temporary fairground villages. And Linda Young briefly discusses the
connection between developments in social history in the 1960s and 1970s
and the prevalence of pioneer village museums in Australia. However,
she, like the others, concentrates on the museums today.[27] Canadian
studies have shown the same tendency, such as Mary Tivy's discussion of
Ontario's material pioneer past.[28] Terry MacLean's comparative study of
Skansen, Williamsburg, and Louisbourg examined these three museums
in the 1990s, noting importantly that the present-day "validity of these
museums is rooted in popular culture."[29] Likewise, Karen Wall has followed
the development of Fort Edmonton Park from its construction in the
1970s through the 1990s, but this material serves as a background for her
discussion of twenty-first-century issues in representing history.[30] With her
own eyes firmly on the present, Laura Peers narrowed her focus to rep-
resentations of Aboriginal cultures at five living history museums. Her
work contrasted the performance of aboriginality with popular culture
expectations and made recommendations for constructing more inclusive

interpretation programs.[31] More typically, a recent doctoral thesis has looked at the presentation of gender history at several Ontario museums, principally between 2003 and 2009.[32] All of these studies show the value of investigating living history museums as subjects.

While there is much to learn from these studies of present-day living history museums, they do not represent the only approach to understanding the subject. Certainly, they have policy implications, and they address issues for museum managers and interpreters. They also offer educators platforms for instilling critical historical sensibilities in students, among other benefits. However, few have seen living history museums as artifacts of history themselves, windows on the cultures of the past that constructed them. This approach offers a different perspective on such museums, one that not only helps us to put them in historical context, but aids our understanding of their limitations in presenting history. For instance, the experimentation at Upper Canada Village was a reaction to a decline of interest in living history museums since the heyday of the 1970s. Indeed, according to the general manager of the St. Lawrence Parks Commission, visitor levels were less than half of what they had been in the 1970s.[33] As MacLean suggests, the popularity of living history in the 1960s and 1970s, and therefore the proliferation of these museums across the country, must have been rooted in the popular culture of those years. This book is an examination of that phenomenon.

Thus, the lines of critique offered by the historical perspective differ from those of anthropological or critical museum studies. Tracing historical interpretations as they changed over time allows us to understand how historical knowledge – and by implication knowledge in our own times – is rooted in political and cultural constructs. From the perspective of the early twenty-first century, such an insight is neither new nor original. The men and women who built Canada's living history museums in the 1960s and 1970s demonstrated their faith in the "truth" of history, but it would be too easy to echo the common criticism that heritage sites market only one version of history as truth, often one that bears only a faint resemblance to the record of events as revealed by scholars.[34] However, their belief that they could reconstruct an authentic historical environment underwrote their confidence in the power of living history to impart a greater historical understanding than anyone could get from the written word. In her discussion of Historyland, a Wisconsin hybrid of living history museum and theme park, Maura Troester asks why, if everyone knew that the past was no more, so many people believed that they could reconstruct

its material reality in post-war America. She concludes they were motivated by a quest for authenticity, which they believed could be built in the physical environment.[35] How people came to embrace these beliefs is one aspect of the rise of living history. How they chose to structure the historical environments they created is a second.

Addressing these issues involves unpacking people's expectations of authenticity. Living history museums are a form of heritage tourism that speak to people's expectations about how history is presented. What made these versions of the truth acceptable or even preferable for public consumption was the sense of authenticity they conveyed. Indeed, this subject has preoccupied scholars of heritage sites generally, and examinations of living history museums in particular. But deciding which aspects of a recreated past are the "authentic" ones and which are intrusions from other cultures or periods is a difficult task. The construction of a physical environment that recalls past material reality is one means by which living history attempts to cultivate a sense of authenticity. Among historical re-enactors, the details of weaponry, uniforms, and positions on a battlefield are part of the experience of reliving a historic moment. Similarly, as Magelssen points out, living history museums attempt to immerse visitors in the world of the past by carefully recreating its banal, everyday details. By and large, historical recreations and living history sites may be seen as realistic depictions of the past, but realistic is not the same thing as authentic.[36]

As Richard Handler and William Saxton write, "authenticity is a dominant value of living history," one connected to the existentialism of Martin Heidegger.[37] David Lowenthal argues that "heritage" and history are known in different ways. Heritage *feels* true, often in defiance of history, precisely because it confirms what people want to believe. It is this feeling of the past that transforms realistic representations into authentic ones. Commercialization, politicization, and inattention to detail can prevent the feeling from arising, but equally distracting is the failure to live up to preconceived notions of the past. It is a question not so much of whether an individual "truly" has an authentic experience, but rather what endows the experience with authenticity. In this understanding, authenticity is perhaps better grasped as a concept to be appreciated in its absence. It is much simpler to point to anachronisms, spuriousness, cultural imports, and fakes than to establish the organic belonging of certain aspects of the past. More succinctly, it is much easier to point out what does not fit the expected narrative of history than to specify what confirms it. It is an

emotional experience that is felt as much as seen or touched.[38] As Handler and Saxton note, existentialist philosophers understood authenticity as a form of becoming, focusing on the origins and intensity of one's emotional commitments. Moreover, the preoccupation with authenticity is a product of modern living: "The relationship of Heideggerian authenticity to living history lies in this: *Living historians share with other moderns the notion that an authentic life is a storied or emplotted life.* Their ideal of self-realization in an integrated, complete, and fully individuated life is precisely that which can be found in modern narratives, whether historical or fictional."[39] In other words, the history told at a living history museum felt authentic because it supplemented the construction and, more importantly, the affirmation of collective identities by contributing to the plotted narrative of the community's formation.

Even when living history museums deal with unpleasant aspects of the past, as they have recently begun to do, they help affirm the values of the present.[40] Some of the largest, and therefore first studied, examples presented a version of history that was stripped of strife, conflict, oppression, and exploitation. The most famous of these was Colonial Williamsburg, which ignored the massive population of African American slaves that lived there during the eighteenth century. As Thomas Schlereth famously put it, "it wasn't that simple." Yet, although Williamsburg has corrected the worst of its earlier omissions, it and other living history museums of the 1970s adhered to an American consensus historiography of the 1950s that encouraged the celebration of "American values" and functioned as shrines more than museums.[41] Schlereth's critique, delivered in a post-civil-rights America, is suggestive of another feature of living history museums: they are constantly under pressure to adapt to changes in the predominant historiography. The past they depict may appear to be static, but its interpretation changes. Their representations of an "authentic" past, then, cannot be separated from the belief and knowledge systems of the culture that produced them and continues to use them.[42] If we are to understand the creation of living history museums, and to unpack their place in the culture that created them, we must examine them as artifacts of history.

Negotiating Modernity

As Handler and Saxton's reference to Heidegger suggests, living history museums were products of a modern culture. The watchword of recent Canadian historiography has been modernity. Historians of the twentieth

and late nineteenth centuries have posited the modern era as a direct contrast to an earlier pre-modern social formation, one that modernity obliterated. In this dichotomy, modernity consists of social, economic, and cultural conditions of life that differ from those of the earlier period. In his study of the mid-twentieth century, Philip Massolin defines modernity as the "replacement of a Victorian value system with one more attuned to a secular and materialist society."[43] Such a characterization would seem to suggest that the materiality of living history reconstructions of historical environments both made them popular and reinforced their claims on truth. Others have contended that industrial society's ability to mass manufacture exact copies is a hallmark of modernity.[44] According to Massolin, modernity emerged from a process of modernization that subsumed the moral values of the past, especially Christian morality, beneath "attitudes and values consistent with an industrial, technological, and consumer society."[45] But such a description of the conditions of modernity is too simplistic.

Modernity, for lack of a better word, goes beyond the loose association with secularization as described by Massolin, even as it encompasses it. Secularization is insufficient to encapsulate the meaning of modernity, yet it does suggest modernity's replacement of faith in spirituality with a reliance on technology. It is the lived experience of mass society in which everyday people rely on abstract systems and technological expertise that are beyond their own comprehension, much as they had once relied on the certainties of religious doctrine to cope with an incomprehensible world. However, unlike slow-changing religious dogmas, technological change is rapid. For Zygmunt Bauman, modernity is characterized by its very embrace of change. It is a "liquid" concept, one that flows almost freely with the changes that it ushers in.[46] It was both "monstrous," in its dehumanizing of social interaction, and optimistic, through the increased economic wealth and rationalism that accompanied it.[47] Modernity, then, whatever else it may encompass, involves a deceptive experience of change.

This ambivalence surrounding the process of change draws modernity into the discussion of living history museums. Modernity's unremitting change was the very thing that called into question the authenticity of life under its own conditions. Modernity's liquid promise of change and progress seemed to accelerate in the mid-twentieth century, especially after the Second World War. The economic catastrophe of the Great Depression and the horrors of global warfare were compounded by social

and technological changes. People contended with the optimism of the space race alongside the anxieties of the Cold War and its threat of nuclear annihilation. As prosperity returned to North America following the war, consumer culture penetrated farther and farther into family life. Shopping and the acquisition of material goods for desire rather than need became part of North American culture. However, living under the conditions of mass consumer society distanced people from one another and removed a pre-modern, face-to-face community of the past, all the while connecting them in an unseen web of abstract systems. At the same time, this consumer behaviour commodified culture, providing choices for consumers but depriving them of intrinsic value. Modernity thus represented a double challenge to the authenticity that living history museums tried to convey. On the one hand, the process of modernity challenged the authenticity of everyday experience. Modern progress ploughed across the traditional social formations and landscapes of Victorian Canada. As new skyscrapers raced to the skies and new roadways spread across the countryside, many people felt a profound sense of loss. This was the sentiment that drove Henry Ford to rescue his own boyhood home and then to expand his mission to the salvation of a disappearing America. On the other hand, the sundering and segmenting of the modern consumer market meant that the past had to compete for the leisure attention of the public, thus diminishing its power to reach consumers' consciousness and inform their identities.

The great irony of the mid-century rise of living history museums was that their attempt to preserve the lost past for future generations relied utterly on the technology and systems of modernity to recreate it and on the modern tourist industry to sustain it. Recreating the environment of the past was a thoroughly modern proposition. Complex planning and research were required to pull together multiple elements of past material reality and manufacture it anew. Historical programming required sophisticated research plans and systems. Perhaps most symbolically, many museums embarked on the relocation of authentically historical buildings to reinforce in material form their historical accuracy. Yet, moving a historic house from one location to another involved the careful cataloguing of architectural features, massive industrial equipment to lift and transport the structure, co-ordinated control of roadways and traffic, often to the extent of temporarily removing other modern infrastructure such as overhead wiring, and the guidance of highly trained specialists to reassemble the building and return it to its original state.

Moreover, tourism and the pursuit of tourists played a crucial role in shaping the historical messages of living history museums. The market for historical depictions offered North Americans a range of choices for how they might consume the past. Living history museums struggled to differentiate the "authentic" histories they told from the fantasy or Disneyfied histories that were available at theme parks, on television, and at the movies. One way of approaching this was through an emphasis on the authentic sensory experience. Visiting a living history museum was more than simply observing the past. As more than one museum planner proposed, entering the recreated material environment of the past, populated by people dressed in period costume and performing obsolete chores and tasks, was almost a form of time travel.

Plotting Forward

Time Travel investigates the development of Canada's living history museums from the 1930s to about the end of the 1970s. By the end of the 1970s, living history museums had become entrenched in Canada's tourist landscape, and the living history approach was widely accepted, applauded for its ability to break down barriers between museum visitors and historical education. However, the end of the decade also marked the beginning of the movement's decline. In the 1980s, governments began cutting their support for cultural programs, and the interpretive programs of the museums faced growing criticism for their claims on historical truth and authority. As museum work began to adapt to new cultural contexts in the 1980s, living history lost its prominence and its sense of innovation. New trends propelled historians and museologists in new directions. *Time Travel* does not pass judgment on those developments; it leaves the decline of living history museums for another study. It is not intended to demean the quality of the historical and archaeological research that the museums conducted, but rather to see them as the products of their own times and to trace the influence of Canadian culture on the generation of historical knowledge. The book is national in scope, examining museums from the Atlantic to the Pacific, but it is not an exhaustive survey. Instead, *Time Travel* uses selected museums to discuss their place in the construction of Canadian identity and their position in Canada's culture in the mid-twentieth century.

The book is laid out in three major parts: Foundations, Structures, and Connections. Foundations explores the origin of living history, connecting

it to developments in museum culture and to the expansion of mass tourism. Chapter 1, History on Display, explores the emergence of museums in the nineteenth century and demonstrates the centrality of artifacts to historical understanding, as communicated in natural history museums. The chapter links the development of ethnology and anthropology to an expanded understanding of natural history that brought material displays of human history into museum exhibitions. Lastly, the chapter connects these developments to the growth of historic house museums as settings for the communication of historical information. Chapter 2, The Foundations of Living History in Canada, traces Canadians' interest in preserving and rebuilding historic sites and structures. The chapter opens with a discussion of the early preservation of Fort York in Toronto and moves on to the notion of preserving historic sites as a sacred trust, especially at Louisbourg. The chapter reveals how governments became involved in this sacred trust during the interwar years and began to think of coupling historic places with tourist attractions. It concludes with the 1930s reconstruction projects at Fort Henry and Port Royal, which initiated the living history movement. Chapter 3, Tourism and History, explains the importance of tourism to the post-war economy and how various levels of government became increasingly involved in its promotion. The chapter pays particular attention to the use of history to mark a distinctive brand for Canada and its provinces, especially as tourism became increasingly international in scope during the 1960s and 1970s.

Part 2: Structures depicts the development of living history museums by looking at a number of key case studies. Chapter 4, Pioneer Days, traces the development of the pioneer village model of museum, especially in Ontario. It connects these museums to a post-war "pioneer ethos" that celebrated the first (European) settlers of the country. It links this ethos to the conservation movement and scientific water management that was emblematic of provincial conservation authorities, where many pioneer village museums were located. It also traces the increasing professionalization of museum staff in the 1960s as governments took over the initiatives of local historians and volunteers. Chapter 5, A Sense of the Past, examines the efforts of museums to convey a message about history. It discusses the types of displays and interpretation programs that museums offered to uncover an overall message about what the pioneer past was like. Using evidence from school field trips and educational programs, the chapter reveals how museums helped shape the historical consciousness of young

Canadians. Chapter 6, Louisbourg and the Quest for Authenticity, uses the case study of the Fortress of Louisbourg to examine efforts to construct an authentic reproduction of past material and cultural reality. Louisbourg was the most expensive and best researched of all living history museums, but it could not escape the conundrum of its own artificiality. Admittedly, the story of the Louisbourg reconstruction is vast and complex, and could easily occupy several books on its own. This study focuses on how the people who built it pursued the concept of authenticity. Whatever their successes and failures, evidence suggests that their work was enormously popular and that it helped shape public ideas about what a living history museum should look like, and thus what people thought the past was like.

Part 3: Connections links the history on display at living history museums to the culture of post-war Canada. It implicitly argues that we can understand why interpretations at living history museums today reflect certain ideas by looking at how they reflected the cultures that constructed them in the 1960s and 1970s. Chapter 7, Fur and Gold, concentrates on province building in British Columbia and on how the living history model was adapted to differing settlement pasts at Barkerville and Fort Steele. The popularity of both sites shows how thoroughly the model was embedded in the public mind. Chapter 8, The Great Tradition of Western Empire, traces various ways in which the Laurentian thesis of Canadian national development, and in particular its popular association with the fur trade, was reflected at two museums. The contrast of Old Fort William and Fort Edmonton reveals how education and entertainment could both distort history. The chapter also explores Ontario's "historical systems plan" as an example of 1970s social science rationalization. Chapter 9, The Spirit of B & B, deals with efforts to foster a specific idea of national unity – bilingualism and biculturalism – at historic sites that emphasized the shared French-English past of the country. It also exposes the weakness of this approach through examining resistance to the spirit of bilingualism and biculturalism and the relative non-existence of living history in Quebec. Chapter 10, People and Place, looks at a related idea of national unity – multiculturalism – and explores how it came to insert itself into living history interpretations in the 1970s. The chapter also reveals how some cultural groups used living history museums to tell their own stories, bringing living history closer to the ecomuseum model then emerging in Europe. Chapter 11, Genuine Indians, looks specifically at how depictions of Aboriginal people at living history museums have changed over time. It concludes with a discussion of northern British Columbia's 'Ksan

Historical Village and its effect on inspiring an artistic revival among the Gitxsan people. Thus, the chapter helps reconnect the discussion to the early days of ethnology and anthropology, especially through the person of Marius Barbeau.

Living history museums were thus a product of their times. Their histories reflect the Canada of the mid-twentieth century, a crucial period in the formation of its national identity. The middle years of the century saw Canadians attempt to forge a national historical consciousness that celebrated their unique past. However, living history museums did more than simply contribute to that developing consciousness. They themselves were another reorientation of the material world, one that reproduced the Canadian past in physical, three-dimensional form and breathed life into it through animation and interpretation. But what made these recreations authentic to Canadians was also a product of the times. How people came to understand the fantasy replicas of the past they built for themselves as authentic historical environments reflected their faith in themselves as builders. Their legacy is their persistence as material reminders built into Canada's tourism landscape.

PART 1
Foundations

1

History on Display

WHEN UPPER CANADA VILLAGE opened its doors in the 1960s, the mood was optimistic for living history. Across North America, living history museums were not only opening, but finding governments and private sponsors who were willing to invest large sums of money in them. A 1971 American survey, which was not exhaustive, found 123 museums in forty-two states. Similar growth occurred in Canada, although on a smaller scale.[1] Like these predecessors and contemporaries, Upper Canada Village found a ready demand for its displays and its interpretation of history. This kind of museum was new – it captured imaginations about what history was and what it could be. It opened new ways to think about what could be preserved and what lessons might be learned. For many people, it represented new possibilities for the teaching about the past and for the preservation of memory.

Recently, the Swedish museologist Sten Rentzhog has claimed that open-air museums must be seen as distinct both from other types of museums and from the theme parks that people feared Upper Canada Village might become. Rentzhog argues that they are unique institutions, with particular cultural and community missions of their own. He agrees with the eastern European adoption of the name Skansen as a generic term for them and urges people to drop the word "museum" from their description.[2] In many ways, Rentzhog is correct to differentiate open-air museums from their traditional counterparts. All history museums segregate contemporary lived experience from the past by presenting selected and often isolated remnants of past events, cultures, or societies in static displays. For Rentzhog, open-air museums go beyond this. With their "live interpretations," as Andrew Robertson explains, they situate artifacts, people, events, and places in historical context. Thus, crucially, they are institutions of emotion and affect, and they must be conscious of this. For such authors, they are therefore embedded in their communities with a mission to keep collective memories alive.[3]

Although Rentzhog's argument has merit, living history museums cannot be so neatly separated from the broader historical development of museums. They are indeed unique cultural institutions, and they can tell us much about the cultures that created and used them, but they are also part of the historical development of the modern museum. Museums have always reflected the cultures that produced them. Emerging from elitist, private collections known as cabinets of curiosities, they developed in response to Enlightenment ideas of equality of education and later adapted to the commercialization of leisure in the nineteenth century. Museums are thus spaces where artifacts are put on display for the education, betterment, or simple enjoyment of visitors. Moreover, these displays reflected the currents of Anglo-American intellectual life. At first, they were primarily concerned with natural history, but developing practices of antiquarianism, anthropology, ethnology, and folklore studies brought human history into their displays of the past. Understanding how artifacts have been exhibited is therefore tied to the connections that cultures have drawn between the material world and the nature and purpose of knowledge. Living history museums thus reflect a tradition of stressing the importance of artifacts and material culture to human understanding that emerged from the traditional museum. They must be understood in this context.

Cabinets and Collectors

Collecting and displaying treasured objects is perhaps as old as civilization itself. Amassing and exhibiting items of value has long been an expression of an individual's wealth and power. Egyptian pharaohs acquired assortments of old, unusual, and interesting articles to demonstrate their personal power. Collecting was an expected function of ancient Greek temples, such as the treasures preserved at Delphi to celebrate victory at the Battle of Marathon. In the Middle Ages, Europe's cathedrals and monasteries continued this role of preserving sacred relics. Moreover, this habit was not restricted to the leaders and temples of Western civilization, as Asian and Muslim shrines also housed collections of treasures.[4] However, to see all forms of collecting as essentially similar misplaces the vastly different cultural contexts behind these practices and paints an overly simplistic picture of human behaviour. The museum, as it emerged in the West, was quite different from these ancient stores of riches. It developed from a Renaissance understanding of the potential for learning through observation. The prototype of the museum thus arose during

the Renaissance revival of learning, first in Italy and later in northern
Europe. This prototype was the Renaissance Kunstkammer, or cabinet of
curiosities.

Cabinets of curiosities were a significant departure from the collections
of cathedral treasures and other hoardings kept by rulers and aristocratic
families in the Middle Ages. Renaissance collecting reveals a significant
shift in understandings of the material world. Scholars have identified
an antiquarian impulse in northern Italy as early as the 1460s, but the
practice of private collecting was certainly firmly established by the mid-
sixteenth century.[5] Owners of cabinets brought together, often in a single
room, wondrous objects and inventions. They crammed stuffed animals
and skeletons next to minerals and fossils; they displayed old sculptures
and unique paintings, as well as fascinating inventions such as clockwork
automatons.[6] However, Renaissance cabinets differed from earlier collec-
tions by what their owners hoped to accomplish. They were characterized
by philosophical inquiry and the belief that specimens and objects were
valuable subjects of study. Thus, they changed perceptions of artifacts.
Certainly, their unsorted mix of items of different types and from different
places and times smacked of the disorganized "pre-scientific" era's fas-
cination with the bizarre. Not a few cabinets contained bits and pieces of
mythical beasts, such as unicorns or Scythian lambs. Yet, these chaotic
mixtures of art, nature, fantasy, and science helped cement a new under-
standing of the material world that was closely associated with an emerging
scientific inquiry based on direct observation.[7] Moreover, they anticipated
the idea of a museum as a special place where learning and scholarship
were informed by interaction with artifacts.[8] Inspired by the contempor-
aneous developments of the scientific revolution in the seventeenth and
eighteenth centuries, cabinets recast the value of their collections around
their potential to yield factual knowledge. In this understanding of the
construction of knowledge, the accumulation of objective data from a
wide spectrum would make possible the spontaneous production of reli-
able conjecture. Knowledge in this formulation became, not the scholastic
deductions of medieval Christianity, but something to be discovered in
the material world. In this new empiricism, collections became sites of
inquiry, providers of a stable foundation for factual investigation.[9]

Not surprisingly, some of the best collectors of the late seventeenth
century and into the eighteenth were people whose professional status
depended on their reputations as discoverers of this empirical knowledge
and the practical use they could make of the material world. Doctors and

apothecaries were among the most prevalent collectors. Patrician illnesses required expensive potions and cures, using exotic spices and herbs brought to Europe from newly discovered parts of the globe.[10] Moreover, as Europe's explorers, soldiers, and missionaries penetrated ever farther into the hitherto unknown regions of the world, they brought back new and sought-after curiosities to augment many collections. For physicians and chemists, new ingredients required experimentation to turn the curiosity into something practical. Amassing and publicizing collections increased their professional status. Apothecaries such as James Petiver, and doctors such as John Woodward and Richard Mead, gathered collections of shells, fossils, dried insects, and stuffed reptiles. Once the preserve of royalty and aristocrats, the collecting of curiosities had become a fashionable hobby and even a vehicle for career advancement for the upper middle class by the eighteenth century.[11] Yet, while wealthy commoners had become collectors, their cabinets remained private and exclusive.

However, eighteenth-century Enlightenment thinking had a profound influence on how people saw the uses of these private collections. The Enlightenment belief in equal opportunity in learning prompted calls that private collections be opened to the public. Historians of museums have noted that in England and France, proposals for public museums coincided with the development of the first encyclopedias, or textual compendiums of knowledge. In England, Ephraim Chambers's *Cyclopaedia: or, a Universal Dictionary of Arts and Sciences* first appeared in 1728 and was frequently republished through the middle decades of the century. In France, the thirty-five volumes of Denis Diderot's *Encyclopedia* appeared between 1751 and 1777. And in 1747, Étienne la Font de Saint Yenne suggested that the royal collections at Versailles should be returned to Paris, where they would be housed in the Louvre palace and opened to the public. The demand was repeated regularly by other French *philosophes* in subsequent years.[12] Both museum and encyclopedia shared the goals of compiling an exhaustive collection of all knowledge and of making knowledge universally available.

An exemplar of these trends was Sir Hans Sloane, a physician, scientist, and collector whose will helped establish the world's first public museum. Sloane had built his collection over the years, gathering items during his travels and buying the estates of other collectors. He purchased Petiver's collection in 1718. Indeed, he amassed his treasures in leaps by regularly acquiring collections from across Europe, adding those of Petiver, Cardinal Filippo Antonio Gualterio, Leonard Plukenet, the duchess of Beaufort,

Adam Buddle, Paul Hermann, and Herman Boerhaave, among others, to his own.[13] And in 1749, he offered his entire collection to England, proposing that it be opened to the public. When he died in 1753, Parliament accepted the gift and appointed a board of trustees to oversee the creation of a national museum. The next year, the trustees bought Montagu House, a seventeenth-century mansion on Great Russell Street in Bloomsbury, and, combined with the library of George II, Sloane's collection of some seventy thousand objects formed the nucleus of the British Museum. When it opened in 1759, the museum was a new and unique institution. Although its collections were nominally public, the trustees jealously guarded access. If they wished to gain entry, visitors had to apply in writing, giving their name and occupation. Admission was clearly seen as a privilege reserved for the better classes, as occupations were no doubt vetted for their suitability, and the investigation of the applicant's credentials might take several months, again ensuring that the main users of the museum would be artists, scholars, and people of privilege.[14] Nevertheless, admissions expanded after about 1800 due to pressures from Parliament for greater access to collections that were funded by the public purse. By 1810, anyone of decent appearance could gain entry on three days a week. By 1818, annual attendance had exceeded fifty thousand people.[15]

The British Museum was unique in its arm's-length freedom from the government and the monarchy. It was insulated from political or personal control, which conferred institutional authority on its interpretations. But, of course, the trustees' conservatism and their close association with the leaders of British society and the state ensured that the museum reflected the interests of England's elite. Those interests were closely connected to the growth of British imperialism. Indeed, the museum became a sort of repository of British exploration and expansion, gathering together gifts from explorers and sailors on such voyages of exploration as James Cook's South Seas missions.[16] The museum also benefitted from the success of British military and diplomatic power. British agents abroad served as key sources for the addition of new wonders to the collection. For instance, the Elgin Marbles, a series of marble sculptures, were removed from the Acropolis in Athens by the British ambassador to the Ottoman Empire, Thomas Bruce, earl of Elgin. The museum bought them in 1816. However, the trustees also curtailed its expansion, routinely trying to limit collecting to the classical world of Greece and Rome, reflecting the Enlightenment values of the museum's origins. Thus, the British Museum,

as an institution of British society, was as much an artifact of its times – a reflection of British imperialism and pretention – as the objects in its displays were representative of antiquity.[17]

In the nineteenth century, key archaeologists managed to nudge the trustees, bit by bit, into a more expansive vision of human history. One example was the development of the museum's Department of Antiquities. Its origins are found in the Egyptian artifacts provided to the museum by Henry Salt, Britain's consul-general in Cairo. The trustees were initially reluctant to accept Salt's treasures, but public taste for non-classical antiquities was growing.[18] Beginning in the 1820s and especially after the 1840s, a rapid expansion in prehistoric discoveries around the world caught the imagination of the educated middle classes. The Department of Antiquities thus expanded its mandate, especially under the guidance of its second keeper, Edward Hawkins. Hawkins developed the department into one of the world's greatest collections of human artifacts. In 1839, the museum started to sponsor its own archaeological expeditions, beginning with Charles Fellows's work in Asia Minor. Other missions followed in the 1840s and 1850s, and helped forge the museum's focus on Assyrian studies. Gradually, the Department of Antiquities broadened its gaze. As late as 1850, the museum had only four display cases of Roman-era British artifacts, and another thirteen held a negligible collection of medieval curiosities. Hawkins increased the commitment to Britain's past, eventually leading to the establishment of a Department of British and Medieval Antiquities in 1866.[19] By the middle of the Victorian age, the British Museum had transformed itself from a collection of classical curiosities to the principal repository for British archaeological artifacts. It had embraced the use of material culture for the study of the national past.

Museums of America

Across the Atlantic, a similar museum culture was developing. According to Joel Orosz, American museums emerged as uniquely American institutions: unlike the aristocratic museums of Europe, they were compelled at an early date to be democratic. They were not the creations of the elites, but of the bourgeoisie, and they depended on "the people" to support them.[20] Orosz overstates the case, as there were broad similarities between American and British museums. Early American museums arose from private collections of curiosities based in the leading colonial towns, such as the cabinet of the Library Company of Philadelphia. They began to democratize only out of necessity following the American Revolution. The

first "American" innovation was the commercial museum. In April 1782, Pierre-Eugène du Simitière, a Geneva-born American painter, announced the opening of his American Museum in Philadelphia.[21] Chronically in debt and denied government aid, du Simitière opened his museum to the public, not in ideological support of the democratic ideal, but from a position of financial precariousness.[22] Yet despite being public, the American Museum was not particularly democratic. Admission was a steep fifty cents, tickets were limited to a few patrons per day, and tours were brief, following the model of the British Museum. Similarly, du Simitière shunned popular entertainments in his establishment, keeping his displays "scientific."[23] Some scholars, most notably Charles Coleman Sellers, have criticized the American Museum for being nothing more than a chaotic "magpie's nest" of objects.[24] However, this dismissal ignores both the nature of eighteenth-century cabinets and du Simitière's real contribution to the development of American public museums. Not only his "open" admission policy but also the restriction of the displays to American historical and natural history artifacts helped establish a tradition of the focused museum mandate. Although the American Museum did not survive du Simitière's death in 1784, it played an important role in the development of museums in these two areas.

The Philadelphia-based artist Charles Willson Peale was the next to embrace du Simitière's model. The two men had known each other in Philadelphia; indeed, Peale had visited the American Museum and could accurately recall its contents long after he opened Peale's Philadelphia Museum in 1786.[25] Peale wanted his museum to be a cultural and educational centre, and he stocked it with portraits of great men, scientific specimens, and assorted curios. He hoped to build a national museum supported by a handsome government subsidy.[26] Yet, at the same time, he recognized the importance of attracting a range of patrons and strove to create an institution that would appeal to both learned scholars and everyday people. With this in mind, he took on the mantle of the showman and exhibited outrageous and fantastic displays, often of abnormal biological specimens, although he felt that they detracted from the proper science of normal biota.[27]

Peale relied heavily on friends and public donations, but the public did not seem to share his tastes. As the donated objects came in, they turned his collection into a telling example of what people expected a popular museum to be. They were looking for "a wonderworld of the offbeat and weird, the two-headed pigs, the root resembling a human face, the knot

tied by the wind in a storm at sea. People [donated to the museum] what they themselves delighted to see."[28] Peale's museum also tells us something about public behaviour. He could not stop visitors from handling his delicate specimens – some might finger the feathers of a stuffed bird even while reading the notice asking them not to – so Peale developed glass-fronted cases to protect his treasures. His cases established a new standard for the display of specimens. Rather than simply place his collections in their display cases, he mounted his stuffed birds and animals in showcase settings that were designed to replicate their natural habitats.[29]

Peale's venue was not alone in expanding museum patronage through the open admission system. In 1791, the Tammany Society, more famously known as the political machine that controlled New York politics, opened its American Museum in lower Manhattan. At first, the Tammany Museum, as it was also known, was open only to society members and their families, but it too quickly adopted the open admission system for two days a week.[30] Accessibility, at least in theory, improved the financial security of museums, which was no doubt its primary goal. However, greater accessibility, appealing to both scholars and the families of working people (or at least those who could afford the admission fees) also advanced a more noble cause, one that museum proprietors were keen to trumpet. By providing a forum for the education of the lower classes, museums served a national purpose. Even the frequent recourse to the name "American Museum" suggests something of this. Museums became places where the material world was put to use for national education.

Like other museum proprietors, Peale found that the expansion of the open admission idea increasingly pushed him toward the role of showman. However, it was his son Rubens who greatly expanded the entertainment program when he took over management in 1810. Scientific education remained an important mission for the Peales, but entertainment fuelled the growth of the business. In 1825, Rubens Peale opened Peale's New York Museum (his brother Rembrandt had opened Peale's Baltimore Museum in 1814). The New York museum pushed ever farther into the entertainment business: included among its popular displays was Romeo, a dog that could bark answers to its handler's questions.[31] And, in 1828, Martha Ann Honeywell began a two-year run of appearances. Honeywell, who began performing at age seven, had been born without arms and legs but could entertain patrons by feeding herself, drinking from a glass, and executing simple tasks such as needlework.[32]

British North America lagged behind these developments. Little has been written about cabinets in Canada, although private collectors such as Montreal's Jacques Viger are well known. Early subscription libraries in Canada, such as the one established by Governor Haldimand in Quebec City in 1779, brought together middle-class gentlemen eager to expand their access to literature. Another opened in Montreal in 1796, and through the early nineteenth century, subscription libraries were established in British North America's principal towns.[33] There is little direct evidence that they also housed cabinets, but the fact that these same towns soon opened museums suggests a connection. A museum in Fredericton was even described as "the Library Museum."[34] At the very least, early libraries and museums were part of the same spirit of improving that gripped the nineteenth-century urban middle class.

In 1817, Newfoundland businessman Valentine Merchant briefly made his private cabinet available for viewing on Water Street in St. John's. During the following decade, Canadian museums opened on a more permanent basis.[35] In 1824, perhaps hoping to draw patrons to his Montreal tavern, Tommaso Delvecchio announced the opening of his Museo Italiano, essentially a cabinet of curiosities. Delvecchio had come to Canada from Italy late in the eighteenth century and was a Montreal innkeeper before 1800. By 1812, he was running the Auberge des Trois-Rois, one of Montreal's most popular establishments. However, construction of the New Market (today's Place Jacques-Cartier) may have siphoned off some of his business to the eastern end of the city. Delvecchio first proposed launching a museum attached to his inn in 1822. After trips to the United States to gather curiosities, he opened his cabinet in August 1824.[36] For a small fee, visitors could admire his collection of stuffed reptiles, birds, and mammals. Delvecchio also displayed wax figures of South American Indians, automatons, musical instruments, and many other curiosities, including "a lamb with eight legs, a pig with two bodies in its lower part, four ears, and eight legs, and a ram's head with four horns."[37]

Through the 1820s, proprietary museums like Delvecchio's opened across British North America. William Wood briefly displayed his natural history collections at York's market square in 1826. In 1827, Thomas Burnett added his Niagara Falls Museum to the growing tourist attractions of the waterfall.[38] More significantly, Pierre Chasseur established a natural history museum in Quebec City at about the same time. Although he came from a humble family, Chasseur appears to have been caught up in the cultural

and educational awakening then percolating in Lower Canada. However, unlike Delvecchio's Museo Italiano, his museum was not an unstructured cabinet of curiosities: it was scientific.[39] His collection included some six hundred specimens of birds, mammals, reptiles, and fish, arranged, as Peale had done, in ways that might evoke their natural habitats. He also included some Aboriginal artifacts and man-made curios, such as an axe used in a notorious murder case and, perhaps most famously, a bronze cannon retrieved from the St. Lawrence River and attributed to Jacques Cartier.[40] Unfortunately, even with these showpieces, people preferred Delvecchio's more sensational freaks and curiosities to Chasseur's scientific specimens. However, his respectability and his close political ties to the Parti Patriote helped him keep his venture afloat with subsidies voted by the Assembly in 1828 and again in 1830. Yet, constantly spiralling into debt, he was finally forced out of business and donated his collection to the government in 1836.[41]

Chasseur's case represents a wider problem for museums in North America. By the 1830s, they had reached a crossroads. In the United States, rapid expansion of material wealth and widening democracy helped forge a national identity and create a unique national culture. British North America, geographically and politically divided into separate colonies, all trailing the United States in population growth and commercial development, lagged. Nevertheless, in both societies, a growing urban middle class projected its values into movements to reform economic and cultural life by improving educational opportunities. Many reformers saw museums as lending themselves to education, and thus their democratization was associated with social uplift. Yet at the same time, entrepreneurs hoped to exploit the commercial opportunities generated by the growth of towns. Towns created markets for leisure entertainments, and North American museums came under increasing pressure to fulfill conflicting missions.

Constructing the Nineteenth-Century Compromise

Museum owners reacted to these developments with two major strategies.[42] The first and more profitable was to embrace the lowest common denominator and cater to the tastes of the masses. No example better characterizes this strategy than Cincinnati's Western Museum, a regional natural history museum that once employed John James Audubon as its taxidermist and illustrator. Established in 1820, it was originally a scientific museum at the centre of Cincinnati's intellectual life. However, its backers

soon found that science did not pay. Two years after opening, most of its original staff was gone, and it was sold to a shady character named Joseph Dorfeuille, who may or may not have been a French scientist, but who was most definitely a showman.[43]

Dorfeuille's Western Museum slid ever farther into popular entertainment. His greatest triumph was "The Regions of Hell," a series of wax figures inspired by Dante's *Divine Comedy*. This farcical "hell" consisted of an attic room, populated by a wax Lucifer with moving eyeballs, and numerous other displays intended to titillate the masses. While the clergy fretted, the public flocked to see the exhibition.[44] In New York, the great showman P.T. Barnum recognized the entertainment potential of museums and bought out what remained of John Scudder's American Museum. Transformed into a spectacle of American popular culture, Barnum's museum was sarcastically derided as "one of the most worthwhile and entertaining places typical of New York. Behind its magnificent name ... it displays a collection of all kinds of playful sense and nonsense to please children of all ages."[45] Barnum's displays of gypsies, albinos, dwarves, and assorted "freaks" was little more than a fairground sideshow capitalizing on customers' desires to see the victims of real (though sometimes fabricated) deformities and illnesses.[46]

The second option for museums was to embrace the mission of scientific education. This direction represented the growing importance of public museums, institutions supported by governments and endowments, over the more financially precarious proprietary museums of the early nineteenth century.[47] Joel Orosz calls this the "American compromise," a coupling of professional research with public education.[48] However, the compromise was never uniquely American in its inspiration or application. The British Museum was moving, albeit reluctantly, in the same direction. In America, the leading institution in the professionalization of museums was the National Institute for the Promotion of Science. Established in 1840, it was at first the repository for artifacts gathered by the Wilkes Expedition, authorized by Congress to explore and survey the Pacific Ocean basin. First housed in Washington's Patent Office Building, the institute's cabinet was subsequently combined with the mineral collection of the Columbian Institute. This museum's nucleus was given a boost in 1846, when an act of Congress authorized the creation of a national museum, using the bequest of British scientist James Smithson. Smithson's will left his wealth to the republic to create what became the Smithsonian Institution.[49]

On a much smaller scale, public initiatives were also under way in Canada. For instance, Chasseur's failure led to the creation of the first government museum in British North America. It did not last long. The collection was open to the public from 10:00 a.m. to 4:00 p.m. every day except Sunday. In 1841, when the parliament of the United Canadas relocated to Kingston, Chasseur's legacy was transferred to the Literary and Historical Society of Quebec. A decade later, when the roaming Canadian parliament returned to Quebec City, the expanding collection was set up in the new parliament buildings on the Côte de la montagne overlooking the Lower Town. In combination with the legislative library and its collections of historical documents, transcribed from European archives under the guidance of J.B. Faribault, it brought considerable scholarly prestige to the Old Capital. Unfortunately, the collection was lost in the Great Fire of 1854.[50] Yet, although Canada's first public museum was short-lived, the goal of establishing a national scientific museum was not. In 1841, the legislature of the newly created United Province of Canada had voted £1,500 to conduct a geological survey of the territory that would become Ontario and Quebec. It hired the well-known geologist William Edmund Logan to set up the Geological Survey of Canada, as it came to be known. As Logan and his team conducted their survey, they amassed a number of geological and biological specimens from across the colony and stored them in their Montreal offices. Some specimens became part of the popular Canadian displays, both arranged by Logan, at the 1851 Universal Exposition in London and again at the Paris Exposition of 1855. By that point, the idea of teaching from objects had won support from leading Canadian educators such as David Boyle and John George Hodgins.[51] Two years after the Quebec fire, and following the success of London and Paris, the assembly authorized the opening of a museum to display the survey's collection. In fact, Logan had been quietly doing this since 1844, when he rented a house on Great St. James Street in Montreal to serve as the survey's headquarters and laboratory. However, his focus had been on exploration and geological mapping.

Logan retired from the survey in 1869, passing on its direction to others. In the summer of 1875, George Mercer Dawson, the son of McGill University's principal, Sir William Dawson, joined the Geological Survey. Much to his father's dismay, Dawson's appointment kept him in the field in distant British Columbia, rather than at the survey offices in Montreal. However, field work in the west demonstrated the younger Dawson's skills and secured for him a reputation as an expert in theoretical and practical

geology, geography, and the emerging field of ethnology. The latter expanded the Geological Survey. Dawson included systematic ethnological inventories in his work to inform the government's Indian policies. For instance, his *Sketches of the Past and Present Condition of the Indians of Canada* (1879) connected the declining numbers of Aboriginal people to the apparent inevitability of European Canadians' political dominion over western Canada. From these works, especially in British Columbia, Dawson earned his reputation as "one of Canada's foremost contributors to ethnology" and as a "father of Canadian anthropology."[52] For the history of museums, Dawson's influence broadened the Geological Survey mandate and reveals how colonialism underwrote Canadian museums. By 1881, the survey's collection had become the nucleus of Canada's National Museum (although it took that name officially only in 1927) and was relocated to Ottawa.

The Rise of the Folk
The relocation of the Geological Survey's offices and collections was seen as a betrayal in Montreal, and Sir William Dawson took it particularly hard. Since his arrival at McGill in 1855, he had worked to build a natural history collection at the university, seeing the Geological Survey as a means to establish Montreal as a centre for research in geology. The departure for Ottawa struck Dawson as a personal betrayal, but he quickly regrouped. Aided by a donation from Peter Redpath, he worked to develop the Redpath Museum at McGill into an institution that combined the display of artifacts with education. When it opened in 1882, it included a theatre for two hundred students, a library, and meeting spaces for professional associations.[53] Two years later, the British Association for the Advancement of Science held meetings there, out of which emerged a committee for the study of the people of the Pacific Northwest. Between 1888 and 1894, this committee sponsored expeditions by another founding figure of anthropology, Franz Boas. Although unconnected to either the Redpath Museum or the Geological Survey, Boas's expeditions were crucial for the development of Canadian anthropology.[54]

Anthropology and its kindred field ethnology thus developed as adjuncts to natural history. Not surprisingly, anthropological artifacts were expected to perform the same educational function as their natural history counterparts. Objects were at the centre of museum anthropology, and their use demanded the same careful presentation and systematic arrangements that natural historians had developed earlier in the century.

Victorian ethnologists and anthropologists therefore used artifacts, however decontextualized they were in display cases, to stand in for entire cultures.[55] At the National Museum, George Dawson began to lead anthropological surveys in 1897, but progress sputtered after his sudden death from bronchitis in 1901. The museum itself continued to grow, eventually moving from inadequate space in a former hotel to the Victoria Memorial Museum Building.[56] In 1910, the Geological Survey hired recent Columbia University graduate Edward Sapir to lead its new Anthropology Division. Sapir, a student of Boas, was an expert in Aboriginal linguistics, a dedicated field researcher, and an energetic leader. Under his direction, which lasted until he left to teach at Columbia in 1925, the division rapidly expanded. Sapir hired the first generation of Canadian anthropologists, including Harlan Smith, Marius Barbeau, and Diamond Jenness. Of the three, Barbeau has had the most lasting impact on the development of Canadian folklore and, though peripherally, on living history museums. According to two of his biographers, by the end of his life, Barbeau was "Canada's best known folklorist and anthropologist."[57]

Marius Barbeau was born in 1883 in Sainte-Marie, a village some fifty kilometres south of Quebec City on the Chaudière River. Like many young French Canadians, he planned to join the priesthood but later opted for a law degree at Université Laval. In 1907, he won a Rhodes Scholarship and joined a host of other young Canadians at Oxford University, where he studied anthropology, archaeology, and ethnography at Oriel College while also pursuing courses at the Sorbonne. Originally interested in Egyptology, he was discouraged from following this path by the resident anthropologist R.R. Marett, who felt there was more potential for the young Canadian in North American anthropology. During his sojourns in Paris, Barbeau met the French anthropologist Marcel Mauss, who also helped convince him to study the folklore of North American Aboriginal peoples.[58] Returning to Canada as one of Oxford's first graduates in anthropology, Barbeau quickly secured a position in the Anthropology Division, starting only four months after Sapir himself. He focused his research on the Wendat (Huron) people as well as on Pacific coast nations. However, while recording folk music at Lorette, a Wendat community near Quebec City, Barbeau also became interested in the folk customs of his own people. In collecting Wendat folk songs, he encountered aspects of French Canadian folklore and grew increasingly aware of the intermingling of Aboriginal and Canadien cultures. A chance meeting with Boas in 1913 convinced him that a study of the folklore of French Canada

would also be fruitful.[59] Boas shared with Barbeau a belief that Ernest Gagnon had not exhausted the repertoire of French Canadian folk songs in his classic collection, *Chansons populaires du Canada*.[60] Field work quickly proved the assumption correct, and Barbeau soon convinced the Anthropology Division to expand its program into the folk music and handicrafts of French Canadians and eventually English and German Canadians as well.[61]

Victorian ethnologists were greatly influenced by the cultural exhibits of the era's many world's fairs, which offered a fascinating taste of the authentic life of exotic peoples.[62] At the 1876 Centennial Exhibition in Philadelphia, Spencer Baird of the Smithsonian organized ethnological exhibits of American Aboriginal groups. The show also introduced the American public to the cultures of faraway lands and scandalized many with exotic dances and displays. However, no fair had a more lasting impact than the World's Columbian Exposition of 1893. Under the direction of architects Frederick Law Olmsted and Daniel Burnham, the Chicago World's Fair was a monument to the City Beautiful movement then becoming prominent in American urban planning. Its temporary public buildings, laid out in a landscaped setting, established the burgeoning neoclassical and Beaux-Arts styles. Covered in white stucco and illuminated at night by electric light, the fair's "White City" offered a stark contrast to Chicago's sprawling tenement blocks. It also walked a balance between entertainment and the dissemination of knowledge. One of its legacies was what became the Field Museum of Natural History, but the nearby Midway Plaisance offered more popular amusements, including George Ferris's observation wheel, concessions, and sideshows. Sprinkled among the midway's amusements were a series of folk villages and performers, often of dubious authenticity, imaginatively depicting "primitive" peoples from around the world and helping to popularize ethnology.[63] In this popular guise, ethnology mirrored natural history museum practices of displaying "specimens" in environments that evoked their "natural habitats."

At the same time, anthropology was drifting away from its origins in museum ethnology. Museums continued to look to the universities to staff their growing anthropological interests, but under Boas's influence, anthropologists lost faith in the power of objects to inform understanding and slowly distanced themselves from museum matters.[64] Boas himself had worked in both museum and university environments: he had been a curator at both the Field Museum and the American Museum of Natural History. However, after 1905, he became increasingly disillusioned with

museum work and focused on his appointment at Columbia University. His followers likewise grew disenchanted and became wary of the ethnologist's attempt to use primitive societies to demonstrate the progressive development of human civilizations. The worldview of many Victorians was premised on a hierarchical continuum between savagery and civilization, which could be scientifically measured and categorized. From this conviction, it followed that a museum should use artifacts to teach lessons about progress and civilization (and savagery).[65] Boasians, in contrast, rejected as artificial the long-standing division of cultures into such categories as "savage," "barbarian," and "civilized." However, the split also reflected a deflation of the so-called American compromise. Museums continued to emphasize, and indeed expand, their commitment to public education, using objects and displays to tell readily grasped stories about other cultures. Academic anthropologists no longer believed that objects held such power and turned increasingly to sophisticated theories and complex theses, as the discipline became progressively tied to university departments.[66]

However, the vogue for folklore was not confined to scholars who worked in ivory towers. By the first decades of the twentieth century, folklore studies were in full bloom, and Barbeau and the National Museum assumed a leadership role. Barbeau was never Canada's most sophisticated anthropologist. Even if he enjoyed a solid reputation among the scholars of his own day, his theories have not survived more recent scrutiny. But his public outreach, an area where he truly excelled, made him not just a pioneer in his academic profession, but someone who made a major contribution to developing Canadian identity in the early twentieth century. Folklore quickly became popular and helped museums bridge anew the gap between education and entertainment. Interest in the displays at world's fairs helped popularize the very notions that Boasian academics rejected.[67] In popular understanding, racial types existed and Victorian schemes of categorization could be applied to their cultures. For instance, folk song collectors sought out purity in their recordings of old-time songs, mimicking the stress placed on authenticity by the canonical folk song collector Francis James Child. Folklorists saw cultural change as the equivalent of corruption.[68]

Interest in folk culture, perhaps paradoxically, expanded with modern technology. Barbeau was among those folklorists who seized on the opportunities that technological innovation provided. In the spring and summer of 1919, he travelled around Quebec and French-speaking parts

of Ontario, giving lectures and organizing concerts of folk songs he had collected during his field work the previous year. He employed the new technology of radio to bring folk music to the masses. Alongside the Montreal archivist Edouard-Zotique Massicotte, he launched a series of radio performances of folk music that became the famous Veillées du bon vieux temps (Evenings of the Good Old Days), which launched a number of recording careers, including that of Quebec's most renowned folksinger, Mary Travers.[69] Through the 1920s, folk song remained popular among French Canadians. It also began to reach anglophone Canadian audiences, who saw in the various cultures of Canada's immigrant groups an exotic and quaint "other." Barbeau continued to popularize anthropology by working on two motion pictures that portrayed the culture of Pacific coast Aboriginal peoples, *Nass River Indians* and *Totem Land*, both of which accompanied an important exhibition at the National Gallery.[70] Toward the end of the decade, Barbeau had a hand in popularizing the song and dance of Canada's Ukrainians, Poles, and Dutch, among others. Working with J. Murray Gibbon of the Canadian Pacific Railway, he organized a series of sixteen folk festivals at CPR hotels across the country. Such festivals allowed cultural authenticity to be performed, and they helped bring cultural categories and notions of cultural purity to life. By the mid-twentieth century, as Ian McKay argues with more than a touch of irony, the folk had become a veritable industry.[71]

From the Folk to Living History

Similar trends were well established in Europe, where interest in the folk can be traced to the eighteenth- and early-nineteenth-century European nationalisms characterized by the works of Johann Herder and the Brothers Grimm. However, in the late nineteenth century, folklore took on a new mantle among Europe's intellectuals and educated middle classes. Folklore and the celebration of folk culture offered Europeans tangible links to "authentic" national identities in a rapidly modernizing world. Obviously, Europe had no Aboriginal population of its own, so its anthropologists and ethnologists turned their attention to the romanticized primitive life of so-called simple peasants. Romanticism's grip on European nationalists cast the peasantry as the "true" or "pure" folk. Among aristocrats, the fascination with the peasant past produced the replica peasant homes that adorned royal parks and estates. By the end of the nineteenth century, this practice had evolved into the building of replica villages that served as open-air museums.

Most studies of living history museums cite Skansen, which opened in 1891 on Djurgarden Island near central Stockholm, as the first open-air museum. As Sten Rentzhog puts it, "Skansen in Stockholm – it is there we have to begin."[72] However, Skansen was not the first open-air museum. It was partially modelled on an open-air museum established in 1881 near Oslo, later incorporated into the Norsk Folkemuseum that grouped together a series of buildings intended to demonstrate Norwegian construction styles from the Middle Ages to the modern era.[73] However, Skansen pushed the idea farther. Under its visionary builder, Artur Hazelius, it became not only the model for Europe's living history museums, but lent its name to the concept of the open-air museum.[74]

Like many middle- and upper-middle-class Europeans, bourgeois Swedes were alarmed by the social upheavals produced by the Industrial Revolution and its accompanying political revolutions. Across Europe, as in Canada and the United States, people who were concerned with social turmoil turned to the imagined simplicity of the rural folk to offer a comforting myth of stability. Hazelius came from a patriotic Swedish family. His father was a high-ranking military officer and nationalist, who travelled in Sweden's elite political and intellectual circles. Hazelius inherited his father's love for his homeland and developed his own romantic vision of the rural Swedish peasantry, ideas he carried with him to his studies at Uppsala University.[75] Doctorate in hand, he became a lecturer in language and literature, as well as a language purist, joining a movement to rid Swedish of foreign words.[76] He seems to have become interested in folklore by 1870. On his travels in Scandinavia, he collected the artifacts that eventually formed the nucleus of the Nordiska Museet, or Nordic Museum, which he established in Stockholm in 1873.[77] With a parliamentary grant awarded in 1875, Hazelius accelerated his collecting scheme, expanded his displays, and sharpened his idea for a folk museum. Like Peale, who had displayed stuffed birds and reptiles in their "natural habitats," Hazelius used historical period rooms to stage dramatic or sentimental tableaux of the folk.[78] He also took his displays on the road. He reproduced one sentimental scene, a Swedish family mourning the death of an infant, at the Philadelphia Centennial Exhibition in 1876. This scene joined a collection of thirty "living paintings" set up at the 1878 Exposition Universelle in Paris, where Hazelius worked out his idea to place his tableaux in a village setting.[79] By 1888, he was working on a plan to gather together in one place the landscape, flora, fauna, and folk of a romanticized rural past.[80] He had several models to work from, but what made

Skansen unique was Hazelius's approach of coupling artifacts with their functional context. In this, he linked the artifact to people, events, and places in a novel way. Upon opening in 1891, Skansen was immediately popular. In the years before the First World War, some 500,000 people visited annually.[81]

Skansen's celebration of the folk served a political need, and it was quickly copied across Europe for similar reasons.[82] Many European nations, particularly in eastern and central Europe, planned to open permanent museums in the years leading up to the war. They were connected to nationalist aspirations for independence among Finns, Ukrainians, Czechs, Hungarians, and Estonians, living under the empires of Russia and Austria-Hungary.[83] Celebrating the folk, especially in these multi-ethnic empires, helped justify nascent nationalist movements. In North America there was no comparable push to establish new ethnic nations, and consequently ethnology and folklore played a less direct, although still important, role in the development of living history museums. Ethnology and folk studies influenced the collections of North American museums and encouraged Canadians and Americans to reconstruct others' villages at world's fairs and exhibitions but did not inspire them to rebuild replicas of their own ancestors' homes. Thus, although many scholars cite Skansen as the original living history museum, its influence in North America was primarily rhetorical. Few US museums are based on Skansen. American living history museums emerged from historic preservation and, in particular, the historic house museum.[84]

Historic Houses and Reconstructions
In 1848, the same year that the cornerstone of the Washington National Monument was dedicated in Washington, DC, John Quincy Adams died. The sixth president of the United States and the son of its second president, Adams began his political career under George Washington himself. His passing represented the closing of a chapter of American history and the final severance with the revolutionary era and the early republic.[85] The realization that the last heroes of the revolutionary period had passed into memory spurred the mid-century interest in house museums and the preservation movement that saved many old homes from destruction.

Patricia West argues that the early house museum movement was supported by conservative women who sought to reinforce women's private, domestic role. Yet, the preservation of domestic shrines also attracted activist women, seeking to expand the domestic role as a part of social

reform.[86] Both sides attempted to connect an idealized domesticity to a regeneration of American society, which was undergoing profound – and for some frightening – social, economic, cultural, and political changes. Alongside electoral and territorial expansion, the commercial revolution, and continuing division over slavery, a rekindling of domestic values was a form of conservative social salve. For example, a cult developed in the early nineteenth century around the memory of George Washington and reached its apogee as American civilization seemed to be collapsing into civil war.[87] Not surprisingly, sites associated with Washington were an early focus of the preservation movement. In 1850, his headquarters in New-burgh, New York, became the first American historic house museum.[88] A decade later, Washington's Mount Vernon home was another major target of house preservationists.

The first calls to save Mount Vernon's crumbling mansion were linked to ideas of social improvement, but the spectre of northerners interced-ing on sacred southern territory galvanized the first real efforts. In 1853, Ann Pamela Cunningham, a self-styled "southern matron," appealed to southern women to save Washington's tomb and home from spoliation. This call led to the creation of the Mount Vernon Ladies Association (MVLA), which broadened its mandate to include women of the north. Cunningham's appeal called on a universal femininity rooted in women's domestic role and ability to rise above sectional divide. Constrained by the gender norms of the nineteenth century, women were largely excluded from the more powerful historical and patriotic societies. In this environ-ment, the preservation of historic houses was regarded as their domain, though men controlled its ideological content.[89] The MVLA itself relied on the fundraising aid of Edward Everett, a Massachusetts Whig.[90] Lying behind the overt sectional divisions of north and south was an implied vesting of republican purity among the patrician families that could trace their bloodline to the revolutionary age and who could restore American culture to its proper deferential state. However, north and south divided within the MVLA regarding exactly what needed to be preserved in the nation that Washington helped forge. For Cunningham and many southern women, the constitutional states' rights (including that of slavery) were in need of defence. Everett, on the other hand, played on Jacksonian-era concerns about democracy and mob rule, and suggested that a voluntary association, guided by women and therefore aloof from partisan politics, could safeguard proper values at a national shrine to the founding presi-dent. At a time when the Union itself was in doubt, this was especially

appealing. The MVLA acquired Mount Vernon in 1858, but the Civil War delayed restoration work. Mount Vernon sat on the Potomac River, right on the boundary between Maryland and Virginia. But it was sacred to both sides and survived unscathed as battles raged nearby.[91]

Mount Vernon was a landmark in the preservation and house museum movement. It helped cement a female role in the protection of national heritage. It was not the first such museum, but Cunningham's energy and drive inspired other groups to rally around other houses. The success of Mount Vernon and its nationwide fundraising campaign drew attention to the wider goal of historic preservation.[92] The number of preserved historic houses grew during the second half of the century, particularly in the northeast and in the south. Of course, for much of the United States, the nineteenth century was still "pioneer times," and structures that are now considered historic were still in use. The focus of preservation and interpretation remained fixed on the founding fathers and the American values that patrician Victorians believed they had established. Indeed, despite the popularity of ethnology, folklore, and folk life, the relics of great men were key features of early house museums.[93]

Again Canada lagged, though it followed a similar pattern. The first Canadian historic house museum was Montreal's Château de Ramezay, a French regime manor built in 1705 by Claude de Ramezay, governor of Montreal. In 1891, on the occasion of the Royal Society of Canada's annual meeting held in Montreal, the Antiquarian and Numismatic Society of Montreal proposed converting the chateau to a museum of historical artifacts, which was accomplished by 1893.[94] A few years later, the Women's Wentworth Historical Society (WWHS) organized to preserve Battlefield House, the Gage family farmhouse that American troops had occupied as their headquarters during the Battle of Stoney Creek in the War of 1812. By the end of the nineteenth century, the house was dilapidated, and Sara Calder, a granddaughter of the original owners, rallied history-minded women to its defence. Rather than let it be torn down, they raised the money to purchase and restore it as a public museum. Although chronically plagued by financial problems, the Battlefield House Museum was an important local institution. Centred on 17.5 acres of parkland, the home became a focus of patriotic celebrations. Early in the twentieth century, a memorial and observation tower were built on the grounds, and the house became a period showcase for relics of a patriotic past. Unfortunately, the building (not to mention the memorial) was "in constant need of repair and consequently the museum ... suffered."[95] Financial

difficulties continued to dog the WWHS into the 1930s, and repeated appeals for government support solicited only minimal funds. The museum eventually passed into the hands of the Niagara Parks Commission and more recently has become the responsibility of the City of Hamilton.

By the early twentieth century, the house museum was commonplace in the northeastern states and eastern Canada. They were so popular that in 1933 the American Association of Museums published a guide to opening new ones.[96] Typically, these houses presented period reflections on the lives of past local community leaders. In part, this was simply practical. The homes of the wealthy and powerful were frequently more durable than those of everyday people. However, the trend also reflected a tendency in museum interpretation to stress conservative values. Patrick Wright has similarly connected the 1895 establishment of the English National Trust to efforts to reconcile private property rights with traditionalist values encompassed in historic places. Once national interest could be established as a public concern that did not threaten private property, English conservatives were able to embrace the preservation movement and hold it up as their own.[97] But, nowhere was the early preservationists' focus on patrician values more evident than at Williamsburg, Virginia.

The story of Colonial Williamsburg is well documented and well known. It was the product of Dr. William Archer Rutherford Goodwin, an Episcopalian minister who was alarmed at the pace of urban development brought about by the automobile in the 1920s. By that time, Williamsburg had become just another highway town, and its colonial-era architecture was almost lost. But Goodwin saw it as the "cradle of the Republic" and the "birthplace of her liberty." He was convinced that its public buildings and stately homes could be preserved as a window on Virginia's colonial past and indeed America's colonial heritage. He approached many of the country's greatest philanthropists, including members of Henry Ford's family, appealing for aid. The countryside had been spoiled by the triumph of the automobile, and Ford was the principal beneficiary. He had already committed himself to building Greenfield Village in Dearborn, Michigan, but Goodwin believed that the automobile magnate owed a debt to the nation. Ford flatly refused to help. Undaunted, Goodwin pushed on to other philanthropists and finally convinced John D. Rockefeller to support him.[98]

Rockefeller had committed himself to historic preservation in 1923, when he donated $1 million for the restoration of French chateaux at

Versailles, Fontainebleau, and Rheims. He was particularly pleased to learn that his money was used to restore Marie Antoinette's mock peasant village.[99] At Williamsburg, Rockefeller's approach was more clandestine. He authorized Goodwin to buy up, quietly and anonymously, property throughout the colonial centre of the town. When Goodwin finally revealed the man behind the purchases, some southerners were offended by a Yankee intrusion onto Virginian history. However, at a public meeting in June 1928, Goodwin argued that the restoration project would provide benefits, both spiritual and material. More importantly, Goodwin, Rockefeller, and a host of consultants convinced the (white) people of Williamsburg to reimagine their heritage and their past. In this way, they helped reorient local identity from an association with the Confederacy to one connected to the more nationally palatable colonial era and the American Revolution.[100]

By selecting a cut-off year of 1790, Rockefeller and his experts attempted to freeze Williamsburg in a particular vision of the past. The organization proceeded to demolish all 720 post-eighteenth-century buildings, restore the surviving 88 structures, and, following meticulous historical research, erect 341 "period" buildings. Accuracy was the watchword of the day. In one case, when further research discovered that a house had been built six feet off its original foundations, Rockefeller paid to have it moved. No one would be allowed to question the integrity of the project. When the work was completed in the mid-1930s, Colonial Williamsburg had cost nearly $80 million. The Commonwealth of Virginia was delighted, naming Rockefeller an honorary citizen, a distinction he shared only with the marquis de Lafayette.[101]

In contrast to the house museums and historic preservations that preceded it, Williamsburg was an effort to recreate the entirety of a past environment. Explaining his motivations in the 1930s, Rockefeller argued that restoring a single house was of little value if its surrounding environment had changed. Williamsburg, on the other hand, represented the restoration of an entire area and its preservation from the pollutants of the present.[102] Here was a belief in the purity of the past, and a belief that, in some way, such purity might be recaptured. Colonial Williamsburg pushed this belief to extremes. It did not claim merely to borrow or mimic the past – it offered to recreate a historical period in its entirety. Yet, the Williamsburg of the 1930s was a highly selective past that privileged the position of a tiny minority of colonial society.

Rockefeller was not remotely interested in portraying the lives of ordinary people and certainly not the lives of the real Williamsburg's African

Americans. His Williamsburg was a town of colonial elites. As with other museums, the attempt was to educate the masses, this time reconnecting them with the "true" culture of America. Williamsburg's original statement of purpose, which was written in consultation with Rockefeller, argued that costumed interpreters and an authentic three-dimensional environment were essential to understanding fully the life and times of early Americans and their contributions to the culture and ideals of the United States. Culture, in this case, meant high culture, and the ideals might be translated as the concepts of self-government and individual liberty, as elaborated by the great patriots, Washington, Madison, Henry, and Jefferson.[103] The town commemorated the planter elites that had dominated American society until the Jacksonian era, presenting them as progenitors of timeless ideals and values. They represented the "very cradle of that Americanism of which Rockefeller and the corporate elite were the inheritors and custodians."[104]

Nevertheless, North American interest in folk culture also played a role in the emergence of living history museums. Before Rockefeller began the Williamsburg project, Henry Ford was working on his own open-air museum in Michigan. He began collecting in about 1919, when he discovered that his family homestead was to be demolished for a new road. Once he had safely relocated and restored his childhood home, Ford caught the bug for collecting and, only a few years later, had become the country's biggest buyer of Americana. He also moved to Michigan buildings he deemed historically valuable. In 1928, he decided to relocate his mentor Thomas Edison's Menlo Park laboratory complex from New Jersey to Michigan to make it the centrepiece of a museum of American ingenuity. The following year, President Herbert Hoover dedicated what became Greenfield Village.[105]

By June 1932, the date of its official opening, Greenfield Village contained nearly a hundred structures that had been relocated from throughout the United States. They represented three centuries of American popular history, and they included a replica of Philadelphia's Independence Hall, the one-room cabin where William Holmes McGuffey was born, the more comfortable home of Noah Webster, a seventeenth-century forge, and the Wright brothers' bicycle shop. Some of the choices were more whimsical: one house was the cottage where Mary of "Mary Had a Little Lamb" fame might have lived. Using his enormous wealth, Ford amassed an unrivalled assortment of artifacts to furnish his buildings. And his museum, displaying his collection of engines and vehicles, allowed

visitors to follow the story of American technological progress leading up to the (Ford) automobiles of the 1930s.

This dedication to preserving American history at such enormous expense might appear an odd legacy for a man who once denounced history as bunk. But Henry Ford's famous adage is frequently misquoted. Although he repeated the comment many times, he consistently meant that history, as then written to cover only war and politics, was bunk. For Ford, real history involved the lives of people, technological innovation, and common experience. There was a method to his assemblage. Like Rockefeller, Ford had absorbed the Victorian lesson that the written word could not convey the past as faithfully as the material artifact. Objects were the tangible remnants of the past, and they could transmit its meaning, unmediated by academic scholarship, directly to the visiting public. His museum brought relics of this history together into one place. But Greenfield was also replete with ironies. Ford, whose wealth derived from the technological innovations that were most characteristic of modernity, applied his wealth to the salvation of pieces of the past that modernity had trampled underfoot. He embraced the common man, yet his village assembled into one magical "neighbourhood" the homes of exceptional people. Amidst all this irony was a remarkably sentimental vision of the past as a tranquil time free of strife.[106]

Together, Colonial Williamsburg and Greenfield Village became the prototypes for living history museums in North America. Yet, the two have quite distinct approaches. Williamsburg recreated a specific place and time, whereas Greenfield aimed at a broader sweep of America's pre-industrial history, choosing representative pieces from a range of periods and places. Their purposes differ as well, and in this, like all open-air museums, they share the legacy of the nineteenth-century museum compromise: Greenfield is first and foremost a tourist attraction with a vocation for public education, and Williamsburg combines its commercial function with an important centre for scholarly research, which is connected to the College of William and Mary. Most major living history museums that followed, such as Plimoth Plantation (opened in 1947), Old Sturbridge Village (1946), and Deerfield Village (1952), borrowed from the spectrum offered by Williamsburg and Greenfield. Canadian museums likewise turned to these American examples, not across the Atlantic to Skansen.

Like the museum innovations that came before it, living history represents a particular interpretation of the material world. Williamsburg and

Greenfield show how a set of late-Victorian intellectual currents came together to influence ideas about the preservation or reconstruction of past environments and the proper display of human history in the twentieth century. They demonstrate a progression from the effort to link material artifacts with knowledge about the past to a recognition that artifacts require context to be meaningful. Historic houses and interest in folk culture helped flesh out the context. Both Ford and Rockefeller felt that the history taught in books was insufficient. They believed that tangible objects and the ambience and environment of past reality provided for a greater understanding. These ideas lay at the root of living history. Despite their conservatism, they were quite progressive for their day. Williamsburg and Greenfield were, as Rentzhog suggests, a new form of museum. Yet at the same time, they retained many features of traditional museums. They continued to separate the past from the present by segregating it in a special place – the museum building. But the attempt to recreate the look, feel, touch, and smell of past environments illustrates a uniquely modern faith in the relationship between knowledge and material reality.

2

The Foundations of Living History in Canada

AMBIVALENCE ABOUT AMERICAN modernity underlay the development of both Greenfield Village and Colonial Williamsburg. Although Ford and Rockefeller made their fortunes on automobiles and oil – quintessential products of the twentieth century – their desire to preserve disappearing values reflects uncertainty about the benefits of modern life. Anxiety regarding the effects of the rapid social change that characterizes modernity exposes one irony about the origins of living history museums. On the one hand, modern development alters the material world in which we live, replacing the old homes and farmsteads of yesteryear with skyscrapers and highways. A sense of loss drove Henry Ford to rescue his boyhood home and then to save relics of an America that his own corporate success had helped to push aside. This type of nostalgia reinforced interest in the past during the years of North American expansion at the dawn of the twentieth century. At the same time, the modern consumer market creates competition for leisure activities, thus diminishing the power of the past to reach our consciousness and inform our identity. Recognition of development's assault on historic landscapes and townscapes spurred some people to preservation efforts that took the form of innovative leisure parks. Thus, the effort to preserve the built heritage often took the form of altering it and dramatically changing its use.

There is another irony hidden in the rise of Canadian living history museums. The obsolescence of colonial Canada's military heritage in the twentieth century necessitated that old forts be torn down or put to new uses. Often, "old forts" were a locale's oldest (and thus most "historic") architectural artifacts, and they caught the attention of preservationists. In the United States, living history can trace its roots to historic house preservations, expanded to create the imaginative domestic worlds of Ford and Rockefeller. Canadians were also moved to rescue historic houses, but they did so on a much smaller scale. Instead, Canada – the "peaceable kingdom" – turned first to saving relics of its military and expansionist

history. Certainly, Americans also celebrated their martial past and preserved historic forts, even in the midst of modern urban development, such as lower Manhattan's Castle Clinton. But in Canada, perhaps due to the relatively more recent settlement history in much of the country, the relics of European occupation most often deemed historic were the old French, British, and fur trade forts.

Living history, the animation of historic sites with period costumes and crafts, began in Canada at those fur trade and military relics. The first salvage efforts came with the waning of the Victorian age. As the example of Toronto's Fort York reveals, the Canadian preservation movement developed out of anxieties over perceived changes in national values. Rescuing the heritage of the past was thus a means to preserve and promote its, particularly British, values. During the first decades of the twentieth century, this impulse drew governments into the protection of sites and structures that were sacred to Canada's historical development. Yet, at the same time, the ability to reproduce the material environment of the past represented the era's confidence in technical and intellectual prowess. At first, the push for preservation came from traditional late-Victorian leaders. But as the century progressed, self-proclaimed and often self-trained experts stepped forward to pilot the twentieth century's reconstruction of the past. Perhaps ironically, the emergence of the expert and his (primarily his) confidence coincided with the 1930s collapse of faith in classical capitalism's ability to secure prosperity.

Preservation against Progress

The former British fort at York, which came to be known as Fort York during the 1930s, is one of the first examples of this phenomenon. It also demonstrates how the interplay of progress and preservation can affect local heritage. The first British fort that protected York, built by Upper Canada's first lieutenant-governor, Sir John Graves Simcoe, was captured and burned in the War of 1812. Following the war, strategists on both sides of the border recognized that the American failure to sever communications along the St. Lawrence River had been key to Upper Canada's survival. Britain thus devoted much of its post-war defensive energies to eastern Ontario and southern Quebec. Fort York's strategic role was the protection of a secondary route from Lake Ontario to Georgian Bay, or possibly to cover a retreat in the event of another invasion through Niagara. Engineers rebuilt sections of the fort, but as technological and diplomatic

realities changed, its strategic value slipped away.[1] Neglect characterized the fort's nineteenth-century history, as disuse and urban development became its principal enemies. Fort York faced destruction three times, not by enemy forces, but from the ravages of modernity and progress.

The first major challenge to its survival came in the opening decade of the twentieth century.[2] In October 1903, the Department of Militia and Defence sold the garrison common and fort to the City of Toronto for $200,000, stipulating that the site must be used as a park. But shortly afterward, the City imagined converting it into a parkway that would link the Canadian National Exhibition (CNE) grounds to the main railway terminus at Union Station. This was part of its interest in promoting the CNE to enhance Toronto's metropolitan prestige. The CNE, as the old Toronto Industrial Exhibition was styled from 1904, had occupied lands on the shore of Lake Ontario at the western end of the garrison common since the 1870s and had gradually expanded. At that time, the Toronto waterfront was overrun by railway lines that limited public use. Inspired by ideas of the City Beautiful movement, especially as seen at the 1893 Chicago World's Fair, plans involved building a broad boulevard, punctuated by a graceful fountain, to connect the train station to a terraced esplanade along the lakefront. This proposal would have entailed demolishing a number of the old fort's buildings. However, faced with a more pressing need to replace its crumbling exhibition halls, the CNE soon dropped the parkway plan.[3] City fathers still felt that linking the exhibition grounds to Union Station was an urgent matter, as visitors poured into the city during the August fair. So bureaucrats devised a second plan that threatened the heart of Fort York. The City proposed a streetcar line that would run from Union Station through the fort to the CNE. Such a plan appeared to violate the agreement with Militia and Defence, but that had already been breached, apparently without public comment, by the demolition of the glacis of the southeastern bastion to make room for a slaughterhouse.[4]

At first, there was little opposition to the new streetcar scheme. However, by 1905 several local newspapers had raised the alarm. In October, the *Toronto Globe* published an appeal from a local schoolteacher, Miss Jean Earle Geeson, to save the old military buildings.[5] The article roused a general outcry and spurred the Ontario Historical Society (OHS) to action. Under its leadership, a broad public movement coalesced to protect the fort from what the *Toronto Evening News* declared was commercialization's destruction of national heritage.[6] Aided by the intense

pressure from the daily press, with the *Toronto Star* and the *Toronto World* joining the *Globe* and *Evening News,* the OHS convinced the mayor and city council to table the plan. However, a large parcel of open land along the city's waterfront was too valuable not to develop. The OHS mobilized again early the next year against a Grand Trunk Railway scheme to use the fort for a shunting yard, and the City unveiled plans to extend Bathurst Street south to Lake Ontario, with yet another streetcar line threatening Fort York. Convinced of the need to extend Bathurst Street, city council called a plebiscite for New Year's Day, 1907. The OHS campaigned energetically in the weeks leading up to the vote. Yet, although voters rejected the extension, probably due to cost rather than heritage, the City persisted with the venture. The battle waged on. One OHS member, Frederic Barlow Cumberland, set up the ad hoc Old Fort Protection Association to pressure politicians and planners. Moved by concerns about rapid immigration, Cumberland sought to protect Fort York as a tangible reminder of Canada's British past. It was, in his words, "an heirloom of Empire" that would strengthen Canadian patriotism and teach newcomers about crucial values.[7] Finally, Sir Wilfrid Laurier intervened and put an end to the battle. Fort York was saved, if only for the time being.[8]

The fight to save Fort York inspired Cumberland and the OHS to broaden the struggle for historic preservation across Ontario.[9] Within a few years, the OHS happily noted success in "arousing the interest of those concerned in the preservation and restoration of historic sites and landmarks throughout the Province."[10] Across Canada, historical societies sought to salvage relics in the local landscape, often linked to events of political or military history. One example was Fort Beauséjour in eastern New Brunswick. Built by the French in 1750, it played a role in the Acadian expulsion, as the Acadians who were found there provided a pretext for mass deportation. Renamed Fort Cumberland by the British, it had been left to deteriorate. By the early twentieth century, when local residents became interested, all that remained was some earthworks and a British powder magazine. In 1902, the military erected a fence around the fort to help preserve it, and in 1913 the Department of Public Works was consulted on the possibility of a restoration. The start of the First World War scuttled the plan.[11]

Despite the clear interest, local advocacy had only limited success. Many people believed that a more centralized body was needed to galvanize the spirit of preservation. Even the OHS relied primarily on the prompting of local societies to learn about endangered sites. When in 1901 England's

National Trust asked the Royal Society of Canada (RSC) to help fund the purchase of English historic properties, it inspired the RSC to emulate the effort in Canada. At its annual meeting that year, the RSC set up its own Committee for the Preservation of Scenic and Historic Places in Canada.[12] Its members were all late-Victorian men of letters, such as Benjamin Sulte, James McPherson Lemoine, George Taylor Denison, and John George Bourinot, and they were particularly inclined toward the preservation of historic rather than scenic places. This was the first "national" organization aimed at promoting the built heritage of the country.

By 1907, the preservation committee was caught up in the governor-general's hope to celebrate the three hundredth anniversary of the founding of Quebec. The RSC held a convention in Ottawa that produced the Historic Landmarks Association (HLA), which broadened the appeal of historical preservation. Initially, its focus was on developing the Plains of Abraham into a park to save the site of the "Conquest of Canada" from urban encroachment that had already seen a jail and a rifle factory blot the landscape. However, Ottawa's establishment of the National Battlefields Commission in early 1908, a story told in greater depth by H.V. Nelles and Ronald Rudin, made the HLA's work redundant, and it recast itself as an umbrella group for local historical societies.[13] Its main effort involved developing a national inventory of historic sites, relying on local societies to provide information and take any initiatives. By 1915, when the HLA issued its first annual report, it had accomplished little of substance.[14]

National Treasures

The success of the National Battlefields Commission in securing the Plains of Abraham had been invoked by Barlow Cumberland in his defence of Fort York, but it was more forcefully marshalled by supporters of historic preservation in Nova Scotia. The ruins of Louisbourg, on Cape Breton Island's rocky Atlantic coast, drew the attention of late-Victorian historians and imperialists anxious to consecrate the site of one of the British Empire's most important military victories. Louisbourg was an eighteenth-century seaport, constructed by the French after the 1713 Treaty of Utrecht had deprived France of its Newfoundland fishing bases. As the town grew, so did its importance in French imperial strategy. By mid-century, Louisbourg was key to the military plans of both France and England, who recognized its position at the entry to the Gulf of St. Lawrence as crucial for the protection of New France. Twice besieged, Louisbourg also fell twice. Some of its relics were carried off as war

trophies. An iron cross found its way to Harvard University's library, following the siege of 1745. After its second fall in 1758, American colonials assured its destruction by tearing down its defensive walls as well as its shops and homes. Two regiments laboured for a year at its demolition, leaving behind a field of ruin and rubble.[15]

In the intervening centuries, a new Louisburg arose.[16] Whereas the French court had situated its fortress on a peninsula that guarded the harbour, English fishermen chose a more sheltered spot two miles distant. They used the old French stones to build their cellars and fence their properties, and in time the residents of the new Louisburg occupied the old one as well. They built farmhouses and outbuildings between its crumbling walls, giving the site an undignified and dilapidated appearance. For example, by 1901 when the new town was incorporated, cattle grazed between the ruins, and a cattle shed occupied the site of the Queen's Bastion.[17] Some, however, sought to mark the spot where two great empires once fought for control of a continent. As early as 1882, some Canadian imperialists imagined they could turn the ruins of Louisbourg into an imperial memorial park, as suggested in George Munro Grant's *Picturesque Canada*.[18] However, the first commemoration was an American celebration.

In 1895, the Society of Colonial Wars, which had recently organized in New York to foster American patriotism, planned to raise a monument at Louisbourg to honour the sesquicentennial of its 1745 conquest by New England militia. Even before the monument was unveiled on 17 June, some Canadians had taken offence: Acadian newspapers protested the plan as an aggressive insult to Canada's past by American intruders. The Acadians were joined by the United Empire Loyalists Association, which petitioned the prime minister to block the project. However, the monument's opening ceremonies showed considerable diplomacy on the part of the Society of Colonial Wars. The large column was unveiled by the lieutenant-governor of Nova Scotia, on behalf of the governor-general, who sent his regrets, as did the American president, Grover Cleveland. Moreover, each orator made sure to speak approvingly of Canada and French Canadian civilization. Far from jingoistic American patriotism, the event was intended to be a friendly gesture between two countries.[19]

Despite the diplomatic tone of the ceremonies, opponents pressed to keep foreign hands off the neglected site. American interest thus roused Canadians' sense that the locale was somehow sacred. In 1895, Acadian senator Pascal Poirier rose in the Red Chamber to inquire into the status

of the property at Louisbourg. The answer shocked him: when the British government had transferred ordnance lands to the Canadian Department of Militia and Defence in the 1880s, the site was not included. This meant that, by the time Poirier asked his question, Louisbourg had already been divided into more than twenty privately owned lots. The banal use of this "sacred" place was not just legal, but deeded. Yet, ironically, it was the subdivision of land into private plots that permitted private developers, such as David J. Kennelly and John Stewart McLennan, to gain title to part of the site.

Kennelly was Irish by birth but had been a true servant of empire. An officer in the Royal East India Company's naval service, he helped supply Britain's soldiers during the Crimean War and later ferried troops from South Africa to Bombay to help suppress the Indian Rebellion of 1857. Retiring from the India service in 1868, he studied law in London before arriving in Nova Scotia during the 1870s.[20] He had made his fortune in Cape Breton's burgeoning coal and steel industries, and felt compelled to contribute to the preservation of the colony's history. By 1903, he had acquired more than a dozen lots at Louisbourg and had begun to restore the casemates of the King's Bastion by digging out layers of earth and rock, and pouring cement to reinforce them. Like Poirier, he desired to secure the place for future generations, and his efforts were the first "Canadian" commemoration of Louisbourg. He was also a promoter who saw commercial potential in the site. He planned to fence, restore, and preserve the old burial grounds, further stabilize the casemate ruins, place commemorative plaques on the property, and eventually erect a memorial tower and museum. Apparently, he built a restaurant within the ruins and charged admission before there was really anything to see.[21]

When Kennelly died in 1907, his vision for Louisbourg died with him (and his will complicated later efforts to acquire the historic properties). Although Kennelly had pushed the Nova Scotian legislature to incorporate a group of eleven trustees and had energetically raised funds for his scheme, all interest fell away after his death. When a meeting of the trustees was called in 1913, only one member appeared.[22] However, Kennelly's efforts furthered the idea that protecting the Louisbourg ruins was a sacred trust. Victorian enthusiasts had envisioned them as a relic of the greatness of French Canadian civilization, and John George Bourinot and Senator Poirier each read papers at RSC meetings, saying just that. However, Victorian analyses were based less in historical inquiry than in the contemporary politics of British imperialists as they attempted to

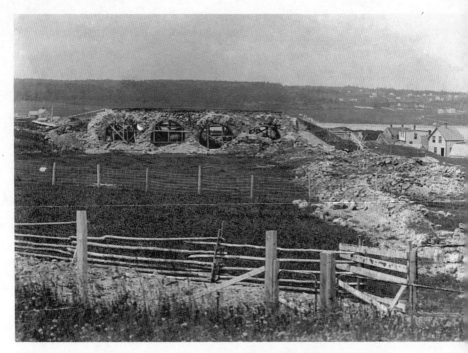

Louisbourg in 1907 | Source: F1075-15, Image I0016664, Ontario Archives

reconcile French Canada with their own vision of the country.[23] Bourinot, for one, singled out the ancient fortress-town as a symbol of the former greatness of French Canadian civilization as a way to incorporate French Canadians into his imperialist vision.[24] Kennelly likewise promoted Louisbourg as a site of imperial history. He solicited donations from British regiments and planned a monument to Edward VII on the grounds of his memorial park.[25]

John Stewart McLennan also regarded Louisbourg as a sacred trust. Like Kennelly, he had moved to Nova Scotia as an adult and made a fortune in the coal and steel industries around Sydney. He became a director of both the Dominion Iron and Steel Company and the Dominion Coal Company, as well as the owner of a newspaper, the *Sydney Post*. He also took a keen interest in Cape Breton history, having been one of the authors of the 1882 call for a memorial at Louisbourg. In 1908, he described the old ruins as a "national charge," a historic site so valuable that it demanded government protection.[26] Later in life, he wrote a book that became a standard volume on Louisbourg's history. Despite its title, McLennan's *Louisbourg, from Its Foundation to Its Fall* paid very little attention to the

community between foundation and fall. His interests clearly revolved around the place of the fortress-town in the imperial development of Canada, for he too focused on integrating this jewel of French civilization into the British Empire. McLennan also first thought of rebuilding the fortress to stand as a silent memorial to imperial greatness.

Meanwhile, the federal government was taking a more active interest in developing the country's historic sites. In 1913, the Parks Branch of the Department of the Interior acquired Fort Howe in Saint John, New Brunswick, primarily to develop the surrounding area for recreational use. The move also established a Parks Branch presence in the Maritimes. Until that point, Canada's national parks were all in the west, with the exception of one in Ontario. Fort Howe was not a particularly important historic site. Built after the American Revolution, its guns fired mostly in celebration, not combat. Despite representing the origins of the national historic parks system, it was declassified and turned over to the City of Saint John in 1930.[27] A more conspicuous start to the national historic parks system, and a better example of national-local interaction, was the acquisition of Fort Anne at Annapolis Royal in western Nova Scotia.

Fort Anne, as it came to be known in the nineteenth century, was the seat of successive Acadian and Nova Scotian governments until the founding of Halifax in 1749. However, the area's history is often confusing due to its repeated conquest and reoccupation by British and French forces throughout the seventeenth century. Here Samuel Champlain built a settlement, called Port Royal, in 1605. Abandoned for Quebec by Champlain and his companions in 1608, Port Royal continued to serve French traders until 1613. Later, in 1629, Scottish settlers under the command of William Alexander established their own settlement. In 1632, after Scotland's flirtation with colonization failed, Charles de Menou d'Aulnay, a French sea captain and sometime governor of Acadia, whose long rivalry with Charles de La Tour dominated Acadian history to 1650, built a new Port Royal on the site of the Scottish settlement. Further confusing matters, between 1632 and 1710, Acadia changed hands between Britain and France another half dozen times. Even the Dutch briefly pressed a claim in the 1670s. However, after 1710, when New Englanders captured Port Royal, the fort, renamed Annapolis Royal, remained in British hands until the time of Confederation.

In 1883, the British government transferred control of Annapolis Royal to Canada. It consisted of a series of earthwork bastions, initially built under French control as two successive forts. A group of British-built

structures, dating from a much later period, completed the property. The cornerstone of the officers' quarters, which became the main museum building, was laid in 1797 by the father of Queen Victoria, Edward, duke of Kent.[28] As the fort no longer held any military purpose or significance, it was allowed to crumble. It was partially rescued in the late 1890s, when a group of local residents shored up the magazines and officers' quarters. In 1899, townspeople organized a Garrison Committee to oversee the preservation of the fort and to commemorate its history. The committee had some limited success, managing to secure funding for repairs and to erect a tablet commemorating the French fur trader Pierre Du Gua de Monts, but after 1911 the Department of Militia and Defence cancelled its support.

Under the leadership of Loftus Morton Fortier, a retired immigration inspector, the Garrison Committee approached the Department of the Interior, which eventually agreed to turn Annapolis Royal into Nova Scotia's first national historic park.[29] However, the Parks Branch lacked experience and had no expertise to assess the historical value of sites such as Annapolis Royal. As a result, it accepted the Garrison Committee's suggested name, Fort Anne, as the official name for the park and fort. The name ignored the previous and coincident French and Acadian occupation of the site, and said nothing at all about the Mi'kmaq. Indeed, it plastered over the long history of the area and sparked sharp criticism led by a former anti-Confederate and local historian, Judge Alfred William Savary. The controversy was an embarrassment.[30] Hoping to prevent its recurrence, the government created an advisory committee in 1919, the Historic Sites and Monuments Board of Canada (HSMBC), consisting of the country's leading historians, many of whom had been key players in the RSC and the HLA. None of them held university positions or made their living writing history. Thus, Ottawa drew on amateur researchers, local enthusiasts, and literary gentlemen to steer its preservation of the physical environments of the past. In part, it relied on their interpretations because university historians had largely ignored national history. Citizen enthusiasts continued to play a crucial role in shaping the government's interpretation of Canada's historic landscapes throughout the interwar years.

Through the 1920s, the HSMBC focused on its main objective of marking a tourist landscape of historic sites with stone cairns and explanatory plaques. At the same time, though, interest in the material remains of Canada's past was growing. For instance, working for a precursor of a

national tourism office, Ernest Voorhis gathered documentary evidence of lost military and fur-trading posts, which he compiled into "Canadian Historic Forts and Trading Posts" in 1930. And in 1922, six more old forts were transferred from Militia and Defence to the Parks Branch. Each one had a local champion. For instance, Fort Beauséjour in New Brunswick was backed by a pharmacist from Amherst, Nova Scotia.[31] In addition to Fort Beauséjour, the six included Forts Chambly and Lennox in Quebec, Fort Wellington in Ontario, Fort Edward in Nova Scotia, and Fort Prince of Wales in northern Manitoba.[32] Despite these exceptions to the rule, a 1932 Carnegie Corporation report on Canada's museums lamented "the absence of folk and open-air museums."[33] Gradually, however, the views of local enthusiasts and government officials converged to create the idea of a national historic park.

This idea was shepherded by James Bernard Harkin. A former secretary to Clifford Sifton, the powerful minister of the interior, Harkin had taken charge of developing Canada's national parks in 1911. By 1920, he was forty-five years old and a seasoned bureaucrat. He believed firmly in the economic value of parks, particularly as attractions for foreign tourists. Among his objectives was making Canada's wilderness accessible to the travelling public through a series of car-friendly initiatives.[34] However, wilderness preservation in Canada was most clearly associated with the mountain landscapes of Alberta and British Columbia. Eyeing a more national reach for the parks system, Harkin proposed linking nature preserves with other land uses and leisure pursuits, such as camping and picnicking. Following the example of the Plains of Abraham development, he too realized that places of historic interest could be landscaped and turned over to leisure activities. Although today the connection between historic sites and national parks seems obvious, there was nothing natural or inevitable about it. Savary had ridiculed the idea in his complaint about Fort Anne. Certainly, the old RSC preservation committee was interested in both historic and scenic places, nominally at least, as was the National Trust in England. But the particular combination of historic sites and national parks was the product of Harkin's bureaucratic imperialism and his goal of expanding the parks system across the country.[35]

Buoyed by these developments and his 1916 appointment to the Senate, John Stewart McLennan renewed his appeal to rebuild lost Louisbourg. Ottawa had surveyed some of the property in 1919 and allocated a bit of money to buying land, but nothing of substance had been accomplished when the six forts were designated as historic sites. Not surprisingly,

McLennan was highly critical of the government's inaction at Louisbourg and schemed to circumvent its authority.[36] Yet, accusing the Parks Branch of inaction was unfair. The situation at Louisbourg was complicated by questions of landownership and the legacy of Kennelly's work. When another local enthusiast, Walter Crowe, explained the problems of the Kennelly Trust and other property claims on the site, Harkin was able to negotiate an agreement with the Nova Scotia government to transfer the Kennelly properties to the dominion.[37] But a variety of small landholders thwarted further development. Moreover, no one was really sure what to do with the site. But seeing Louisbourg languishing, McLennan embarked on a new plan. Together with Crowe, and eventually with J.C. Webster of the HSMBC, he tried to wrest control of Louisbourg from the Parks Branch. In 1927, he invited some MPs to Cape Breton Island and encouraged them to speak in Parliament in favour of a Louisbourg reconstruction. Then, as the Senate debated appropriations for further maintenance of the Plains of Abraham, McLennan himself rose to complain that Louisbourg was being neglected. By 1929, he had successfully leveraged $23,000 for its development.[38] He then sought to create an independent federal commission similar to the National Battlefields Commission to supervise a reconstruction, and Charles Stewart, the minister of the interior, announced to the House of Commons that the government was considering that very thing.[39]

Stewart's announcement was premature. Harkin immediately reminded him of the enormous expenditures that such a commission would incur, all the while remaining outside government control. Indeed, these two issues, costs and government control, fuelled Harkin's opposition to any talk of a Louisbourg commission.[40] Eventually, Crowe worked out a compromise whereby two Maritime members of the HSMBC – himself and J.C. Webster – formed a subcommittee that in turn drew on the advice of local representatives, including the mayor of Louisburg and McLennan's daughter Katharine.[41] The Parks Branch had reinforced its control over the site but also immediately surrendered it through inaction. An engineer was sent to Cape Breton Island in the summers of the early 1930s to conduct surveys. His efforts included some piecemeal restoration of unearthed stoneworks and attempts to beautify the site, all of which greatly disappointed Webster and Crowe.[42] The branch also built the Louisbourg Museum in 1936, placed under the control of Katharine McLennan, but the twin shocks of the Great Depression and the Second World War curtailed greater ambitions.[43]

Tourism and History

The fiscal and economic crisis of the Great Depression had a double impact on the development of Canada's living history museums. A few meagre public works projects to provide relief for the unemployed helped restore some historic buildings. Many of these projects were tied to the hope that tourism could provide more sustainable employment for the long run. Harkin singled out the Louisbourg Museum, then under construction, as "a tremendous magnet" that would have the long-term benefit of promoting tourism.[44] Yet, although tourism appears to have outperformed other Canadian industries during the Depression, its decline was clear to contemporaries.[45] In 1929, tourism had added some $300 million to Canada's gross national product, but that figure slumped to a mere $117 million at the depths of the Great Depression in 1933. The industry faced devastating market shifts. Tourism in Canada was dependent on car travel, so declining car ownership rates posed another challenge.[46] Moreover, since the 1920s Canadian provinces had relied on legal liquor sales to lure Americans north. But in December 1933, the United States repealed the Eighteenth Amendment, a move that exacerbated Canada's problems because it legalized the sale of liquor south of the border. This double shock prompted the instigation of a special Senate investigation, which concluded that massive and aggressive promotional campaigns were needed to draw attention to Canada's numerous attractions.[47]

Concerns over tourism and the need for unemployment relief through public works spurred the opening of a number of historic attractions during the 1930s. In Ontario, the Niagara Parks Commission began restoration work at potential tourist venues, such as two surviving forts from the War of 1812. In Toronto, leisure tourism played a prominent role in getting sections of Fort York repaired. In 1931, city council decided to commemorate the centennial of York's incorporation as the city of Toronto, borrowing the idea from recent celebrations in Boston and Philadelphia.[48] Many North American communities had staged historical pageants over the years, and in Canada the 1908 tercentenary was only the most spectacular example. However, the anniversary of a municipality's incorporation was an unusual choice that did not lend itself to mass appeal. The organizing committee therefore decided to focus celebrations at Fort York, a military installation that was already obsolete and in disrepair when Toronto was incorporated in 1834. This in turn posed interpretive problems, and the committee was obliged to read history

loosely, adopting all of Toronto's past, real and imagined, into the centennial of incorporation.

The celebration began quietly, with a series of spectacles on 6 March 1934, the anniversary of incorporation. But the real events waited for the key long weekends of the summer tourist season. The official opening took place over the Victoria Day long weekend, already recognized as the unofficial start of summer. Ironically, given the City's transit schemes of earlier in the century, spectators who wished to attend the festival days were encouraged to take the streetcar to the fort. On opening day, a parade marched from the Danforth in the east end of the city to Fort York, where the governor-general ceremonially opened it for public use. Included in the parade were floats depicting various episodes from the city's history, beginning with the first fort's construction in 1793 and capturing major events from approximately every fifteen years. Between the floats marched First World War veterans and other men dressed in the uniforms of the Queen's Rangers, soldiers of the War of 1812, the Northwest Rebellion, and the Fenian invasions.[49] The preponderance of Union Jacks gave the parade a very British look, but other ethnic groups were encouraged to celebrate, and folk festivals were organized over the summer, with dancing performed at Fort York. Performing ethnic cultures

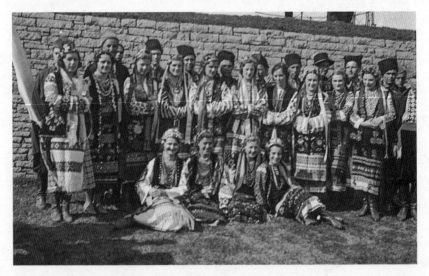

Ukrainian folk dancers at Fort York, 1934 | Source: F-1075-13, Image I0001778, Ontario Archives

was another way of adding life to the restored historic site. However, the event that most highlights the interest in tourism over historical accuracy was the Fourth of July celebration. In hopes of attracting American tourists, Toronto staged a Fourth of July carnival, complete with evening fireworks, at a fort built to replace one that the Americans had burned down in 1813.

The Toronto centennial was one of the earliest Canadian efforts to use a restored and repurposed historic landscape to promote tourism. Its goal was to employ the "historic" setting of Fort York to attract American visitors and their dollars to a city that was suffering from high unemployment. Finding work for the jobless was a key concern. By 1934, over 200,000 people in Toronto, about 20 percent of the population, were living on some form of relief. The mayor insisted that the City's enormous expenditures would provide direct employment for many, but the greater potential lay in tourism's ability to generate jobs, however unjustified the hopes may have been.[50] Here was another emergent irony behind the development of living history: to capture the modern tourist market, promoters looked to restoring the past. But the past had to be made amenable to consumer behaviour. The Centennial Committee placed so much faith in the economic power of tourism that it bent history to fit the summer travel season.[51] The old fort provided a setting that evoked the past, and its materiality lent credibility to historical claims, but it remained a backdrop to modern entertainments. It was a historic venue for a modern festival, not the recreation of a past environment.

A more significant Depression-era step toward living history involved the restoration of Fort Henry near Kingston, Ontario. Once again, efforts focused on a curious choice for a historic site. As an internment camp during the First and Second World Wars, Fort Henry participated only peripherally in Canada's military history. It played a minor role during the Upper Canadian Rebellions, one that J. Castell Hopkins disparaged as being the target of a planned, but never executed, rebel attack.[52] Although it replaced a series of lesser fortifications built during the War of 1812, Fort Henry itself postdated the war. Its guns never fired in its defence. In fact, when the restored fort was opened in 1938, Mackenzie King declared that it would "further the cause of peace."[53] After the withdrawal of the British garrisons from Canada during the 1870s, the fort had fallen into disuse and was left to crumble, like so many other military relics. In the 1890s, it was partially dismantled for safety reasons and had declined

to a deplorable condition by the 1920s. The army saw little purpose for it and was understandably not inclined to allocate its limited resources to an unused and unwanted site.

Nevertheless, in the mid-1920s, Fort Henry caught the attention of activists who were interested in preserving the historic built heritage of the country.[54] "I have been informed," wrote Colonel W.J. Brown to the minister of the interior in 1928, "that a great many tourists have visited Kingston apparently for the express purpose of seeing Fort Henry. Information has been received that during the annual influx of tourists old buildings, fortifications and other historic sites and structures are among the chief attractions."[55] Repairs, conservatively estimated at $130,000, stalled development in the 1920s. However, the Depression prompted governments desperate to find a way back to prosperity to take a closer look at tourist attractions. Ontario's dynamic minister of highways, Thomas McQueston, was said to be "keenly alive to the importance of Fort Henry as a tourist attraction," and he offered to put money from his own budget toward its restoration.[56] With the Province offering to share costs, Ottawa and Queen's Park agreed to restore the fort in the summer of 1936.[57] Restoration was made a relief project, reducing the labour costs and finding work for Kingston's unemployed. At one point this precedent-setting federal-provincial compromise on unemployment relief engaged five hundred men, excavating and cutting stone, all under the supervision of a young Queen's University graduate, Ronald Way.

Ronald Lawrence Way was born in Kingston in January 1908, where his father briefly taught engineering at Queen's. Ronald's first inclination was to follow his father's path into engineering, but he became a history major instead. In 1935, he began graduate studies with a planned master's thesis on the historical fortifications of the Niagara frontier. A Kingston native with expertise in historical fortifications, Way was a natural choice to supervise the Fort Henry restoration. Moreover, after the project established his credibility, Way also consulted with the Niagara Parks Commission on its restorations of Fort George, Fort Erie, the William Lyon Mackenzie house, and Navy Hall. Thus, he quickly emerged as a leading expert on historic restorations and played a founding role in the development of living history. For Way, recreating these structures "instead of merely preserving the unintelligible ruins, is a significant contribution to the teaching of Canadian history and to its general appreciation." History, he wrote, was best understood where it had happened: "When it is possible to associate the story of some past event with the actual location

where it occurred, when the story of a battle can be related upon the actual ground where it was fought, the topographical surroundings, surviving trenches or other remains are a stimulus to reality."[58] Thus, Way argued that the physical environment was a factor in teaching about the past. But he went beyond just invoking the topography. His preference for reconstructions over "unintelligible ruins" reveals his belief that it was possible to reconstruct, from the existing remnants, the built environment of the past. And he suggested that the physical environment, the material reality of the past, could arouse the imagination and stimulate historical understanding. By "crossing an antique drawbridge" (something you could actually do at Fort Henry), a visitor could be transported back to another age surrounded by its material reality.[59] As Canada's first large-scale historical tourist reconstruction project, Fort Henry dwarfed earlier efforts at Fort Anne and Fort Beauséjour. It took an entire installation and did not simply repair it or explain its past – it rebuilt it to the specifications of an earlier time. As such, it provides a significant clue to how people understood the relationship between the material world and historical knowledge. Given the broad public support for Fort Henry as a tourist attraction, the belief that the tangible was a gateway to historical understanding seems to have been widely held.

Finding Foundations

Ronald Way was also involved in a historic site project in Nova Scotia, although only peripherally. Throughout the country, the prospects of recreating the past enchanted people. For some, the past represented a chance to reap financial rewards in the present. Others had more patriotic or altruistic motives. However, all recognized that capitalizing on history required providing people with the past's physical environment, even when nothing remained to restore. Champlain's habitation at Port Royal is one such example. At about the same time that people in eastern Ontario urged the restoration of Fort Henry, some in Nova Scotia's Annapolis Valley imagined rebuilding Port Royal. However, unlike Fort Henry, Port Royal was no longer extant, and thus the project relied on imagination to reinvent a past reality. It represents an even greater faith in the power of the material world to inspire historical understanding and attract paying visitors.

In the summer of 1605, after a terrible winter on Île Ste-Croix on the boundary between present-day Maine and New Brunswick, Pierre Du Gua de Monts relocated his tiny settlement across the Bay of Fundy to the

Annapolis Valley, where Samuel Champlain began to assume a leadership role. The French stayed at Port Royal until 1608, when de Monts lost his fur monopoly, and Champlain relocated the trading post to Quebec. Port Royal itself was abandoned, although Jean de Biencourt de Poutrincourt returned with settlers in 1610, planting the seeds of Acadia. As the centuries wore on, and Acadia's fortunes swung from empire to empire, Port Royal disappeared, and knowledge of its exact location was lost. It was only in 1911 that the Harvard-educated botanist and historical cartographer William Francis Ganong tried to fix the exact spot where the original settlement had stood.[60]

Several years later, Loftus Morton Fortier, by then honorary superintendent of Fort Anne National Historic Park and president of the Historical Association of Annapolis Royal, pushed the government for national recognition of Champlain's Port Royal as well.[61] He had limited success in 1924, when the HSMBC graced the Ganong site with one of its plaques. The plaque explained the significance of Port Royal, as well as its disappearance from the landscape, in the following way:

> Site of the First French Fort or "Habitation" of Port Royal. Built by the French under De Monts and Champlain, 1605. Attacked and partially destroyed by a British force from Virginia, 1613.
>
> Restored and occupied by Scottish Colonists, 1629
>
> Laid waste on their retreat from the country, 1632.
>
> Home of the "Order of Good Cheer."
>
> Birthplace of Canadian literature and Drama.

James Harkin found it "gratifying to hear that tourist traffic to the site ... increased" following the erection of the plaque.[62] As far as the government was concerned, this plaque, coupled with the national historic site at Fort Anne across the river, was sufficient to memorialize the early days of Acadian history in the Annapolis Valley. However, while the government may have been content, local people – especially Fortier – were not.

Fortier was a constant source of irritation for Harkin. His propensity for treating Fort Anne as his personal domain was particularly annoying to the government in Ottawa. For instance, he regularly invited foreign associations to place their own historic markers in the national park. In

1925, he invited a group called Souvenir Colonial français to commemorate the life of Charles de Menou d'Aulnay. Fortier also invited the Society of Colonial Wars to place its own memorials at Fort Anne, an action that finally prompted the Parks Branch to censure him.[63] Undaunted and indignant, Fortier continued to treat local history as his private preserve. He once even held a funeral for Menou d'Aulnay. In 1932, Fortier discovered some human remains that he claimed could "be none other than the remains of Charles de Menou, buried in that spot in 1650."[64] So confident was he that he invited officials from the provincial archives and reporters from Halifax to watch him make his "discovery." After a brief speech, he invited his friend Harriette Taber Richardson to turn the sod, then had a workman dig a hole to reveal some rotten wood and bone fragments. A few days later, these remains were reinterred at another ceremony.[65]

Fortier and Harriette Taber Richardson also dreamed of a complete reconstruction of Port Royal, which they referred to as "Champlain's Habitation." Fortier took a leading role but was quickly overshadowed by the dynamism of Richardson, an American summer resident of the Annapolis Valley. A matriarch who would have been at home in the Mount Vernon Ladies Association, she rightly figures prominently in every discussion of the Port Royal reconstruction. However, few accounts flesh out the brief preamble to the finding aid for her papers at Library and Archives Canada, which simply describes her as an American woman who had spent her summers at Annapolis since 1923.[66] Richardson was born Harriette Taber in Boston in 1875. The Tabers were a wealthy, connected New England family that traced its history back to the seventeenth century and the arrival of the *Mayflower*. In 1895, Harriette married Frederick Albert Richardson, a student at Harvard University (class of '97) who went on to become the founding editor of the *International Monthly*, a New York magazine of politics, diplomacy, and scholarship that was aimed at America's educated elites. The Richardsons and their two children, a son and a daughter, appear to have divided their time between New York and Cambridge, Massachusetts, before they began to summer in Nova Scotia during the 1920s.[67]

It is likely that the Taber family background nourished Harriette's passion for the seventeenth-century history of North American colonization. Soon after she and her husband arrived in Nova Scotia, she developed an interest in Annapolis Valley local history, particularly in the early French

exploration of North America and the exploits of Samuel Champlain. This enthusiasm was probably also inspired by the recent publication of the first volume of *The Works of Samuel Champlain* by Toronto's Champlain Society.[68] In 1926, she translated Marc Lescarbot's play, the *Théâtre de Neptune*, which was staged at Port Royal and is considered the first dramatic work composed in the Americas. That same year, the Historical Association of Annapolis Royal marked the birth of drama in North America with its own plaque near the federal marker for the site of Port Royal. On the evening of the unveiling, in the presence of the lieutenant-governor of Nova Scotia and a group of American summer residents, Richardson's translation was read by John Daniel Logan, a leading proponent of the study of Canadian literature.[69] Richardson and Fortier hatched their scheme for a Port Royal reconstruction at about the same time. The idea was Fortier's, but Richardson's energy and American connections proved decisive. In April 1928, she issued an appeal for donations to the cause, citing the colonial history that bound Canadians and Americans together, "a common inheritance to the entire coast, a memory in which we share."[70] The reconstruction would be a goodwill gesture between Canada, the United States, and just for good measure, France. Thoroughly convinced of her social position, Richardson corresponded freely with American, Canadian, and international dignitaries about her ambitions, enlisting the support of the presidents of William and Mary College and Harvard University, as well as approaching John D. Rockefeller and Calvin Coolidge for their aid. Early in the 1930s, she organized the anachronistically named Hundred Associates of Port Royal, a loose organization of the American supporters of the reconstruction.[71]

Fortier once claimed that Mackenzie King enthusiastically supported his plan, but King's governments steadfastly declined to fund it.[72] When Fortier died in 1933, Colonel E.K. Eaton assumed his role. Eaton himself almost immediately infuriated Ottawa with a proposal for a memorial on Fort Anne's grounds that would have given more prominence to Fortier than to the fort itself.[73] Through the 1930s, Eaton and Richardson continued their efforts to raise the $10,000 they believed would cover the costs of reconstruction. From his office in Ottawa, Harkin recognized that the project would require a considerably greater sum. In August 1936, he informed the prime minister's private secretary of his concerns regarding the Port Royal venture. He was sympathetic to the idea of the reconstruction, and he recognized that it would be a powerful draw for tourism

to the area, but a fear of the precedent held him back: "The inauguration of a policy of reconstruction would involve the country in very extensive expenditures, much beyond any funds so far contemplated for historic work done by the Department of the Interior."[74] This was not a claim against the historical significance of Port Royal, but a reminder that it had already been recognized and a warning against costly commitments.

Meanwhile, the Hundred Associates bought two properties adjoining the Ganong site. On one of them, French colonists had planted a garden in 1605, and Richardson worked to recreate it, using vine cuttings from New England and seeds from Virginia and France. Her hope was "to restore [the garden] to its original appearance, and to plant in it the same grains as Champlain planted there over three hundred years ago."[75] In Richardson's mind, rebuilding the Habitation meant more than generating a replica of the structure. She extended the idea to remaking the whole physical and sensory environment of the past. In her garden, she believed she had established a living link to France's seventeenth-century colonists. (Whether it was even possible to determine which varieties Champlain's companions had planted is another matter altogether.) Her garden produce would make it possible to experience something of the tastes of Port Royal's food and drink. These activities also helped to publicize the plan and kept up pressure on the Canadian government, which began to look more favourably on the reconstruction proposal between 1937 and 1938.

About this time, C.W. Jefferys joined the adventure. Charles William Jefferys was already famous as an illustrator when he was hired as a consultant on the Port Royal project. A childhood immigrant from England, he had apprenticed at the Toronto Lithographic Company and helped found the Toronto Art Students' League. He later worked as an illustrator for the *Toronto Globe* and then at the *New York Herald* for nearly a decade. Upon returning to Ontario in 1901, he settled at the *Toronto Daily Star* and *Toronto Star Weekly*, rising to the position of art director before beginning another career as a freelance book illustrator around 1910. Between 1912 and 1939, he also taught painting and drawing at the University of Toronto's School of Architecture. His art came to symbolize Canadian historical illustration, and it is as intimately connected to the visual representation of Canadian identity as are the landscapes of the Group of Seven. His early book illustrations focused on children's literature, but he soon emerged as Canada's premier historical illustrator. Jefferys's brisk

pen sketches were known for their depictions of the formative moments in Canada's past. Executed in an expressive style that showcased both his attention to historical detail and his mastery of the medium, Jefferys's work featured in textbooks on Canadian and British history, written by historian George M. Wrong. He contributed over two hundred illustrations for *The Ryerson Canadian History Readers* of the 1930s, and Ryerson Press also published numerous volumes of his illustrations, starting in 1930, with *Dramatic Episodes in Canada's History*.[76] He was fiercely proud of the accuracy of his work, once claiming that his very livelihood depended on his knowledge of the details of history.[77]

Jefferys seems to have recommended himself for the Port Royal project a decade earlier, when Fortier first proposed it.[78] When Ottawa finally announced its approval in 1938, he again volunteered to act as a historical consultant and recruited the support of Charles Trick Currelly, the director of the Royal Ontario Museum. Currelly was emphatic in his endorsement. "I know of only one man who can handle that kind of a job," he informed Fred Williamson at the Parks Branch, "and that is C.W. Jefferys ... the artist who has devoted so much time to the Champlain buildings." To drive the point home, he implored the government, "Let me beg you, if this thing goes through, to get Mr. Jefferys."[79]

Meanwhile, in the fall of 1938, the Hundred Associates hired its own "expert." Landscape architect C. Coatsworth Pinkney was contracted to conduct excavations and locate the exact placement of the original Port Royal. He was a former student of Bremer Pond, a professor in the landscape architecture program at Harvard and a friend of the Richardsons. He had some experience in France, as well as at Colonial Williamsburg, where he gained his familiarity with archaeological survey methods. He had no knowledge of Port Royal or of the history of French exploration when he assumed the contract, so he relied heavily on Richardson and Jefferys for his information. As a result, his excavations reveal as much about their understanding of the material past as they do about Port Royal itself.

Arriving in Annapolis at the end of September, Pinkney set to work, sifting through the soil at the Port Royal site and searching for the foundations of Champlain's habitation. The remarkably rocky soil made it difficult to find evidence of any seventeenth-century foundations.[80] Pinkney seems to have started from the premise, supplied by Richardson, that a large stone was "the underpinning of the north east corner of the store house of the Habitation."[81] But working from this starting point seemed to throw other calculations out of line. Having dug some trenches,

which he thought confirmed the alignment of the buildings, he could find no indication of either flooring or foundations. Documentary evidence revealed that the storehouse cellar floor was paved, but nothing surviving on-site confirmed it. Pinkney concluded that the floor must have been made of clay, not actually paved, because he found a layer of clay in the cellar of a nearby resident's home. Despite the difficulties, Pinkney could report having made "great progress" and was certain that he would finish placing the buildings with "a little more work."[82]

By the end of October, Pinkney was ready to close up the site for the winter, and workmen rushed to refill the trenches before the ground froze. Although he had difficulty making his findings conform to the drawings of Champlain, Pinkney was at first satisfied with his efforts. Jefferys, who had travelled out to Nova Scotia to meet him, was equally positive. Although they found no evidence of foundations, Jefferys concluded that the buildings probably sat on stone piers instead of continuous foundations. In this speculation, he could point to Ronald Way's concurrence. On his trips between Toronto and the Maritimes, Jefferys stopped at Kingston to consult with Way, and the two men shared ideas about their work. Supported by Way's growing authority, Jefferys could make a convincing case to the government. And Ottawa's chief engineer reported that "although few actual foundations of the buildings have been discovered [Pinkney] has been able to determine principally by a careful examination of soil selections, definite proof of the position and dimensions of most of the buildings."[83] Even Pinkney's mentor, Professor Bremer Pond, was "completely satisfied."[84]

If most were satisfied with the results, Richardson was ecstatic. After returning to Boston, she gleefully wrote her many correspondents to tell them of her findings. "We returned from Nova Scotia about ten days ago," she informed Julius Tuttle of Boston's historic monuments committee, "and the day before leaving had finished packing the collection of objects found at Port Royal. Curiously enough, that was exactly 325 years after Argall had finished the burning [of Port Royal]."[85] Richardson took personal ownership of the reconstruction, quite literally. She brought home a collection of artifacts uncovered by the excavations, thoroughly convinced that they dated from the time of Champlain. She wrote to William Francis Ganong to tell him that, not only had the outlines of all the buildings been located in three weeks of surveying, but that scorched wood uncovered during the excavation "was in fact the charred upright of the cross drawn and mentioned by Champlain."[86] "The outline of the

building," she told a physician friend, "was exactly as we supposed and in the place I had suggested in my report, and they were entirely visible ... and the staked outline alone will show where the buildings will stand when they are restored next year."[87] As far as she was concerned, the whole adventure had been a great success.

On the other hand, Pinkney began to have second thoughts. Despite Richardson's claims, his surveys revealed a number of deviations from Champlain's drawings, building dimensions did not match, and what Richardson had identified as a well was blocked by an enormous stone that lay twelve feet underground and prevented reaching the water table.[88] Parks officials also began to temper their initial enthusiasm. One government architect noted that though Champlain's drawings suggested flat terrain, the survey sat on a sloped parcel of land, which might cause drainage problems for the reconstruction. Of greater concern was the fact that the site was far larger than Champlain's given dimensions would indicate. Richardson dismissed the concern with a theory that Champlain had given the interior measurements of the buildings, which explained why the site *should* be larger than it appeared in his drawings.[89]

Although Jefferys found some reason to accept this latest theory, he was also growing suspicious of Richardson's involvement.[90] In a report to Ottawa, he noted that Richardson's claims about the kinds of utensils that Lescarbot and Champlain had with them were completely unsupported by the documentary evidence and mused that her artifact "collection" (he used ironic quotation marks) was probably of little archaeological value.[91] As the reconstruction planning proceeded, he repeatedly encouraged the government to seek better advisers:

> I have every desire to satisfy the Associates as to the accuracy and historical correctness of the reconstruction and I realize that Mrs Richardson's researches and Mr Pinkney's work have been most valuable. But I feel ... that the expert assistance we have had from Professor Traquair, Mr Barbeau and other authorities in Canada, who know the human and social background, are [sic] more useful to us and a surer guide than the more or less speculative commentary of our American friends.[92]

One might presume that Jefferys was expressing some anti-American sentiment. Maybe he picked it up while living in New York. But his remark played more on the importance of professional expertise (which he felt

he possessed), advocating reliance on a McGill architecture professor and Canada's leading anthropologist. Jefferys's advice to the government amounted to urging the hiring of experts to get the history right.

At the same time, he steered away from claims of certainty and urged the use of "probability" and "one's general knowledge of the social life of the period" to build the most accurate replica of Port Royal.[93] He was not sure that the archaeological work had, in fact, uncovered the remains of Champlain's Port Royal or of Poutrincourt's later occupation. In a lengthy report, he even recommended suspending judgment on the data from Pinkney's excavations until historical research could shed light on what he had found. "The construction must be based on all available data," he argued, but unfortunately "the facts themselves are often meagre and open to various interpretations: common sense and reasonable probability must often decide the question."[94]

In the spring of 1939, government architect Kenneth D. Harris was assigned to assume control of the Port Royal site and to prepare plans for the reconstruction itself. Harris drew on the assistance of Jefferys and of Ramsay Traquair of McGill University, both of whom based their advice on what could be inferred from the construction techniques and tools that were available to the French in the early seventeenth century. "The restoration of such buildings, from the very slight historic record," Traquair informed a government engineer, "is one of great difficulty, it requires not only knowledge, but sympathy with the methods of the old craftsmen and their methods of work."[95] For Traquair and Jefferys, the matter became one of aesthetics. For instance, Traquair suggested that the kitchen at Montreal's Château de Ramezay, a building whose foundations date from 1705 – a century after Port Royal – could provide the model for the Port Royal fireplace.[96] Jefferys, for his part, complained that iron strapping across the Habitation's wooden doors looked *too* antique and recommended toning it down.[97] Harris could be just as choosy. Commenting on a suggestion for wood siding, he noted that it looked "too refined and finished for Port Royal."[98] The final product became an exercise in picking and choosing from a range of "authentic" old techniques according to the aesthetic sensibilities of the chief architect and his advisers. Yet, as Jefferys wrote in the *Canadian Historical Review*, "from the beginning of the project and throughout its progress the department has been determined that the reconstruction should be made as authentic as possible."[99]

The Fort Henry Guard, with women in period costume and goat mascot, 1957 |
Source: RG 65-35-3, Image I0005568, Ontario Archives

Bringing It to Life

Jefferys touched on a key point. Constructions like Port Royal and Fort
Henry recreated the material environment of the past, but their success
depended on their ability to convey a sense of authenticity. Richardson's
garden, although it did not appear to survive her initial enthusiasm, was
one means to support the genuineness of her imagined past. It was a
way to add sensory depth to the historic environment. Whether built up
from surviving ruins or pieced together from scraps of evidence, historical
reconstructions depend on a faith in their accuracy to win public approval
and impart a sense of history. Unlike film and television sets built for
Hollywood productions, they must work from all angles. As visitors walk
the empty barracks of an ancient fort, they expect to feel the press of his-
tory around them. Restorations and reconstructions are real-world lessons
that allow them to experience first-hand the sights, spaces, sounds, and
smells of the historical environment. They expect to touch, literally, arti-
facts from vanished days and thrill at the experience of a physical connec-
tion to the past. Without a belief in the authenticity of the work, these
feelings would never develop, and the reconstruction would be no more
than a stage piece for amusement. Jefferys knew this, as did Ronald Way.

For Way, no matter how authentic his restored Fort Henry might be, its deserted spaces rang hollow and he yearned to breathe life into his creation. He needed his own means of adding sensory depth to the historical environment he had built. On a cold, windy day in 1937, as he later told a reporter, he realized that Fort Henry would be as frigid as a Kingston winter if it remained unpopulated. As he daydreamed about how the fort would have looked when it was garrisoned, the idea for the Fort Henry Guard struck him. He recruited university students and trained them in time for the fort's official opening in August 1938, a three-day celebration of history incorporated into Kingston's Old Home Week.[100] There were formalities to be pursued, such as the official transfer of ownership from the Department of Defence to Ontario's Department of Highways. That was accomplished when Brigadier Hertzberg handed a symbolic golden key to the Honourable Colin Campbell. There were speeches to be given by local, provincial, and national politicians, and following the release of a flock of pigeons, the prime minister declared the museum open. But the highlight of the occasion was the drill of the Fort Henry Guard.[101]

Old Home Week included a nightly historical pageant in which a series of costumed performers played out fifteen episodes from the history of Fort Henry or Kingston. Prior to each one, a narrator used a loudspeaker to explain the details of the events. But the pageant was designed to permit visitors to come and go at their convenience, so they might enjoy the fort's exhibits as well as the performance itself.[102] The Guard was something different, and Way always cited it as his most cherished accomplishment. For the opening ceremonies, thirty-two guardsmen, "dressed in the scarlet tunics and blue trousers of the British infantry uniform of a hundred years ago," provided additional colour and pageantry. As the officials and honoured guests arrived for the ceremonies at 2:30 in the afternoon, the Guard marched out of the guardroom to present arms, accompanied by a fife and drum band. And, following the opening, the Guard staged a ceremonial "changing of the guard" for visitors' enjoyment.[103] Way continued to parade the Guard on a regular schedule and conducted daily drills for tourists. Years later, he received a postcard written by a nine-year-old boy from Chicago who had been to Fort Henry on holiday and praised it for being a "living museum." Way claimed that the postcard inspired him to apply the phrase "living history" to his approach to historical education.[104] He had populated and animated the martial space of Fort Henry and thus turned a historical reconstruction, an open-air museum, into a site of "living" history.

3

Tourism and History

RONALD WAY CLEARLY understood the importance of history for tourism, but he was hardly alone in making the connection. C.W. Jefferys and James Harkin were also motivated by the potential of historic sites to attract the travelling public. Adding a living component to restored or recreated sites was a central part of building that appeal. Commercial tourism played an important role in the reconstruction of the North American economy following the Second World War, and the reconstruction of past material environments was part of it. However, with the post-war return to prosperity, and increasing leisure time and leisure opportunities, museums and historic sites had to compete for consumer attention. The problem accelerated as the post-war tourism and entertainment industries expanded options for leisure spending. Yet, history also seemed to present a tool for branding countries and cultures for tourist consumption, and living history museums quickly emerged as key features in promotional strategies. However, their success also depended on getting the history right.

History for Tourists

Options for the commercial use of the past were widespread, but none was more threatening to living history museums than the enormous influence of Disneyland and its many imitators. When Walt Disney opened his first theme park in southern California in 1955, it distorted history in the name of amusement, but in ways that were reinforced by popular culture.[1] Amusement parks, like the world's fairs that preceded them, offered enclosed spaces where a variety of diversions might coexist. Although it also helped promote the development of ethnology and anthropology, the World Columbian Exposition was a crucial step in the later progression from fairs to amusement and theme parks, especially through its wildly popular Midway Plaisance attractions.[2] The midway rides were popular amusements that served as a model for commercial parks. The famous

Ferris Wheel that thrilled Chicagoans and visitors alike was copied on a smaller scale at New York's Coney Island only a few years later.[3] Coney Island had evolved from a conglomeration of independent ride operators to a collection of four competing amusement parks by the early twentieth century. Sea Lion Park (opened 1895), Steeplechase Park (1897), Luna Land (1902), and Dreamland (1911) generated themed rides drawing on American imaginations of fantasy or exotic places and thus offered customers opportunities to travel – at least in imagination – beyond the confines of daily life.[4]

Half a century later, Disneyland set a new standard for the safe family entertainment destination. Whereas Coney Island had been a space for couples and single adults who were willing to tolerate an element of risk in their leisure, Disneyland and its many imitators set themselves up as child-friendly spaces. Where Coney Island had "aspired to be proletarian and of the masses, Disneyland strove to be a middle-class experience of the family."[5] Disney brand entertainment banished the untidy, the unkempt, and the unpleasant aspects of daily life to offer a daydream existence of fantasy travel. Imagining a voyage to other times and places had long been part of the amusement park's allure. Disney's innovation was not the idea of a theme, but the segregation of multiple theme districts in a single park as safe entertainment. For Disney, the past was a welcoming entryway to his entertainment complex. For instance, whereas Frontierland recalled the Wild West era of American history, it did so in a tame cinematic format that was familiar to American movie audiences, interspersed with fun rides and children's treats. Disneyland's greatest impact on history tourism was its rendition of a typical American main street of the past. Main Street, USA, was a childlike replica of a "typical" small-town main street that served as a funnel past shops and souvenir stands on the way to the rides and entertainments of the theme lands deeper inside the park. Although inspired by Disney's nostalgic memory of growing up in Marceline, Missouri, Main Street was conceived as a celebration of "anytown" at the start of the twentieth century. Yet, much as Colonial Williamsburg was designed to limit and direct how people remembered America's past social relations, so too Disneyland portrayed a restricted view of anytown's past. This was a middle-class past of consumer culture centred on the nuclear family. It was a nostalgic vision of a small-town past, constructed to a child-friendly scale and family-friendly security, that recalled, not an actual past, but a fantasy one.[6]

Tourist promoters were not immune to indulging in fantasy themselves, even when they made use of "real" history. The Dominion Atlantic Railway's reconstruction of Grand Pré in Nova Scotia is an illustrative example. An Acadian settlement dating from the late seventeenth century, Grand Pré was also one of the embarkation points for the forced deportation of Acadians in 1755. It was immortalized as the probable home of the probably fictional Acadian woman Evangeline, made famous by Henry Wadsworth Longfellow's poem of 1848. Longfellow's *Evangeline* was enormously popular, especially in the United States. Not surprisingly, the mythologized Acadian woman entered into tourist promotion. The Dominion Atlantic Railway, a London-based rail and steamship company, had been playing up Nova Scotia history – it named its locomotives after de Monts and Champlain – since the 1890s. By the 1920s, the railway was transporting tourists to Grand Pré, christened "Land of Evangeline," where a recently dug well stood in for the one mentioned in Longfellow's fictional account. The railway also erected a statue of Evangeline and built a church, presumably on the site of an eighteenth-century original, to greet visitors to the Land of Evangeline. A figment of Longfellow's imagination took on physical reality.[7]

Promoters (including all levels of government) built an infrastructure that supported the history told at such tourist attractions. Their decisions and their selections, often made in anticipation of the tastes and convenience of the travelling public, played a role in shaping an official message of Canada's past. Between the end of the Second World War and the mid-1970s, Canadian governments found themselves involved and increasingly invested in all aspects of the tourist industry. At first responding to the hope that tourism would be part of the new economic order following the devastation of war and recession, they quickly became partners with the tourism business. They built bureaucracies to regulate, plan for, and support private enterprise. Soon they found themselves drawn into crafting the message of tourist promotion and, in this way, articulating ideas about Canadian identities by drawing on the country's past, using history to give flavour to each tourist area.[8] Moreover, the construction of sites like Port Royal altered the landscape to suit that version of history. Thus, tourism and the tourist industry profoundly affected historical consciousness.

Governments were interested in the tourist potential of the past as early as the 1920s. Indeed, the commercial prospects of tourism were an

emerging feature of interwar economic thinking, and many in Canada experimented with using history to promote them. In Quebec, the provincial governments of the 1920s presented an image of the province that was intended to evoke the simple, rural lifestyle of a seventeenth-century society. The Province also created its own monuments commission to identify and mark sites of potential historic value.[9] In Nova Scotia, Will R. Bird famously pushed the government to harness history to the needs of the provincial economy.[10] In 1923, the Nova Scotia government celebrated the 150th anniversary of the arrival of the *Hector*, an eighteenth-century barque that brought 189 Scottish settlers to Pictou Harbour. This commemorative festival was used to gauge the potential of history as a promotional vehicle for tourism.[11] And this process accelerated as the tourist industry expanded in the post-war years. Tourist tastes thus exerted pressure on the landscape. Not only did they alter places that were associated with historic events to make them appear more "historical," but they also transformed landscapes, as an infrastructure was built to promote tourist convenience.

Driving Travel

The rise of the automobile was one of the most important developments in North American tourism. It changed the mobility and leisure patterns of North Americans. In the decade after 1902, rapid growth in automobile use accentuated needs for road improvements as the car assumed a central place in North American consumer capitalism. By 1912, about a dozen Americans had attempted to drive across the country. By the start of the 1920s, that number had risen to twenty thousand.[12] In Canada, although cross-country driving was not really possible before the 1946 completion of a gravel road linking the lakehead cities of Fort William and Port Arthur (today's Thunder Bay) to communities east of the Great Lakes, the rise of the automobile was just as dramatic.[13] Canada's first cars were bought in the 1890s, and by 1900 perhaps 500 were registered in the country. In 1918, there were 275,000, a number that more than doubled by 1923. As the 1920s drew to a close, Canadians had registered almost 1.9 million cars.[14] The growth of the automotive industry obviously had economic ramifications for Canada's manufacturing, but it also altered tourism by allowing people to follow their own schedules and set their own itineraries and destinations. No longer tied to railway schedules and routes, leisure travel became, for those who could afford it, a form of personal freedom.

Car travel reoriented the infrastructure of tourism through a dispersal of services. To accommodate this growth in automobile tourism, new forms of rest stops developed, and automobile clubs promoted the interests of motorists. The clubs did more than meet the needs of their members; they increased their membership by developing a market and culture for drivers.[15] Car travel also encouraged greater government participation in the construction of infrastructure. Canadian governments had certainly been involved in building the transportation infrastructure of the age of steam. The various governments of British North America subsidized canal building, port facilities, and railway construction before Confederation and famously bankrolled the construction of the Canadian Pacific Railway in the 1880s. Automobile transportation similarly called for government support through the creation of roads and the setting of rules and laws for safe and efficient motor travel.

By the terms of the British North America Act, road construction and maintenance fell under provincial jurisdiction. At the turn of the twentieth century, when cars in Ontario numbered in the handfuls, the provincial government transferred control over roads from the Department of Agriculture to a new commissioner of highways, housed in the Department of Public Works. The commissioner's office grew quickly and, by 1910, was known colloquially as the Highways Branch. Between 1914 and 1917, Ontario built its first intercity highway, the $600,000 Toronto to Hamilton Highway along the shore of Lake Ontario. Financing for the project was split between the Province, the City of Toronto, the City of Hamilton, and the various municipalities that lay between its terminal points. Critics complained of corruption in the awarding of supply and construction contracts, and it is certain that patronage guided employment decisions.[16] A public commission argued that highways had grown beyond the capability of a simple branch to administer and recommended the creation of a full government department. In 1915, the Department of Public Highways was elevated to an independent department, although it continued to report to the minister of public works.

With these developments, Ontario became Canada's car vanguard. Quebec was the only province undergoing similar expansion, and it had its eye firmly on motoring tourists. Indeed, three-quarters of Quebec's visitors arrived by car, and their numbers had jumped from 15,000 in 1915 to 650,000 by the end of the 1920s, not counting day trips from Ontario.[17] By 1928, Quebec had allocated $17 million to highway construction, primarily with tourism in mind.[18] Although the 1919 Canada Highways Act

encouraged the provinces to link Canadian cities from coast to coast, road construction was tentative in most provinces before the Second World War. Prince Edward Island even prohibited automobiles. The first car was driven on the island in 1905, but the Province banned them in 1908, a law that lasted only five years before limited use was approved in a plebiscite.[19] In British Columbia, provincial communications relied on the more established railway and steamboat connections. Vancouver was linked to the Interior by road only after 1927, and as late as 1941, the province had only a skeletal system of unpaved roads. Only the Fraser Valley was well served.[20] Moreover, where highway construction advanced, links with the United States were preferable to interprovincial connections. And even this effort was mostly concentrated in central Canada.

As the American middle class hit the roads after the First World War, car travel further democratized tourism. "The wealthy could make the fashionable tour in 1825, the well-to-do built up the summer resorts of the 1890s," quipped Foster Dulles in 1940, "but every Tom, Dick, and Harry toured the country in the 1930s – thanks to the automobile."[21] Dulles overstated the case, but car travel greatly expanded tourism. Speaking about Canada, James Harkin remarked that "the automobile has brought a wider and more democratic use of [national] parks."[22] Like that of Dulles, his claim was premature. Not every North American took a vacation in the 1920s. Economic historian Thomas Weiss has estimated that as little as 5 percent of the American population visited its best-known tourist destinations in 1930.[23] But few working-class North Americans enjoyed paid vacation time or possessed the wealth to travel. And the celebration of mobility associated with car ownership ignores the real barriers to travel placed on racial minorities. As a result, working-class people and minorities tended to enjoy leisure pursuits close to home, usually during weekends and government-imposed holidays. Still, the family car made short pleasure jaunts possible for the middle class.[24] One estimate suggests that 80 percent of American white-collar workers received some paid vacation time in the 1920s and possessed sufficient disposable income to afford modest trips to nearby destinations.[25] Typically, these trips would be most affordable by car.

Automobility altered the landscape of cities and countrysides. As technological improvements permitted faster and faster car travel, the landscape began to fly past at increasing speeds, so that it was not so much seen as remembered or recalled. For the driver, watching the changing scenery was imperative, but it was watched through an increasingly narrow field

of vision as speed required greater concentration on the road ahead. At twenty-five miles per hour, a driver normally focuses attention 600 feet ahead of the vehicle and enjoys a viewing field of 100 degrees. But that quickly changes with speed, as the eyes become more focused on the horizon. Travelling at forty-five miles an hour, a driver looks 1,200 feet ahead and can take in a 45-degree field of vision. By sixty-five miles per hour, the driver can see only 40 degrees and must focus his or her attention on a spot about 2,000 feet ahead of the vehicle. Passengers have greater visual freedom but are similarly affected by a serialization of landscape, with objects of interest quickly appearing and then receding into the distance.[26]

Roadside marketing had to adapt to the increased speed and shortened attention of passing motorists. Complex, text-heavy billboards that permeated the pedestrian cities of the nineteenth century gave way to simpler images capable of quickly evoking the message of the product.[27] Given only seconds to capture the attention of passing motorists, advertisers embraced simple messages and relied increasingly on vibrant colours.[28] Although multiple advertising strategies overlapped in the 1920s and 1930s, many advertisers romanticized the past as a way to reinvent America as a frontier of travel and exploration. Tourism became celebrated as exploration and pioneering, linked to America's historical development. The car and modern mobility stood in as a reworking of the wagon trains of nineteenth-century western expansion. Billboards paired cars and tires with cowboys and Indians. A 1919 ad for Fisk Tire Company depicted stereotypical but nondescript Indians on horseback, watching a passing car through the dust it left in its wake.[29]

With a less advanced road network, Canada trailed the United States in roadside developments. American car ownership continued to rise even through the Great Depression, but car purchases stagnated in Canada and even declined before the end of the war. In 1929, after the growth of the 1920s, there was one car for every 9.9 people in the country. In 1945, there was one for every 10.4 people. Even in Ontario, which led the country in automobile ownership, the figures stayed just as flat at one car for every 7.0 and 7.2 people respectively.[30] However, the end of the war brought a new prosperity, and buying a car was the most obvious way to join in. Motor vehicle registrations doubled in Canada between 1945 and 1952. The same feat was accomplished again by 1964, as car ownership outpaced population growth.[31] Indeed, as studies of Canada's post-war suburbs have demonstrated, it became a virtual necessity just to live and work. In 1941,

fewer than half of the Canadian families that lived in the suburbs of major cities owned a car. A substantial majority of them had bought one by 1961.[32]

All those cars required new roads. Construction on Ontario's Queen Elizabeth Way had begun in the 1930s and continued through the war, even if some sections remained unpaved. Once hostilities in Europe ceased, the project gathered speed. To facilitate travel across the mouth of Hamilton Harbour and over the Welland Canal, new high-level bridges were added, opening in 1958 and 1963. But the more ambitious provincial project was the creation of the 400-series of superhighways that began with the opening of Highways 400, 401, and 402 in 1952. Unlike the Interstate system in the United States, Ontario's new highways were not designed with commuters in mind, at least at first. Instead, they were intended to move goods quickly around and across the province, bypassing city centres to speed transportation. Thus, Highway 402 was little more than a trucking access to the Blue Water Bridge between Sarnia and Port Huron, Michigan. For its part, Highway 401 was laid out so that it passed miles to the north or south of Kingston, Toronto, Kitchener, and London on its eight-hundred-kilometre journey from the Quebec border to Michigan. This was a feature of the provincial highway system that later governments regretted.

In British Columbia, the war had jump-started highway construction. After the bombing of Pearl Harbor, a highway through the province was central to American plans to defend Alaska, and Prince Rupert became a staging centre for US bases and highway construction. Following the war, the provincial road network continued to expand. Between 1952 and 1958, W.A.C. Bennett's Social Credit government spent more money developing highways than every previous provincial administration combined. The completion of the long-awaited Trans-Canada Highway also played an important role in expanding road service through the BC Interior, although Bennett's Socreds claimed the credit.[33]

The Trans-Canada Highway Act of 1949 was designed to overcome the regional nature of Canada's road network. Before 1946, Canadians who wanted to drive across the country, and corporations that wished to ship goods by truck, had to detour through the United States. Ontario, and to a lesser extent Quebec, were served by a decent road network. Less developed regional networks linked towns and cities in the BC Lower Mainland and the Prairie and Maritime provinces. However, they were more effective at connecting Canada's regions to the United States than

to each other. The Trans-Canada Highway, a national project funded by both levels of government, upgraded existing highways and built new ones to link the country from coast to coast. Although it was initiated in 1949, construction problems through the Rockies and across the vast forests of northern Ontario delayed completion until 1962. And even then, some three thousand kilometres remained unpaved.[34]

All these new highways and highway drivers encouraged entrepreneurs to develop new business models to cater to car travellers. The infrastructure required for automobile travel was both similar to and different from that of rail travel. Railway schedules and stations, with their adjacent hotels, had once regulated the tourist experience; motorists found far greater freedom and personal choice in their travel options. A preference for accessibility and affordability influenced the development of roadside businesses. In some cases, it meant minor adaptations to older practices. But more often it involved the introduction of new types of businesses, as entrepreneurs rushed to sell fuel, food, and rest to road-weary travellers.[35] Access to gasoline was imperative for car travel, and refuelling was a constant need. By 1920, major oil companies had established chains of look-alike gas stations that, with the low price of gasoline, competed for business by offering services and giveaways such as road maps. The car also reshaped the experience of travel as tourists abandoned traditional hotels for roadside camping after the First World War. Some small American towns even set up free campgrounds on their outskirts to encourage campers to stay nearby and also to discourage "wildcat" camping on highway shoulders. However, free camping was quickly replaced by commercial, fee-based campgrounds. Another step up was the cabin camp or tourist court. By mid-decade, campground owners began erecting small cabins to afford travellers more comfort and to garner higher fees. Increasing comfort continued. By the end of the 1930s, tourist courts, or motor courts, were common in the United States. The term described accommodations that integrated a number of rooms under a single roof, typically organized around a courtyard.

In the post-war years, road-based commerce thrived as never before. For the most part, roadside commercial strips were not designed with tourist travel in mind. Rather, they provided goods and services to local consumers. Shopping malls, for instance, offered post-war consumers a modern shopping experience linked to their newfound prosperity and car transportation. What is now recognizable as the modern shopping mall emerged, not surprisingly, in the densely populated northeastern

United States. In the late 1950s, malls such as the Bergen Mall of Paramus, New Jersey, began popping up in America's major metropolitan areas.[36] It is often said that Canada's first shopping mall was Park Royal in West Vancouver, which opened its doors to Pacific coast consumers in 1962. Other major developments, such as Yorkdale Mall north of Toronto, which opened its hundred air-conditioned shops in 1964, quickly followed suit. Yorkdale especially captures the marriage of the car and commerce. Centred on a sea of parking spaces, it was built adjacent to the new Highway 401 and effectively had its own interchange. At times, traffic officers were needed to keep the cars moving. However, even before these mega-malls, Canadians had developed smaller-scale shopping complexes that were linked to car traffic. For instance, the Don Mills Centre in suburban Toronto began life in 1955 as a car-based strip plaza. Although it was accessible to pedestrian traffic from nearby rental apartments, it quickly became a regional shopping centre that most of its customers reached by car.

As car ownership altered the experience of shopping, it similarly affected other aspects of daily life. For instance, roadside food services, which had developed haphazardly, began to standardize as restauranteurs remade themselves in the image of the car. Before the Second World War, the business of selling food to drivers was left to local entrepreneurs and small businessmen. In the 1920s and 1930s, although chain restaurants had arisen in Canada, they tended to confine their efforts to traditional eating-out markets in central cities. The first drive-in restaurant offering curb service opened in 1924 in Dallas, Texas. Other roadside establishments proliferated, offering travellers the possibility of a quick meal. At the start of the Depression, a company called English Inns announced its plans to develop a chain of ten restaurants along the highways of Ontario and New York State. No doubt the sudden economic collapse ruined the dream, for it never materialized and the company was out of business by 1931. More successful was the chain of Hi-Ho Drive-Ins operating in Windsor, Ontario, from 1938 or the White Spot chain in Vancouver, which began operating with a single outlet in 1928.[37]

In the United States, fast-food chains had established themselves along the nation's motorways long before the 1940s. Among the early examples were such prominent hamburger restaurants as White Castle (established 1921), Krystal (1932), Wimpy Grills (1934), and Big Boy (1936). However, not until the mid-1950s did the American chains start to look to Canada for further expansion, and Canadian businessmen began to set up local

equivalents. Dairy Queen opened its first Canadian outlet in Estevan, Saskatchewan, in 1953. A&W set up shop in Winnipeg three years later. Canadian competitors included Harvey's and Ottawa's Royal Burger (both established in 1959). By 1970, three-quarters of fast-food restaurants were controlled by national and regional franchising companies.[38] Not all fast-food outlets were successful. For instance, the short-lived Tim Horton Drive-In hamburger restaurants opened for business in 1962 and closed the same year.[39] However, the development of quick and consistent, if often bland, food that catered specifically to car travel further encouraged automobile tourism by making eating a convenient part of the experience. Families on the road in unfamiliar surroundings now had access to familiar restaurants on or just off the route to their destination. Sometimes, they could even enjoy a meal without getting out of the car.

Longer trips also required convenient places to sleep. The Great Depression had seriously challenged the hotel industry in the United States. Nearly two-thirds of America's hotels went out of business during the 1930s. For the motel segment of the market, the situation was more dire if only because, whereas hoteliers had the American Hotel Association to speak for their interests, no similar organization existed for motor courts and motels. As a result, in 1933, motel owners banded together to form what became, by 1944, the American Motor Hotel Association as a lobby group and to encourage co-operation among members.[40] Unlike the fast-food industry, motels remained the purview of local businessmen well into the post-war period. As a result, quality also remained inconsistent. After a disappointing experience with inadequate lodgings during a trip to Washington, DC, Kemmons Wilson hit on the idea of opening his own motel, what became the Holiday Inn. He inaugurated his first three motels in Memphis in 1952 and began franchising five years later. By 1958, there were 79 Holiday Inns in operation, and by 1964, with 531 motels open, the chain's territory stretched from coast to coast.[41]

Even without the injection of capital that the chains and franchises represented, motels opened at an astonishing rate after the war. Their construction boomed in the 1950s and 1960s. The industry benefitted from an increasing decentralization of towns and cities, fuelled, in part, by automobile ownership and the car culture. The American Interstate highway program, begun in 1956, helped accelerate urban decentralization. But, more importantly, putting a motel on a vacant lot was more lucrative than other forms of real estate development, which meant that

loans were easier to amortize. In addition, motel property values appreciated quickly due to their connection to successful commercial strip developments and the pull they exerted on decentralizing towns and cities. Simply put, a successful highway commercial strip, of which a motel was a part, raised local property values. This, in turn, attracted more development and raised property values further. Thus, motels, sitting on relatively large commercial properties, returned substantial capital gains when they were sold. Banks looked favourably on the model and regularly lent sums against fairly small downpayments. Due to this rosy financial situation, at least sixty-one thousand motels were in operation in the United States by 1964.[42] Canada followed suit. In Ontario alone, the number of motels jumped from about 150 in 1951 to nearly 500 three years later and leapt to more than 2,000 by 1962.[43] At the same time, the number of hotels was in decline, demonstrating the power of automobile travel.

The rapidly developing automobile and consumer landscape was not intended to service tourists, but it shaped their behaviour. With car manufacturers evoking the freedom of the road to sell their vehicles, tourists hardly needed convincing. The cost of fuel was low, so more and more families could jump in the car and see the country on their own schedules, with gas, food, and lodging always readily available just off the highway system – and sometimes integrated into it. By 1960, car tourism was clearly Canada's main concern. However, this feature of post-war tourism soon posed new problems for promoters. Travel by car gave tourists perhaps too much freedom for the liking of promoters and operators. No longer did families travel to a location and stay put for the duration. Summer holidays could now be mobile, and in the quest for entertainment, attention spans seemed to shorten. An Ontario study of visitor behaviour discovered that the average American tourist spent less than a week in the province during the late 1960s. This, for the tourist industry, was a problem, and operators turned to governments to support their businesses.[44]

The New Tourist Economy

Even if the actual economic value of tourism was difficult to quantify and measure, and even if expectations of its power to deliver prosperity often fell short, tourism itself became central to post-war thinking about the new economy. Widespread and general convictions that the end of the war would result in a boom in tourist traffic gripped the industry during the mid-1940s. Pent-up demand for travel was about to be unleashed, and

Canadians stood to benefit from American prosperity, as they had during the war. Raw numbers for the first post-war decade bore out the assumption. The US Bureau of Statistics counted 29,650 hotels and 25,919 motels in America in 1948, combining for receipts of nearly $2.4 billion. In 1954, the National Parks Service reported that over 54 million people visited America's national parks, up from 21 million in 1946. Travel and leisure were significant components of the post-war economy, and they were rapidly growing too.[45]

In Canada, Ontario's newly created Department of Travel and Publicity urged promoters and entrepreneurs to capture that market. In 1946, *Canadian Business* predicted that industrial workers, enjoying "holidays with pay for the first time in their lives," would swarm North American highways in the coming summer.[46] The war had done more than just stifle the demand for travel. Paradoxically, it had also provided the means to travel. American corporations had become convinced of the value of paid vacations during the Depression, in part to co-opt union demands. They also found that "time off" improved productivity, although this wisdom was applied selectively.[47] Wartime industry extended paid vacations farther down the social hierarchy. In the United States, wartime conditions of full employment and wage controls encouraged the labour movement to press for vacation time. By 1949, 93 percent of collective bargaining agreements included paid holidays, and fully 62 percent of Americans took a vacation that year, averaging a week and a half in length. Moreover, with fully half the nation's wage earners winning paid vacation time by 1940, either through legislation or collective bargaining, the travel and tourism industry stood to benefit.[48] North of the border, most Ontario workers had gained a one-week paid leave in 1944, with most of the country following suit in subsequent years. In Ontario's manufacturing sector, the average number of vacation weeks rose gradually from 2.3 per year in 1949 to 3.6 in 1979.[49]

Despite tourism's apparent importance to the economy, economists had difficulty in calculating its exact value, in part because tourism itself was difficult to define. Economic data gathering measured such indicators as the number of foreign visitors or the aggregate revenues of restaurants across the country. But these measures are not approximations for tourism. Local residents and out-of-town visitors might equally patronize a restaurant, and foreign tourists represent only a portion of leisure travellers. In the United States, the Curtis Publishing Company, which produced

Holiday magazine, conducted national surveys for tourist associations, but its survey data were also questionable. Commenting on a 1956 study of tourists who visited Colorado, Professor L.J. Crampon claimed that 40 percent of them stayed with friends and relatives, making them nearly invisible in the economic data.[50] Yet, even if they could not quite put their finger on it, economists "knew" that tourism was a major component of the modern economy. It generated tax revenues and was a source of foreign capital that every rebuilding economy of the post-war world needed. Even the Japanese government began to worry about lost tourist revenues and sources of foreign currency. Although Japan's peak pre-war tourism year, 1935, had seen only 9,000 American visitors (and 375 Canadians), the government recognized the big-business potential of trans-Pacific tourism and looked forward to increasing air travel to regain the lost markets.[51]

Tourism thus affected the national balance of payments. For economists, Canadians who travel to other countries are considered to be imports, because, like imports of goods, they cause Canadian capital to flow out of the country. On the other hand, foreign visitors to Canada are seen as exports, because they bring foreign capital into the country, like the sale of natural resources or manufactured goods abroad. Thus, just to maintain a balance, for every Canadian dollar spent on travel abroad, a foreigner would need to spend the equivalent in Canada. For instance, during the 1947 currency crisis, caused by appreciating the Canadian dollar to parity with the United States, Canada's reserve of American dollars dipped to dangerously low levels. In response, Ottawa slapped restrictions on both imports and travel to foreign countries.[52] Speaking at the 1947 Dominion-Provincial Tourist Conference, C.D. Howe emphasized that the federal government's priorities included rebuilding currency reserves.[53] And, according to the prime minister, in 1948, tourism represented an inflow of $270 million from the United States, making it "one of the most important sources of American dollars."[54]

Travel at home, seeing America (or Canada) first, was a continuation of the rhetoric of the Second World War.[55] In British Columbia, promoters had responded to the war with creative advertising campaigns that linked the war effort to visits to the province. For instance, with American neutrality at the outbreak of war, Canadians were hit with a series of new visa restrictions on travel to the United States. BC boosters made travel in their home province a patriotic response. After America entered the war in December 1941, promoters portrayed Canadians and Americans

as neighbours in peacetime but brothers in wartime. In the face of travel restrictions and rationing, the plan shifted to "salesmanship in reverse," encouraging American military personnel to buy war bonds to save for their British Columbian vacations once peace returned.[56] *Holiday* seemed to confirm this kind of thinking. An April 1946 editorial implied that increased opportunities for leisure travel had been a motivation for going to war.[57] At the very least, they were an outcome of victory and a sign of the superiority of the Western way of life.

As the world moved into the armed stalemate of the Cold War, tourism also demonstrated the superiority of capitalism. The post-war tourism boom coincided with the decades-long confrontation between the Western democracies, led by the United States, and international communism, led for the most part by the Soviet Union. North American consumers had already been sold on the connection between automobile ownership and personal freedom. As individual freedom became ever more import-ant in the ideological battle to define communism as evil, the connection to driving became obvious. The ability to jump into the car and take a trip, without being compelled to carry government papers (except, of course, a driver's licence) offered a stark contrast to the stereotype of state oppression in the Soviet Union and communist eastern Europe. Leisure became a symbol of prosperity and, with tourism becoming more wide-spread, of democratic equality. Moreover, tourist travel had already become a part of consumer culture. The abundance and choice that drove the culture of mass consumption became a regular feature of Cold War propaganda. Western images of the communist world concentrated on scarcity and stagnation, a stark contrast to the increased prosperity, in-creased choice, and increased leisure that capitalism brought to working people and the middle class.

Tourism also served Cold War ideology in another way. Canada's prime minister saw in international tourism the hope of peace. Speaking to the Quebec Chamber of Commerce, Louis St. Laurent said he wanted to build a tourist industry that would lead to peace between nations. By visiting each other regularly, Americans and Canadians had set a back-ground for problem solving. He implied that complete travel freedom could expand this idea to peace among nations.[58] In an era during which the world seemed to be remaking itself, tourism offered the promise of modernity, prosperity, and now peace. Tourism, then, was central to economic planning for Western nations, including Canada. It reinforced, if only rhetorically, ideological claims about a new way of life.

Planning Is Essential

In the post-war years, Ottawa became ever more involved in the organization and promotion of tourism as an industry. The Canadian Travel Bureau had been established in 1933 as an arm of the Railway Department and placed under the direction of former journalist Leo Dolan. The bureau was transferred to National War Services in 1941 and was "demobilized" alongside other war industries when hostilities ended. Significantly, tourism promotion came under the control of the Department of Reconstruction in 1948. Constitutionally, tourism fell between the division of powers spelled out in sections 91 and 92 of the British North America Act. The division of powers established in 1867 had posed intractable problems for addressing modern economic issues during the Great Depression, prompting proposals for constitutional realignment, such as those of the Rowell-Sirois Royal Commission on Dominion-Provincial Relations. As for tourism, no one seriously imagined a constitutional reorganization on the model of Rowell-Sirois, but dominion-provincial co-operation was encouraged. In October 1946, the various provinces and the federal government met for the first Dominion-Provincial Tourist Conference in Ottawa. Often overshadowed by the dominion-provincial conferences on reconstruction and fiscal relations, the series of tourism conferences that followed the war played an important role in organizing tourism in Canada.

Government tourist boards were particularly interested in promoting improvements in Canada's tourism support infrastructure and in hospitality services. At the second Dominion-Provincial Tourist Conference, Leo Dolan decried the "unCanadian" activities of unscrupulous operators who threatened to damage the country's entire tourist industry: "When any United States tourist is exploited or gypped in any part of Canada, then the whole Canadian tourist industry is injured, because, when a tourist is so treated, he does not go back home and tell how he was gypped in a particular city or tourist place, he says 'I was gypped in Canada last year.'"[59]

The message was reinforced in the 1949 Canadian Government Travel Bureau (CGTB) film *Welcome Neighbour*, which emphasized the vital importance of the warm friendliness of Canadians for tourism. A later film, *Tourist Go Home!*, offered a parody of poor behaviour, using irony and sarcasm to encourage better hospitality.[60]

If nothing else, it was clear that tourism created jobs. In the words of one prominent economist, many American businesses had moved away from meeting subsistence needs. Now, they offered goods or services "for the filling or killing of leisure time." "We may say," continued Dr. Edwin

Nourse, "that some workers' leisure is other workers' livelihood. This is conspicuously illustrated in our flourishing amusement industries and in 'tourism.'"[61] Tourism also affected people who might not see themselves as working in the leisure or hospitality trades. In one CGTB film, *Travellers' Cheques,* a cartoon coin called Mr. Tourist Dollar walked through various transactions, dropping wedge-shaped bits of himself as he went. In case this image failed to convey the message, the narration hammered it home: almost everyone in Canada benefits from tourism revenues because, although tourism "is an invisible export industry, it earns Canada 250 million export dollars every year."[62] Certainly, people in the industry benefitted most directly from tourism, but through the magic of the money multiplier, local employment in tourism created consumer spending, which in turn produced employment across the province or the country.

Provincial governments worked to organize their own segments of the Canadian industry and to shore up the bureaucracies devoted to them. The Quebec government of Maurice Duplessis created the Office de publicité de la province de Québec, which, until a Quiet Revolution reorganization in 1961, had responsibility for tourism promotion as well as publicity for all government departments and the production of government films.[63] To the east, in the Maritime provinces, a haphazard complex of private and public initiatives began to fall under provincial control during the war. In Nova Scotia, a 1941 departmental reorganization devoted half the energies of the new Department of Industry and Publicity to tourism. The new division wasted no time, establishing offices to inspect accommodations and to develop publicity and liaise with the press; it even dabbled with loan guarantees to hotels.[64] In Ontario, the Travel and Publicity Bureau was elevated to become the Department of Travel and Publicity in 1946. It too was reorganized and expanded in the 1960s.

Across the continent, in British Columbia, the changing status of the provincial tourism bureau or office through the post-war years likewise reflected that province's growing recognition of the importance of tourism. The British Columbia Government Travel Bureau (BCGTB), fashioned at the end of the Great Depression, saw its budget increase dramatically in the post-war period. From the end of the war to the mid-1950s, its budget for promoting its province ranged from about $60,000 per year to just under $100,000. In 1957, the BCGTB became one of five units in a newly created Department of Recreation and Conservation. The new department revealed the government's recognition of the increased importance of leisure and recreation to the provincial economy. In 1967,

when tourism had become the province's third-largest industry, and the annual publicity budget had reached $860,000, a dedicated government department was created. The Department of Travel Industry had expanded expenditures to just under $1.7 million by 1969–70.[65] Although the growth of the BC tourism bureaucracy slightly lagged behind Ontario's, its developments demonstrate a general trend. By the end of the 1960s, no one could doubt that tourism had become a structured and organized industry in Canada. Ontario's tourism ministry noted this simple fact in one of its annual reports: "Once tourism was assumed to be the kind of industry that would continue to grow, like Topsy, of its own volition and momentum. Now it is recognized that tourism, like any other industry, must be carefully nurtured and developed along specific guidelines. Planning is essential if the Ontario tourist industry is to continue to prosper."[66]

Let's Cash In on History

Sometimes governments promoted tourism indirectly, through the unintended result of other initiatives. For instance, the Massey Commission, established in 1949 as the Royal Commission on National Development in the Arts, Letters and Sciences, recommended government support for art galleries, museums, and historic sites to protect Canadian culture. The commission's report ushered in an era of state funding and responsibility for cultural enterprises. Its far-ranging recommendations led to enormous federal investments in universities, scholarships, galleries, and theatres. It encouraged the CBC to embrace television as a public broadcaster. It recommended the creation of granting councils to provide direct support to researchers and artists. In short, it helped shape how Canadians came to see the relationship between the state and intellectual life, and it dominated thinking about the arts, letters, and sciences through the rest of the twentieth century. Ironically, the commission chairman, Vincent Massey, was unimpressed by middlebrow commercial culture and openly scornful of the consumer culture emanating from the United States. Yet, his recommendations gave these cultural forms unintended support. Thus, although as Paul Litt has cautioned, Massey himself was culturally and socially quite conservative, the results of the 1951 Massey Report were revolutionary.[67]

Tourism itself fell outside its mandate, but the cultural institutions that the Massey Report discussed were also tourist attractions, and their cultural products could become souvenirs. Some commentators felt that the Massey Report did not go nearly far enough on this issue. Local historian

W.E. Greening, for one, complained that "in a country where our tourist trade is so much discussed, it is surprising how little attention has been paid" to the potential of historic restorations.[68] Nevertheless, one of Massey's recommendations was that the HSMBC be replaced by a more powerful body. The report noted that Canada's historic sites and monuments were "attractions both for visitors from abroad and for Canadians on holiday," but it was sharply critical of Ottawa's commemorative programs.[69] Not surprisingly, individual members of the HSMBC, such as D.C. Harvey, were defensive in the face of this condemnation; he bristled at what he alleged were the commission's confused and contradictory recommendations.[70] Nevertheless, the Massey Report urged the government to pay more attention to the use of historical resources and prompted a restructuring of federal policies and agencies. The report had a similar effect on museums, which it noted suffered from insufficient funds, inadequate staff training, and poor facilities. Little had changed since the Carnegie Corporation report had raised the same issues in 1932. Local museums were in particular jeopardy and desperately needed assistance to preserve a threatened material heritage and interpret it for the visiting public.[71]

Ronald Way likewise urged a massive expansion of government funding for historic sites in a 1951 memorandum to the Ontario premier. The problem for Ontario, as he saw it, was in making intelligent and practical uses of the historic sites that were available. There were already a limited number of partially restored sites, such as the old forts in Niagara and Sainte-Marie among the Hurons, a Jesuit mission near Midland, which he incorrectly called Fort Ste-Marie. But Way envisioned something grander still: a centralized plan would permit differing historic sites to specialize in teaching about various, co-ordinated, elements of the past. "I feel that while the military aspect of our history is adequately taken care of by Fort Henry," he informed the premier, "there is need for emphasis on other equally important phases of our past." To this end, he proposed using "Fort Ste-Marie" to teach about the French and Indian period, using the Niagara forts he had already worked on to explain the War of 1812, and building a stagecoach inn to teach about pre-railway travel. Social history might best be served, he suggested, by building a replica pioneer farm somewhere between Ottawa and Smiths Falls. This was a grand scheme for a survey text in three dimensions.[72]

Not only would all this be educational, he argued, but it could benefit the provincial economy. He put it bluntly: "Our theme might be 'let's

cash in on history.'" Way's plan was a form of product differentiation. He would market a distinct historical product, a unique brand of the past that would catch the eye of international, especially American, consumers. As he explained it, without this differentiation, Americans would quickly become disenchanted with Canada:

> A conclusion I have formed through close contact with many thousands of American visitors is that the vast majority of them came to Canada out of plain curiosity. Anything different or foreign to their American way of life seems to intrigue and captivate them while the apeing [sic] of American customs and flying of American flags by Canadians seems to lead to disillusionment and a reaction bordering on contempt.[73]

And from this alleged aping of American identities, Way led directly to what, for him, was the greatest benefit: the furthering of national unity. An appreciation of history would help Canadians determine their own customs and bind the nation together. History, he felt, was the key to national solidarity, and everyone should appreciate how the past united Canadians. Elsewhere, he contended that, whereas some might measure success from the standpoint of tourism revenues or unemployment relief, historians felt that "the criterion for success really lies in the answer to this question. Can historical restorations assist not so much the advanced student, but the general public, in the appreciation of history?"[74] Many elements of Way's plan eventually came into existence but not as part of the co-ordinated effort he envisioned. Upper Canada Village, a project under his control, did develop a sort of stagecoach inn and a working historical farm. The Province undertook a reconstruction of the Jesuit mission Sainte-Marie, which tells part of the story of French colonial and missionary contact with the Wendat people of the seventeenth century. Cashing in on history never reached the co-ordination and centralization that Way imagined, but the exploitation of the past did expand.

Through the 1950s, the federal government intensified its support for preserving, and in some cases creating, historic properties, embarking on an ambitious program of site acquisition. From Fort Langley in British Columbia to Signal Hill in St. John's, which became national property when Newfoundland entered Confederation, the Parks Branch added nine new sites to its system of national historic parks in the 1950s. Some of these acquisitions were simple transfers of holdings from other federal departments, especially National Defence. In other cases, acquisition was

more convoluted. For instance, in a pair of transactions with the Société national de l'Assomption, an Acadian national society, and the Dominion Atlantic Railway in December 1956, the branch came into possession of the Grand Pré tourist site.[75] Although the "history" of Grand Pré was questionable, linked as it was to Longfellow's fictional account of the Acadian deportation, it nevertheless evoked a significant event from Canada's past. It was also a popular attraction, drawing at least twenty thousand visitors annually.[76] Ottawa was certainly willing to incorporate Longfellow's imagination into the national historic landscape. Elsewhere, such as at Batoche, Saskatchewan, where the HSMBC had marked the end of the 1885 Northwest Rebellion with its standard plaque and cairn in the 1920s, the branch began a program of acquiring properties for further development.[77] And in Quebec City, it assumed responsibility for the city's walls and made repairs to the Dufferin Terrace.[78] This renewed program of historic site development culminated with the plan to restore Louisbourg, which dominated the federal government's historic sites budget in the 1960s. But the era of the heritage megaproject, as symbolized by Louisbourg, really began in the 1950s.

Alongside the work at Quebec City, the restoration of the Halifax Citadel stands out as a top priority of the 1950s development of historic sites. In 1950, anticipating the release of the Massey Report, the Parks Branch convened a special committee to investigate its options for the Halifax Citadel.[79] The citadel was the fourth fortress built on the hill overlooking Halifax and its harbour. The first, a simple stockade, was erected for protection in the colony's first year, 1749. It was rebuilt during the early 1760s, and again in the 1790s, as new military dangers associated with Britain's imperial wars threatened the people of Halifax. Following the War of 1812, the British government embarked on a program of military construction at strategic points across British North America. The fourth citadel, a part of this work that included Fort Henry and the Quebec Citadel, represented the height of fortification construction in the 1820s. Upon completion at the end of the 1840s, "the Citadel occupied a most enviable position among the more powerful of Great Britain's colonial defences."[80] Yet, only two decades later, it was virtually obsolete.

Obsolescence led to deterioration. The citadel was garrisoned by British troops until 1906, used as a detention camp during the First World War, even briefly holding the Russian revolutionary Leon Trotsky, and incorporated into civil defence plans for the Second World War. However, aside from quick repairs for these occasional uses, it had been allowed to slide

into near ruin. In 1951, when National Defence transferred control of the citadel to the Department of Natural Resources, the Parks Branch inherited the management of a dangerous and open site.[81] In the first few months, the branch spent $88,000 on repairs and asked for continuing funds to permit a full restoration.[82] By the 1960s, the money was pouring in. The minister overseeing this work, Walter Dinsdale, claimed that historic site restorations were worth "every penny" because they showcased the Western values of freedom and national independence: "These sites also serve as a reminder to our young men and women of the courageous spirit of those who came before, so that we may complete their work and develop a Canadian nation that will continue to be a source of inspiration for the many nations now achieving independence and freedom throughout the world."[83] Tourism was an equally strong motivation. Speaking specifically about the citadel, the Atlantic regional director of the Parks Branch made an explicit connection: "Historic Sites, once the exclusive ground of the antiquarian and the historian, are today included in tourist promotion programs, discussed as contributions to civic improvement or local and regional development, studied by both teachers and pupils, and visited by several million Canadians and US visitors a year."[84] Government intervention to preserve historic properties made both patriotic and economic sense.

Historic tourism remained a sacred cow in tourism strategies, and every province sought to capitalize on its own past. Nova Scotia invented the Order of Good Cheer, which it pretended was a revival of Samuel Champlain's Ordre du bon temps from 1606. This order permitted visitors who spent ten days in the province to receive a membership card that linked them, however improbably, to the first French settlers and explorers in North America. The scheme seemed to pay off: by 1956 some 200,000 people had joined this largely pointless club.[85] Although one journalist lamented that Canada was neglecting its history as a source of tourism revenue, Canadian planners had actually embraced the potential of the past.[86]

Over time, though, some people began to question the easy assumption that historic sites attracted tourists and that tourism was a straightforward benefit to the national economy. When a federal Travel Bureau survey of 1965 found that 44.8 percent of tourists claimed an interest in historic sites, Ontario's researchers disagreed with this estimate, stating that it was too high. In the same year, the province's reception centres, situated at its highway entry points, reported that only 11 percent of visitors were

interested in Ontario's historic sites.[87] Historic attractions were only part of a broader strategy to develop the province's tourist industry. In 1957, out of the 2.25 million tourist pamphlets printed by the government, some 50,000 detailed the province's various historic attractions. And the following year, the reception centres distributed 82,000.[88] Ontario's Travel Research Branch repeatedly found evidence that the province's own citizens were the main audience at its historic sites. A 1969 study for the Canadian Tourism Association revealed that tourism had become a $3 billion industry, with Canada once again suffering a trade deficit, this time of roughly $100 million. Over all, the report found that travel spending (for transportation, lodging, food and beverage) amounted to 8.0 to 8.5 percent of total consumer spending. Of that travel budget, Canadians spent 50 percent in their home province, 17 percent in the rest of Canada, and 33 percent in other countries, almost all of that in the United States. Of travel spending in Canada, 37 percent of it came from US visitors and other foreigners, which meant that 63 percent of travel spending in Canada was dependent on Canadians. On average, 47 percent of total tourism spending came from people travelling within their own province.[89] Clearly, tourist attractions needed to be geared toward a "home" market as much as they depended on drawing Americans.

Even locals sometimes derided the economic potential of new tourist attractions for the local economy. In debating the construction of Old Fort William at Thunder Bay, Ontario, in the early 1970s, one resident was particularly scathing:

> I visited one of these things in BC and there was only my wife, my sister and myself in the place. I was disgusted and tried to get my money back but they wouldn't give it to me. This fort will do nothing for the city other than provide jobs for a bunch of guys in blue suits who will be walking around all day trying to sell a necktie. If you build this thing I won't help pay for it. I will deduct it from my taxes.[90]

Many experts agreed. In a 1976 report to the Canadian Conference on Historical Resources in Victoria, British Columbia, consultant J.D. Herbert analyzed the economic arguments in favour of historic site developments. Herbert had over a quarter-century of experience in heritage tourism development. He had been the chief historian for the federal Parks Branch in the 1960s, before moving on to a series of positions on the Prairies. Although he admitted that little research had been done on

the specific economic impact of historic sites, he disparaged the more exuberant claims about millions of foreign visitors and coffers of cash. Indeed, he argued, his own experience with historic reconstructions had taught him that they were not economic engines. Certainly, development spending created local jobs, but once historic sites were built, their operation employed very few people. Secondary benefits, from sales of fuel, food, and lodgings, might boost local economies to some extent, but as so many sites were already located near population centres, this was difficult to measure. Instead, Herbert suggested, Canadian support for historic site developments was largely a phenomenon of the educated middle classes, who saw such sites as "public goods" and bristled at the thought of tainting the nation's cultural heritage with crass economics.[91]

The Allure of the Past

No matter what the critics thought, governments had clearly accepted the importance of tourism to the domestic economy. In 1963, for the first time since 1950, Canada had attained a favourable balance of trade in tourism. Expenditures of US and other foreign travellers in Ontario alone reached $350 million that year, an increase of 11 percent over the year before. Combined with the money spent by domestic travellers, the tourism dollar represented well over $1 billion to Ontario's economy. But competition for this prize was intensifying.[92] The provincial tourism department was concerned that few travellers spent their entire vacation in Ontario. Many passed through the province on their way to somewhere else, facilitated by the province's principal highway, the 401, that passed miles to the north or south of the most likely attractions. In the centennial year, facing stiff competition from Montreal's Expo 67, the department's Travel Research Branch determined that 20 percent of Americans who passed through Ontario were en route to Expo 67, and for 18 percent this was the only reason for being in the province at all.[93]

Air travel presented an even greater threat to Canada's tourism industry. The first passenger air service ran seaplanes between Tampa and St. Petersburg, Florida, in 1912. However, early success for American airlines was connected to winning airmail contracts from the federal government. Under the Hoover administration, these contracts were manipulated to force mergers and create a small number of major airlines. For example, Trans World Airlines (TWA) emerged from the union of Transcontinental Air Transport and Western Air Express in 1930. In Canada, Mackenzie King's minister of transportation, C.D. Howe, mandated the creation of

Trans Canada Airlines (TCA) in 1936 as a wholly owned subsidiary of Canadian National Railways to link Atlantic Canada with the Pacific coast. Transcontinental flights were just becoming feasible in the late 1930s, and most airlines relied on railway legs to complete a "flight" across the continent. However, as early as 1930, TWA could fly passengers across the United States in thirty-six hours by landing ten times, including an overnight stop in Kansas City. Pre-war passenger aviation might seem both strange and curiously familiar to twenty-first-century travellers. On the one hand, unpressurized aircraft flew at low altitudes, with windows that could open. On the other hand, in-flight service was minimal. However, with technological improvements, and multiplied airfields, air travel became more common, even if it remained a privilege of the wealthy.[94]

During the Second World War, national governments took an interest in air travel, although specifically for military purposes. Nevertheless, wartime innovations improved aviation, trained thousands of pilots who would seek new employment once the war ended, and generally subsidized the business of building and flying airplanes. Although military historians have studied the technological advances in aviation of the war years and the Cold War, few historians have investigated the early years of North American commercial air travel. However, a cursory glance suggests that they were a pivotal point for the industry. A number of Canadian-based airlines were established in the 1940s, such as Nordair, Eastern Provincial, and Colonial Airlines. Most importantly, Canadian Pacific Airlines (CPA) took to the skies in 1942. Although regulators repeatedly thwarted its efforts to compete with TCA, by 1960 CPA had been licensed for service to Winnipeg, Toronto, and Montreal.[95] Between TCA and CPA, Canada emerged from the Second World War with two national air carriers, each linked to one of the two transcontinental railways, fed by a system of small regional carriers.

Air travel seemed to offer a promise of expanded markets and, for tourists, enhanced options for destinations. It brought competition closer to home. For instance, in the late 1940s, with Europe and much of Asia damaged by war, Mexico became an alternative holiday destination. The Mexican government ploughed resources into tourism infrastructure, such as airports, beachfront hotels, and roads, to promote development. As air travel increased, foreign visits to Mexico nearly quadrupled between 1960 and 1970.[96] Once Europe recovered from the war, it re-emerged as a premier travel destination for North Americans, and even for Asian tourists.[97] In 1955, CPA inaugurated over-the-pole flights from Vancouver

to Amsterdam, and the same year TCA announced that it was in the market for jet airliners to begin service in the 1960s.[98] Jet engines and other technological improvements made transatlantic travel simpler, faster, and cheaper. Competition from European destinations was very real. By mid-decade, even communist countries had begun to compete for their share of the world's tourists. The Hungarian intellectuals who had manned the barricades in 1956, *Life* magazine reported in 1964, were now concerned with attracting tourists to Budapest.[99]

Government bureaucrats paid close attention to these trends. For example, in a 1967 confidential report, Peter Klopchic of Ontario's Travel Research Branch warned of coming tourist industry problems for the 1970s. Klopchic worried that the greatest challenge to Ontario tourism was air travel. The introduction of the Boeing 747 "jumbo" jet for 1969 (with full impact felt in the 1970s) would allow airlines to offer cheap packages to compete with Ontario's usual markets in Canada and the northeastern United States. Air travel, restricted to households with annual incomes above $10,000 in the 1960s, would become more affordable as larger aircraft spread out the cost per passenger. Airlines would then be able to mass advertise "pleasant vacations at reduced rates to, for instance, Lebanon, Algeria, Turkey, [and] Greece."[100] In other words, Ontario's (and indeed Canada's) competition as a travel destination was becoming the more exotic and historic sites of the Old World. Klopchic urged a stronger attention to historic sites, and in particular military history, to showcase Ontario's own distinctiveness.

Part of the allure of Europe was that it seemed more "historic" and its history more real.[101] Canada's historic sites countered this perception with an emphasis on animation. By the start of the 1960s, visitors to historic sites regularly expected to see action, and live interpretation became an unmediated communion with history itself. Speaking to the Halifax Kiwanis Club, Parks Branch director J.R.B. Coleman argued that although textbooks could provide information, "seeing the men in old-fashioned uniform performing an authentic drill from the manual of arms heightens the impression of the past, stimulates the imagination and leaves one with the feeling that he has had a unique and very enjoyable lesson in history without a teacher getting between him and the physical reality."[102] Living history thus added layers to the role of the museum. The performance of military drills put on a show for the entertainment of visitors. At the same time, it served to teach about military life in the past. Combining education and entertainment, living history thus reformulated the

American compromise of mid-nineteenth-century museums.[103] A century later, museum curators once again sought innovations to attract public interest to the historical lessons they wished to teach. The twentieth-century public was accustomed to more elaborate forms of entertainment than those of the 1840s. Hollywood films, television westerns, and theme parks all offered enjoyable versions of history that museums had to compete against.

Similarities between living history and theme parks played an important role in the development of Canada's living history museums as they struggled to draw distinctions "between a true restoration and the Disneyland approach."[104] Obviously, both are tourist attractions that attempt to create an experience segregated from everyday life. Both try to organize the way in which visitors experience the inside and outside worlds. Theme parks and living history museums thus share the effort to restrict visitors' impressions by providing a self-contained environment that evokes a particular place and time. Neither can be wholly complete, and thus they also share recourse to a selective reconstruction of a vanished (or never-existing) lived environment. They do this by limiting vistas to screen out the intrusions of the modern or outside world. And within the created environment, they conceal elements of the past that would interfere with the intended impression; sometimes, due to ignorance, they eliminate entire past experiences.[105]

They similarly overlap in their efforts to attract visitors, and especially families and children, with "fun" activities. From their inception, living history museums targeted children as an important demographic. This, in turn, drove them back into the direction of the proprietary museums of the nineteenth century. They had to emphasize entertainment if they wished to attract visitors and become meaningful components of the state-supported tourist industry. However, they also faced pressure to be educational and to portray, not just an enjoyable version of the past, but one that was accurate as well. Unlike theme parks, living history museums had to answer visitors' questions about the history they portrayed. Living history promised, in Coleman's words, history lessons "without a teacher getting between [the students] and the *physical reality*."[106] Living history was more real than textbook history because of its materiality. Its power to connect individuals of the present to those of the past lay in that physical reality. The Halifax Citadel was intended to be such a living museum. According to Walter Dinsdale, Ottawa recognized the importance of bringing the past to life: "The federal government plans to spend another

2 million dollars with the ultimate aim being the establishment of a living museum. It is our hope that by 1967 when we celebrate our centennial, the famous Halifax Citadel will be a living replica of the post used as a defence centre for Canada during a critical period of our history." This, he claimed, would entail "moving in the military people to provide us with a living museum."[107]

To adapt David Lowenthal's later characterization, if the past were a foreign country, it must be possible to travel there and visit with its inhabitants. Visiting the past became a sort of foreign travel. To be fair, Ronald Way had imagined populating Fort Henry with actors conducting military drills long before Walt Disney added cartoon characters to his version of the past. This is an important distinction to draw between living history museums and theme parks: both populated fantasy spaces with characters, but the motivations and results of their efforts were vastly different. Theme parks could make hay out of imaginary pirates and princesses who were three times removed from those history, but living history museums could not.

Although major undertakings, such as the Halifax Citadel, required major expenditures, not all living history museums needed the same access to capital. A host of smaller local museums also emerged in the 1960s and proliferated during the 1970s, often justified in part by claims about the local tourist economy. These museums took advantage of local knowledge and local resources, and although they were often supported by municipal governments, they commonly arose from private initiatives. Nevertheless, federal and provincial governments had been drawn, bit by bit, into the business of historical tourism. By the end of the 1950s, it seemed obvious that history had become a feature of national and provincial tourism marketing. Megaprojects, such as the Halifax Citadel and Fort Henry reconstructions, dominated thinking about living history and provided models for many of the smaller museums that sprang up across the landscape and helped mould people's expectations of what such museums should provide. They ushered in a reorientation of how history could be told, displayed, and acted out. Moreover, by building three-dimensional representations of past environments, and by populating them with costumed actors, they not only shaped understandings of life in the past, they also manufactured the material evidence that supported those understandings. Thus, these museums, conceived as educational tourist attractions, refashioned tourists' interactions with Canadian history.

PART 2

Structures

4

Pioneer Days

DESPITE SO MUCH INTEREST in historic site tourism from Canada's governments, travel promoters demanded more. A *Toronto Star* travel reporter complained about the quality of Canada's attractions in a thinly veiled critique of the Historic Sites and Monuments Board of Canada's (HSMBC) plaques program: "The one big thing tourist people seem to overlook is that folks on holiday hunger for side attractions ... Things historical should be identified by something more than fieldstone cairns erected along the highway." Instead of putting up boring plaques, the reporter mused, someone should build "some Indian villages and wax museums depicting Ontario pioneer days" for tourists to enjoy.[1] Yet, even as Alex Henderson made this appeal, a number of local groups were already at work, bringing the province's pioneer history to life. Historical societies and conservation authorities, as well as municipal governments, private entrepreneurs, and not-for-profit organizations, turned to the innovations of living history in the 1950s and 1960s. Ontario led the way. Doon Pioneer Village south of Kitchener, Ontario, had its genesis in a 1953 proposal, and the origins of Black Creek Pioneer Village northwest of Toronto can be traced to 1954. The idea to build a pioneer village near London, Ontario, was endorsed by the local conservation authority in 1956. The land for Westfield Pioneer Village was duly bought in 1960, and the village opened in 1964. A number of like-minded Canadians, not just in Ontario, came to similar conclusions about how to present Canada's history at roughly the same time.

Widespread enthusiasm for this specific cultural institution is a clear demonstration of the acceptance of ideas about the interaction of historical knowledge with the physical world. Across Canada, at least twenty pioneer village living history museums had opened by the end of the 1970s, as the message of hands-on social history caught on. East of Montreal, Village historique Jacques de Chambly recreated the eighteenth-century rural past of the Carignan seigneurie. In 1964, Heritage Park opened to showcase early Prairie settlement in a park-like setting on

Calgary's Glenmore Reservoir. At the other end of the country, King's Landing Historical Settlement officially opened in New Brunswick in 1974. It was later joined by the Village Historique Acadien in 1977, and Orwell Corner Historic Village opened near Charlottetown, Prince Edward Island, in 1973. These museums reflected the complex play of past and present in the landscape. They demonstrate how the earliest European settlers in Canada's various regions came to be lauded as symbolic of the origins of the country. But equally, the celebration of the pioneers fed off concerns about changes in the natural environment and the importance of managing them. A number of competing, complementary, and sometimes contradictory motivations coalesced to generate a celebration of the supposed pioneers of Canada, each of which sustains a discussion in turn. And, although living history museums were initially designed and built by local, amateur enthusiasts who were keen to honour local pioneers, over time many became professional museums tied to local tourism promotion campaigns.

Motivations
An appeal to tourism was not the only, or even the most important, motivation for the builders of pioneer village museums. Like the heritage activists that preceded them, those of the post-war years were driven at least in part by nostalgia and anxiety about the shape of the future. Looking back on the early 1960s, Goldie MacDonnell, one of the founders of Westfield Pioneer Village, remarked, "It was a time of change ... Everything was built new, and old buildings were in the way."[2] Indeed, the pace of change was remarkable, brought about by the triumphant car culture of the post-war years. In testifying before the Massey Commission, the people who were responsible for Montreal's Château de Ramezay Museum lamented the disdain for historical museums in Canada, "a country where monuments of historical value are destroyed 'merely to enlarge a parking lot.'"[3]

As if to drive the point home, and with an irony that was not lost on preservationists, Fort York was again threatened with destruction. In January 1958, the newly amalgamated Municipality of Metropolitan Toronto announced its intention to tear down the old fort to clear space for an elevated expressway along the city's western waterfront. This was part of a large-scale scheme of highway construction in which a network of expressways would be overlaid on existing city neighbourhoods. (One

of the more infamous – and celebrated in its failure – features of this plan was the Spadina Expressway, which was cancelled by Premier Bill Davis on 3 June 1971.) To be fair, planners intended to "save" the fort by tearing it down and rebuilding it closer to the shore of Lake Ontario. Some even suggested that the relocation would be "more historical" because the fort had once stood at the water's edge. Landfill works between 1850 and 1920 had pushed the shoreline farther south, isolating the fort from its original lakefront setting.[4] However, thanks in part to the tourist-minded restoration of the 1930s, the old fort was far more central to Torontonians' civic identities than it had been at the start of the century. Volunteer members from the Toronto Civic Historical Committee started running guided tours in 1953. Following the model of the Fort Henry Guard, a Fort York guard began to drill for visitors in 1955, and women in period dress were added to the fort's living history program two years later.[5] Fort York had a constituency.

One of the fort's most vocal supporters was A. Gordon Clarry of the York Pioneer and Historical Society. Clarry wrote to journalists, politicians, and his counterparts at Ontario's many local historical societies to block what he called an act of historical vandalism and an abandonment of Canada's heritage.[6] Invoking the memory of the War of 1812, one correspondent suggested, perhaps tongue-in-cheek, that the engineer who proposed tearing down the fort must be an American.[7] By 1959, support for moving the fort had evaporated, and engineers laid out the highway to bypass both it and its military cemetery. There were a number of reasons for this sudden turnabout, including the vigorous lobbying of the historical societies. However, military historian G.F.G. Stanley had been prophetic when he suggested that though "it will be argued that historic sites must not stand in the way of what is known as progress ... it would seem very hard to believe that engineers are incapable of finding an alternative route which would not injure Fort York."[8] As it turned out, rerouting the expressway was cheaper than the costly and time-consuming task of dismantling and rebuilding Fort York on a yet undetermined plot of land.[9]

Certainly, nostalgia underpinned this appeal for preservation. As Stanley implied, modern Ontario seemed to act as though history were in the way of progress. He was not alone. At a heated meeting of the Toronto Civic Historical Committee in the midst of the Fort York battle, members complained that "today Torontonians take the unrestricted growth of the City for granted." For its part, the committee claimed for itself the responsibility

to preserve symbols of tradition "intact" and to be "the custodian of the memory of Toronto," because memory was being lost to progress in North America's mass consumer society.[10]

The mass consumer society, of which post-war tourism was one manifestation, brought with it these anxieties. Often hailed as the success of capitalism, mass consumerism also provoked fears that an older, personal society was being paved over. Even its benefits raised concerns. Although consumers and vacationers embraced the opportunities afforded by automobility and its developing services, people often disliked the same effects in their home communities. Steve Penfold reveals that suburbanites near Toronto rallied against the excesses of drive-in culture, even as they benefitted from its advantages.[11] Mass consumer society, although it took on its most visible form in the commercial landscape of the highway "strip," also began to affect the character of local neighbourhoods and communities. Not only was the strip becoming less distinctive, but so too were the residential streets. There, amid the rows of identical bungalows and manicured lawns that lined virtually identical gently curving streets, stereotypes of the mass-produced landscape were born. As early as 1946, a *Toronto Globe and Mail* editorial condemned the soulless conformity of the city's outlying suburbia.[12]

Unlike in large US cities of the same period, large numbers of middle-class Canadians did not flee to the suburbs in an attempt to escape the poverty and ethnic diversity of the central city. Canada's suburbs followed a different path, and their pull was more constrained than in the United States. For instance, residential densities remained relatively high in Toronto, Montreal, and Vancouver, as compared to large American cities. Nevertheless, in both countries, suburban growth involved greatly reduced densities, compared to earlier pre-war suburbs. They continued to fall through the 1950s, 1960s, and 1970s, although at a lower rate than south of the border, as car-induced expansion sprawled across the landscape. Toronto again serves as an instructive illustration. Even with substantial apartment building during the post-war period, densities after 1950 for the city as a whole were only half those seen before the Second World War. Whereas, early in the post-war period, much of Canada had maintained its pattern of small-scale owner-builder suburban home construction, developers gradually crept into a dominant position. As Canada moved into the era of the corporate suburb, where developers planned and built entire subdivisions, the suburban pattern changed. As early as the 1950s,

Canadian planners began to see William Levitt's development company as the model for urban growth and planning, and the federal Central (later Canadian) Mortgage and Housing Corporation (CMHC) did what it could to promote the success of large-scale developers. The American suburb came to dominate Canadian thinking about urban growth.[13]

The CMHC's preference for financing single-family homes, and the increasing lot sizes of residential properties, spread fewer families over larger areas. One estimate suggested that, alongside accompanying lands for parks, roads, and schools, each new home built between 1950 and 1970 added six-tenths of an acre to (sub)urbanized land.[14] With lot widths of fifty and sixty feet, the pace of expansion across the countryside accelerated as suburban growth gobbled up acres of farmland. Yet, although the farms disappeared, most new homes occupied less than half of their lots, leaving ample green space. Nevertheless, the landscape was being remade, as farms that had operated since the nineteenth century were exchanged for the plush lawns of suburban subdivisions, and historic relics of early settlement were replaced by modern bungalows and side-splits. A 1950s *Maclean's Magazine* cover by Peter Whalley made a similar comparison. Whalley's cartoon poked fun at suburban development: in its top panel, pioneers clear the forest and live in a log cabin; the next shows agricultural land being bulldozed by a developer as farmers move out; what finally remains is a treeless suburb of identical homes. For Whalley, the joke was that suburbanites were planting trees to beautify their once forested properties.[15] Taken another way, it suggested that Canada's historic landscape was being supplanted by those who had forgotten the past.

Local historians and museum directors across North America agreed that a way of life was being lost to economic progress. One author, writing in the *Bulletin of the Canadian Museums Association*, attributed the postwar growth of local history museums to a need to cope with the onslaught of modernity through nostalgia.[16] The past, even if it were idealized, represented a foil to modern development that helped people express their concerns about mass society's effects on family and community life. Nothing better illustrated these changes than the physical transformation of a once idyllic landscape. Speaking to the Waterloo Historical Society in 1960, Norman High of the Ontario Agricultural College connected the construction of Highway 401 across the valuable agricultural land of Ontario to the loss of old farm homesteads, "submerged in this ribbon of pavement."[17]

For many people, this nostalgia manifested itself as a pioneer myth. The celebration of pioneers captivated many Canadians through the early post-war years. Mid-century Ontarians certainly seemed incapable of hearing enough about the labours and achievements of the province's early settlers.[18] Recently, scholars have attributed this fascination to a cultural phenomenon known as antimodernism, which is often construed as a straightforward rejection of modernity. Yet it might be better understood as a recoil from some aspects of modernity, particularly its "over-civilization," and an effort to balance its effects through recourse to more intense forms of physical or spiritual experience. It represents an effort to recapture the authenticity of human experience without surrendering the benefits of technological or material progress.[19]

The celebration of pioneer settlers, believed to have lived simply in self-built log cabins on basic farmsteads laboriously carved out of the virgin forest, can be seen as an example of twentieth-century antimodernism. It provided stability and a point of reference to balance anxieties produced by living under the condition of modernity. But, at the same time, Ontario's pioneering myth was not a novel reaction to post-war conditions alone. Sharon Wall has outlined another strain of Ontario antimodernism in which parents shielded their children from modernity through the modern institution of the organized summer camp. From the 1920s to the 1950s, summer camps romanticized a simple life of face-to-face community and harmony with nature, which was often associated with vague and naive notions of Aboriginal people's lives. Yet equally, camp life helped socialize children in ways that prepared them for the regularized, gendered, and class-structured modern world they would enter as young adults.[20]

However, not all references to the past – even stereotypical references to a simpler past – are so easily cast as antimodernism. Post-war interest in history was also connected to what Paul Litt terms a "genesis complex," an obsession with local historic firsts. Historic firsts helped answer the fundamental question of how we got here. As Litt argues, "the genesis complex reflected people's natural curiosity about their society's origins." However, it "also conveniently reduced the complexities of history to a manageable set of facts."[21] In its simplest form, the genesis complex can be a search for the earliest incidents, the uncovering of historic firsts. Being first establishes a right of priority and proclaims legitimacy, much as First Nations people base land claims on their prior occupation of the territory. Indeed, their employment of the term "First Nations" rather than the externally imposed "Indians" or "Natives" makes an explicit

reference to the legitimacy conferred by being first. Firstness also supports the authenticity of the "meanings" associated with the past. Thus, the importance of the genesis complex is its elaboration of a myth of origins. This myth interprets the past as a continuous history, a coherent narrative that ignores messy inconsistencies. Moreover, it diminishes the historical importance of anything that lies outside its tidy narrative. The genesis complex thus inevitably involves selective readings of history's body of facts and a forgetting of contravening evidence.

Pioneering fit into this myth through a "man-versus-nature" ethos. In extolling the early days of European settlement, people invoked the pioneer as an allegorical figure who represented an individualized foray into the wilderness. With meagre resources, the pioneer survived and, in time, prospered through hard work and industriousness, leaving behind a legacy of a new civilization in the New World. During the Cold War, which followed after a global conflict brought about by European moral corruption, this was a powerful myth reinforcing Western ideals. Importantly, the image of the pioneer supplied a moral narrative that highlighted a selection of accepted mainstream values.[22] The pioneer was thus inevitably invested with considerable symbolic importance. On the one hand, the pioneer was held up as a paragon of individual self-reliance who achieved success through hard work, thrift, and perseverance. Yet, even as it glorified individuality, the pioneer myth, through the simple interdependence of the pioneer community, likewise affirmed social cohesion in the modern community through the presumed traditional values of family and faith.

These combined values wound their way into the development of the first pioneer village museums. At the first session of the twenty-fourth Ontario legislature, John Root, the newly elected Conservative MPP for Wellington North, rose to second the motion to adopt the Speech from the Throne. With the approval of Premier Leslie Frost, Root took the opportunity to propose building a pioneer life museum somewhere in the province.[23] No doubt Root was influenced by the emerging pioneer myth, for his museum would be one of "pioneer life" and would capitalize on the growing interest in Ontario's nineteenth-century history. Later, speaking again in the legislature, Root pledged that a pioneer village museum would be a memorial to "the courage and the hard labour of those who have gone before." After singling out the support of "history-conscious" organizations and people, such as the Women's Institutes, the Junior Farmers, and various historical societies, Root told his colleagues

that a pioneer village museum would be a place where modern visitors could see that "people with faith in God, with vision, courage and initiative can lay the foundations for great developments." And, he interjected, it would offer a defence of "our system of free enterprise."[24]

This insertion of Cold War sensibilities into the pioneer past may seem odd or idiosyncratic at first glance. However, it reveals that Root saw pioneer settlement as the genesis of modern Ontario. Pioneering thus fed the genesis complex by associating the prosperity of the present with the actions and values of those who were imagined to be the province's first settlers. Far from simple antimodernism, the pioneer myth sat at the head of a chain of history that led to the present. Root's museum would thus be a measure of Ontario's progress. The pioneer myth was not nostalgic: it was an embrace of modernity. Indeed, the development of pioneer village museums often grew out of modernization itself. Many Ontario examples, such as Black Creek or Fanshawe, as well as the provincially owned Upper Canada Village, were by-products of flood-water management programs, as water management and conservation underwrote this aspect of museum development.

There had been some trend toward water management earlier in the century, as part of the same conservation movement that produced Canada's national and provincial parks systems. In 1932, Ontario's first conservation authority, the Grand River Conservation Commission, was established to manage the persistent flooding of the Grand River watershed in southwestern Ontario.[25] In the mid-1940s, the Province expanded the program, passing the Conservation Authorities Act to permit municipalities that shared a watershed to create joint authorities to manage flood waters. Within five years, sixteen new authorities had been organized.[26] However, the real impetus for flood control came in October 1954, when Hurricane Hazel revealed the inadequacies of the water management system. Hazel's devastation forced a reorganization and strengthening of the system. A number of key ideas had shaped the earlier development of conservation authorities, and these also guided the political response to the destruction of 1954. Not the least of these was the idea that people played a role in environmental disasters. Under this kind of thinking, human decisions and human behaviour acted in tandem with natural events to aggravate the damage caused by "natural" disasters.[27] Holistic thinking, then, incorporated human activity into the regulation of nature, an idea that made it easy to imagine human history as an equal component to be conserved.

In deciding to combine flood-water management, nature conservation, and historical preservation, the province's conservation authorities were guided by the ambitions of Arthur Herbert Richardson. Richardson had become head of the Conservation Branch of the Ministry of Planning and Development in 1944 and had been instrumental in drafting the original Conservation Authorities Act. He was also a devotee of what he called the "conservation ethic," which drew lessons for conservation from past practices. In 1950, Richardson's technical teams began to spread out across the province to detail land use, hydrography, wildlife, and local history for the watersheds that came under conservation authority control.[28] In the reorganizations prompted by Hazel, conservation authorities began altering their mandates to include the preservation of historic sites and buildings.[29] Nothing in the Conservation Authorities Act empowered agencies tasked with flood-water management and the preservation of nature to construct living history museums. Equally, there had been nothing to prevent the practice. Instead, Planning and Development's decision simply followed what seemed a natural extension of the mandate. The reports generated by these studies began to argue that relics of human history ought to be conserved alongside the natural environment, so that "future generations would reap the greatest value" from them.[30] The *Don Valley Conservation Report*, for instance, suggested that an effort be made to protect churches, houses, and mills in the Don River watershed. The report went so far as to suggest that they be grouped together in a village museum.[31]

This was a logical extension of the conservationists' holistic view of the material world, in which human history was entwined with present-day nature. Indeed, "to understand our present problems of conservation," one museum curator later wrote, "we must look back to the early settlement of our region ... With the clearing of upstream land for farming, the spring freshet grew in magnitude, until floods threatened the very village which sought power and shelter from the river and its valley."[32] This understanding of how the environment and human history interacted made the acquisition and preservation of historic structures seem natural to conservationists. For instance, in 1954 the Humber Valley Conservation Authority (HVCA) had embarked on a program of historic property restoration when it purchased fourteen acres lining Black Creek in Woodbridge. On this property was a barn originally raised in 1809 by a Pennsylvania-German settler named Johannes Schmidt. The HVCA converted the barn into a pioneer museum, which boasted exhibits of such

activities as flour making, coopering, and butter making, as well as displays of agricultural and household implements. At the time, Toronto had no fewer than four conservation authorities, struggling independently to manage the Humber River, Etobicoke Creek, Don River, and Rouge River watersheds.[33] But the 1956 reorganization provoked by Hurricane Hazel dissolved these four small bodies and amalgamated their operations into the Metro Toronto and Region Conservation Authority (MTRCA).[34] Recognizing the need to make greater use of the Black Creek museum it had inherited, which was then open only by appointment, the MTRCA established its regular hours that spring. Displays of pioneer life proved popular. Eight thousand people visited during the museum's first summer of operation. The following year, the hours were expanded and attendance more than doubled. This farmers' museum eventually became the nucleus of a living history museum at the Black Creek Conservation Area. The Grand River and Upper Thames authorities were also pioneers in living history. Indeed, conservation authorities played a dominant, but by no means exclusive, role in developing Ontario's pioneer village museums. Their involvement so early and in such a central way demonstrates the forward-looking nature of living history museums. They were not simply appeals to nostalgia.

The Museums Section and the Growth of Professionalism
Before the Second World War, governments had relied on amateur experts and history buffs, such as Harriette Taber Richardson, C.W. Jefferys, Loftus Morton Fortier, and Katharine McLennan, when they became involved in historic reconstruction or restoration plans. Like those projects of the interwar years, the conservation authority villages were often driven forward by dynamic and dedicated advocates. Westfield Pioneer Village was a labour of love for two teachers, and Nina Marsdan of the Lake Simcoe South Historical Society played an essential role in developing Georgina Pioneer Village. However, the increased government involvement in planning and directing the economy that characterized postwar modernity depended on new, specialized technical expertise. As governments moved into planning for tourism – and historic tourism in particular – they also sought out new professionals to fill this need. However, this change did not sweep aside a previous generation of public historians. Many continued to advise the new planners, and some, such as Ronald Way, helped invent a new profession to serve them.[35] Nevertheless, under government development, amateur historians

were gradually replaced by the advice of technicians and professional planners.

At the same time, these amateur builders sought out and developed institutional supports for their work. Much like the so-called amateur historians who dominated historical scholarship in Canada before the First World War, the builders of local museums were "amateurs" in the sense that they had no professional training and many were unpaid.[36] However, pioneer village museums were a new type of institution that fell outside the usual scope of the Canadian Museums Association (CMA). The CMA had been established in 1947, when the American Museums Association held its annual meeting in Quebec City, and it aimed to be a national organization of professional museum workers. It restricted membership to the employees of institutions that were open to the public at regular hours and were managed by professional curators.[37] Although this policy was intended to establish and maintain professional standards for the fledgling body, it nevertheless excluded participation by smaller, local museums, which were often staffed by volunteers under the direction of local historical societies. As Carl Guthe, then director of the University of Michigan's Museum of Anthropology, noted, these museums were simply ill-equipped to provide basic public services. Indeed, many of their volunteers had little idea even of where to go for guidance.[38] In response to this deficiency, Wilfrid Jury of the University of Western Ontario assembled an informal gathering of local curators during the annual meeting of the Ontario Historical Society (OHS) in 1945. By 1953, this informal assembly had become the Local Museums Committee, and in 1956 it became the Museums Section of the OHS.[39] It saw its role as establishing standards for local museums through the sharing of information and best practices, and the training of personnel through publishing a regular newsletter and organizing workshops.[40]

The Museums Section approached professional development collegially. At workshops, ideas were shared and problem solving was consensual, with participants discussing issues among themselves and bringing their personal experiences to bear on them. Ruth Home of the Jordan Historical Museum took an early leadership role as president of the section, a position she passed to Andrew Taylor in 1956. Home had professional experience with the Royal Ontario Museum, and her leadership was instrumental in linking local volunteers to museum professionals. Louis Jones of New York State's Cooperstown Farmer's Museum was the keynote speaker at the first Museums Section workshop, held in Jordan in May

1954. In some ways, Jones's ideas anticipated more recent concepts in museum studies such as dissonance and sharing authority. He argued that a museum's responsibilities to its public outweighed those to its board of directors or wealthy benefactors. A local museum must be embedded in its community as an institution of public enlightenment and engagement, and as such, must strive for coherent public education. The central dilemma facing most small museums was the rational control of collections, which, in amateur hands, had too often become little more than modern cabinets of curiosities characterized by the unplanned thrusting together of all manner of artifacts and subjects. Jones insisted that a coherent and restricted narrative should guide each museum's collecting practices, lest it permit individual whim and uncontrolled donations to dictate its educational mandate. An unplanned museum would be less than useless, he suggested, because it would serve only to confuse visitors.

There was nothing particularly novel about Jones's recommendations to the Museums Section workshop. He straightforwardly conveyed ideas about museum displays and organization as formatted by his predecessor at Cooperstown, Edward Porter Alexander, who had become vice-president of interpretation at Colonial Williamsburg. In 1946, Alexander began to reorient Williamsburg's interpretation program from poorly contextualized and artifact-centred discussions of material culture to one based on human achievement told in historic settings. To do this, he needed to outline a clear narrative framework for the museum's message. He developed themes built around colonial government, colonial society, material culture, architecture, and the restoration project itself. Incorporating these themes into an articulate interpretive program required increasingly sophisticated and professional training programs and presentation techniques. He initiated new events, such as antique forums and fairs to draw in larger and wider audiences. And he expanded research activities and history courses to furnish interpreters with a deeper contextual background for their discussions with visitors.[41]

Similar ideas were percolating in Canadian museum circles. Careful selection of material and judicious restriction of the museum's mandate were incorporated into the Massey Report in 1951.[42] Ronald Way had certainly developed a similar approach at Fort Henry, and he later expanded on it at Upper Canada Village. However, small, local museums faced particular challenges in meeting this professional objective. For one thing, they were rarely staffed by experts who were capable of designing and following such a collections plan, including all the discretionary

judgments necessary to determine the suitability of new acquisitions. The Museums Section workshops were partly intended to offset this problem. In addition, unlike large institutions, local museums were often the only agency charged with the preservation of a community's memories. In such an environment, it was difficult for volunteer curators to turn away donations of locally significant collections that fell outside the museum's direct mandate.

Through the 1950s, the Museums Section continued to hold workshops and to distribute pamphlets and newsletters that aimed at professional development. Progress was slow. In 1957, Carl Guthe led a workshop that replicated Jones's message. Guthe had come to Canada to conduct a study of museums for the Canadian Museums Association. At the workshop, he drove home the familiar message that modern museums could not be simple storehouses of objects. What he saw in Canada was a continuation of the older habits of collecting at whim, displaying whatever pleased the curator's aesthetics and completely failing to recognize the educational function of the museum as a public institution. The professional or modern museum had to move away from such archaic practices, which owed more to the antiquarian's impulse than to the historian's mission. Unlike the museums of the nineteenth century and before, the museum of the second half of the twentieth century had a duty to preserve community memory and to teach it to the public by identifying and demonstrating a historical narrative through judiciously selected exhibits. The museum's role was almost sacred. It was the only civic institution that could employ artifacts to reveal how each community had gained its distinctive identity.[43] Although the situation that Guthe saw in Ontario's local museums better resembled what he did not want than what he did, one student of museums claims that he influenced key curators at some of the province's more important local museums.[44]

Pioneering the Pioneer Village

In the spring of 1953, a local physician proposed to the city councils of Waterloo and Kitchener a plan to develop a folk museum along the lines of a Dutch open-air museum he had visited on holiday. The Rijksmuseum voor Volkskunde in Arnhem, Holland, had opened in 1912 and was one of the many imitators of Skansen that fanned out across Europe in the years before the First World War. Armed with photos, pamphlets, and the museum's constitution, Dr. A.E. Broome proposed building in Waterloo County an Ontario Museum of Pioneer Life.[45] The museum, in

Broome's initial conception, employed the ethnographic and folkloric orientations of European open-air museums. Like the European "Skansens" that deployed folklore and folk life to normalize nationalist understandings of history, Broome's museum would be a shrine to a specific reading of the provincial past. He hoped it would be built in an "unspoiled" natural setting, where it might combine exhibits of southern Ontario's flora and fauna with a village representing pioneer settlement. The village would house the now familiar structures of a pioneer village museum, such as a blacksmith's shop, a log cabin, a grist mill, a cooperage, and "Indian Habitations."[46] And, like Skansen, Broome's venture was not meant to be a specific village, just a representative one. The buildings would contain displays of furniture, clothing, and tools suitable to the period and to the pioneer culture and crafts they would demonstrate. Broome thus hoped to recreate the European model of folklore and craft demonstrations, using wax figures and staged scenes in a pastoral setting. His museum would honour the natural and built environments of Ontario's pioneer days.

In September, Broome took his proposal to the Waterloo Historical Society (WHS), which had already turned its attention to preserving memories of the county's small villages. Broome's museum also aligned nicely with the recent celebration of the Waterloo County centennial, during which pageants had told the story of local history. The WHS was enthusiastic. A few months later, it helped organize the Waterloo County Pioneer Museum Committee (WCPMC), which enjoyed broad support from the governments of Waterloo, Kitchener, and Galt, as well as Waterloo County. An organizational meeting held in the village of Doon, just south of Kitchener, brought out representatives of these municipal governments, local politicians of the federal and provincial levels, members of the WHS and the OHS, and representatives of the Women's Institutes, the Ontario Junior Farmers Association, and the Pennsylvania-German Folklore Association.[47] The committee selected Cressman's Woods in Doon as an ideal place to recreate the environment of a century ago. Encouraged by the local MPP, the WCPMC petitioned for sponsorship from the provincial government.[48]

However, Broome's was not the only early 1950s proposal for a rural life museum in the province. The WCPMC met stiff competition from neighbouring communities such as Jordan and Guelph.[49] The former had just opened its own history museum with the support of a local winery and had contracted the services of Ruth Home. Her professional reputa-

tion gave the Jordan Historical Museum instant credibility as a viable site for a pioneer life museum.[50] Guelph was also a serious contender. John Root's proposal for a provincial museum there had been based in part on a 1946 resolution of the OHS, which had called on the Province to build a rural life museum incorporating a replica pioneer homestead at the Ontario Agricultural College in Guelph.[51] When Broome spoke to the city councils, he implied that Root had abandoned his plan, but actually Root was still lobbying the premier to build a pioneer museum in Wellington County.[52] At its general meeting in the fall of 1954, the OHS gave the Doon project a qualified endorsement. Although it supported the plan, the OHS cautioned that the Doon museum should reflect the pioneer life of Waterloo County alone, not the province as a whole. Moreover, its development should "not in any way interfere with governmental support of other rural life museums or of museums of regional importance."[53]

Despite forceful petitioning, and the happy coincidence of Ronald Way's 1951 memo outlining a plan for museums across the province to "cash in on history," Premier Leslie Frost balked at the required outlay of money. Personally, he was keenly interested in history, but as premier he could not so blatantly favour one community. And as premier, he had to keep his eye on government expenditures. To be certain, the Frost administrations oversaw an enormous expansion in government disbursements, building schools, hospitals, and roads to accommodate the population growth of the baby boom and to underpin post-war prosperity. Moreover, through the Ontario–St. Lawrence Development Corporation that was building the St. Lawrence Seaway, his government was supporting a budding plan for a pioneer life museum in eastern Ontario. Perhaps Frost felt that the Doon, Jordan, and Guelph proposals would merely duplicate these efforts. Without provincial funding, the Guelph and Jordan schemes dried up. However, Waterloo's proposal, the best organized and the most polished of the three, was better able to survive the disappointment.[54]

One of the WCPMC's strengths was the site it had selected. Cressman's Woods, named after the pioneer farm of Isaac Cressman, was steeped in history. It had been Six Nations land granted by George III following the American Revolution. Purchased by the Canada Company for settlement in the 1820s, it incorporated the landing where the Huron Road, planned by John Galt in 1828, crossed the Grand River on its route between Goderich and Guelph.[55] In 1913, a citizens' committee featuring such local

notables as D.B. Detweiler, A.R. Kaufman, and the painter Homer Watson bought the farm's woodlot, a stand of virgin forest, intending to make it a park. The park was later dedicated to Watson, and across the river stood the Pioneer Tower, constructed in the 1920s as a memorial to the county's original Pennsylvania-German settlers. The Cressman site was also strategically close to the route of Highway 401, which stretched the length of the province, making it attractive as a potential tourist venue.[56] Indeed, when Doon Pioneer Village eventually opened, Broome singled out the location as a benefit. "Due to our fortunate location, with close proximity to Highway 401," he declared, "we are more than ever on a tourist route. The same culture-conscious individual who visits the Stratford Drama Festival will be interested in our exhibition."[57]

A second, and much more important, advantage for the WCPMC was its strength as a volunteer organization, capable of planning and fundraising without provincial support. Speaking to the committee in the fall of 1954, local archaeologist Wilfrid Jury commended it for raising $13,000 in its first year and insisted that the sum was sufficient to start right away.[58] Following Jury's advice, the WCPMC reorganized itself into the Ontario Pioneer Community Foundation (OPCF), with Broome as president, and turned to the Grand Valley Conservation Authority (GVCA) for support.[59] Like other conservation authorities in the province, the GVCA had already adopted the preservation of historical relics as part of its mandate. Its 1954 conservation report had even suggested co-operating with local historical societies to identify and mark historic sites in the Grand River watershed. Moreover, it had established a policy of appropriating natural, scenic, or historic areas and setting them aside for public use.[60] The coincidence of interests made a natural partnership. Thus, Broome's idea of a Skansen-type open-air museum merged with the conservation authority's decision to preserve local historic structures. With its greater resources, the GVCA was able to buy and expropriate farmland in the vicinity of Cressman's Woods to establish what became the Doon Conservation Area, which would incorporate the Ontario Rural Life Museum.

In the meantime, the OPCF began the process of identifying historic structures to be moved to the village site. When the museum was dedicated in June 1957, a bridge, a barn, and two sheds had been set up at Cressman's Woods, and through the following year the number of historic structures grew.[61] More importantly, the OPCF had hired its first paid administrator, Andrew Winton Taylor, then president of the OHS Museums Section.[62] Despite his association with the OHS, Taylor was not a

professional museologist. He was an active local farmer and amateur historian. Born on a farm in North Dumfries township and educated at the Ontario Agricultural College, Taylor was keenly interested in farming and local history. He sat on the executive committees of a number of local farmers' associations and was a member of the Waterloo Historical Society. He wrote books on the local history of the United Church and his home township in the late 1940s and early 1950s, and became vice-president of the WCPMC when it was organized. In that capacity, he attended the first OHS local museums workshop in 1954. There, Taylor absorbed Jones's ideas, especially the virtues of professional and efficient collections management, research-based exhibit narratives, and the display of artifacts in contextualized, rebuilt environments. Essentially, Jones had advocated telling accurate and specific histories in an environment that recreated that of the past.[63] Taylor took it to heart.

As administrator, Taylor worked to create a plan for the village museum. Besides Jones's teachings, he followed the model of Old Sturbridge Village in Massachusetts. Indeed, Taylor maintained a regular correspondence with Jones and Frank Spinney of Old Sturbridge for years. His first plan laid out the village in a circular pattern, with paths and bridges radiating from a village common like spokes on a wheel. This was clearly an ahistorical layout, but it served an organizational purpose. The spokes would lead visitors to six major theme areas. The majority of the village would be developed to the period between 1840 and 1867, but other parts of it would teach about earlier times and would balance history with practical concerns. Two theme zones would represent early pioneer life before 1840, including a Pennsylvania-German display depicting the earliest European settlers in the county. A farm area would teach about agriculture "from early pioneer times up to the present." One area would consist of a cluster of administrative and service buildings, an agricultural museum, a restaurant and gift shop, a lecture hall, and public rooms. At the centre of the village common, Taylor planned to build a replica of the Guelph Priory, Guelph's first permanent building, helping to make the museum village more provincial in focus. Finally, Taylor proposed a "show window" as an advertisement for passing motorists on the 401. From their speeding cars, they would be able to see a "pioneer scene" and its reflection in a millpond.[64]

But, as Taylor tried to control the message of the museum, his efforts were repeatedly overruled by members of the OPCF. The Doon project lacked clear lines of authority, and the WHS, OPCF, GVCA, and Taylor

often did not see eye-to-eye. Taylor believed that the village should confine itself to telling the story of Ontario settlement before 1860, or roughly before the coming of the railway. But members of the OPCF happily accepted donations from a range of time periods. The issue came to a head in the spring of 1960, when Taylor, frustrated at the lack of support from his employers, resigned after a heated OPCF meeting. He angrily denounced the OPCF planning committee for redesigning the village without consulting him. "I have never had any say in the plan of the village," he insisted, "I felt I never had any say." The OPCF president Oliver Wright shot back that Taylor was the obstructionist who refused to work with the foundation's members. Tempers flared and at least one member threatened Taylor. In his letter of resignation to Wright, he asked to "completely drop out of the organization." The OPCF gladly obliged.[65]

With Taylor gone, the OPCF moved ahead with its plans to open the village and museum in the spring of 1960. Taylor was replaced by Howard Groh (who had his own problems with the OPCF) to organize the museum exhibits.[66] Despite Taylor's efforts to restrain the museum's message, the exhibits spanned several centuries, from prehistory to the twentieth century, and claimed to represent "the pioneer community province-wide in its scope."[67] Finally, on 15 June 1960, A.E. Broome cut a ribbon to mark the official opening of Doon Pioneer Village. On that day, only the recently constructed museum building was actually open to visitors. Broome had opposed the inclusion of any modern buildings on the site, but the WHS and GVCA, perhaps during his recovery from a heart attack in 1957, had opted to erect a concrete museum and administrative building. Ironically, this decision was what allowed the OPCF to open on schedule, for, although a number of buildings had been moved to the site, they were not yet safe for public use.[68] Instead, visitors toured the museum, which housed the eclectic range of objects gathered by OPCF members. The display reflected Groh's enthusiasm for amassing artifacts "found in the sheds and attics of Waterloo County."[69] It was a haphazard assemblage of implements, household utensils, and other curios.

Although the OPCF was the first to begin building a pioneer village museum, Doon opened as Ontario's (and Canada's) third example. Pride of place went to Fanshawe Pioneer Village, near London, Ontario. The Fanshawe project experienced nothing of the organizational infighting at Doon, in part because it was so dependent on one visionary leader. Its origins can be traced to the creation of the Upper Thames River Conservation Authority (UTRCA) in 1947. To manage the river's

watershed, the authority began to dam at three sites where flooding had been a problem. The reservoirs and appropriated farmland became conservation areas in Woodstock, St. Mary's, and Fanshawe, just northeast of London. In 1952, when the plan for Fanshawe Conservation Park was approved, the UTRCA also began to consider adding a pioneer museum. And, in 1956, at roughly the same time that planning started at Doon, the UTRCA approved a proposal for its own village at the new Fanshawe Conservation Park.

The UTRCA invited Wilfrid Jury to be the village's technical adviser. Born in 1890, Jury grew up in Lobo Township, northwest of London. His father, Amos Jury, was a farmer and sometime painter who introduced his son to C.W. Jefferys. Like Jefferys and his father, Wilfrid Jury believed strongly that experience was a better teacher than book learning, and consequently he quit school in Grade 6 or 7. He was the first young man of Lobo Township to enlist for the First World War, although his military service initially consisted of being a local recruiting officer for the Royal Canadian Navy. He found himself in Halifax on 6 December 1917, aboard the HMCS *Niobe*, when the *Imo* collided with the *Mont Blanc*, setting off the Halifax Explosion. Severely wounded and washed ashore, he later contracted tuberculosis in hospital and was discharged in July 1918. From there, he headed west to Oregon to, in his own words, "live like a native" for a brief time.[70]

A self-taught man, Jury set about developing his credentials as an archaeologist. Native archaeology became his primary love, something he shared with his father, Amos. Together, he and Amos amassed a considerable collection of artifacts of Aboriginal and early European settlements, sometimes displaying them at a London cigar store.[71] In 1927, the president of the University of Western Ontario, Sherwood Fox, invited the Jurys to show their collection at University College on Western's new campus. A few years later, when the university began to plan for a new library, it included a museum. The Jurys donated their collection to the museum and in return were named honorary curators. Over the next decade, Wilfrid Jury continued his own practical education by conducting a series of archaeological digs in southwestern Ontario. By 1945, he had become a paid curator of the museum and one of the few professional archaeologists in the province.[72]

By the time Jury agreed to become Fanshawe's technical adviser, he was spending most of his time in Midland and nearby Penetanguishene, researching the Wendat (Huron) people whom Samuel Champlain

befriended in the seventeenth century. However, he agreed to return to London once each month to advise the museum's development.[73] Originally, the UTRCA had planned only to build a log cabin to house a collection of Aboriginal artifacts amassed by its first chairman. But Jury and his wife, Elsie, shifted the museum's focus to pioneer life. Jury claimed that the idea of a pioneer village had come to him years earlier and that he had drawn up its plans while recovering from pneumonia in 1956.[74] As far back as the 1940s, he had contemplated building scale models to teach about pioneer life.[75] He also arranged to lend his and his father's artifact collection to the finished pioneer village to aid in furnishing it. And, as a founding member of the Ontario Archaeological and Historic Sites Board, he helped secure minor financial support from the Province.[76] Over the years, Jury vested a great deal of energy in the museum, and it bears his stamp. He later donated his father's house to the village and contributed $2,000 of his own money for its relocation.[77] In addition, among the structures that he helped select for preservation at the site was the weaving shed owned by his maternal grandfather. And, of course, his artifact collections found prominent positions in the stores and workshops, and even helped direct the development of interpretation. When it opened in June 1959, the museum included a stable, a store, a blacksmith shop, and a carpenter's shop, mostly assembled with found materials. An Orange Lodge from Nissouri Township was also standing on the site but was not formally presented to the UTRCA until the following summer.[78]

A year later, and still two weeks before Broome cut his ribbon at Doon, the MTRCA opened what was first known as Edgely Pioneer Village. Inspired by growing interest in pioneer life, the MTRCA held a Pioneer Festival in September 1957, where visitors watched demonstrations of such "pioneer chores" as spinning, weaving, sausage making, and butter churning. The next year, more than three thousand people turned out for the Second Annual Pioneer Festival, where the program featured the MTRCA's plans to build a picturesque village modelled on Colonial Williamsburg.[79] Thus, by 1958, "it had become obvious that facilities dealing with Ontario's pioneer development were most popular and very much needed in the community."[80] Encouraged by this belief, and by a Canadian Mortgage and Housing Corporation (CMHC) donation of fifty-five acres just south of North York Township, the MTRCA undertook to develop a pioneer village replica at Black Creek Conservation Area.

Fanshawe Pioneer Village, 1959 | Source: RG 65-35, Image I0005710, Ontario Archives

The CMHC land had originally been the farm of Daniel Stong, and a two-storey log house from 1832, an older log cabin, a barn, and a piggery from the 1820s were still standing.[81] Working with a descendant of Stong, the MTRCA restored these buildings to their mid-nineteenth-century state. Elsa Neil, a retired schoolteacher and amateur historian from Thornhill, who had been the Dalziel Museum director from 1956 to 1958, urged that the property be turned into a pioneer village like the one being planned at Doon: "Probably nowhere in America," she claimed, "could be found five log buildings between 130 and 150 years old in their original setting."[82] Although Neil retired that year, her argument held sway. Encouraged by Arthur Richardson, the farm became the nucleus of a growing collection of historic buildings relocated from around the region. This work began with a frame house from Woodbridge, a smaller dwelling from Newtonbrook, a smithy from Nobleton, and a cider mill from nearby Downsview. The work progressed with incredible speed. On 2 June 1960, Lieutenant-Governor J. Keiller Mackay ceremonially opened Black Creek Conservation Area at the corner of Jane Street and Steeles

Avenue in the sprawling suburbs north of Toronto. Even then, the village was still a work in progress, with some buildings opened and others in various stages of restoration.[83] After his opening address, the lieutenant-governor crossed a bridge over Black Creek to the pioneer village, where he planted a chestnut tree beside the Blacksmith's Shop to dedicate the new museum.[84] Calling it "a great and noble enterprise," Mackay went on to insist that "we should know and remember our pioneer background, and teach our children about the trials and unfailing faith of those sturdy antecedents who laid the foundation of our way of life."[85]

Heritage Park

The centre of this sudden and pronounced interest in building replica pioneer villages was in Ontario. The pioneer myth was not confined to that province, but Canada's varied settlement history meant that pioneering differed across the country. Museums had to reflect local conditions of early European settlement, but more importantly, they also had to accommodate tourist expectations. Heritage Park in Calgary might be a case in point. According to a staff member, it was intended to portray "life in the West from the days of the fur trader to 1914" by bringing together "typical houses, stores, and other buildings traditionally found in a Canadian railway town; as well as an Indian encampment, a Hudson's Bay Company fur trade fort, a mining camp, and ... a settlement of log structures, all representing the era prior to the railroad."[86] However, predictably, it also included a railway to entertain children.

Like Ontario's pioneer villages, Heritage Park was built on parkland that was created for water management. The Glenmore Dam on the Elbow River, and the Glenmore Reservoir it produced, was intended to manage the city's water supply. Built as a Great Depression works project, the reservoir served as Calgary's only source of drinking water until the 1970s. Obviously, the lands surrounding it needed to be protected from urban encroachment, and the City set them aside in 1955 to create Glenmore Park, a "natural" parkland for public use.[87] The idea to install a pioneer village museum at Glenmore Park emerged from discussions between the trustees of the local Woods Foundation and city commissioners looking to build a children's playground.

Eric Harvie, one of the foundation's trustees, developed the idea of converting the playground into a hands-on museum to teach children about Alberta's past, and he arranged for a $150,000 donation toward that end.[88] By the end of 1963, with city council approval, the Heritage

Park Society was incorporated to build the museum. Bill Pratt was brought on as project manager. Today, Pratt is celebrated as the man behind such Calgary projects as Stampede Park, McMahon Stadium, and the holding of the 1988 Winter Olympics in the city. Pratt himself has fond memories of building Heritage Park. "Of all the things I've done," he later told the *Calgary Herald,* Heritage Park "was the most fun ... It was a peanut-sized job, but it's what I'm most proud of."[89] Alongside Pratt, John "Red" Cathcart of the Glenbow Foundation brought his extensive knowledge of the Alberta countryside (and its abandoned historic buildings) to help populate the park with heritage structures.[90]

Working without a set plan, the Heritage Park Society was willing to use just about anything to stand in for the past. The desire to quickly build and furnish a complete village meant that shortcuts were often taken. Hopes to use costumes and props from the theatrical production of *Foxy,* a Klondike-themed musical produced for the Dawson City Gold Rush Festival of 1962, were dashed once it was discovered that they had been sold or destroyed.[91] Harvie contributed some items when he bought a display of a BC mining town used in the Vancouver Eaton's Department Store windows, including mock-ups of a saloon and its barkeeper, a Chinese laundry, and a courtroom complete with a mannequin judge.[92] In this zeal, history, entertainment, and consumerism sometimes collided. Jerry Puckett, a restaurateur who became the restaurant manager of Wainwright's Hotel in the park, used to spin pistols to entertain children and borrowed his "olden" expressions from John Wayne movies. Moreover, the designs for the waitress uniforms in Wainwright's were based on *The Harvey Girls,* a 1946 Hollywood musical starring Judy Garland and Angela Lansbury. The movie told the story of a group of young women who worked at a Harvey House restaurant, an early chain that developed to exploit railway tourism.[93]

The Heritage Park Society did not set out to build its own version of Disneyland. In its first year of operation, proposals for an exhibit called Long Ago Land were dropped as the society stated that its rationale for the park was to produce an "aura of authenticity."[94] As it highlighted the accuracy of Heritage Park's replica fur trade fort, a 1970s pamphlet spoke in terms that could have been applied to many other sites. "In building this replica in 1964," the pamphlet explained, "workers used the same type of hand tools – the axe and the adze – that built the original fort 145 years earlier." Historical reconstructions, going back to Jefferys's Port Royal, presented the use of old-style tools and materials as a mark of

authenticity. They demonstrated the "truth" of the reconstruction. So too did connections to real-world people. The replica Hudson's Bay fort at Heritage Park was partially based on excavations conducted by the Glenbow Foundation, but it was mostly copied from Rocky Mountain House.[95] Copying from elsewhere fit with Heritage Park's ambitions. Despite admissions of impracticality, the board seemed intent on incorporating every aspect of Alberta's pre-1914 history into the park.[96] Cathcart summed up the ambition when he told one correspondent that, by the summer of 1964, he intended to include a "complete early village, a full scale railroad, a miner's camp, a trapper's cabin, an Indian village, the reconstruction of the second fort at Rocky Mountain House and a ranch."[97] The park aimed to give everyone a taste of the past they wanted to see, whatever it may have been.

Heritage Park emerged from vague plans for children's entertainment and education, but once it was built, the focus turned increasingly to tourism. Following the first summer of operation, it anticipated becoming a tourist destination. It never forgot its commitment to education, but commerce became ever more prevalent. If most visitors were local residents, the first summer's weekends were dominated by tourists. Presumably, effective promotion and publicity would keep them coming.[98] No park feature more clearly played to popular tastes than the replica railway, which promotional literature repeatedly emphasized. The locomotive and its period cars delighted both railway buffs and children. By the end of the 1970s, Heritage Park could boast that even eastern newspapers billed it as Calgary's top tourist attraction.[99]

At the same time, Heritage Park also renewed its educational program and developed a new master plan. In 1979, the education committee reported being "very pleased" to have expanded the educational program so that nine thousand students took classes during the winter months and another eleven thousand attended tours in the spring.[100] Moreover, the master plan of that year proposed more clearly delineating the time periods of the various areas of the park and asserted that "historic authenticity must be maintained within the era depicted."[101] Indeed, the plan envisioned three distinct epochs for commemoration: the settlement phase (1819–83); the town era (1884–1914); and a new interwar period (1915–39) to advance the depiction of history into the twentieth century. Nearly two decades after its genesis, Heritage Park had grown and become more professional. Ironically, as it expanded, its layout more closely resembled Disney's segmentation of theme areas in a single park. However,

its purpose remained "to provide a living, historic exhibit recording the evolution of Western Canadian society which will educate, entertain and generally enhance the quality of life of the citizens of Calgary and their visitors."[102] Although it had to look and feel like the past, it still needed to be entertaining.

Conclusion

In a very short time, Canadians across the country opened replica pioneer villages to teach about the country's founding settlers. Local variations aside, their own histories were broadly similar. Usually championed by a local enthusiast, they quickly came under the watch of governments and arm's-length agencies, and they often found homes on vacant land set aside by water management schemes. Thus, pioneer village museums represent a time when the efforts of amateurs, enthusiasts, and history buffs were overlaid on the technical aptitude of bureaucrats and professionally trained experts. The sudden appearance and proliferation of these museums can thus be explained, in part, by a generational moment in Canada's history. In such projects, the values and interests of people who grew up during the post-war era came together with those of preceding generations.

The mixing of fun and learning at Heritage Park and other living history museums was more than just an updating of the nineteenth-century museum compromise. It revealed real uncertainty about the best response to rapidly changing social values, the transformative effect of modernity on the lived environment, and anxieties about what role an understanding of the past might play in the future. Paradoxically, it also demonstrated confidence in post-war society's ability to manufacture authenticity. But most fundamentally, it highlighted the pervasiveness of the consumer culture of those years. To flourish, a museum had to compete with other leisure attractions, and if it wished to satisfy its paying customers, it had to produce an enjoyable experience.

5

A Sense of the Past

Post-war confidence and prosperity, as well as planning for more of the same, underpinned efforts to recreate past material environments and past Canadian cultural life. Consequently, these ideals also influenced the historical messages provided at living history museums. The enormous popularity of "pioneers" serves as a useful case study for examining museum interpretations of what past life was like. The relatively widespread distribution of pioneer village museums offers a close approximation of a national survey of mid-century Canada's sense of its past. Moreover, the museums were also a relatively common experience for school field trips, influencing the historical consciousness of young Canadians. Taken together, the pioneer village museums tell a story about how Canadians understood the lives of their ancestors.

It Must Attract Visitors

The popularity of pioneer villages at Doon, Black Creek, and elsewhere quickly drew various levels of government into their creation. Government concern for economic development and the promotion of growth was a feature of post-war economic thinking. Canadian governments poured hundreds of millions of dollars into building the infrastructure of the post-war world, and major development projects became almost ordinary as the world recovered from the Second World War. Journalists routinely gushed over the size and scale of the projects, listing statistics and figures that reinforced the brilliance of human ingenuity. Confidence in the future was the mood. The road and highway projects that supported tourist transportation were only a small part of governments' infrastructural construction lust. A few, mostly localized, voices protested the environmental damage or loss of traditional ways of life that massive resource extraction or construction projects inevitably entailed. But most people saw only good in these endeavours. The most controversial Canadian project was probably the Trans Canada natural gas pipeline championed

by C.D. Howe that helped defeat Louis St. Laurent's Liberal government in 1957.[1] Others were less contentious but equally high profile and central to post-war economic development. In fact, one project, the construction of the St. Lawrence Seaway, became a tourist attraction itself. In a 1958 press release, the Hydro-Electric Power Commission of Ontario claimed that 3,000 people came to look at the modern marvel of technology that had altered the landscape, would open up the Great Lakes to seagoing shipping, and would provide power to the province. Over 1.5 million people, the power commission estimated, had already used the lookout platforms built three years earlier, and 55,000 turned out to watch the river flood the countryside when the dam went into operation.[2] But the seaway also had an effect on living history museums. The water management projects of conservation authorities had set aside space for the preservation of historic structures in parks and pioneer villages. The seaway was different, for it made the salvation of historic buildings necessary.

The construction of the Moses-Saunders Hydroelectric Dam, the first step in the St. Lawrence power and seaway project, gave birth to Upper Canada Village. The dam, just west of Cornwall, flooded twenty thousand acres of Ontario, submerging 10 villages and forcing the relocation of 6,500 people. On the American side, another eighteen thousand acres were engulfed, including 225 farms and 500 cottages.[3] The rush of water that submerged parts of Ontario and New York on Dominion Day 1958, known to project officials as Inundation Day, was also an irreversible obliteration of a historic landscape. Now, the river would cover the graves of the first settlers, the site of the Battle of Crysler's Farm, and dozens of historic homes. As early as 1952, delegates from the Ontario Historical Society (OHS) approached the provincial power commission to sound an alarm in anticipation of the destruction. Over the next few years, discussions between the commission and the OHS, supported by the Royal Ontario Museum, the provincial Women's Institutes, the University of Toronto's History and Archaeology Departments, and the provincial archives, produced the Ontario–St. Lawrence Development Commission, a provincial agency charged with building a system of parks along the new waterfront.[4] In December 1955, the commission began the work of relocating historic homes to create Upper Canada Village. And, in 1958, to simplify co-ordination of historic properties, the Province transferred the administration of Fort Henry to the development commission. Thus, Ronald Way became historical director of both Fort Henry and Upper Canada Village.

When Upper Canada Village opened to the public on 24 June 1961, the ceremony was a bit of a fiasco, one that the *Toronto Globe and Mail* described as "a hymn to officialdom at the expense of the public."[5] The main problem was that the opening ceremonies ran behind schedule. On a less than pleasant day, a crowd had gathered to be first to tour the new museum. But the official opening was delayed by more than an hour and a half, beginning at slightly after 6:00 p.m. After sitting through a lengthy ceremony that many felt dwelled too much on the battlefield park, and not enough on the pioneer village, a few spectators toured the village, forced to rush through the exhibits before making the long drive home to Toronto. More gave up and left early, and even the security guards did little to prevent others from sneaking past the fence to see the village before it opened. Yet, this debacle simply demonstrated the enormous popularity of the pioneer museum.

Tourism was key to the development commission's plans. In 1958, Arthur Bunnell, a political consultant to W.M. Nickle, the Ontario minister of planning and development, explained to his minister that "to justify the large expenditure now being made it [Upper Canada Village] *must* attract visitors."[6] The museum's press kit drew attention to the fact that 2.2 million people lived within 100 miles of Upper Canada Village, and a whopping 73 million lived within 450 miles.[7] The 8,000 slightly disappointed people who were counted at the official opening were quickly outnumbered by the thousands more who visited the village in its first year of operation. With an average daily attendance of nearly 3,500, the commission was forced to hire additional staff to cope. And, despite an initial plan to close in mid-September, the first season had to be extended to the Thanksgiving weekend to accommodate everyone.[8]

Manufacturing the Look and Feel of History

Ronald Way was given free rein to develop his principles of living history at Upper Canada Village. Although he joined the project only after the initial stock of historic houses had been identified and relocated, and though he quickly moved on to other projects, he shaped the message and plan of Upper Canada Village. Characteristically, he was more interested in the "look and feel" of history than its details. It was imperative, he argued, to pay careful attention to the details and to get the history right. However, Way was also pragmatic, recognizing that some details could remain forever unknown and that costs and modern requirements

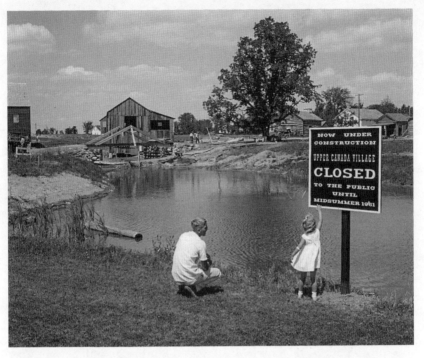

Upper Canada Village, June 1961 | Courtesy of Library and Archives Canada
1971-271 NPC

would necessitate certain compromises. The goal, Way explained, was to
produce an overall effect:

> While factors beyond his control may compel the historian to accept some
> compromises, I am convinced that he may rest happy if the general effect,
> the atmosphere, or the illusion – call it what we will – of authenticity has been
> created. If, in spite of the shortcomings and imperfections, of which he alone
> may be aware, there is a convincing over-all effect, one may experience that
> satisfaction the ancient armorer must have had, when the sword of his manu-
> facture rang true. It is a clear case of the whole being greater than the sum
> of the parts thereof. The objective has been achieved if the reconstructed
> site inspires in the beholder a sense of the past, a feeling impossible of analysis
> but very real nevertheless.[9]

Elsewhere, he said that "a true sense of history ... is, in reality, as much a
feeling, or state of mind as it is the scientific accumulation of facts."[10] For

Way, the success of the reconstruction was grounded in how it looked and how it felt.

In this model of living history, Way drew on existing American proto-types, such as the Cooperstown Farmer's Museum and Colonial Williams-burg. But he paid the closest attention to Old Sturbridge Village. Opened in 1946, Sturbridge mixed old and new buildings to represent a "typical" New England village of the nineteenth century. Way sent staff members Jeanne Minhinnick, Douglas Hough, and John Quail to visit Old Stur-bridge because, as he told development commission chairman George Challies, "they might learn a lot there which would be of assistance in their work for us."[11] Like Andrew Taylor before him, Way put considerable stock in the views of Frank Spinney, the director of Old Sturbridge, and followed his recommendations on such issues as staff homes, the hand-ling of exhibits, hiding modern heating and electrical outlets, and land-scaping. Admittedly, Way felt that Old Sturbridge was "curiously lacking in professional assistance" and that its buildings were restored without research or real knowledge of nineteenth-century construction tech-niques.[12] In one case, a vaulted ceiling used ship timbers simply because they provided a rustic look. Nor were Old Sturbridge staff certain how buildings of the past should appear. Some were freshly painted and cleaned, but others were made to look weathered to suggest the passing of time. For Way, Old Sturbridge remained an amateur project in which senti-ment overshadowed historical accuracy.[13] However, Way and Spinney saw eye-to-eye on a number of important issues. Both felt it better not to use buildings associated with specific or famous people, but to aim for a typical look to present the history of the everyday. Ontario's minister of tourism acknowledged as much at the opening of Upper Canada Village, when he pointed out that it represented a cross-section of life, not a specific place.[14] Both Way and Spinney were also disappointed with museums in which preservation took precedence over interpretation. Spinney dis-missed the Skansen-style folk villages of Europe because he felt that their employees were guards, not guides, and that they made little attempt to interpret the past for visitors. His approach, and the one that Way set for Upper Canada Village, was a hands-on presentation of history. Visitors, and especially children, were encouraged to touch the artifacts, to play with old tools, to sit on the furniture – in other words, to experience the material life of the past. Spinney waved off any protests about the protec-tion of his antiques, claiming that he lost more to staff misuse than to visitor breakage.[15]

Of course, inspiring in the beholder a sense of the past at a manufactured "historic" site was no easy task. Historic house museums, given their focus on specific individuals, were prone to dwelling on the details of their owners' lives.[16] Pioneer village museums, on the other hand, were fantasy fabrications without detailed histories. They combined replica settings with tourist amenities and frequently moved historic buildings from their original sites, stripping them of their historical context. Therefore, restoring an aura of authenticity was a challenge, one that required careful attention to the museum's interpretive framework. This in turn meant avoiding the haphazard amassing of buildings and other artifacts. For example, once local historical societies discovered that the government was moving historic buildings to Upper Canada Village, requests to save local treasures flooded into the commission, some from as far away as Ohio.[17] For various reasons, the village rejected at least nine houses during its initial years; many had been expanded or rebuilt from their original, and presumably historical, condition, and were thus considered unsuitable.

Local sentiments also played a role. In 1958, the Sisters of Sacred Heart Congregation of Williamstown near Cornwall requested that the commission take possession of the Sir John Johnson House and move it to the village. Sir John Johnson was a British army officer and superintendent of Indian Affairs who negotiated the settlement of many Iroquois people in what would become Upper Canada after the American Revolution. The house bearing his name had been built in the 1780s as part of a mill intended to form the nucleus of a new community of United Empire Loyalists. Over the years, it had been considerably modified, which made it difficult to relocate and restore. But just as importantly, although the nuns were willing to sell the house (fundraising appears to have been a key motivation for them), many local residents resented the idea of transporting a relic of their history to an artificial tourist village. The house stayed in Williamstown and is now a national historic site run by Parks Canada.[18]

Another reason for rejecting requests was the potential that preservation would damage historic structures. Way had Cook's Tavern rebuilt after discovering that relocation had severely compromised its structural integrity.[19] Another case involved the Heck House in Prescott. The Prescott Historical Society asked the commission to save the Barbara Heck House, one of a handful of pre-1815 homes in the province. Barbara Heck, a follower of John Wesley, had migrated with her husband from Ireland to

New York in 1760, where she helped found its first Methodist society. During the American Revolution, the Hecks became Loyalist refugees and eventually settled in what became Augusta Township in Upper Canada. When the Methodists joined the United Church in 1925, her home, allegedly the house where she died, became part of church heritage.[20] Unfortunately, it was also on land slated for development by the DuPont Corporation. Way was sent to assess the prospects of moving Heck House to the village in the fall of 1959. After careful inspection, he decided against the move, primarily because he was certain that the building would suffer severe structural damage. He pointed to the example of Willard's Hotel, which, had he been consulted, would have been dismantled on the spot rather than moved in one piece to Upper Canada Village. The projected cost for dismantling and relocating Heck House in this fashion was well over $125,000, a sum that Way considered indefensible. Despite an offer from DuPont to help defray the costs, Heck House stayed in Augusta Township, at least for a few more years.[21] Other suggestions met similar responses.

Properties were also turned down due to Way's desire to develop a coherent historical message and not to accumulate without purpose. Like the technicians and bureaucrats who planned the St. Lawrence Seaway, he placed enormous stress on the importance of planning. In the early stages of his job, a revealing power struggle developed between Way and Anthony Adamson, previously hired as "general consultant." Way and Adamson knew one another from Fort Henry. In fact, Adamson had first taken the Ontario Architectural Conservancy's case for the fort to General McNaughton of the Department of National Defence in 1933, while Way was still an undergraduate. Both men had field experience with historical preservation and reconstruction.[22] However, in Way's opinion, Adamson was surrendering a grand project to whimsy and capriciousness, continuing an amateur tradition that was grounded in personal aesthetics. In his restoration work, his decisions were based on personal taste and his ideas about how things *ought* to have looked. Way felt that his own method was more rigorous. He wrote to W.M. Nickle, the provincial minister of planning and development, to set out his position. Citing his twenty years of experience, he cogently argued that all work should follow the historical research completed by his staff under his direction. Efficient planning would prevent guesswork from running up costs. This completed archival research could then be supplied to Adamson, after which Adamson should convene an advisory committee,

go over recommendations, and submit them to the commission prior to drawing up work plans and committing funds. For Way, the issue seemed to be historical accuracy, but he knew that money would motivate a cabinet minister.[23]

Anticipating tourist tastes was another element in these calculations. Way felt that a series of restored houses might become repetitive (and boring) for visitors unless properly framed. He had first encountered this problem at Fort Henry, where barrack rooms had originally served largely similar functions. Rather than replicate, room after room, soldiers' quarters from a century past, Way opted to use surplus rooms for more conventional displays. The fort's museum exhibited infantry, cavalry, artillery, and naval arms and equipment. Way was particularly proud of the naval pieces, as they had been salvaged from wrecks of the War of 1812. At Upper Canada Village, he expanded the idea, converting each building to tell a different story about the nineteenth century. One structure, a piece of unknown use that had been recovered from an abandoned field, became a general store to display consumer goods. Another house served as a "typical" middle-class home. Rather than repeat furnished room after furnished room, the upstairs was used to display period clothing on mannequins. Other buildings became venues for appropriate crafts, such as horseshoe making in the blacksmith's shop, probably the most ubiquitous living history museum craft display in North America.

Way also needed to co-ordinate the periods of restoration. In his view, the historian's initial problem was choosing which historical period to display. Buildings are evolving things. They change over time through renovations, different uses, deterioration, and even shifting environmental contexts. But restoration presumes that one given moment can present the essential meaning of the structure. The simplest solution would be to restore a building to its original, or earliest, condition. However, this option comes with its own list of problems: renovations or additions would naturally be removed, even historically significant ones; the original condition might be unrepresentative of the historical importance of the structure; and it might fail to educate visitors about an appropriate time. To counteract these problems, Way recommended restoring or constructing all buildings to their appearance in a single year, which would be selected to match the historical message of the museum as a whole. For Fort Henry, Way had chosen 1867, the year of Confederation. He does not seem to have felt the need to justify his selection much beyond 1867's association with Confederation and the fact that

the fort was still operational and properly garrisoned in that year. He decided that Fort George at Niagara-on-the-Lake should be restored to its original condition, as built by order of John Graves Simcoe between 1796 and 1799. However, this had entailed the removal of a second Fort George, which had been superimposed on the foundations of the original, and as it disappeared to reveal its predecessor, local antiquarians protested the authenticity of the work. Moreover, the job represented a certain degree of historical vandalism, in one case felling a seventy-five-year-old tree to rebuild a 150-year-old bastion.[24]

Upper Canada Village presented a more delicate problem. Its oldest structures dated from the 1790s, eight were entirely new, and most were from the middle decades of the nineteenth century. Compounding this problem was the village's location next to Crysler's Farm Battlefield Park, which stood on the remaining unsubmerged site where two armies fought in 1813. Way's solution was to divide the two projects, insisting that his village be a "typical" 1860s eastern Ontario community and keeping all references to the War of 1812 outside its gates. In so doing, Way hoped to distinguish between the established Upper Canadian society of the 1860s and its founding years, dominated in popular culture by the United Empire Loyalists. Many Ontarians believed that the Loyalists had founded Canada. Forced into exile for having vowed their loyalty to the British monarchy, they later secured Canada from invasion in the War of 1812. This was the romantic mythologizing Way hoped to quell. But as visitors approached the village through the battlefield park, they inadvertently linked the War of 1812 with the period of Confederation and the emergence of the Dominion of Canada. Surveys and correspondence show that visitors connected the village and the Loyalists through the Loyalist myth's association with the War of 1812.[25] Even University of Toronto historian Donald Creighton found it difficult to separate the village from the Loyalists. He wrote to George Challies in 1959 to commend the accuracy of the "re-creation of the Loyalist community of Upper Canada."[26] Perhaps Creighton was thinking of the descendants of the original Loyalists, but Minister of Planning and Development W.M. Nickle's interpretation further confused the time periods. Nickle repeatedly referred to the village commemoration of "Loyalist times" and saw it as "a worthy memorial to the United Empire Loyalists."[27]

An intriguing case of how this overall look and feel could dictate the direction of Upper Canada Village was an English building that was offered for relocation but eventually rejected. The case is particularly

intriguing because it was closely studied and the reasons for its rejection carefully enumerated. The relocation was championed by senior government officials, at least one corporate leader, and many MPPs. Not surprisingly, no one wanted "to say no to this request without some information on the building and whether it is physically possible to actually move it or not."[28] Way remained aloof from this decision. He was already devoting much of his time to the reconstruction of Louisbourg in Nova Scotia, but the language of the correspondence shows some adhesion to what he had already accomplished. Officials made frequent references to his ideas about the authenticity of an 1860s Canadian village and its overall look and feel.

The building in question was Wolford Chapel, built at Wolford Lodge in England, the ancestral estate of Sir John Graves Simcoe, first lieutenant-governor of Upper Canada. In January 1962, the *Toronto Globe and Mail* reported that Toronto City Council had debated the indignity to which Britain had subjected Simcoe's remains.[29] Although his official memorial is located inside Exeter Cathedral, his remains, as well as those of Elizabeth Simcoe, were interred in Wolford Chapel, which had become a storage shed. This story had probably reached Toronto alderman Rotherberg through Floyd Chalmers, the president of MacLean-Hunter, but it was not entirely accurate. Wolford Lodge had deteriorated with the declining fortunes of the Simcoes and had passed out of the family's hands by 1920. It became a pig farm and the chapel itself was used for manure storage, but only because its original function had been forgotten. In 1926, the Harmsworth family bought the estate and, in restoring its dilapidated buildings, discovered the true purpose of the chapel. On 27 December 1926, Mackenzie King wrote to Harold Harmsworth, thanking him for restoring the dignity of Simcoe's final resting place.[30] Early in 1951, Harmsworth offered the chapel as a gift to the Canadian government, and on its rejection, to Ontario House, the provincial office in London. By 1958, Floyd Chalmers had taken a personal interest in the file and mentioned it repeatedly during meetings with Premier Leslie Frost. Drawing a comparison between the esplanade at Edinburgh Castle, which was declared Nova Scotian territory in the seventeenth century, Chalmers felt that Ontario was entitled to similar consideration at Wolford Chapel. However, the premier was unmoved.[31]

Frost's legacy for heritage development is mixed. His administration sponsored a conference on preservation at Niagara Falls in 1949 and held a more dedicated one at Queen's Park in January 1950. Out of this second

conference emerged an advisory panel, which helped draft the Archaeo-
logical and Historic Sites Protection Act of 1953.[32] Yet Frost himself felt
that government did not need to play much of a role in culture and should
not incur significant expenses in promoting it. He agreed with his educa-
tion minister, Dana Porter, who asserted that reduced taxation, not "easy
money for projects of all kinds," would better improve the arts and sciences
in the long run.[33]

For supporters of Wolford Chapel, the construction of Upper Canada
Village offered new hope. Surely, they thought, as the government had
already demonstrated its willingness to relocate historic buildings, it could
not reject a proposal to relocate the final resting place of the founding
father of Upper Canada. No doubt, many of these supporters also linked
Simcoe to the Loyalists and through them incorrectly to Upper Canada
Village. In the fall of 1961, Challies began to hear representations in favour
of transporting the chapel across the Atlantic and up the St. Lawrence.
The minister of tourism asked the development commission to investigate
the possibility, although Challies was not thrilled. Still, detailed sketches
and architectural drawings were readied by Christmas 1961. Respecting
Way's wishes that the village remain consistently set in the Upper Canada
of the 1860s, the proposal placed the chapel alone in the battlefield park,
on a triangular point of land jutting into the St. Lawrence, which would
"look very nice from the river."[34] Despite going this far, the development
commission remained unenthusiastic about getting the chapel. An initial
cost estimate for the move was "anywhere from $150,000 to $200,000,"
surely a conservative appraisal.[35] Challies thought that it might be turned
into a centennial project and, not incidentally, paid for by the federal
government. Although cost was the primary strike against this scheme,
members of the commission raised other concerns as well. The tourism
minister worried that some people, notwithstanding those in nearby
Wolford Township, might be opposed to the move and that many other
Ontario municipalities might have a better claim on the chapel. "What is
the historic significance to Canada of this building?" asked Herb Crown,
a senior aide to the minister.[36] However, the greatest concern was one of
authenticity. Most critics of the proposal simply did not see the connection
between Simcoe and Upper Canada Village, and they worried that it would
impinge on the overall effect of what they had built. The decision to place
the chapel outside the village proper revealed that it simply did not fit
with the reconstruction of an Ontario rural community at the time of

Confederation. In the end, relocation was deemed too expensive, and the chapel remained in England, but this incident reveals the extent to which officials at Upper Canada Village fought to maintain the authenticity and integrity of their project.

King's Landing

If Upper Canada Village struggled to distinguish itself from the Loyalist myth, a museum in New Brunswick embraced it. Like its Ontario counterpart, King's Landing Historical Settlement was the product of modern infrastructure development. The Mactaquac Dam was one of several built on the upper Saint John River and its tributaries in the 1950s and 1960s to provide hydroelectricity for the province. Its construction began in 1965 and was completed in 1968. The project also involved the creation of a provincial park that would both protect the shoreline of the headwater reservoir and offer increased recreational opportunities for the area. Early in 1964, New Brunswick Power decided to include a historical village in the multipurpose park, along the lines of Ontario's pioneer museums.[37] Indeed, planners at King's Landing Historical Settlement even solicited advice from the experts at Upper Canada Village.[38]

The project was initially placed under the direction of the Community Improvement Corporation (CIC), an independent Crown corporation established in the mid-1960s to co-ordinate activities under the federal Fund for Rural Economic Development, itself initiated in 1966.[39] The CIC's conceptual plan, produced by a Toronto-based company called Acres Research and Planning, proposed manufacturing a historical landscape for the Saint John Valley between the new dam and Upper Woodstock, some eighty kilometres away. King's Landing would be the centrepiece of an assemblage of historic sites, combining plaques and restored houses with a reconstructed "Meductic Indian Settlement." For Acres, the economic potential of the plan was enormous. Taking its inspiration from the success of Old Sturbridge, Cooperstown, and Upper Canada Village, Acres estimated that King's Landing alone would garner an average of $20 per carload of visitors. If the site managed to attract 250 carloads of visitors each day throughout the two-month season, revenues could reach $600,000, a significant sum in the mid-1960s. King's Landing was thus conceived as "a pilot project designed to test the use of historical resources in regional economic development," as well as a source of employment, especially for older people.[40]

The CIC also engaged architect Peter John Stokes in early 1966 to conduct a feasibility study for four possible history-themed projects. Stokes had studied town planning and architecture at the University of Toronto in the 1950s and had done some work for Ronald Way at Upper Canada Village. Indeed, his efforts there helped him set up his own architectural practice, focusing on restoration. He gained some notoriety for his restorations of the Nicholas Sparks House for Ottawa's National Capital Commission early in the 1960s. By the end of the decade, his resumé also boasted work on the restoration of the Sir John Johnson House, Dundurn Castle in Hamilton, and the Allan Macpherson House in Napanee.[41] In short, he had established himself as one of the principal restoration architects in Canada. He was later a key figure behind the town-wide restoration of Niagara-on-the-Lake, Ontario.[42]

Stokes argued that any historic recreation project would be artificial, a problem that needed careful management to convey an authentic atmosphere. He initially proposed that the village be located at Upper Woodstock in Carleton County, at the western end of the Mactaquac Dam headpond.[43] However, even before he made his official recommendation, the Upper Woodstock site drew complaints tied to local pride and jealousies. Residents of York County feared that buildings from their community would be removed to Carleton. Lieutenant General E.W. Sansom, president of the York-Sunbury Historical Society, wrote to the CIC to protest the idea, going so far as to renounce the village proposal should it mean the loss of York County's own historic treasures.[44] Invited to supply their own recommendation, Sansom and the members of the historical society replied within a few weeks, suggesting a series of possible mill sites.[45] As late as the fall of 1967, the CIC had still not decided on a suitable location and was storing salvaged buildings at Long's Creek about thirty kilometres west of Fredericton. Eventually, the practical concern of highway access decided the issue. New Brunswick's tourism industry was highly dependent on car traffic, meaning that the site had to be near the Trans-Canada Highway. Ultimately, a suitable location was found along the south bank of the Saint John River, with easy access from the province's major highway. Driving home the necessity of road access, planners intended to build King's Landing its own cloverleaf interchange by 1980.[46]

Site selection was not the only problem facing the CIC. No one could agree on what the historic village should commemorate. The Acres conceptual plan noted that "historically, the story is not one of major happenings or of great men." Instead, it would be a "typical" story, one that

could "relate in three-dimensional form an important segment of this legacy in social history."[47] Such an emphasis on "typical" lives echoed Spinney and Way, as well as developing nascent trends toward social over political history among Canada's professional historians.[48] However, exactly what "typical" might mean was open to interpretation. At a meeting in September 1970, officials agreed that the issue was moot: "There is no such thing as a 'typical' settlement, any more than an average man."[49]

In 1968, responsibility for what was still known as the Mactaquac Historical Program was transferred from CIC to the provincial Historical Resources Administration (HRA). The transfer of authority was not without problems. One of the first was the physical relocation of staff to offices on the campus of the University of New Brunswick. R.C. Ballance, general manager of the CIC, was reluctant, fearing that joining the civil service proper would downgrade the position levels of his staff.[50] Perhaps morale did suffer. In September 1971, the *Fredericton Daily Gleaner* reported that nine members of the professional staff had resigned during the past year amidst poor morale and allegations of administrative incompetence. Few of the departed were willing to speak on the record, but the rival *Fredericton Telegraph-Journal* learned that their resignations had arisen from disputes regarding the settlement's educational mission and its tourism and economic development imperatives. Staff opinion appears to have split between those who wished to emphasize tourism and those who favoured education. Curiously, disgruntlement came from those who believed that the site's economic potential was underutilized. If this assessment is accurate, the problem at King's Landing laid bare the compatibility problems inherent in the dual roles of living history museums. Could entertainment be educational, and could the balance attract tourists and create jobs? While some at King's Landing had their doubts, others believed in the possibilities. For his part, Stokes insisted that he could work up enthusiasm among the staff, but that it would dissipate once he left because they were not being used to their full potential. George MacBeath, the deputy minister for heritage, disputed these claims.[51] In a report prepared for the minister six months before the resignation story broke, the HRA noted that two salaried staff members had resigned for personal reasons and that three were dismissed for cause, with their cases upheld by the New Brunswick Supreme Court. However, their names did not match the names reported by the *Telegraph-Journal*.[52]

The following month, former King's Landing director William H. Bradford offered his side of the story in the *Daily Gleaner*. As one of the

nine who had resigned, he felt well placed to outline what he saw as the problems. He certainly agreed with Stokes that low morale due to under-utilization of staff was and continued to be a problem. However, he dis-agreed that a transfer from education to tourism within the provincial bureaucracy would solve anything. Instead, he proposed the establish-ment of a Crown corporation, with the freedom to direct its own mission. King's Landing, he felt, had great potential to be both educational and profitable but not if it were simply an entertainment park. If that were case, he suggested, "its development should be under the direction of entertainment specialists." Bradford advocated a balance but one in which management, "with a background and training in historic sites adminis-tration," would guide "the factual past through proper interpretation." As for himself, he had resigned because of "a changing restoration phil-osophy between myself and Dr. MacBeath," which he felt threatened the progress and eventual success of the project. The HRA had earlier been alerted to discontent among the professional staff regarding the approach to restoration, but it had done nothing. Bradford laid the problems of King's Landing squarely at the feet of its restoration philosophy.[53]

A few months earlier, a provincial museologist, John Patrick (Pat) Wohler, wrote a brief "restoration philosophy" memo that helped steer the museum into the future. Wohler's background was in education. Born in 1939 in Montreal, he studied at Loyola College and St. Joseph's Teacher's College. He had also worked at Montreal's Château de Ramezay Museum before taking up a position at the National Museum in Ottawa in 1966. In Ottawa, Wohler's role was to serve as a liaison between the museum's curators and provincial education departments and school boards. From Ottawa, his work took him around the country, before he returned to the capital to teach at Algonquian College and set up the school's Applied Museum Studies Program in 1972.[54]

In the physical restoration of structures, Wohler subscribed to Ronald Way's thinking: securing the authentic feel of the past was best achieved by employing the materials and techniques that were used to create the original. At Upper Canada Village, Way insisted on using the methods and tools appropriate to a building's original construction.[55] He repeat-edly defended this method as essential to producing accurate reconstruc-tions. But it also involved a painstaking research program and a slow and expensive construction process. Some corners had to be cut. Following Spinney, Way acknowledged that hidden portions of the building could

use modern techniques, a compromise that did not overly concern him. Similarly, Wohler accepted that certain realities, such as safety concerns and durability issues, might force compromises. In the former case, handrails might be required for the visiting public, even in places where they would not have existed in the past. In the latter case, Wohler cited the example of a softwood staircase that would quickly wear away under the footsteps of thousands of visitors. In this example, he suggested using hardwood instead – even though it was not authentic – and dressing it with paint or stain to make it look like softwood. The key criterion, Wohler opined, was "to provide the visitor with *as realistic as possible* a step into the life and way of life" of the past community. Of course, original techniques and materials could be expensive and time consuming, and the skills might not be readily available in the local workforce. In such instances, exposed areas, "where the effect would be apparent to discriminating visitors," should be completed to original specifications, but modern methods could be used wherever they would not be readily visible. Again, creating a genuine look and feel for visitors was the determining factor.[56]

We Must Preserve It in Total

However, the architectural form provided only the look of history. For its feel, museums had to furnish buildings with period artifacts and, more crucially, put them to work. Pioneer village museums were not just open-air collections of stuff on display. Their exhibits were not meant to be static period rooms, showing table settings and quilts safely ensconced behind barriers. They were meant to recreate a way of life. Wilfrid Jury insisted that Fanshawe must come alive if it were to be successful.[57] For its official opening, women from the local Women's Institute agreed to dress in period costume and demonstrate pioneer chores. For Elsie Jury, as much a force as her husband at Fanshawe, "the object" of living history "is to dissociate the old tools and implements from being merely relics displayed as curios in cases. There will be no attempt to make this a museum or a curiosity shop; here the objects will be used as they were originally; they will be restored to their natural environment."[58] Dorothy Duncan, a force at Black Creek and later throughout the province, concurred. Speaking at the Kitchener Public Library in January 1977, she declared that "we must preserve [the past] in total – not just the buildings but also what goes on around them."[59] Black Creek exhibits were animated at first by having women demonstrate weaving and spinning on weekends.

Other museums similarly began using costumed interpreters to perform antiquated tasks. Doon began to stage blacksmith demonstrations in July 1963, and the practice expanded from there.

Right from the start, Upper Canada Village was a living museum. On opening day, it consisted of thirty-eight period structures populated by costumed interpreters giving demonstrations of pioneer chores and tasks. Tourists seemed to embrace the model. One visitor informed staff that "my wife and daughters found the spinning and weaving displays exceptionally interesting ... One should mention that the village actually appears to be *living*."[60] This was exactly what Ronald Way hoped to accomplish. According to his wife, Beryl (Taffy), the village was never intended to represent something that had actually existed, but to provide a cross-section of social history in eastern Upper Canada in the first half of the nineteenth century. Despite emphases on the "typical," the objective of teaching this kind of social history called for specific examples to avoid being purely abstract, and this required animation and interpretation.[61] Another writer enthused about the atmosphere at the village: "Here is no frozen archaeological perfection, labelled and roped off, to be admired from the sidelines. The life of this village is real ... because of the people who are working there at handicrafts which flourished a hundred and more years ago."[62]

Working at handicrafts and other tasks was the most common form of pioneer village interpretation, or animation. An optimistic reading of these performances might suggest that they transformed the artifacts, the tools and equipment used in the chores, from the object of the museum exhibit to its starting point. By concentrating on the use of tools in daily life, living history museum animations reconceptualize history as a process.[63] A more pessimistic view suggests that the focus on work and tools ironically accentuates the role of the artifact in the exhibit by making it the source of the interpreter's claim to historical accuracy. The interpreter's skill at correctly employing obsolete tools serves as a reinforcement of the interpretation. Work, in this context, makes the history appear accurate and therefore the message authentic. Moreover, this authenticity was all the more critical in an era whose own process of manufacturing had been regularized and mechanized by the factory assembly line and was becoming increasingly automated, particularly in the automotive industry. Artisanal skills, or even household chores, therefore presented a useful foil to mid-twentieth-century daily life. They reinforced the distinction

between past and present, and for the more nostalgic museum visitors, they buttressed claims that the past was a simpler and more wholesome place. More crucially, with their obvious and readily reproduced scripts revolving around the process of the task, performances of work represented an easy and reproducible point of interaction between visitors and museum staff.

There are many styles of living history interpretation. For example, first-person interpreters, often called animators, assume the persona of a specific individual from the past, often with elaborate back stories to inform their performance, and stay in character while they speak with museum visitors. Third-person interpreters also dress in period costume, but they comment on the past from the vantage point of the present. Calgary's Heritage Park seems to have featured third-person interpreters who, although they were costumed, did not pretend to be historical characters. In 1979, a new master plan urged abandoning this approach, advocating "live exhibits" instead. "The stress put on this aspect at Black Creek in Toronto is particularly successful," the report argued, suggesting that Black Creek had adopted first-person animation much earlier.[64] In a sense, first-person animators break the "fourth wall" of historical interpretation and speak to visitors as if they were contemporaries. Staying in period character and interacting with tourists in this way is obviously more demanding than simply putting on a costume and explaining the use of a tool. It requires considerable training and was thus probably beyond the means of museums that relied on volunteers. Both approaches have their strengths. Although a few authors argue that the first-person method can be distracting and, in the eyes of some visitors, can diminish the authority of the interpretation by turning it into a performance, most modern students of living history are highly enthusiastic about its potential.[65] The human element that first-person animation injects into the interaction between historian and audience makes it effective, much as Ronald Way felt that the physical environment made historical appreciation easier to achieve.[66] By the start of the 1980s, the trend was toward animation. Unfortunately, the written record is not always clear regarding which style was in place in the museums of the 1960s and 1970s. Moreover, it is impossible to know how individual interpreters behaved. Some may have stayed in character, whereas others may have broken character from time to time to emphasize a point. What is clear is that visitors appreciated some form of costumed interpretation and believed that it helped them understand how life was lived in the past.

Still, although pioneer village museums were intended to teach about "typical" life, what they represented was far from the norm of nineteenth-century British North America. Even in the 1960s, when the pioneer village model was being developed, historian Jacob Spelt was investigating the historical villages of pre-Confederation Ontario. As his study reveals, very few of them enjoyed the number of services that pioneer village museums routinely offer.[67] An analysis of exhibits at twelve village-style museums across Canada discovered a number of important patterns.[68] Most villages represented a rural environment tied to agriculture, and many featured livestock or working farms. The Joslin Farm at King's Landing, for instance, was stocked with crops and animals that were common during the 1860s and even developed a back-breeding system to recover heritage breeds and crop varietals.[69] The museums also stressed domestic and family life, with demonstrations of household chores and food preparation that were attributed to nineteenth-century rural lifestyles.

However, although their promotional literature repeatedly stressed pioneer self-sufficiency, these villages depicted a remarkably commercial past. Certainly, trades common to the countryside were abundant. Most museum exhibits portrayed services that were related to rural life, such as sawmills, cooperages, and grist mills. Blacksmith shops were ubiquitous. All twelve of the sample villages had one, and they were often the first exhibits planned. Blacksmithing was crucial in an era that depended on horse power for transportation and labour. A general store was equally common. However, the range of services on display at some villages was astonishing. Doon was more of a shopping district than a village. Alongside three family residences and a farm, it included a post office, tailor shop, harness shop, print shop, dry goods store, sawmill, butcher shop, and smithy. There were more shops than homes.

The range of businesses and services was often quixotic, probably reflecting the uneven survival of local buildings. Heritage Park, as one example, had a jewellery store, a real estate office, and a pool hall. Many museums operated a printing shop, often producing souvenir posters and weekly newspapers with a frequency that was unlikely in a nineteenth-century village. Many incorporated a railway station and a locomotive, indicative of the importance of transportation history to Canadian national development. But even this could be idiosyncratic, and often sanitized. For instance, transportation-related labour was largely ignored. Although the museum interpreters may have discussed railway construction, none dressed as railway construction workers to show the hardships and racial

segregation historians recognize in the historical railway industry. Similarly, Upper Canada Village had a canal but no canal workers, no navvies, and consequently, no strikes. In this depiction of history, logistically complex construction projects built by thousands of poorly paid workers, often from ethnic minorities, were reduced to a strife-free march of progress. Indeed, aside from the jails at Sherbrooke Village and Heritage Park, and the daily courtroom dramas performed at Barkerville, living history museums presented a past without conflict. Even at Barkerville, the "trials" helped reinforce the romanticism of the gold rush of popular imagination. Given the preponderance of single-family homes in pioneer village recreations, property ownership was clearly emphasized over tenancy. Thus, a misreading of the historical past was given material confirmation in the displays of pioneer village museums.[70] Yet, despite this emphasis on property ownership, with the exception of Heritage Park, few museums had a bank, and none had a law office. With no banks or lawyers, there could be no mortgages, no bankruptcies, and therefore no foreclosures.

Obviously, the requirements of a museum's educational mission, as well as its need for a variety of interesting exhibits to attract motoring tourists, explain much of this imbalance, and some of it was quite deliberate. Ronald Way's use of different buildings to tell different stories at Upper Canada Village was reproduced around the country. A similar imperative drove the proliferation of workplace exhibits. Nevertheless, an emphasis on commercial enterprises reinforced the post-war consumerism that supported the tourist industry, on which living history museums depended in the mid-twentieth century. Consumerism underwrote some of the more consistently popular exhibits at village museums, sometimes in defiance of historical reality. The largest museums operated period hotels and taverns as public restaurants. Willard's Hotel at Upper Canada Village was so popular that it had difficulty accommodating all the guests. But the need to cater to modern appetites often interfered with the authenticity of the menu and atmosphere. Staff at King's Landing made precisely this complaint about the King's Head Tavern in 1977.[71] Perhaps the clearest demonstration of the overlap between post-war popular culture and the dining experience at a living history village was found at Heritage Park's Wainwright Hotel, with its gun-twirling manager and "delightful" *Harvey Girl* waitress uniforms.[72] General stores were another popular display, in part because many marketed candies and other sweets to children. The general store at Heritage Park doubled as a souvenir shop, where pamphlets flogged products even as they provided historical information:

"Cheese, coffee, candy? Certainly – pioneer style! Special Heritage Park brands are sold in the general store." Visitors could also buy postcards in the village post office.[73]

At Black Creek Pioneer Village, the Laskay Emporium was especially popular. A general store built in 1856 in Laskay, Ontario, it remained in operation until its relocation to Black Creek in 1960. The emporium was so popular that it often received top billing in ads for the village.[74] It was also popular enough to be displayed outside the village during the off-season. It was set up at the 1964 National Home Show at Toronto's Exhibition Park. There, stuck between displays of "space age" homes, it offered homeowners and potential homebuyers a chance to compare the goods of yesteryear to modern conveniences.[75] Later that year, it was also exhibited at the Royal Agricultural Winter Fair, where it was claimed "to give a vivid picture of life in the last century."[76] These displays were obviously intended to arouse interest in the village, but comparisons of this nature were another support for the idea of material progress. The pioneer village demonstrated progress through the implied comparison with the comfort of modern living.

The Laskay Emporium served as a focal point in the fictional world of Black Creek Pioneer Village, both in portraying a past society and in directing modern memories. According to curator Dorothy Duncan, local storekeepers were extremely important men and community leaders. Depending on how they assessed a customer, they gave or withheld credit. And they procured specialized items from distant cities that were not regularly available in a village. They were gatekeepers who controlled standards of living and access to the world beyond the farm and village.[77] More recent analysis of storekeeping in Upper Canada indicates that this portrayal is not quite accurate. Douglas McCalla suggests that storekeepers, although significant figures in their communities, were not as powerful as Duncan claimed. His analysis of daybooks reveals patterns of shopping that vested considerable agency in customers. It is apparent that people compared prices in different stores and probably looked farther afield than the closest village for items.[78]

An analysis of the goods in the reconstructed Laskay Emporium confirms its place in fiction. Its main retail product was candy, which was obviously intended to satisfy the wants of visiting children, but its displays of nineteenth-century goods reveal more about its idealized past. It invited comparison with modern shopping in ways that most suburbanites understood. One visitor even suggested that more direct comparisons be made,

asking for the relative prices of goods then and now.[79] However, Dorothy Duncan's first general guide explained a barter system of pioneer trade and outlined how people shopped in pioneer days. Often, she claimed, Joseph Baldwin, the fictitious village storekeeper, "had to take the settler's grain, salt, meat, butter, eggs, ashes, or other products in return for his goods."[80] Speaking specifically about New Brunswick, historian Beatrice Craig argues the opposite: that storekeepers actually encouraged the transition to a monetized economy because they discouraged paying for goods in kind, preferring to deal in store credit.[81] McCalla's analysis of the account books of general stores explores this more calculating approach. A storekeeper would not have accepted such items unless there was a market to resell them, perhaps at local boarding houses or nearby lumber camps, neither of which figure in the world of the pioneer village museum with its imagined past of simple, near-subsistence production. Certainly, Duncan did not have access to these historiographical insights, but her claims about store business reveal an interpretation of the past that was based on personal expectations and assumptions rooted in 1950s and 1960s suburban living. She claimed that 90 percent of store business was carried out by barter, an assertion that invited comparison with modern shopping. Yet this grossly simplifies a complex nineteenth-century commercial system that functioned on credit. Still, official interpretations worked their way into common understanding through the repetition of key phrases. Duncan's claim of a 90 percent barter market was repeated by newspaper and magazine coverage, helping to spread this false impression of a simple past.[82]

Domestic Life

The depiction of the past at pioneer villages entailed more than a frenzy of consumerism. Faith and family were central aspects as well. Churches featured in almost every village, although most had just one, obscuring religious rivalries. And museum depictions tended to normalize gendered conceptions of family by mimicking post-war patterns of domestic life. Much as historians have described post-war suburbs, pioneer village museums were spaces of women and children. In one Black Creek brief, G. Ross Lord defined the role of the village in terms that emphasized gendered animation: "The policy at Pioneer Village is to make it a living village. There are specially trained attendants in each of the buildings. The women, dressed in costumes, perform household activities which were daily tasks in the homes of Ontario over one hundred years ago."[83]

The deployment of interpreters at the pioneer village reinforced traditional gender roles that would be easily recognizable to post-war middle-class suburbanites. Male interpreters were typically stationed only in places of commercial or artisanal labour; they spent almost no time in the homes. Women, on the other hand, were never found anywhere but the private home and its yard. For example, the *Toronto Star* published fifty-two photographs of activities at Black Creek Pioneer Village between its opening in June 1960 and the end of 1969. The vast majority portrayed domestic household activities, even though most displays in the village depicted various forms of artisanal labour. Thirty-one photos – or 60 percent – featured women, and fourteen of these showed women in the kitchen, baking or cooking. In another thirteen, women perform other domestic chores, especially spinning, needleworking, and churning butter. At this pioneer village, women literally embodied a gendered view of history. Indeed, pioneer food preparation became a virtual cottage industry. Some museums produced pioneer cookbooks and sold them in their gift shops for families who were interested in tasting pioneer meals at home.[84] By the mid-1960s, "pioneer" recipes had become central to museum information. One newspaper article, as a preface to recipes for such treats as date loaves, gingersnaps, and oatmeal cookies, urged modern housewives to take a lesson from the past and try the recipes "if you really want to prepare food instead of taking all the short-cuts." But this was more than simply nostalgia for "old fashioned" baking. It also offered modern advice on raising daughters, implying that "pioneer women were wonderful cooks" in part because they used recipes that had been passed "from mother to daughter" and thus brought their daughters into the kitchen at an early age.[85] The issue is not whether the past was gendered, but rather how views of gender affected how twentieth-century women portrayed the past.

Perhaps the most direct comparison came in the context of humourist Gary Lautens's 1963 column in the *Toronto Star*. During his visit to Black Creek Pioneer Village, he interviewed Peggy Riordan, a housewife who lived in two centuries. In her modern life, she was a mother of five and the wife of a fireman. But she spent her days as a "housewife of 100 years ago" in an 1816 cottage. Lautens described their conversation in terms rich with the message of the museum: "She offers some date-and-nut loaf, baked over the open fire by an old recipe. It's delicious. 'I'm going to bake a pie this afternoon,' she explains. 'And, at home, my automatic stove will be turned on by timeclocks to cook our own supper.'"[86] Riordan

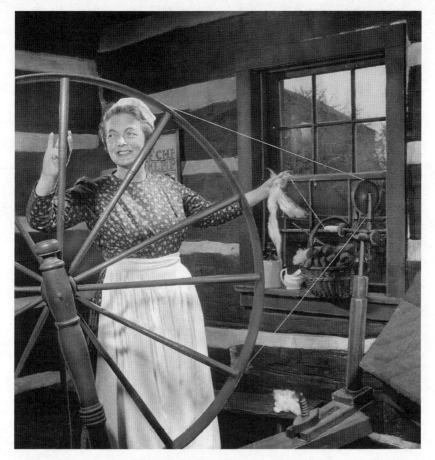

Spinning demonstration, Black Creek Pioneer Village, 1963 | Source: *Toronto Star,* 25 May 1963, 57 | Photographer: Harold Whyte / GetStock.com

clearly understood her role, in both centuries, as one of housewife, but she construed women's work in terms that she could easily grasp. Although historians agree that a gendered division of labour existed in nineteenth-century Upper Canada, this was a simplified and suburbanized notion of the woman in the home, mending clothes and baking.

Children were also key feature of the history "lived" at pioneer village museums. However, it is important to be mindful that children's experience was framed within existing contexts of race, class, gender, and sexuality. As in their daily lives, children's experiences at living history museums reflected the world created by adults. At Black Creek, one of the first structures added to the original farm buildings on the Stong property was a one-room school from Markham township. The Dickson's Hill School,

which dates from 1861, represented a design favoured by Eggerton
Ryerson, the architect of Ontario's public school system.[87] Building a
school would also seem familiar to post-war parents. Across Canada, new
schools were under construction to meet the post-war baby boom. In 1956,
Toronto's three outer suburban townships – Etobicoke, North York, and
Scarborough – had 108 public elementary schools. By 1966, the number
had jumped to 238.[88] An analysis of school construction around the country
would tell a similar story. Not surprisingly, a school featured at every
pioneer village museum, commonly of the typical, one-room design. But
more importantly, most museums depended on school field trips.

Living history museums represented a particular vision of the possibil-
ities of history education. Through much of the twentieth century, history
had occupied a central place in Canadian public education. It had sur-
vived the initial introduction into Canada of American-style social studies
in the 1930s, which remained mostly confined to the elementary grades.
However, the post-war expansion of school enrolments posed new chal-
lenges. A general liberalization of the high school curriculum freed
educators from province-wide examinations and prescribed content, and
opened up broader sets of course offerings. Liberated from set curricula,
teachers looked for new ways to motivate students and were encouraged
to innovate in the classroom. In a quest to find contemporary course
materials, many turned away from history toward presumably more "rel-
evant" courses in sociology and interdisciplinary social sciences.[89]

In this environment, teachers began to supplement classroom learning
with field trips. For other subjects, trips to local factories and public in-
stitutions could teach practical concerns and the application of class-
room lessons; for the natural sciences, conservation authorities and their
interpretive centres could offer hands-on lessons in biology or ecology.
Living history seemed to offer a similar promise of a relevant, student-
centred, and interdisciplinary study of the past. At recreated villages,
students learned about pioneer life by playing at pioneers. They received
practical instruction in daily tasks and learned how people had interacted
with the natural world. This was the point of Arthur Richardson's "con-
servation ethic." Pioneer village museums represented a way to teach in
which the total environment of the past might be recreated so that students
could learn through experience.

The Metro Toronto and Region Conservation Authority (MTRCA), for
one, placed enormous stress on the educational work of Black Creek

Pioneer Village. Teachers repaid this dedication by bringing their classes to the site in ever-growing numbers. Already in its opening year, guided class trips made up a substantial proportion of attendance figures. Only a few years afterward, staff reported that twenty-two thousand students took educational tours of the village each year, making it one of the most popular education programs run by the conservation authority. These numbers made it necessary for the authority's educational division to develop an extensive teaching organization and to produce a teacher's guide to handle the tours and ensure that they were meaningful educational experiences.[90]

At first, teachers did not usually make appointments to tour their classes through the village, which presented obvious problems for its staff. For instance, in May and June 1963, thirty-two teachers arrived unannounced with their classes in tow. In most instances, staff members were able to accommodate them, either by allowing them access to the village, supervised only by the teacher, or when a guide agreed to sacrifice a lunch or break period to lead a tour. However, with only four guides on staff, and with nearly 50 percent of advance requests to book a tour being turned down, this situation could not be allowed to continue. Priority had to be given to those teachers who had planned ahead and contacted the village in advance.

By the mid-1960s, the conservation authority had established a policy for tour bookings that helped to control and regularize the museum's message to school groups. A typical tour lasted about ninety minutes. Some teachers notified the museum beforehand regarding specific aspects of pioneer life to be covered, such as architecture, transportation, or lighting. Others might ask for a comparison tour that contrasted pioneering with life later in the century. If there were no advance requests, classes received a standard tour that moved through all the buildings in the order of the period that they represented. A typical tour group wound its way through the village, starting with the old Stong farmstead and ending with the general store and the blacksmith's shop.[91] Visiting the buildings in order of their construction provided visual evidence of material and cultural changes that occurred over a relatively short period. By implication, students could also contrast the material culture of the past with their own times. Thus, they learned a narrative of life in Upper Canada from the early nineteenth century until about the date of Confederation that reinforced notions of historical progress.

Some museums, especially those supported by provincial agencies, prepared teaching plans from the start. King's Landing, for example, hired its first education officer in 1970, before it opened to the public. Its education program began in the fall of 1972, with guided tours of the Joslin Farm and Hagerman House, and it expanded in subsequent years to include participation programs that involved domestic chores such as spinning wool and making candles.[92] Like many living history museums, King's Landing recognized that school field trips represented a major portion of its revenues, as well as securing its place as an important community institution. Museum staff actively promoted field trips in the 1970s, even producing a brochure titled *Why Make a Field Trip to King's Landing*, which was distributed to local teachers and school principals. The brochure instructed teachers in preparing their classes and lesson plans leading up to and following the visit, as well as providing guidance on how teachers and students should behave in the village.[93] By the mid-1970s, the educational mandate had outgrown the school year, with the Visiting Cousins program bringing children aged nine to twelve to King's Landing in July and August. The "visiting cousins" slept over, spending up to a week in the village, wearing period costumes, and pretending to be city children who were visiting their rural relatives during the mid-nineteenth century.[94] By the end of the decade, King's Landing had constructed seven field trip programs for different ages from Grades 1 through 12.[95]

King's Landing tailored its various educational programs to differing age groups. In its scheme of offerings, the "Our House, Your House" program taught the youngest children, Grades 1 to 3, to compare their modern homes to the historic houses on the museum grounds. Children could also come in smaller groups during November and December to enjoy the "Old Fashioned Christmas" program. Students in the middle grades (4–8) learned about domestic chores and the role of the general store in the local economy. They might also take in a nineteenth-century school lesson taught by a costumed interpreter. Alternatively, teachers were encouraged to use the museum setting to deliver lessons about the coming of the Loyalists to New Brunswick. High school students were given more sophisticated lessons involving a greater degree of student participation in domestic chores or closer examinations of architectural history, the environment, and past lifestyles.[96] Other museums had developed similarly sophisticated offerings by the end of the 1970s.

At Upper Canada Village, school visits also proved popular, and teachers often had their pupils send a thank-you letter to their hosts. Although

very few of these survive, perhaps the most rewarding was written by Sue Pritchard, a Newboro Public School eighth-grader whose class toured the village in April 1962. Her classmates clearly identified with the artifacts and the ability to touch them. Interpreters added to the power of the physicality by telling the children that many of the agricultural implements they handled came from Newboro. It offered them a tangible link with their own ancestors. And, students were especially thrilled to visit the very school that they had read about in Ralph Connor's novel *Glengarry School Days*. At Upper Canada Village, they could sit in the desks and imagine Connor's schoolteacher character, Archie Munro, standing at the head of the class and reading his day's lesson while the children schemed mischief. They could even trace the names and initials carved into the old desks and feel a connection to history, however fictional.[97]

Children's reactions to pioneer village museums seem to suggest, as Sue Pritchard's essay did, that they most appreciated what was closest to their own experience. Surviving class letters to Orwell Corner Historic Village in Prince Edward Island provide another example. Opened in 1973 to celebrate the centennial of the island's entry into Confederation, Orwell Corner explained the architectural heritage and way of life in an island crossroads of the nineteenth century. For the students from St. Jean Elementary School in Charlottetown, who visited during the fall of 1975, seeing farm animals up close was a highlight of the day. Getting a wagon ride was also a lot of fun. Some children also enjoyed learning about "the age of the buildings" and comparing their own modern lives to "how hard it was to live" in the nineteenth century. Aside from the usual fun and games of school field trips, Black Creek Pioneer Village offered sleigh rides every winter weekend, allowing the sound of children's laughter to echo through the site even in the off-season. As one reporter described them, museums were places where "children play in pioneer settings."[98] One of the most popular exhibits at Black Creek was the Percy Band Collection of nineteenth-century toys. This belonged to the Laidlaw Foundation, which appointed the MTRCA its custodian in 1962 and permitted its display in Black Creek's Dalziel Barn to show "how children of the mid 1800s played."[99] More importantly, village staffers taught that "through the medium of children's playthings, we see the way of life of the 19th century."[100] Nonetheless, the childhood that Black Creek evoked had more to do with the leisure and play of the modern suburbs than with the nineteenth century.

Conclusion

Taken together, pioneer village interpretation programs domesticated the message of Canadian history. With their focus on everyday life, they manifest in three dimensions the promise of social history. The sudden proliferation of pioneer villages set a counterbalance to the military forts and fur trade outposts that dominated Canada's historic landscape before the Second World War. More importantly, as governments and public agencies assumed control of the museums, they installed increasingly sophisticated educational mandates for the teaching of social history. Tourism remained an important consideration at museums, but in the years of rapidly expanding baby-boom-fuelled school enrolments, class trips represented a substantial market. Yet, the domestication of history by pioneer villages reflected the middle-class ideal of the post-war period more than it mirrored the past itself. Despite being revolutionary in their approach to telling social history, living history museums presented a conservative historical message that emphasized a gendered society rooted in the nuclear family of the post-war era.

6

Louisbourg and the Quest
for Authenticity

THE RISE OF LIVING HISTORY and its potential for tourism in the 1960s breathed new life into John Stewart McLennan's dream of a recreated Louisbourg. The reconstruction that eventually rose on Cape Breton Island's rocky coast was perhaps the highest form of living history museum in Canada. Phenomenally expensive, Louisbourg was supported by an impressive infrastructure of research, planning, interpretation, and construction designed to produce an authentic recreation of the eighteenth-century fortress and town. A case study of Louisbourg reveals how modern systems, techniques, and knowledge came together to produce a tourist attraction that delivered a sensory experience of a long-vanished past. It was the closest thing to time travel. At the same time, the examination uncovers the limits of authenticity that any such project faces.

The Power of Inexhaustible Satisfactions
Nova Scotia had long used tourism to combat the effects of deindustrialization, of which the plight of Cape Breton Island was only the most dramatic example.[1] The decline of the island's coal and steel industries, the subject of a royal commission in the 1940s, persisted after the war. In 1959, Ottawa launched another inquiry, this time the one-man royal commission of Mr. Justice Ivan Cleveland Rand. Reaction to Rand's report was mixed, following its release in August 1960. Many critics found it too cautious for recommending the replacement of existing transportation cost subventions with direct subsidies to the coal industry.[2] Such tinkering appeared too minuscule to counter the island's long, deep slump. However, Rand's suggestions did more than just fiddle with a sinking industry. In all, Rand made sixteen recommendations, eleven of which dealt with the coal industry. The remaining five discussed the importance of economic diversification for Cape Breton Island, especially through increased tourism.

Perceiving the enormous potential of tourism as an alternative to coal mining, Rand examined the prospects for park and historic site development. The island's resources offered the "power of inexhaustible satisfactions," awaiting only for tourists to come and enjoy them. Rand suggested a two-pronged strategy. Existing tourist attractions needed further development, but aside from fishing, hiking, and other leisure uses of the natural environment, Rand also suggested capitalizing on the tourist potential of the island's human history. He singled out the recently opened Alexander Graham Bell Museum at Baddeck as a masterful example. He encouraged the further development of Nova Scotia's Scottish-themed festivals and celebrations, in hopes that the province would become a mecca for the Scots descendants of the western Atlantic world. And, echoing McLennan's most ambitious dreams, he envisioned a living history reconstruction of Louisbourg to form "the centrepiece of a distinct network of historic parks."[3]

Rand was effusive in his vision of Louisbourg's past: "In the early part of the eighteenth century began the work of building the strongest fortification then existing on the Atlantic coast of North America and of establishing a community bringing to the New World the architecture, traditions and culture of the French people at the direction of the most polished court of continental Europe." He was equally enthusiastic in promoting a full-scale reconstruction of the eighteenth-century town. "What could be more stimulating to the imagination or more instructive to the mind," he asked, "than to look upon a symbolic reconstruction of the Fortress of Louisbourg."[4] The thirteenth recommendation of his final report therefore advised that "beginning not later than the year 1961 work on a scheme for reconstructing Louisbourg as an historic site be commenced and that it be carried through to an appropriate completion."[5] For Rand, such a major, labour-intensive project was the perfect solution to local unemployment.

Not everyone agreed that Rand's plan made sense. Katharine McLennan, for one, dismissed it as simply foolish.[6] From her position at the Louisbourg Museum, and as the guardian of her father's memory, she played an important role in shaping the government's approach to Louisbourg. In the first years of its existence, the Louisbourg Museum was a lonely attraction at the far end of a long, bumpy road, twenty miles from Sydney. Only about ten thousand people a year drove out to the Louisburg fishing town to see the museum and walk among its adjacent historic ruins.[7] The museum building itself was a simple wood and masonry structure with one

main display hall that was plagued by leaks for years. Its exhibits were equally basic, with McLennan hand printing the labels herself well into the 1950s. Ottawa gave her free rein to do as she pleased, and the museum's collection of random displays bore her stamp.[8] For instance, one showcase housed a portion of a wooden boat that had been found in the nearby Mira River, which McLennan presumed – though with neither evidence nor plausibility – to be the one "used by [the Marquis de] Boishébert and his Indians after the retreat after the capture of Louisbourg, 1758."[9] Under McLennan's watch, the museum's mandate remained rather limited. She dedicated its displays to telling the story of the two eighteenth-century sieges of Louisbourg, but in practice she followed the haphazard collecting policies of the nineteenth century. For example, when a cannon was re-trieved from a sunken French warship, it was considered worthy of dis-play despite having no connection to either siege. Through the 1940s, McLennan focused on building a topographical scale model that was to be the museum's centrepiece. When it was completed in the early 1950s, it was as much a monument to her energy and dedication as it was a com-memoration of the fall of Louisbourg.[10] Despite its limited government support, the Louisbourg Museum was a throwback to the days of the amateur, proprietary museums. By contrast, the Fortress of Louisbourg National Historic Park that supplanted it in the 1960s was an enormous leap forward in the work of living history.

However, it would be unfair to characterize the Louisbourg Museum simply as an undisciplined amateur cabinet. In the fall of 1954, Albert Almon, a retired plumber and amateur historian from Glace Bay, offered the museum an "authentic" portrait of Louis IX, king of France from 1226 to 1270. Almon had spent over twenty years authenticating the painting, which was owned by a wealthy American widow. He dated it to 1250, making it over seven hundred years old, and he guaranteed its genuine-ness.[11] There is, of course, little connection between a thirteenth-century French king and the eighteenth-century colony, but Almon claimed that the picture had once adorned the chapel at Louisbourg, having been sent by Louis XV in the 1730s. He pointed to documents in the dominion archives that revealed its presentation at Louisbourg in 1735, but dominion archivists could not confirm the claim.[12] Had the work been accepted as genuine, it most certainly would have ended up in the Louisbourg recon-struction of the 1960s. But, Almon steadfastly refused to allow experts from the National Gallery, or anywhere else, to examine the painting, and without professional authentication, the government refused to accept

the donation.[13] This incident reveals how far the practice of public history had advanced since the 1920s and 1930s. Although McLennan was left largely to her own devices, the word of local historians was no longer considered evidence when contrasted with professional expertise.

Rand's vision for Louisbourg likewise assumed the involvement of professional experts. Although he did not call for a complete reconstruction, he advocated one that was "sufficient to furnish a comprehensive representation of the material and cultural forms set up in a strange land inviting settlement."[14] At the very least, the project should be on a scale large enough to require new highway and possibly even airport construction to accommodate the anticipated influx of tourists. This was work that demanded the guidance of competing groups of professionals. In fact, even before the Rand Commission reported, J.R.B. Coleman, the director of the Parks Branch, believed that the branch's efforts at Louisbourg were likely to expand. It was already heavily invested in reconstruction work at the Halifax Citadel and on the walls of Quebec City. It also got drawn into the Diefenbaker government's northern agenda in its own way. When Louis St. Laurent dissolved Parliament on 12 April 1957, no one seriously believed that the Liberals could be defeated. But, through the charismatic leadership of John Diefenbaker, as well as fallout from the Trans Canada natural gas pipeline debate, the Conservatives stole a victory and formed a minority government. Throughout the campaign, Diefenbaker had championed the idea of northern development to exploit Canada's natural resources and counter American economic influence. On a campaign stop in April, he even suggested developing Dawson City as a tourist attraction, thinking that the Yukon's tourist potential had expanded due to the recent elevation of Alaska to statehood. Once in power, Diefenbaker began to articulate his "northern vision" of Canadian prosperity, which he trumpeted during the 1958 election campaign. When the government decided to back a "gold rush festival" in Dawson, the Parks Branch was committed despite itself. Without first weighing the options or assessing the value of the project, Coleman dispatched the branch's chief historian to investigate the restoration of an old auditorium to its 1890s splendour.[15] Political direction had trumped historical research and existing policy in ways that foreshadowed the development of Louisbourg.

The Message of Restored Louisbourg

Anticipating Rand's final report, Coleman called a meeting in May 1960 to draft a restoration program. Two distinct approaches emerged from

the meeting, one supported by the government engineers who would carry out the reconstruction and the other favoured by the Historic Sites Division that would, presumably, plan it. The division had been created only a few years earlier in response to the Massey Commission's recommendations. Massey had suggested that the government hire its own professional historian, which resulted in A.J.H. Richardson, formerly chief of the map division of the Public Archives, being named chief historian. However, as late as 1958, Richardson commanded a research staff of one and spent most of his time coping with administrative crises rather than producing reports. He passed these responsibilities to his successor, J.D. Herbert, in 1959. The Historic Sites Division and its chief historian were relatively impotent in the Parks Branch of the late 1950s and early 1960s.[16] The Louisbourg project reinforced that powerlessness: although Herbert was able to bring forward sound academic arguments to support his views, he was largely ignored in the eventual reconstruction.

In some ways, the dispute over how to proceed at Louisbourg encapsulated a difference of opinion regarding how the built environment should be arranged to represent history. The Parks Branch engineers, led by G.L. Scott, favoured a wholesale restoration of the fortress and city to a specific point in time. Seized by the enormous tourist potential of such an enterprise, and no doubt salivating at its engineering challenges, they had the benefit of present-day interests on their side. Regional economic development imperatives, as Rand was about to spell out, favoured something spectacular. However, theirs was an ambitious and costly plan that would necessarily mean covering over the existing ruins and thus destroying their archaeological value. Herbert rejected this proposition out of hand. For him, even a partial restoration would be an artificial imposition on history and on the landscape. Moreover, he saw the historian's role as demonstrating the effects of the passage of time. A reconstruction to a specific, single date, he argued, "would not demonstrate the process of history and the changes wrought by time."[17] Indeed, Herbert dismissed the practice of historic reconstruction as a vulgarization, not unlike Disneyland, a popular trend that he feared would cause people to lose sight of history itself.[18]

In an early memorandum on the possibilities for reconstruction, Herbert envisioned three approaches. The first was to leave the ruins alone and demonstrate the town's past by using models like Katharine McLennan's. A second possibility was to rebuild the entire town to its state at a specific date, such as 1758, just before the final siege. But Herbert felt that neither

of these options would "succeed in creating for the visitor the feeling of being part of history, which is essential for a true appreciation of the structural reminders of our past which we designate as historic sites." Instead, he recommended "a third and more satisfactory approach," one that involved "reconstructions of parts of the city and fortifications as they must have looked before the siege of 1758, simulation of the effects of the siege on other parts, while on still others preservation of the desolation of 200 years as silent witness to the inexorable tide of historical evolution."[19] Herbert's approach was an attempt to please everyone, but it pleased no one.

A secondary factor in these discussions was the question of the historical significance of Louisbourg. Herbert believed that its historical significance lay in its destruction following the siege of 1758. This was a climactic moment in the struggle between European empires in the New World. The 1758 siege, he reasoned, foreshadowed the eventual conquest of Canada, and any development in the present should not obscure this fact. His preference for leaving the site in ruins would serve this message. On the other hand, this approach was at odds with the political use of French regime history that federal governments had pursued for much of the century. Following the divisions between French and English over conscription and the prosecution of the war effort in the First World War, successive governments had embarked on a program of reconciliation through shared history. For instance, in 1934, with the support of the Historic Sites and Monuments Board, Ottawa held a series of celebrations of the four hundredth anniversary of Jacques Cartier's first voyage to Canada. Successive federal politicians drew on the theme of shared history at these celebrations to promote unity between Canada's two major linguistic groups.[20] Following the travails of the Second World War, this theme persisted in federal politics, and Louisbourg might be seen as an anticipation of the policies that emerged at the end of the decade from the Royal Commission on Bilingualism and Biculturalism. Yet, the engineers' position might also be seen to anticipate this vision of national unity. In advocating a full reconstruction, their view was that Louisbourg represented, not a reminder of the clash of nations, but a glorious example of the faith, courage, and resourcefulness of the Europeans who together built a new civilization in the New World.[21]

What seemed to resolve this dispute, at least at first, was cost. Although the Rand Commission recommended a comprehensive reconstruction,

Herbert's report to cabinet counselled a more cautious approach: perhaps only the entrance gate to the ruins could be rebuilt, which would give visitors a sense of lost grandeur.[22] In pre-budget meetings in March 1961 and again in 1962, cabinet approved a modest appropriation of no more than $12 million over twelve years. Such a modest amount favoured Herbert's smaller-scale approach. Yet, at the same time, cabinet insisted that the branch produce something spectacular for the coming centennial of Confederation. The local economic impact was felt immediately. Some 225 people, mostly former coal miners, were quickly put to work, but construction began only in 1962.[23] Thus, although Herbert's approach appeared to win out, the rush to meet the demand for a show for the centennial meant that it was soon abandoned. The work proceeded quickly and in the process, Herbert and the Historic Sites Division of the Parks Branch lost virtually all influence over the project.

If the scramble to meet a 1967 deadline helped to push aside the branch's own historians, the decision to engage Ronald Way as a consultant sealed it. By the time construction work began, Way had been seconded to the project by request of the prime minister.[24] True to his practice at Upper Canada Village, Way used his influence with senior bureaucrats to squeeze out opposition to his own plans. He reported directly to Coleman, not to Herbert and the Historic Sites Division, which meant that he could develop his own plan with a relatively free hand. He used this authority to further adjudicate between the engineers' position and Herbert's. Bound as he was by the government's budgetary restrictions, he advocated only a partial restoration as had Herbert. But on everything else, Way sided with the engineers. Thus, under his plan, the land approach to the site would be restored to its past glory, whereas the harbour side would be left ruined, as it had been over the previous two centuries. This, Way explained, would provide maximum effect for visitors, who would see both the splendour of New France and its ruin. Yet, at the same time, Way rejected Herbert's earlier assessment that Louisbourg's fall represented its principal place in history. Indeed, he believed that an authentic restoration to 1758 would also require rebuilding the temporary defences erected by the French: "Should we *authentically* restore the bastion to its condition in 1758, we would have the never-ending expense and problems of mainlining earth-work revetments of fascines and gabions – in conjunction with tottering walls sustained by timber props."[25] This, he stated, would insult both the British forces who captured the weakened fortress and the

French who had built it. Furthermore, visitors would not appreciate the significance of eighteenth-century Louisbourg for both empires. Way believed that "the message of restored Louisbourg should be the story of the progress of Canada's two major races from armed hostility to their national partnership in the Canada of today."[26] The restoration of the fortress, he felt, might actually be its greatest contribution to Canada. This interpretation of history was sure to make a splash for the government's planned centennial celebrations.

On other issues, Way continued to side with the engineers rather than the historians. For instance, he agreed that the reconstruction should focus on a single historical period, a view that he had supported at Upper Canada Village. Rejecting Herbert's belief that the passage of time should be reflected in the site, he contended that a reconstruction to a single date would not be ahistorical. However, he adjusted his argument. The reconstruction would not focus on the final defeat of Louisbourg. Instead, it would be a more impressive version from an earlier period:

> The advantages of the simple over the complex restoration are important from the standpoint of ease of presentation to the public and it was for this reason that I thought it desirable that the fortifications should, if possible, be concentrated upon a single point in time. Today, in light of research evidence, which was not available at the outset of this project, I am inclined to recommend a modification of policy with respect to the treatment of fortifications. The King's Bastion at the time of the first siege in 1745 was an impressive and formidable work. By 1758 – even before the British attack – its defences had become, through faulty maintenance and poor engineering, a first-rate mess. I now believe that both from the standpoint of achieving an impressive showing for the public and of producing structures economically feasible to maintain, it is desirable to focus restoration of the Citadel upon the outset of the first siege.[27]

Concentrating on a single date – in this case 1745, the date of the first siege – imposed unusual limitations on historical research. It simplified construction, but it circumscribed interpretation, ironically precluding the presentation of Louisbourg's final fall and the end of New France.[28] Nevertheless, the reconstruction was built to Louisbourg's state in 1745, and thus Way overruled Herbert. No doubt his marginalization helps explain why Herbert resigned as chief historian in 1963.

Constructing Authenticity

To meet the deadlines set by cabinet, work had to proceed quickly. Even Way's planning was eventually overridden by excitement and ambitious pleas to expand the reconstruction. Indeed, work began even before crucial decisions were taken, such as whether modern building techniques could intrude on a historic reconstruction. For instance, one of the first tasks was the building of a seawall to protect the shoreline of the original harbour from further erosion. The problem was acute, Way insisted, and solving it had the immediate benefit of employing local labour. However, Way recommended simply pouring concrete and concealing this modern intrusion with planking to get the job done quickly. He dismissed the inevitable protests from the historical researchers: "I feel that we must take a calculated risk with respect to restoration – in which the odds are on our side – in order to avoid a greater risk, namely the failure of the project from the standpoint of the Rand Commission."[29] Like C.W. Jefferys and Ramsay Traquair at Port Royal, Way relied on comparisons and calculations of risks and possibilities to guide the project. Indeed, his proficiency at assessing such probabilities marked him as a professional restorer.

It was his skill at calculating risks, Way asserted, that demanded he retain control over every aspect of the venture – historians and engineers who were inexperienced with recreating the world of the past should defer to his judgment. Way complained in a letter to Coleman that the pace of construction was "bordering on panic" and that he would rather delay it than rush the reconstruction to a point where there was no time to evaluate research findings carefully. "I fear," he explained, "we are moving from the realm of the 'calculated risk,' with the odds on our side, into the field of the 'long shot.'"[30] Indeed, Way had good reason for concern. Excavation began in the summer of 1961 and was co-ordinated to the construction schedule rather than to any principles of archaeology. Although the excavations were planned so that a comprehensive single study might be produced, components of the King's Bastion reconstruction were set up in a way that prioritized construction over research, forcing the archaeologists and historians to adapt their planned investigations. The situation improved in 1963, when Edward Larrabee was hired as senior archaeologist to organize the archaeological work.[31] Still, completing such a large-scale dig also obliged the branch's researchers to adapt in other ways. Being tied to the construction schedule meant that

they had to work throughout the year. Shelters had to be erected over areas where intensive excavation was necessary and then heated in the winter to keep the ground from freezing and to make working conditions bearable. Even in summer, shelters proved necessary due to the frequent rain and damp fog that characterize eastern Cape Breton's climate.[32]

With time an obvious pressure, shortcuts were taken. Equipment of all sizes was used to speed up the excavation work. Small tractor-mounted backhoes, bulldozers, a front-end loader, and a large power shovel – equipment rarely seen at archaeological digs – certainly quickened the pace, but at a potentially devastating cost to the project's authenticity. "To be frank," Way continued in his complaint to Coleman, "the employment of machines to destroy surviving remains is so foreign to the best principles of restoration work, that it never crossed my mind."[33] The historic walls of Louisbourg, he insisted, were not just old stones – they had to be treated with proper reverence. This was not simply a sentimental opinion, although Way acknowledged a degree of sentimentality in his view. Rather, without careful hand work in the excavation and removal of surviving stones, the entire reconstruction would be at the mercy of surveyors' estimates and calculations, heightening the possibility of working to inaccurate conclusions. And Way complained that his opinion had not been sought before deadlines made it too late. A system of briefs, memoranda, and formal and informal meetings was conceived in haste during the early years of the project but was retained throughout the research and development phase.[34] Yet, despite Way's concerns, and despite the persistent use of heavy equipment, the majority of the excavation was done by hand and most of the earth was removed in wheelbarrows.[35]

Way's concerns were not the only problems caused by hitching archaeological research to the needs of engineers and architects. Research was required to provide answers to specfic questions about construction. However, with planning for the reconstruction already under way, the research was necessarily biased toward structural information. Much of the early research, then, was geared toward filling in missing information for the engineers. Fully half the decisions upon which a detailed plan of construction was to be built depended on the archaeological analysis of the excavated areas. Historical and cartographical evidence could not provide enough data to reveal the exact placement or alignment of walls and foundations. Nor were the data sufficiently detailed to give the reconstruction an accurate or authentic appearance, which was critical for its success as a historic attraction. The particulars of brick, mortar, cut

stones, and masonry were available only through excavation. Thus, data that might – or might not – be salvageable from the archaeological site were necessary for the reconstruction of Louisbourg in its original location, an act that would obliterate the archaeological site.[36]

In such difficult circumstances, clashes inevitably occurred. In one instance, Way proposed reusing an original cut stone as part of a doorway reconstruction in a King's Bastion casemate. The project manager, parks engineer A.D. Perry, disagreed with the suggestion, thinking it would unnecessarily expose a valuable relic to the elements. The dispute turned personal. Way disparaged Perry as no more than a "former construction manager" who lacked the specialized knowledge that experts, such as himself, brought to the project.[37] Perry bristled at the slight, pointing out that he had worked on the Halifax Citadel project and was well acquainted with the requirements of historic reconstruction. And he fired back at Way's own mistakes. The only original cut stone of value, he noted, had been improperly stored under Way's care and had dried out, meaning that it might expand and crack when exposed to the elements once again. Furthermore, the use of original building materials would inevitably incur wear and tear, which would compromise the long-term educational and interpretive program of the fortress. He allowed that such material could be used in building interiors, where it would be protected from the elements. However, if placed outdoors, the harsh climate of Cape Breton Island would hasten the decay of irreplaceable artifacts. As for the cut stone in question, Perry suggested that it be preserved for study and its instructional value.[38]

Yet Perry's own approach would have limited the educational value of the reconstruction. His main objective was to meet his deadlines and get the work done quickly. Project historian Frederick Thorpe admonished Perry for seizing on research before the historians could complete it. "They should be left to [their work]," he blasted, "without pressure to provide pre-conceived answers. The main point which you do not seem to grasp is that items of evidence have no validity when they stand alone but only in their historical and archaeological context."[39] If Thorpe and the other project historians hoped to gain Ronald Way's support in this fight, they were disappointed. In the spring of 1962, he had argued that construction should be slowed down to provide the researchers with a breathing space between their work and the erection of the buildings. Only once the historical and archaeological research was completed should building begin.[40] The following summer, however, he had second thoughts. The

pressing needs of producing a spectacular showing for the centennial mandated a different and more practical approach.[41]

In the 1950s, the Public Archives of Canada initiated an ambitious microfilming program that enabled its Paris and London offices to obtain complete and accurate copies of records series, replacing the more selective and fallible handwritten copies painstakingly transcribed prior to Confederation. However, in September 1961, before he became the general consultant for Louisbourg, Way recommended a new search of archival collections in France, England, and New England. He suspected that the microfilming was not comprehensive and had missed many valuable sources specific to the needs of the Louisbourg reconstruction. He also hoped that examples of eighteenth-century fortifications still existed in France and that they could help visualize what to do at Louisbourg. He and his wife, Taffy, thus flew to France in search of these resources and to consult with French authorities. They returned enthusiastic about the potential of further European research. "Our trip to France was begun with the belief," they wrote in a preliminary report, "that in out-of-the-way places unaffected by war or modern urbanization, there would be a significant amount of eighteenth century fortifications and houses." What they found "exceeded [their] most optimistic expectations."[42] Indeed, the trip to France inspired yet another recommendation for Louisbourg. Instead of searching for a Canadian firm to design the Chateau St. Louis, the administrative section of the King's Bastion, the Ways recommended placing this work in the hands of the Compagnie des architects des monuments historiques, France's national association of restoration architects. Any Canadian firm contracted to work at Louisbourg should be required to retain a French architect as a consultant. And, they continued, the Parks Branch should hire a Paris-based representative to continue the search for period furnishings and to serve as liaison with French experts. The Ways gushed over the expertise that was available in France, although they recognized the political difficulties of placing so much of the project under foreign control. Nevertheless, they felt justified because an authentic restoration had to draw on French sources "whether we like it or not."[43]

Despite Way's preference for French expertise, a Canadian company called Project Planning Associates won the contract to design the Chateau St. Louis. Peter Collins, an architecture professor at McGill University, wondered what qualifications a firm specializing in landscape architecture

and municipal engineering had for restoring an eighteenth-century fortress. He was particularly dismayed when its architects, Hancock Little Calvert Associates, asked for library privileges at McGill. If the firm truly were qualified, he wondered, why would it make such an unusual request? Collins suspected that patronage lay behind the contract, but the deputy minister insisted it was not political.[44] Despite Collins's reservations, Project Planning Associates was more than just a landscape design and municipal engineering company. Led by the noted planner Macklin Leslie Hancock, who got his start working on the master plan for the new Toronto suburb of Don Mills, Project Planning Associates was one of Canada's first broadly multidisciplinary design firms. It had a hand in many major developments of the 1960s, ranging from Expo 67, to the Toronto Islands, to the master plan for the University of Guelph. By providing in-house teams of planners, architects, landscape architects, civil engineers, and other specialized consultants, it built itself into a leader in the design of large-scale projects and gained a global reputation during the 1970s.[45]

In February 1962, following his preliminary report, Way advised the Parks Branch to send two junior historians to France to examine eighteenth-century plans of Louisbourg held in Parisian archives. Once the historians were in place, the Ways would join them and supervise their work. That spring, a survey team of Frederick Thorpe and J.R. McCartney flew to London and Paris, where they quickly confirmed Way's suspicion that the Public Archives microfilming had missed a rich collection of Louisbourg materials.[46] For the next several years, more missions to holdings in Europe, the United Kingdom, and the United States added to the volumes of fortress-related manuscript collections identified and indexed for reference in the reconstruction. For their part, the Ways returned from their second trip to report enthusiastically on the possibilities of using comparisons to other fortifications to authenticate work at Louisbourg. They had scoured the countryside looking for fortresses that, like Louisbourg, were modelled on the ideas of Sébastien Le Prestre de Vauban, France's foremost military engineer. On their first trip, they had discovered "that all the missing detail for Louisbourg buildings, whether military or domestic, still survives in France."[47] The second trip helped pin down locations for further study. All the fortresses of northeastern France, they claimed, might contribute something essential for the Louisbourg work, even if authentic Vauban-style fortifications were sparse in northern France due to centuries of warfare, especially in the twentieth century. Even the fortifications of the Alps and Pyrenees, despite being designed for very

different terrain and climates, had "many features of interest" and indeed might be the best places to examine military architecture.[48] But the Ways focused specifically on what they had discovered at Lille, Rochefort, La Rochelle, and Brouage.

The latter three towns made sense as models for Louisbourg, according to the Ways, because they had served as the principal ports from which Louisbourg was supplied, and there ought to be an affinity. "From the standpoint of the Louisbourg project," on the other hand, "perhaps the most interesting feature of Lille [was] the current restoration work." Situated on the French-Belgian border, Lille had twice been occupied in the twentieth century. Although spared the worst of the war, like many northern French towns, it needed substantial rebuilding following the fighting of the Second World War. According to the Ways, Lille was "perhaps Vauban's masterpiece," although little of the original remained. Nevertheless, it was an example of French expertise in restoring Vauban-designed fortifications: "With technical supervision being supplied by architects of Les Monuments Historiques, the French Army is restoring the original appearance of some original structures, while adapting their interiors to modern usage. Our consulting architect should certainly see what is being done there."[49] The assistant deputy minister was equally optimistic about the recommendation to use the examples of Brouage and Mont Dauphin in the French Alps.[50] Given the pressure to start designing Louisbourg's Chateau St. Louis, Mont Dauphin's 1698 officers' quarters were of "special significance," as they contained "original mantels, stairways, floors, and doors."[51] Way was not blind to the potential for criticism. He knew this approach would invite comparisons to theme parks and Hollywood sets. A *Toronto Globe and Mail* reporter warned against ignoring sound research and creating such "a pretentious fake" at Louisbourg.[52] It was in part to offset this potential that Way wanted to use original construction materials as much as possible: "The re-use of cut-stones will validate the reconstruction of five other doorways and ten windows in the right flank. In other words, the incorporation of this almost complete doorway and its adjoining windows will make it possible to explain to visitors the extreme accuracy of our restoration."[53] Purists might complain about accuracy, but the use of original material would impress tourists. John Nicol, appointed director of the Parks Branch in 1961, echoed Way's argument: "This re-use of original material will emphasize the accuracy of the restoration through comparison of its original and reconstructed parts, and will lend the necessary credibility to the reconstruction program as

a whole."[54] For the visiting public, this credibility would be what distinguished "between a true restoration and the Disneyland approach."[55] Elsewhere, Way noted that visitors "are invariably impressed by such statements as 'these very cut-stone quoins ... are the stones used when this fortress was built.'"[56] And so, he recommended building Louisbourg in part from a mish-mash of historic structures scattered across the length and breadth of France but sprinkled with materials salvaged from the archaeological site.

Still, Way recognized that, among purists, Louisbourg might easily be mistaken for a Disneyland-style caricature. It would therefore be foolish to imagine that he did not support serious historical and archaeological research. What concerned him about Louisbourg's reconstruction was the influence of what he termed "the university approach." In a missive to J.I. Nicol in the late spring of 1966, Way outlined his displeasure with this approach, which had "impeded the acquisition of results of direct and immediate value to the reconstruction."[57] By the "university approach," Way meant a research method that placed greater stress on producing complete reports, often written by individual scholars, than on providing timely information to support decision making in a number of disciplines. To Way's mind, this was a dichotomy between the ivory tower and the real world. He looked down on a particular kind of scholarship that he associated with the academy. As he was fond of saying, the problems of those who write history are easily evaded, but those who rebuild it are obliged to address them.[58] As he understood the issue, academics were accustomed to working only within their own discipline, conversing only with the members of their immediate circle. Moreover, as university departments were not interested in public history, their graduates were unprepared for its rigours.[59] His experience as a practitioner of reconstruction had soured him on the academic approach, if indeed he had ever contemplated it. He saw himself as a man of practical experience and wisdom who looked past bookishness to develop the best case in a real world. Thus, Way preferred to work with a range of professionals, each of whom required specific details to carry out their tasks. Research, in this environment, meant providing specific information in a timely fashion, and in this case, the use of French prototypes to model Louisbourg's architecture sped up the process.[60] Many university historians, he believed, simply failed to grasp this aspect of the work. For the same reason, he also disapproved of hiring student researchers on summer contracts for a project as complex as Louisbourg. The university approach might take a long-term

view of student training, but for Way the real-world imperatives made the use of students unproductive.

Nevertheless, scholarly research did benefit from the Louisbourg project. Under guidance from its research director, Louisbourg quickly amassed a significant collection of historical materials. Initially, little thought was given to the need for the proper storage, care, and dissemination of research documentation, aside from occasional requests for hiring a file clerk or librarian. Until 1966, the project's historical research unit remained in Ottawa, close to the professionally managed collections of the Public Archives and major libraries. However, between 1966 and 1968, the project's library staff began setting up facilities at Louisbourg. The understanding was that the unit and its work would eventually relocate to Cape Breton Island, even if the eventual relocation took nearly two decades to complete. By the end of the 1970s, Louisbourg historians had gathered some 750,000 documents, a repository that would require several lifetimes to analyze fully.[61]

Although Way objected to hiring student researchers, the project employed many graduate students in history as summer researchers.[62] This helped launch the careers of many young scholars of the late 1960s and early 1970s, such as Allan Greer, Terry Crowley, Dale Miquelon, Christopher Moore, A.J.B. Johnston, and Frederick Thorpe. The latter three continued as public historians throughout their careers. Equally, the Louisbourg endeavour benefitted from the research completed by these young scholars. Using Way's hated university approach, they published articles in scholarly journals, elevating the profile of the modern reconstruction as well as the place of Louisbourg in Canadian historiography. They also produced more specific reports to help the work of the interpretation program, filling in the political, social, and cultural contexts of life in the eighteenth-century fortress. The authenticity of Louisbourg was grounded, not only in Ronald Way's conjecture and comparison, but also in solid historical and archaeological research.

Seaweed and Gold

Another form of practical research that coupled real-world experience with close readings of historical documents was the search for sunken treasure. Whereas living history museums typically relied on donations or purchases of preserved antiques to furnish their displays, many traditional museum exhibits featured found objects. Fort Henry's gallery of War of 1812 relics was retrieved from sunken ships in the St. Lawrence

and Lake Ontario. At the Louisbourg Museum, Katharine McLennan similarly displayed her recovered cannon and had suggested in 1956 that the government underwrite the search for, and salvage of, a treasure ship, which she felt would have enormous value for her museum.[63] Given that the north Atlantic and especially the Cabot Strait were notoriously dangerous for wooden sailing ships, and the association of the fortress itself with naval warfare, the waters off Louisbourg presented particular opportunities for nautical salvage. However, although a Norwegian ship had accidentally discovered an eighteenth-century anchor during the Second World War, which was eventually sold to the federal government and placed at the historic park, the planning of the Louisbourg reconstruction made little provision for the exploration for undersea material in the 1960s.[64]

The prospect of finding submerged treasure has long held a romantic appeal for divers and storytellers. It lured divers such as Alex Storm to the Louisbourg area even before the government announced plans for the reconstruction. Storm, a Javanese Dutch immigrant to Canada, arrived on Cape Breton Island in 1960, attracted by the diving and salvage possibilities of its rugged and stormy coast. He signed on to a fishing trawler, the *Marion Kent,* whose captain indulged his interest in diving in exchange for a portion of the proceeds from the scrap metal that Storm salvaged from wrecks. In July 1961, while searching for a steamer lost in 1923, Storm came across a collection of rusting cannons in ten metres of water. Venturing closer, he found a deeper crevice concealing more relics that convinced him he had located the remains of the *Chameau,* lost with all hands in the summer of 1725.[65]

The *Chameau* was a flute, an armed cargo vessel, built at Rochefort in 1717. On her final voyage, she was carrying 176,000 *livres* in gold, silver, and copper coins, which made her particularly attractive to treasure hunters like Storm. Ottawa's announcement of the Louisbourg reconstruction plans added to the potential profit for divers. As early as August 1961, Storm seems to have offered to sell recovered artifacts to Louisbourg.[66] The real prize, however, would be the bullion that he believed was still entombed in the *Chameau's* hold, somewhere under the dark depths off the Cape Breton coast. Working with Harvey MacLeod and David MacEachern, Storm researched the wreck and planned a grid search of the area. In the spring of 1965, they began a series of difficult dives in the rough waters northeast of Louisbourg. What they discovered was that the ship had broken up to such an extent that only metal pieces too heavy

for the currents to carry remained. By September, after a summer of tracing the currents and the spread of the debris, they had narrowed their focus. Finally, on 23 September, twenty metres below the surface of the Atlantic, they discovered the hoard of coins they had sought. Over the next few days, the three men retrieved thousands of coins, along with silverware, swords, buckles, and jewellery.[67] This was perhaps not the practical application of research that Way had envisioned.

At first, government officials were skeptical of Storm's claims. When asked about it in June 1965, Herbert considered it unlikely that Storm had discovered the wreck of the *Chameau*.[68] However, the evidence soon proved irrefutable, and, with the value of the treasure set at about $700,000, Storm made the discovery public during the following spring.[69] The publicity proved embarrassing for the Parks Branch: it appeared that Storm, a private treasure hunter, had profitted from publicly funded research by Louisbourg's historians. The day after the story broke, the branch took the official line that the three men had only used publicly available resources to complete their research and that no original research by the Louisbourg team or using Louisbourg resources had ever been done on the *Chameau*.[70] The Department of Northern Affairs, then responsible for national parks, also sought legal advice on Storm's ownership of the treasure. However, with Ronald Way's agreement, the minister eventually decided that legislation to protect undersea relics from private looting, or at least to control such searches through licensing, was the best option.[71] Storm did face litigation from former partners, who attempted to acquire the treasure by claiming that his 1961 contract with them was still in force when he discovered it in 1965, but the Supreme Court of Nova Scotia ruled in his favour. Although the Supreme Court of Canada overturned the Nova Scotian ruling, under the terms of the Treasure Trove Act, Storm kept the lion's share of the booty and eventually sold most of it in a New York auction of 1971.[72] Yet, not until the 1980s did the Governments of Canada and Nova Scotia move to protect underwater archaeological sites in even a limited way.[73]

Interpretation

To complete Way's quest for an authentic reconstruction, Louisbourg would have to be a living museum. No one doubted the truth of this. Indeed, in 1956, four years before Rand made his famous recommendation, Father Hugh A. MacDonald, the priest of the Louisburg parish, wrote the minister of natural resources about a tourist attraction he wanted to

build. Shrineland, as MacDonald called it, would appeal to tourists of all faiths. Perhaps modelled on the Martyrs' Shrine above the ruins of a Jesuit mission near Midland, Ontario, Shrineland would have included a massive cross on a hill opposite Louisburg's Catholic church, as well as several grottos to Our Lady and Saint Anne, a statue or other representation of a "French denizen living at the Fort [Louisbourg] at the time," and kindred attractions around the Louisbourg ruins. How exactly this would appeal to non-Catholics was unclear, but MacDonald was confident that the spiritual life of old Louisbourg would be a draw:

> It seems to us that at most, the Government can only restore the material side of the former French culture. One couldn't expect more than that. But to me it seems there should be something tangible to evidence the great spirit of Christianity, which motivated the enterprising ambitions of the colony. That motive power, as I see it, was the colony's Catholic faith.[74]

Although he couched it in terms of Catholicism, MacDonald agreed with the common belief that reconstruction alone was not enough. The museum had to be brought to life. It was what people expected.

Right from the beginning, the reborn Louisbourg was to be a living museum. Even Herbert, who had objected to the idea of the full reconstruction, concurred that it would need to be brought alive: "To complete the historical atmosphere in the restoration one would logically expect to provide guides in period costumes to escort groups and explain history, as well as artisans, craftsmen, shop-keepers, etc., all in period costume, demonstrating the trades, crafts, and special activities which were historically carried out in the reconstructed buildings."[75] As the project moved from construction to operation as a functioning recreation of Louisbourg's historical environment, research shifted toward social and political history. Interpretation at the park required a complex understanding of many facets of eighteenth-century life. However, the development of Louisbourg's interpretation program did not wait for the transfer of archival collections. In 1965, park superintendent John Lunn produced a confidential interpretation program for consideration. A trained museologist with expertise in curating archaeological sites, Lunn brought particular skills and perspectives to interpretation at Louisbourg.[76] By that point, the interpretive program was quite basic. It consisted of McLennan's displays in the museum and at the park headquarters, as well as the reconstructed sections of the King's Bastion, the Royal Battery, and information

panels at Kennington Cove, where the British and colonial troops landed to conduct the sieges of 1745 and 1758. Additions planned for the following year included a lighthouse and the Dauphin Bastion. However, as archaeological and construction work was continuing, exhibits had to be arranged so as to keep the public away from these sensitive areas. Until 1965, visitors left their cars in the museum parking lot and wandered into the archaeological site. That option was closed in 1966 to permit erection of the Dauphin Bastion, and from then onward cars were restricted to the reception centre.[77] However, Lunn understood that visitors did not drive the twenty miles of bumpy road from Sydney simply to spend their time in the reception centre. They had to be welcomed and informed about the history of Louisbourg, but then conveyed to the fortress "as expeditiously as possible."[78] Lunn even mapped walking routes through the buildings that would direct visitors to key points of interest.[79]

Yet, on occasion, the desire to protect the site from the intrusion of modernity had the opposite effect. After visitors were required to leave their cars at the reception centre, staff had to develop a method of transporting them to the fortress without damaging the look and feel of its historic environment. One proposal was to transfer them by monorail. Popular in the 1960s, monorail technology symbolized the decade's conceptions of a futuristic world to come. Indeed, the first regularly operating monorail in North America began carrying passengers at the Tomorrowland section of Disneyland in 1959. Walt Disney had imagined the monorail as a prototype for public transit, but it never really grew beyond a theme park sightseeing attraction. At Louisbourg, the monorail idea had its genesis in the line then being built in Montreal for Expo 67. Following the fairs at Seattle and New York, monorail systems were *de rigueur* for world's fairs in the 1960s, and Montreal ran more than ten kilometres of track on its two Yellow Line loops and its Blue Line. When Coleman asked the Parks Branch to explore the costs of a system at Louisbourg, even the engineers were unenthusiastic. "The notion of rail transport," wrote one engineer, "does not appear compatible with the concept of a historic site."[80] Although the director had written "Why not?" in the margins of the engineer's report, the anachronistic idea of taking a monorail to visit an eighteenth-century town was quickly dropped.

To add animation to the site, Lunn had recommended hiring and training actors to serve as British soldiers to "add materially to the 'living' character it is desired to impart to this Park." Lunn's idea was that they might operate a besieging battery as a costumed gun crew. This was not

the first Canadian proposal to shift from third-person to first-person interpretation, or animation. However, Lunn's suggestion was significant for what it projected for Louisbourg's future. The museum would not simply tell people about life in the eighteenth century – it would show them. Elsewhere, the British battery would be balanced by another artillery unit, this time with French troops, an infantry squad for drills, and an assorted civilian population. The objective, as one reporter later put it, was the "reconstruction of the activities of everyday life in the 18th Century town." Animation, regional director H.A. Johnson concurred, was intrinsic to the project of restoration: "The Park will lose much of its interest unless it is ultimately introduced, along lines similar to the animation of Old Fort Henry and Upper Canada Village."[81] Lunn suggested that every staff member should have a costumed role. For instance, an electrician would be dressed as an eighteenth-century workman and would conceal his twentieth-century tools. Much of Lunn's advice was followed, and by the summer of 1974, the animation program alone employed forty-three staff, including twenty-five in period dress.[82]

Of course, to make the site really come alive, and not look like a theatre set, material depth also had to be added. Rooms would need to be furnished and decorated. But, to avoid comparisons to Disneyland, they would have to be authentic. This meant eschewing the technique used at other museums of simply collecting donations of period furniture and housewares. A more professional approach to locating authentic furnishings involved hiring the film director, painter, and art historian Jean Palardy. Jeanne Minhinnick had recommended Palardy as a furniture expert to J.D. Herbert early in 1962, and Herbert awarded him a few small contracts to provide furnishings for restored houses in Quebec City that year.[83] However, it was Herbert's replacement as Parks Branch chief historian, B.C. Bickerton, who secured Palardy's services for Louisbourg in 1964 and, satisfied with what he had located, awarded him a second contract for a research trip to France in 1965. His role in France was twofold: he was to study period styles of furniture and decorations, and locate items for sale. Palardy made a third trip on behalf of Louisbourg, also in 1965, to buy the pieces he had located. All told, he was paid $40,000 for the three trips.[84]

Not surprisingly, this figure raised eyebrows in Ottawa. Perhaps Palardy's personality played a role in the misgivings. Nothing in the documentary evidence suggests that he had a particular sense of entitlement, but he did ask for a diplomatic passport for his trips on behalf of the Parks Branch.

His request was denied, but he nevertheless saw himself as a special envoy of the government, informing Ronald Way of his pride at being received in France "with all the honours reserved for a diplomat."[85] However, $40,000 was a lot of money, even for a project that was already running millions over budget. Bickerton defended Palardy's compensation to his immediate superior on the grounds that the reconstruction required authentic furnishings. But he hinted subtly that uncovering genuine French contributions to the history of Canada's material culture would serve the Lester Pearson government's loftier goal of fostering better relations between French and English Canadians. "The cultural benefits of these activities," he wrote, "must be viewed not only in terms of the restoration of Louisbourg, but also as one of the first systematic probes of the French origin of Canadian culture and life in the 18th century." Moreover, locating and acquiring real pieces, expensive though it may be, was crucial to the success of the project. In case anyone missed his point, Bickerton put it directly: "The importance is, therefore twofold: as it reflects the reconstruction of Louisbourg and determines the future development of the restoration, and as a means of encouraging and developing the use of one of the principal sources of our culture and our history."[86] In this instance, authenticity coalesced with the government's ambitions for national unity.

Palardy's main objective was to furnish the rooms of the Chateau St. Louis. Fortunately, researchers had found a 1744 inventory that listed the possessions of Louisbourg's governor, Jean-Baptiste-Louis Prévost du Quesnel, possibly his *Inventaire après décès*.[87] The *Inventaire après décès* was a document required under the French civil code – the Coutume de Paris – to dissolve a marriage and distribute to heirs its communal property upon the death of one of the spouses. This inventory detailed all the chattels of the deceased (technically held in common with the surviving spouse), so the Parks Branch had a clear idea of the furniture, china, silverware, and decorations in the governor's residence. The inventory recorded the quantity and value of the items, but it did not provide details on style. However, as du Quesnel had died at Louisbourg in 1744, practically at the moment chosen for the single-date reconstruction, Way was confident that it would be an authentic guide.[88] Using this document, Palardy had located period pieces to match du Quesnel's belongings. He had hoped to buy real eighteenth-century pieces and fabrics, but Way discouraged him. At a meeting in the spring of 1966, Palardy, Way, and Bickerton agreed to use modern reproductions of Palardy's finds, both

to save money and for fear that two-hundred-year-old materials would quickly deteriorate. Very few of the original pieces were rare or costly antiques.[89] Nevertheless, in some cases, originals were procured despite significantly higher costs. As with the architectural structures, authenticity was to be attained by embedding a few original artifacts in the copied environment. As Way explained, these few original pieces were essential: "The Chateau St. Louis shares with much of Colonial Williamsburg the disadvantage of being a total reconstruction. Lacking an original structure, the authenticity of the furnishings assumes greater significance than it would in a building which can stand up on its own pedigree."[90] Thus, Louisbourg's interiors also relied on conjecture and Way's calculations of probability. However, this educated guesswork was supported by an enormous research team that was, even in 1966, still uncovering new historical evidence in support of the interpretation. Its grounding in this archaeological and historical research made Way's "total reconstruction" convincing and, the government hoped, compelling.

As construction proceeded, parks officers began to think about how the finished fortress would teach history. Interpretation would be the key to making the isolated historic park an attractive tourist destination. As Lunn urged in one of his reports, "The park will stand or fall on the adequacy of its interpretation, and no amount of passive display can take the place of carefully planned animation."[91] He laid out a plan for developing the tourist and educational potential of Louisbourg, once the archaeological and construction work had ceased. Contending that not enough planning had gone into the program of animation, he spelled out his personal view of what needed to be done. As the tourist season coincided with the university summer break, he suggested hiring university students to act as the costumed interpreters that would populate the fortress. Louisbourg, he argued, was not a showplace. It was a functioning community – a fishing port, a military garrison, and a commercial and administrative centre. However, recreating the whole site would be impossible, so he advocated making the most of what could be done. Most importantly, he placed heavy emphasis on the trivial or banal details of daily life. These had to be included to provide the illusion of a real community. Empty buckets lying by wells, foul smells of sewage, tools left in gardens, drying fish on racks – all these things would add layers of material depth to the presentation of eighteenth-century life. This sensory flood of minute, accurate detail would confirm the impression that the experience was real and authentic.

Lunn was assigned the job of developing the elements of the Louisbourg animation program. He envisioned a visitor experience like that of Way's interpretations at Fort Henry. He suggested rebuilding an old French road that would lead from a reception centre on a two-hundred-yard walk to the Dauphin Gate, a distance he compared favourably to the walk required at many European castles. At the Dauphin Gate, visitors would cross a drawbridge, be greeted by sentries, and step through time into the eighteenth century. All around them, they would see fishing boats at the quay, costumed staff mending nets, and a full line of buildings along the waterfront's rue du Quai. Indeed, Lunn felt that the illusion would not be convincing unless it included adequate buildings to give depth to the scene. He advocated further reconstruction work, including building up Toulouse Street, as it led to the Chateau St. Louis. And he suggested a total reconstruction of two town blocks, as well as parts of others. "The aim," he said, "should be to create, as in Williamsburg, an environment in which people can wander at their own pace and discover the things that most interest them."[92]

In every direction, the illusion of the past had to be maintained. Sight-lines were protected from modern intrusions, so the reception centre had to be moved farther away from the reconstruction. All employees wore costumes, even security personnel. On-site restaurants, Lunn suggested, should cater to "the hungry tourist" but should also provide an eighteenth-century experience. "Serving wenches carrying platters of pewter beer steins with draught beer" would help do the trick. "Partaking of such a meal in these surroundings," Lunn continued, "a candle lit on the table, dusk beginning to come on and the fog closing in outside the wavy glass window, a horse and carriage clopping by on cobbles outside, these are the things that will make the difference between a visitor looking at a pile of masonry and having it really mean something to him."[93] Presumably, if the serving wenches were buxom, the experience would be even more appealing. Even signage directing and labelling exhibit buildings should avoid the "amateur supermarket" style and the "pseudo-rustic" approach of many parks.

Lunn clearly hoped to avoid evoking a Disneyfied version of the past. Yet, at the same time, there was much in his plan that repeated the Disney approach. Like Disneyland's costumed cartoon actors, interpreters were not to break character. They were to maintain the illusion of being eighteenth-century people. Lunn's suggestion of hiring "serving wenches" evoked a Hollywood imagination of "olden style" tavern life that was

equally likely to distort understandings of the past. Nevertheless, what Lunn suggested was the epitome of every living history museum's aspirations: he intended to transport tourists into an authentic, three-dimensional, and multi-sensory past environment.

Privateering and Profiteering

Another way in which Louisbourg hoped to avoid comparisons to Disneyland was by controlling nearby attractions and marketing. With the reconstruction under way, a number of private entrepreneurs tried to capitalize on the opportunity it provided. By the fall of 1964, Parks Branch officials were becoming concerned that permitting commercial ventures to operate too close to the reconstruction would diminish their ability to protect it. One such example was a proposal to build a diorama of the reconstruction, offering a "bird's eye" view of the whole site for visitors. A complicating factor was that, in 1964, the archaeological research was nowhere near complete, so the proposed diorama could not hope to be accurate. This may not have been a problem for the private sector, but it was precisely the kind of imaginative speculation and commercial exploitation of history that the branch wanted to avoid.[94] The diorama was the brainchild of Anthony Edward (Tony) Price, a lawyer and history enthusiast from Quebec City. His plan was to build a light-and-sound show near the historic park and to operate it as a tourist attraction, using a model, or diorama, of Louisbourg to tell the story of the town and its sieges. This, he reasoned, was something that the private sector could do more efficiently than the government, but equally it would be a complement, not a competitor, for the fortress.[95] Parks Branch staff saw Price as a misguided amateur enthusiast whose input threatened to "Disneyfy" Louisbourg. He was an aggressive promoter – with each letter he wrote to lobby the government, he enclosed three pamphlets from his private Quebec City museum. He had much in common with Loftus M. Fortier, the tireless defender of the Fort Anne and Port Royal projects, and though the branch had once relied on such enthusiasts to develop its sites, they were no longer welcome in the 1960s. Yet, ironically, Price's private Musée du fort was enormously successful. Opened on rue Ste.-Anne in late December 1964, its centrepiece was a three-dimensional model of Quebec City and the surrounding countryside. On the model, the museum portrayed the six sieges of Quebec through a series of captivating light-and-sound shows. Price insisted that the history he told was accurate – the premier of Quebec had even asked for a private showing

– and he urged John Turner, then minister of natural resources, to convince the Parks Branch to let him help. Later, he expressed his disappointment that, even though senior parks officials and Katharine McLennan found his Quebec City show "well done and exciting," Ottawa would not partner with him.[96] Price moved on to other projects. Much later, he was invested in the Order of Canada in recognition of his long service to Canadian heritage, as well as his work as a lawyer and mediator in several Aboriginal land claims cases.[97]

At Louisbourg, however, the Parks Branch was leery of commercialism.[98] In 1966, a parks employee named H.M. Van der Putten apprised senior staff of the dangers of cheap souvenirs. "Viewing the contents of Craftshops around Cape Breton Island, mainly convinces the tourist that he has arrived in Scottish, Indian and fishing territory," he wrote. He urged the elimination of kitschy plastic souvenirs from local shops and that anything sold in the park itself be of good quality and evoke French culture. Van der Putten also warned that "the people in this area ... will have to be completely educated in the subject of *what* to produce as well as *how* to produce." With Louisbourg, the federal government was in a position to guide local producers to make "reasonably authentic," high-quality crafts for tourist souvenirs.[99]

Louisbourg's Appeal

Despite its foibles, false starts, assumptions of probability, and distortions of the past, Louisbourg's successes outweighed its failures. Travel writers immediately showed their enthusiasm. As the reconstruction got under way, newspapers from across Canada and even the United States picked up stories about this new park on the margins of the continent. In just one example, the "travel talk" series in the *Toronto Star* commented on "Fort Louisbourg's" $12 million facelift in May 1963. A small article, surrounded by ads for travel to Quebec, Nova Scotia, Florida, Greece, Denmark, and other locales, highlighted the start of the reconstruction. The story noted that the project was expected to take twelve years, but it was already being placed as a tourist destination of note.[100] By the time the King's Bastion was open to the public, but before any of the secondary buildings had been started, the *Saskatoon Star-Phoenix* marvelled at "a startling sight" reminiscent of a fortress on the rocky northern coast of France. By then, the *Star-Phoenix* noted, "it has long been a tourist attraction."[101] However, nearly every story had to explain Louisbourg's (or Fort

Louisbourg's, as it was frequently called) place in Canadian history. Way's hopes that the reconstruction would bring French and English Canadians closer together required elucidation. Regrettably, reporters were not always careful with the details of Louisbourg's history, as history professor – and former Louisbourg researcher – Terry Crowley complained to the *Toronto Globe and Mail* on one occasion.[102]

What most impressed reporters and travel writers was not Louisbourg itself, but the process of its restoration. In a backward fashion, this fascination helped strengthen faith in its authenticity, which, in turn, helped reinforce its claim on Canadian identity. By focusing on the process of reconstruction – especially the meticulous research on which it was based, the length of time spent in tracking original materials, artifacts, and techniques, and the expertise of those who oversaw the endeavour – writers made the fake fortress seem more real. For example, freelance writer Claribel Gesner noted that, for a construction site, Louisbourg was unusually popular among tourists: "At the moment, you enter a hybrid world, where modern construction machinery and materials sit dwarfed by massive rubblestone walls and heavy stone buildings." However, this hybrid world would soon disappear to reveal a faithful reproduction of the eighteenth century. Built under the supervision of experts such as John Lunn and Jean Palardy (Gesner noted their credentials), the project involved the "painstaking" tasks of historical and archaeological research. Thus, the physical surroundings being created were verified by the work of experienced historical archaeologists.[103] The CBC program *20-20* devoted an episode to the reconstruction process in the spring of 1967.[104] The *Calgary Herald* pointed out that architectural engineers had designed the fortress from archaeological evidence found on the site. Although modern techniques had been used to build the structures, "the outer bricks were specially made to match the originals in size, color and texture."[105] Another writer highlighted, with a photograph, the actual use of original cut stones in a doorway.[106] This no doubt made Ronald Way very happy. It demonstrated the success of his plan to have a fantasy fortress stand in for an authentic historical one. As Lunn wrote in *Canadian Antiques,* "increasingly one finds the visitor expressing the belief that the restoration of Louisbourg is precisely the kind of material reminder of our shared past that is important to Canada today."[107] Having become part of the built environment, the reconstruction was thus a physical confirmation of the interpretations of history that underpinned it.

The popular coverage also emphasized the way in which Louisbourg's animation program brought to life the sights, sounds, tastes, and smells of the eighteenth century. This was, of course, exactly what Lunn hoped to accomplish when he first proposed a multi-sensory experience. Unfortunately, animation also had its drawbacks. Many tourists, unprepared for travel back to France's eighteenth-century colonial empire, complained about the poor posture, slovenly appearance, and lack of enthusiasm of the young men who played the soldiers at Louisbourg. Parks staff explained that their attitudes mirrored those of the real Troupes franches de la Marine, stationed at the fortress during the 1740s. But expectations of military discipline persisted. By the mid-1970s, the administration had prepared a brochure to warn visitors that the animators "work hard at establishing convincing roles, even to reflecting the boredom and lack of personal pride so characteristic of garrison life in eighteenth century Louisbourg."[108] Accuracy and anticipations of authenticity in past human behaviour did not always match perfectly.

Picking up on the theme, Silver Donald Cameron returned to the sensory experience of Louisbourg in the pages of *Saturday Night*. Like many travel writers, Cameron narrated his own trip to the site, starting with parking his car at the new reception centre, hidden in the woods a mile and a half from the Dauphin Gate. Moreover, by the time he wrote, in 1980, Louisbourg had expanded to include the Chateau St. Louis and the King's Bastion, many other defensive works, and two town blocks of civilian homes. It had achieved a greater degree of Lunn's everyday reality. Cameron focused on the banal but richly evocative aspects of his visit:

> Once inside, you're plunged directly into an eighteenth-century French colonial town. The bakers slide their long wooden paddles into brick ovens to extract round loaves of brown bread. Housemaids and children weed the gardens. Buff-coloured cattle browse along the grassy slopes, and a young soldier feeds the governor's chickens. Sentry parties file down the streets. A young girl drops to her knee and crosses herself as she passes through the white-and-gold chapel. Soldiers and fishermen stop in at Pierre Lorent's tavern, Hôtel de la Marine, for a beer, a bowl of soup, a plate of stew, some bread and cheese.
>
> Follow them in, for eating is one of the fortress's pleasures.[109]

Indeed, for Cameron, "Louisbourg is not merely an intellectual delight; it's a tactile, sensuous experience."[110] Living history had reached its apogee at the Fortress of Louisbourg.

However, if Louisbourg were to be truly successful, it had to resonate with tourists. Its authenticity would be confirmed when travellers voted with their feet. And Louisbourg was tremendously successful. The decision to build it prompted a surge in tourist travel to Cape Breton Island. Lunn wanted to keep the entire project under wraps until its completion and then open it with a spectacular bang! Thus, as one reporter noted, a tourist attraction that did not really want tourists in 1966 expected to welcome 175,000 visitors.[111] Interest was worldwide. Perhaps it even reached the Soviet Union: in the House of Commons, an Opposition MP asked for confirmation that Soviet ships had sailed within a few miles of the Nova Scotia shoreline, just off Louisbourg, in October 1969.[112]

Parks kept close watch on visitor statistics. Attendance grew from a pre-reconstruction low of 16,904 in 1954–55 to a record 175,000. Visitation levelled off in the early 1980s at a fairly consistent 150,000 per season.[113] But closer analysis revealed some troubling figures. Lunn ordered a survey of signatures in the museum guest books between July and the end of October 1966. During that four-month period, 151,094 people visited the fortress, which was still under construction. Surprisingly, only about a third of them (54,389) stepped inside McLennan's Louisbourg Museum which, at the time, was the only real interpretive centre on the site. Nearly 42 percent of the museum visitors signed the guest book, giving a sample of 22,799, or about 15 percent of the visitors to Louisbourg. Canadians represented the vast majority of signatures at 82 percent, and only 18 percent of visitors were from the United States. Given Ronald Way's hopes that Louisbourg would contribute to national unity, these numbers could be seen positively. However, on closer analysis, a disturbing truth emerged. Fully 32 percent of the Canadian visitors lived on Cape Breton Island. A further 25 percent came from elsewhere in the province, which meant that 57 percent of the Canadian visitors lived in Nova Scotia. Moreover, as Lunn wrote in a memo outlining the results, the fact that two-thirds of park visitors skipped the museum suggested that they had been there before, probably because they lived relatively nearby.[114] Far from bringing outside money to the struggling local economy, Louisbourg seemed dependent on Maritimers.

Conclusion

By the 1970s, living history had reached its full potential. Popular expectations set out what a living history museum should do. It should recreate the past, using costumed interpreters or role-playing animators. It should have a rich depth of material culture to provide substance to the interpretation and make it seem real. Indeed, although the exclusive use of original materials to build, furnish, and decorate living history museums was impossible, the success of Louisbourg in conveying an "authentic" environment vindicates Way's insistence on using original materials. Such a practice reassured tourists that the museum's recreation of the past was based on historical research. Even if few sites could match Louisbourg for the depth of its research team, people demanded that they not be a Hollywood or Disneyland approximation of the past. Yet, at the same time, they expected the past to be entertaining and to conform to their values. They were often disappointed when the past turned out to differ from the present. Nevertheless, they remained highly enthusiastic about living history's possibilities. Louisbourg was simply the most sophisticated example of the genre.

PART 3

Connections

7
Fur and Gold

THE POST-WAR POPULARITY of living history museums was reflected not only in their numbers, but also in their adaptability to differing historical contexts. It also reveals the power of myth history over historical accuracy in important ways. The pioneer ethos that was popular in Ontario reflected the province's settlement patterns and the common sense lessons that people believed they imparted. Accepted simplifications of the past, often reinforced in popular culture, swayed people's sense of history. To remain relevant, living history museums had to incorporate public tastes. However, Canada's regionalism complicated this task. Regional stereotypes also produced historical myths that wound their way into living history portrayals, as an analysis of British Columbia's museums reveals.

The history of British Columbia, what Jean Barman describes as "the west beyond the west," diverges from that of the rest of Canada in a number of important ways. The Aboriginal peoples of the Western Cordillera typically lived in more rigidly hierarchical societies than other Canadian First Nations. And there was enormous variation in how they translated the diverse environments of coast, mountain, and plateau to their ways of life, although all Aboriginal societies varied considerably. Of the Aboriginal language families in use at the time of contact between the Old World and the New, half were exclusive to what became British Columbia. The history of European contact and exploration in the province is similarly varied. European explorers first coasted the Pacific Northwest in the sixteenth century, with the voyages of Francis Drake and Juan de Fuca, although their exact itineraries are not known and often contested. Over the centuries, British, Spanish, Russian, and eventually American explorers and traders arrived intermittently to swap furs with the many Aboriginal peoples who lived along the coast and on the islands, as well as to explore the coastline and its many inlets. Some built semi-permanent trading posts, such as a fortified Spanish outpost on Vancouver Island. By the 1790s, traders from Montreal were beginning to cross the continent in

their own search for furs and wealth. The living history museums of British Columbia reflected some of this diversity.

Ottawa gained control of one of the province's surviving fur trade posts, Fort Langley, in the 1920s, but the fort benefitted more from a wave of reconstruction projects in the 1950s. At Fort St. James, the Historic Sites and Monuments Board of Canada (HSMBC) unveiled a plaque and cairn in 1953, and commenced discussions on restoration work in the 1960s.[1] However, while designating historic sites might lend moral support to local activists seeking to restore or preserve the country's heritage sites, the division of powers in the British North America Act restricted what the federal government could do. As a result, it co-operated with the provinces to develop historic sites, a practice that emerged in the 1950s in an ad hoc manner.[2] However, this did not always work to the satisfaction of provincial governments, which had their own regional development concerns. During W.A.C. Bennett's years as premier, British Columbia built a number of open-air and living history museums that presented a provincial take on Canada's national history.[3]

Fort Langley

Fort Langley was the first living history museum in British Columbia. The original fort was a key piece in the British Empire's defence of the Pacific slope against American competition, especially from John Jacob Astor's Pacific Fur Company. Britain had not really taken an interest in the Pacific coast until George Vancouver's arrival in the 1790s. Following his voyages, the region's profitability was signalled by rich hauls of sea otter pelts as well as the expansion of the North West Company's operations overland to the Pacific (indeed, Vancouver missed encountering Alexander Mackenzie by a month and a half in 1793). To the north, the Hudson's Bay Company (HBC) had to contend with Russian traders, but it reached manageable agreements to limit the Russian threat. However, before the nineteenth century dawned, the intense competition between the HBC and the Nor'westers spilled over the Rockies as far as the Pacific coast. To the south, vigorous and unresolved competition between British and American trading companies produced a curious compromise in 1818, when an agreement was reached to share the territory west of the Rockies between latitudes 54°40' and 40° for the next ten years, creating the Oregon Territory. This was the political situation when, in 1821, the Hudson's Bay Company and the North West Company merged operations.

Strengthened by the elimination of competition from Montreal, the HBC governor, George Simpson, turned his attention to American rivals. The company's Pacific territory was divided into the northern New Caledonia District and the Columbia District to the south. Simpson was disillusioned with the Columbia District, seeing in it little prospect for profit. However, he found it useful as a frontier to keep American traders away from the richer New Caledonia District. As part of his plan to thwart American competition, he ordered the overhunting and underselling of his rivals in the southern district.[4] Simpson also mandated the construction of a new depot along the Fraser River to replace Fort George to the south. After three years of surveying, a site was selected and twenty men dispatched to build Fort Langley, named for an HBC director, in the summer and fall of 1827. Under instructions to be self-sufficient, the traders at Fort Langley bargained extensively with the Kwantlen people, many of whom relocated to be closer to the fort. Fort Langley introduced more than just trade goods to the region. Agriculture began in 1828, and soon Aboriginal people were making use of introduced European crops, such as potatoes. Moreover, with a multiracial population of about two hundred people by the end of the 1830s, Fort Langley saw a general mixing of Europeans and Natives. Intended to frustrate American competitors, it never really accomplished its mission. In 1839, the post was moved four kilometres upriver to be closer to its farm.[5]

On 19 November 1858, Fort Langley became the provisional capital of the new Crown colony called British Columbia. A border agreement with the United States in 1846 had continued the boundary at the forty-ninth parallel from the Rockies to the coast. The HBC had already moved its Pacific headquarters to Victoria in 1841, but the loss of its forts below the forty-ninth parallel left Fort Langley as its principal post on the mainland. The opening of a new trade route through the Thompson and Fraser Rivers in the 1850s had even revived Fort Langley's importance in supplying the New Caledonia District.[6] However, it was the discovery of gold that brought the fort to this historic moment.

For some time, the HBC had traded with Aboriginal miners for their gold and tried to preserve its monopoly by concealing knowledge of it, but rumours began to circulate. News of a gold strike at the confluence of the Thompson and Fraser Rivers reached the depleted Californian goldfields in the spring of 1858. Almost immediately, prospectors in the United States turned their eyes to the north, hoping to exploit the gold deposits in British territory. Between 19 May and 1 July 1858, 6,133 men

from San Francisco, carried in some forty-two vessels of all sizes, disembarked at Victoria, with dreams of gold riches in their heads. On a single day later in July, nearly 3,000 prospectors arrived, looking for transportation to the Fraser. Thousands more trekked overland or arrived by sea in small, private boats.[7] In short order, the influx threatened to swamp the Aboriginal population and the isolated pockets of British settlement, such as Fort Langley. Aboriginal miners continued to assert their ownership of natural resources, and violence often erupted as Native people sought to fend off the flood of prospectors.[8] To help maintain order and British control of the territory, Britain created a new Crown colony, christened British Columbia by Queen Victoria. One of the first pamphlets produced for the restored fort trumpeted this role in Canadian history: "The Fort was not doomed to pass from the scene without one more contribution to Canadian history. Fort Langley's final – and greatest – glory was achieved when it was chosen for the proclamation of the Crown Colony of British Columbia."[9] Thus, it was fitting that the restoration of Fort Langley coincided with the 1958 centennial of the proclamation of British Columbia, with an opening ceremony presided over by Her Royal Highness Princess Margaret.

Why British Columbia decided to celebrate the 1958 centennial is not clear. Its history is full of potential "birthdays" to commemorate: James Cook's 1778 voyage, which initiated British trade on the coast; the 1849 creation of the colony of Vancouver Island; the 1858 creation of the mainland colony; the 1866 union of Vancouver Island with the mainland; and Confederation with Canada in 1871. Indeed, the 1971 centennial inspired the building of the Burnaby Village living history museum in Vancouver's suburbs as its own commemoration. The idea of celebrating the proclamation of British Columbia as a Crown colony seems to have been first raised by the Native Sons of British Columbia (NSBC) in 1953. The NSBC was a fraternal organization founded in Victoria in 1899. Its members, initially restricted to BC-born men over the age of eighteen, were drawn from the ranks of skilled labourers, professionals, and the white-collar middle class.[10] Officially non-partisan, they nevertheless became involved in political issues such as citizenship and immigration, as well as provincial economic development. However, their real passion was in preserving and protecting BC history and historic relics. Organized locally, the NSBC drew on BC heritage. Local branches were called "posts," in reference to the fur trade posts from the province's earliest European history. The president of each branch was styled the "Chief Factor" for

similar reasons. And at Langley during the late 1920s, the local post began to hold its meetings in the trade store, the only surviving building of the old fort.[11] It is not surprising, then, that the NSBC would be at the root of this idea to celebrate BC history.

The centennial also fit with Premier W.A.C. Bennett's province-building agenda. Bennett recognized the importance of provincial control over transportation and communication policy in signifying possession, and in stimulating new opportunities in the Interior and the north. He made it clear that British Columbia needed its own development scheme to defend against jurisdictional and economic encroachment by Ottawa and Alberta. His governments therefore planned for development that would defend the province's territorial interests by building new roads and railways to link the Lower Mainland to the north and the Interior. The Bennett administration thus embarked on a series of megaprojects similar to those being undertaken by Ottawa and other provinces.[12] The centennial seemed to fit this agenda. It could diversify the economy and create symbolic sites, where the distinct identity of British Columbia could be extolled.

At the NSBC provincial annual meeting in 1953, Bruce McKelvie, a reporter and popular historian, called on the Province to celebrate the centennial of the mainland colony. The NSBC quickly adopted his motion to remind the government of the coming centennials of both the Fraser gold rush and the creation of the mainland colony. There is no reason to believe that the government listened, even if the group was vocal in its advocacy.[13] Nevertheless, by 1955, interest in the anniversary was coalescing. Perhaps the example of Alberta and Saskatchewan's jubilees that year prompted British Columbians to stir. In January, the *Vancouver Sun* appealed for a celebration, and the idea was picked up by Opposition politicians and the British Columbia Historical Association.[14] Soon afterward, a cabinet committee recommended the creation of a centennial planning body, which was duly constituted. The British Columbia Centennial Committee, in turn, recommended as one of its projects the restoration of Fort Langley, where British Columbia was "born."

The idea of a Fort Langley reconstruction had actually been around since 1923, when rumours circulated in the Lower Mainland that the federal government would restore the fort after it assumed control.[15] A full reconstruction was impossible because some of the land was in use by the Canadian Pacific Railway as it ran to its terminus in Vancouver. During a visit to Fort Langley, the HSMBC's BC representative, F.W. Howay, received

an unsigned proposal recommending that the southern portion of the fort, including its stockade, bastions, and other buildings, be reconstructed as a tourist attraction.[16] However, Ottawa contributed only to minor repairs of the main warehouse, in conjunction with a local restoration committee. The provincial Department of Trade and Industry and the Town of Langley also unveiled a plaque and cairn that commemorated the site of the original 1827 Fort Langley, on land owned by a local history buff, Alexander Houston.[17] And through the 1930s and 1940s, the HSMBC continued to work with the NSBC to improve landscaping on the site of the second fort and to operate a small museum in its only surviving building. There, the museum displayed a number of minor artifacts, including old weapons and tools, some Aboriginal utensils, animal teeth, bones, and pelts, and a model of the fort as it appeared in 1840. It may also have briefly housed a coach used by Lord and Lady Dufferin during their 1876 visit to British Columbia.[18] However, the excitement of the coming 1958 centennial provoked more substantial efforts.

A group of local residents, probably members of Post 9 of the NSBC, incorporated the Fort Langley Restoration Society, which had one obvious goal. They also harboured ambitions to use the centennial celebrations to entice senior levels of government to fund their project. "We believe," Leonard Greenwood informed the premier on behalf of the restoration society, "that the whole of British Columbia will be interested in the Centenary when it takes place in 1958 and what would be more fitting than the restoration of the old Fort as it was when British Columbia was first proclaimed by the late beloved Queen Victoria."[19] Important voices in the government and the ruling Social Credit Party supported these efforts. From Fort Langley, Alex Hope, a former MLA for Delta and chairman of the restoration society, led the push. But perhaps the strongest, though reserved, voice in favour of the reconstruction came from Willard Ireland, the provincial archivist. With his wealth of historical knowledge and sound reputation in the government, Ireland articulately defended the necessary expense in reconstructing an old fur trade post for the centennial. He explained to the premier that the mainland colony had been initiated at Fort Langley, the oldest occupied European site on the BC coast, and that therefore "the project historically merits consideration." Moreover, it was already a tourist attraction, had been partially restored, and featured a museum "containing many interesting exhibits." Thus, "if the government proposes in any way to take formal note of the

centenary of the Fraser River gold rush in 1958 this project might well be considered an important part."[20]

Ireland prodded the premier through 1954 and by the spring of 1955 had organized a high-level committee, bringing together representatives of the BC Archives, the provincial finance department, and the Departments of Municipal Affairs and Trade and Industry, along with local representatives including Alex Hope. The committee estimated the cost of the restoration at $204,471 and suggested that the sum be divided between the federal and provincial governments and the restoration society. If Ottawa agreed to contribute 50 percent of the funds, and the restoration society could raise 10 percent, the Province agreed to match with a 40 percent contribution.[21] By November 1956, all parties had agreed.[22] Indeed, the British Columbia Centennial Committee planned to make Fort Langley the focal point of its program of celebrations.[23]

Through 1957 and into the spring of 1958, Ottawa and the Province co-ordinated the restoration of the surviving warehouse and the erection of the stockade and other buildings. The actual construction was often grounded in conjecture. The Big House, for example, was based on sketches of other HBC posts and two drawings from 1858. This evidence suggested that it had not been equipped with a fireplace, something that baffled officials familiar with the cool, damp climate of the BC coast. The restoration architect, John Calder Peeps of the University of British Columbia, planned to insert a fireplace into the centre of the house, despite available evidence to the contrary. This concerned E.A Côté, the federal assistant deputy minister in charge of historic parks. Peeps, he thought, changed the drawings for aesthetic reasons, a step that marred the historical correctness and therefore the authenticity of the Fort Langley project. "I think you will agree," Côté wrote Ireland, "that it is more important to have something which approaches likely historical accuracy."[24]

By the time Princess Margaret arrived, on a late July afternoon in 1958, the reconstruction was complete. Broadcast live on CBC-TV, the brief opening ceremonies involved speeches by Alex Hope, W.A.C. Bennett, and the twenty-eight-year-old princess, who dedicated the fort and declared it open. Reading her prepared remarks, she commented on the "magnificent work of reconstruction," which she described as "an important link with the romantic past of this province."[25] The National Historic Parks brochure released in 1958 told a slightly different story. Centred on the fort's role as the site for proclaiming the Crown colony, the brochure

offered a more sanguine interpretation of history: "Flag followed trade, and the presence of Fort Langley as a base from which the Hudson's Bay Company could organize the trade of the interior was a decisive factor in affirming and maintaining British influence on the Pacific Coast of Canada."[26] This was more in the spirit of the centennial's goal of linking history to modern prosperity. The magnificence of the reconstruction lay, not in the romance of history, but in what it signalled for the BC economy.

Barkerville

The centennial committee's other major historic project was a restoration and reconstruction of Barkerville, a gold-mining town in the BC Interior. Located a few miles from the modern mining town of Wells, Barkerville was the centre of Canada's biggest gold rush before the Klondike rush of 1897. Some British Columbians thought it was of greater historical significance. In the summer of 1956, CCF MP Thomas Barnett claimed that, had it not been for the Cariboo gold rush of 1862, the province would have fallen into the hands of the Americans, and thus he urged at least a partial restoration of historic Barkerville as a fitting commemoration.[27] Barnett's appeal was part of a broader campaign supported by local politicians, the Wells Historical Society, and some local residents to counter the effects of the declining mining industry in the Cariboo region.

Strictly speaking, the Barkerville project had little to do with the 1958 centennial. It commemorated the Cariboo gold rush, not that of the Fraser, and Barkerville itself had not existed until 1862. The earlier gold rush had spawned its successor, as prospectors moved up the Fraser Canyon to the Thompson River in 1859 and then progressed farther north to the Cariboo River during the next year. Reports of gold nuggets, or flakes, rather than the dust found in the Fraser, sped down the river and reached Victoria. From there, the news spread around the world and by 1862, the European and American population of the Cariboo had mushroomed. Boomtowns sprang up along the goldfields, the largest of which was Barkerville, founded in 1862 by the prospector Billy Barker. At least one heritage agency pointed out the anachronism of including it in the centennial committee's plans.[28]

However, the reconstruction of Barkerville fit perfectly with the objectives of the centennial. Barkerville, on the western edge of the Cariboo Mountains, lies nearly three hundred miles north of Vancouver. Its development leant itself to province-building objectives in the Interior in

ways that Fort Langley in the Lower Mainland could not. Reversing the logic behind the creation of the Crown colony in 1858, the 1958 Government of British Columbia sought to draw outsiders to the far reaches of the province to reinforce its territorial claims. Moreover, Barkerville's story of prosperity through resource extraction suited Bennett's economic development plans very well. Provincial success was the theme of the centennial: the committee approached history as the foundation for present prosperity, not a foil that accentuated the superiority of modernity over the past.[29] The official centennial publication accentuated themes of transportation and mining, and Barkerville offered both.[30] It was not surprising, then, that alongside rebuilding historic Barkerville, the committee chose to recreate the Yale-Barkerville stagecoach run, although its route between Barkerville and Victoria was historically inaccurate. The plan was to run an authentic 1860s stagecoach through the province as a unifying symbol, linking community to community. However, as a protest against the inaccurate route, the local centennial committee at Yale urged a boycott of the stage when it passed through town in May 1958.[31]

If some of its details were controversial, the centennial, including Barkerville, was an instant hit. In many ways, its appeal resembled that of the pioneer theme that swept Ontario at the same time. As Elizabeth Furniss argues, North America's European-descended societies share a sense of history that links historical progress to the arrival of European missionaries, settlers, and industries. In more remote regions, this sense of history generated a "frontier complex," a flexible set of metaphors, symbols, images, and narratives that usually glorify the colonizer's conquest of nature, landscape, and original inhabitants. As her study of Williams Lake, British Columbia, suggests, the complex can support counternarratives, but in the hands of the dominant society, it rarely does.[32] This frontier complex gave the centennial committee an obvious link to existing tourist promotions of the BC Interior as a frontier. Despite its anachronism, Barkerville was again a perfect match.

In August 1959, the centennial committee established the Barkerville Restoration Advisory Committee (BRAC) to guide the reconstruction. The original plan had been to buy up the southern portion of the townsite, where the Crown already owned some land. Chester Lyons of the BC Parks Branch originally estimated that acquiring twenty-three lots in the historic part of town would cost only $10,000. However, some landowners resorted to a new kind of prospecting and held out for higher prices, no doubt

smelling another get-rich-quick scheme. Brothers Bill and Walter Kelly were particularly hard-nosed bargainers. Bill Kelly claimed that his unoccupied house could be rented, a factor that should be figured into the price. Walter demanded nearly $8,000 for his five lots. In another case, William McGowan claimed to own two properties, but the deeds listed other men as the owners. The BRAC recommended seizing those lots for unpaid property taxes. However, not all acquisitions were so difficult. The purchase of George Kelly's local museum went smoothly enough that Kelly was permitted to continue running it for a time.[33]

The townsite itself was a shambles in the late 1950s. Many of the old miners' shacks and houses were dilapidated fire traps, and the BRAC had to appeal to the provincial fire marshal to restrain the local marshal's penchant for condemning unsafe buildings.[34] Chester Lyons was certainly concerned that the old buildings were dangerous, but he was more concerned with preserving the authenticity of the reconstruction. He wanted to interview "old timers" to gather information, to produce copies of old musical recordings, and to pump in the sounds of the gold rush, including horses' hooves, carriages, and the din of pick axes breaking rocks, all of which would help provide an appropriate sensory atmosphere for tourists.[35] Sound was key to Barkerville's air of authenticity, because the various committees decided not to use costumed interpreters or performers at the site. The first system for providing information to tourists was nothing more than a series of signs, but this was never intended to be permanent. As buildings were restored and opened for public use, a broader mix of interpretive techniques was employed. Early displays were populated with mannequins to suggest a lived-in space. Later, craft demonstrations by costumed guides, guided tours, and audio-visual presentations joined the mix. However, the costs of staffing such an isolated location necessarily urged restraint. Lyons was reluctant to expand programming and interpretation as this would require hiring and training more staff. It would also entail finding housing for them, in a situation where locating suitable accommodation for tourists was already proving difficult.[36] As a result, when freelance journalist (and later Greenpeace founder) Bennett Metcalfe visited in 1962, Barkerville was still mostly undeveloped. Aside from the mannequins and information panels, there was just one restaurant and two performances to take in. If tourists wished to amuse themselves, they could also pan for gold at fifty cents an hour.[37]

In 1959, the BRAC printed its first Barkerville brochure. Titled *Barkerville Historical Park: Gold Capital of BC,* it was an amateur production, with

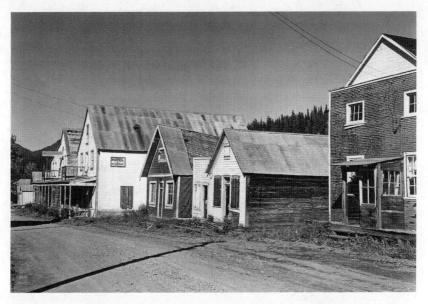

Reconstructed Barkerville, 1956 | Image I-21231, courtesy of the Royal BC
Museum and Archives

simple drawings, apparently hand-lettered titles, and a cover sketch that
depicted a prospector celebrating a lucky strike, pan at his feet and gold
tossed in the air. The short pamphlet made it clear that, although British
Columbia began its life as "fur country" (at least in Anglo-American eyes),
the gold rushes of the Fraser and Thompson Rivers had transformed
the territory. Now "the lure of gold" drew men. Once news of Billy Barker's
find got out, the "rush to golden Cariboo was in full flood." The aim of
the reconstruction, the pamphlet proclaimed, was to provide an "accurate
portrayal of Barkerville between the years 1869 and 1885," the "picturesque
Barkerville that arose after the great fire of 1868."[38] Here was a recasting
of the Euro-American occupation of the Pacific Northwest. Whereas a fur
trade history saw it as the outcome of commercial expansion from the
metropoles of Montreal and London, the gold rushes presented a differ-
ent picture.

Gradually, more buildings opened and Barkerville began to add more
entertainment for visitors. Tourist gold prospecting, panning in a sluice
box that had been salted with flecks of gold, began in the 1962 season.
That same summer, an actor began portraying the ghost of Barkerville's
notorious "hanging judge," Matthew Baillie Begbie. Sitting in the Richfield
Courthouse, Begbie's ghost regaled visitors with stories of frontier justice,

generously embellished with mirth.[39] Metcalfe naively believed that
Barkerville was not intended to turn a profit. During the summer season,
its average daily income was just $255, evidence to him that its purpose
must be something else: "It's not money the committee is primarily after
at Barkerville, though that is bound to come. Before all things, the com-
mittee wants to recreate the scene of Canada's first gold rush [sic] as
it was when William (Billy) Barker's $600,000 strike turned a sprawl
of creek-side tents into the largest city north of San Francisco and west of
Chicago."[40] However, gold "prospecting" and Begbie's ghost quickly be-
came two of the most popular attractions at Barkerville. They were joined
by the stagecoach ride, a saloon selling root beer and confectionaries,
and song and dance performances at the Theatre Royal. The portrayal of
a famous ghost and souvenir gold prospecting may be reminiscent of a
Disneyland approach to the past, but their popularity was undeniable. A
visitor survey revealed that, while 3,400 visitors took guided historical
tours of Barkerville during the summer of 1975, 10,000 visited the court-
house ghost, 15,200 panned for gold, and 37,200 attended the theatrical
shows.[41] The BRAC clearly had its eye set on enticing tourists. Promotional
radio spots prepared by advertising firm Cockfield Brown emphasized
salacious and stereotypical depictions of the gold rush frontier, playing
heavily on images of saloons, hurdy-gurdy girls, and Chinese gambling
dens.[42] As radio host Dick Batey claimed on CJVI, Barkerville had two
purposes: to provide British Columbians with "a colourful chunk of our
historic past" and to be "yet another magnet to draw tourists – and their
welcome dollars."[43] Unlike the living history museums then being built
in the east, Barkerville was not intended to be educational. Indeed, when
the BRAC produced a promotional film titled *A Day of Fun in the Histor-
ical Town of Barkerville* in 1963, its focus was clearly on attracting business
rather than promoting education.

Ironically, the film was more educational than fun. Narrated in a plod-
ding style with a simple piano accompaniment, its script dispensed bits
of historical information and trivia about life in the 1860s. It opened and
closed with a statement that Barkerville, in its day, was the largest city
north of San Francisco and west of Chicago, a curious claim to fame that
featured in promotional pamphlets and was repeated in nearly every
magazine and newspaper travel story about the town.[44] As the film fol-
lowed tourists around the park's favourite attractions, the narrator drew
contrasts between historic Barkerville and what modern visitors could

see and hear there. But the script could not help falling back on popular stereotypes, however true they might have been, that directed attention to the trivial. Women and liquor featured prominently in the narrator's thoughts, and apparently in the lives of miners. Even the fire of 1868 that destroyed the town was caused, viewers learned, by "an amorous miner in pursuit of a dancing girl." And, "like many a miner, Billy [Barker] spent his fortune on a woman and died a poor man." The film itself was a bit anachronistic. It was reminiscent of a silent movie from the early twentieth century, with actors pantomiming exaggerated gestures and facial expressions to the piano accompaniment. It delivered a simple historical message. It proclaimed that Begbie's stern justice was "directly responsible" for keeping the Cariboo region a British possession, but otherwise portrayed the gold rush in terms that could be summed up as "boys will be boys."[45]

Perhaps fittingly, Barkerville sparked an entrepreneurial spirit among the people of British Columbia, many of whom sought to cash in on the new Cariboo rush. As early as 1962, a series of makeshift roadside stands cropped up to line the highway into Barkerville, much to the chagrin of the BRAC. The committee concluded that new roads needed to be built to preserve the authentic look and feel of the site.[46] But not all entrepreneurs simply took advantage of the park's popularity to cash in. Others sought official sanction for their schemes, such as H.G. McWilliams, who proposed to rent umbrellas to tourists for a nominal fee.[47] Some tried to win concession rights at snack bars in the park and its parking lot.[48] And some hoped to insert their own creations into the park's version of history. More than one aspiring songwriter penned a "gay nineties" song for the Theatre Royal troupe. The troupe's producer and director, Fran Dowie, no doubt cringed at their unsuitability. For instance, a 1964 song titled "Barkerville" had nothing to do with history, other than perhaps its chorus, which made reference to "girls with their bustles and ruffles." According to one Barkerville musician, the song simply did not "meet the required standards of any musical composition."[49] However, another example reveals something of the park's efforts to maintain a degree of authenticity. In 1965, H.M. Matthews of Powell River submitted a ditty titled "There's Gold in Them Thar Hills." Franklin Johnson, best known for his portrayal of Begbie's ghost, dismissed it as "very ordinary" and of the kind that the Theatre Royal songwriters "could turn out in about five minutes," but he recommended letting Matthews down easy with the excuse that Dowie would use only authentic period songs. The message was passed

on.[50] Despite the tendency at Barkerville to slide toward popular entertainment in preference to education and accuracy, Fran Dowie, at least, was concerned with the maintenance of an authentic historical message.

One of the most ambitious plans for Barkerville was presented to the Province in 1961 by the well-known impresario Gordon Hilker. "The modern 'synthetic' world," he informed L.J. Wallace, the deputy provincial secretary "makes an older simpler way of life very attractive." The gold rush was a time of simple adventure, something difficult to comprehend in a space-age world where "personal adventure ... seems to need a $25,000 space capsule to be daring in." Hilker's plan was to animate the site by designing an entertainment program that would break down the barriers between visitors and exhibits. Visitors, he felt, should not just see what historic Barkerville looked like – they should understand how and why life took the shape it did, and how the people of the past felt. In broad terms, Hilker's proposal would not have been out of place at Louisbourg. Workers would be costumed and rehearsed in anecdotes and folklore, and ought to work with period tools. Park employees would be assigned the names of characters from the past and should interact with visitors as those people. Services in the town might reflect what was available in the 1860s. For instance, a nineteenth-century barber shop would be a hit because "tourists always need haircuts ... particularly children who are tourists." And, although Hilker insisted that performances remain lighthearted, they should not become spoofs of the period. However, they should also be adapted to the talents of available performers, which would render them perhaps only loosely accurate. Hilker's plan, then, placed an emphasis on performance rather than strict accuracy, as one might expect from such a showman. Nevertheless, the BC government took his suggestions seriously, even if his scheme was never brought to fruition.[51]

Still, if the promotional work and some of the attractions at Barkerville were perhaps not "authentic," public enthusiasm was undeniable. Attendance kept growing, from the roughly 10,000 visitors in 1959 to 100,000 in 1962, the year of Barkerville's centenary. The numbers climbed higher still, reaching 200,000 in 1966, but afterward they fluctuated between 70,000 and 320,000 in the peak year of 1973.[52] Considering the remoteness of the attraction, this turnout was remarkable. Yet, attendance figures alone do not reveal the impact that Barkerville made on people's sense of the gold rush past. One visitor from Calgary commented that his entire family loved Barkerville and that he himself thought it the "finest restoration project I have ever seen."[53] A 1976 visitor survey described

tourist satisfaction as high, but in ways that reinforced Barkerville's entertainment mission over any educational one:

> Most visitors seem to be highly satisfied with the Historic Park. Eighty percent of visitors said that they experienced a general feeling of enjoyment on completing their visit. One-quarter of the visitors stated that that they now had a greater understanding of the history of Barkerville and the Cariboo Region while fifteen percent mentioned they had achieved a greater understanding of the way of life in the past.[54]

In other words, 75 percent of visitors left the park without feeling that they had learned anything, a statistic that should have been an indictment.

Although many people believed that Barkerville was a source of accurate historical information, its greatest draw was entertainment. However, its remoteness made it difficult to reach. Thus, many communities asked that Barkerville come to them. In 1966, Vancouver's Pacific National Exhibition planned a "gay '90s" theme and, clearly unaware of Fran Dowie's insistence on staying in period, asked to use Barkerville to promote it. That fall, the Theatre Royal troupe toured British Columbia as a "Best of Barkerville" show, playing such towns as Kamloops, Vernon, and Kelowna. Other requests also came in. Gordon Hilker, having moved on to a position as artistic director for Expo 67, wanted to bring the troupe to Montreal, at least for BC Day at the Western Provinces Pavilion. There was even a proposal by a former Barkerville performer to take aspects of the program on a Caribbean tour. Barkerville had clearly captured people's imaginations about the past, but it also revealed the power of the theme park approach to overwhelm history. Despite its attempts at historical accuracy, British Columbia had created a version of the past that would not have been out of place in Hollywood or Disneyland.

Sam Steele

British Columbia's third open-air museum, Fort Steele in the province's southeastern corner, was built around a historical figure who was ready-made for a theme park. Like Barkerville, it fit into the Bennett government's preference for spreading development to the provincial Interior. Also like Barkerville, Fort Steele offered tourists a lesson about the association between British justice and Canada's refusal to join the United States. Whereas Barkerville had Judge Begbie, Fort Steele's story revolved around the legendary Mountie Sam Steele.

The town of Fort Steele began life as an 1860s gold-mining settlement called Galbraith's Ferry. In 1863, when gold was discovered at the confluence of Wild Horse Creek and the Kootenay River, thousands of prospectors and miners swarmed to the area, setting off yet another BC gold rush. The next spring, John Galbraith began operating a ferry service to take advantage of the surge of prospectors and merchants heading to the creek. Although he continued to operate his ferry until the late 1880s, the gold rush itself was short-lived. The early diggings ran out quickly, and once news of easier pickings on the Columbia River reached Wild Horse Creek, most of the British and American prospectors left. Of course, this little European settlement's origins obscured the earlier Aboriginal use of the lands along the Kootenay, primarily by the Ktunaxa (Kootenai) people. Led by their charismatic leader, Isadore, the Ktunaxa resisted the reserve system that British Columbia attempted to impose in 1884. Then, in 1886, one of his followers was arrested and jailed on suspicion of killing two miners. Incensed at the insult to his own authority, Isadore forcibly released the man, Kapula, from jail and thus provoked fears of an "Indian uprising" in the Columbian Interior. In response, the government dispatched Sam Steele to defuse the situation.

Sam Steele was already something of a legend by the time he arrived at Galbraith's Ferry in August 1887. He was dedicated to service of the British Empire, having joined the militia to defend against the Fenian scare of 1866, and later went west under Colonel Joseph Wosley to restore order to the Red River colony during the Red River Rebellion. In 1873, he volunteered for the newly created North-West Mounted Police (NWMP) and was placed in charge of travel arrangements for the Long March, the arduous trek of 275 officers and men from Fort Garry west to the Saskatchewan River during the summer of 1874. A few years later, he was a member of the party that rode to Fort Walsh to negotiate with Sitting Bull when he fled the United States. He was also one of the few NWMP officers to emerge from the Northwest Rebellion with his reputation enhanced.[55] At Galbraith's Ferry, Steele built the first NWMP post west of the Rockies to serve as a base of operations. Then he "negotiated" with Isadore. Through a combination of the display of force that his seventy-five men provided, and a threat to replace Isadore with a rival chief unless he accepted the government's reserves, Steele resolved the situation and restored order. In gratitude, the settlers renamed the community Fort Steele.[56]

Although he stayed in this insignificant gold-mining community for only about a year, the historical importance of Fort Steele was enhanced

by its connection with the legendary Mountie. Indeed, Steele was practically the archetype of the Mountie myth: broad-shouldered and tall, he combined physical strength with moral certitude. Ironically, in the years before Fort Steele became a tourist attraction, it got an unintended boost from American cultural imperialism. Hollywood's romantic infatuation with the Mountie image in the first half of the century played on the officer's supposed physical and moral strength, and added to it romantic chivalry and personal restraint. The major studios churned out almost 250 Mountie movies before 1939.[57] Often Hollywood's Mountie movies simply reinterpreted tropes of the American western frontier, replete with "cowboys and Indians," and transposed them onto Canada's northwest. Nevertheless, the appeal of the Mountie image of clean-cut men, stoic chivalry, and cold justice made for good cinema. Hollywood's popularization of the Mountie fantasy certainly influenced the appeal of the force's most famous historical officer.

Steele's legend had expanded over the years. His career took him to the Yukon, where he famously policed the Klondike gold rush. He served in the South African War with Lord Strathcona's Horse and helped recruit and train Canada's volunteers for the First World War, even briefly and controversially taking command of the Second Canadian Division. He ended his career as an administrator for the British Army in southern England and died there, one of the many victims of the influenza epidemic of 1918. Although late in life, his arrogance and ego tarnished his reputation for impartiality, his public persona and legend remained that of the archetypical Mountie. As Roderick Macleod wrote of Steele in the *Dictionary of Canadian Biography,* he was the quintessential Canadian man of action in the Victorian era: "Physically strong and courageous, he personified the heroic qualities of the early North-West Mounted Police. He even looked the part to perfection: tall, barrel-chested, and handsome, inspiring confidence in men and admiration in women."[58] Tellingly, Macleod wrote this dreamy appraisal in 1998, three decades after Fort Steele opened to the public. Such a legend could not help but impinge on the public assessment of Fort Steele, and historians struggled with it.

In 1928, only a decade after Steele died, the HSMBC decided to mark the NWMP post with its standard plaque and cairn.[59] However, interest in restoring the fort first came from Steele's son, Harwood, who had fictionalized his father's stories in a series of adventure novels. The younger Steele began investigating the possibility of restoring the police buildings at Fort Steele in 1951 but could not convince the government to take on

the project.[60] The federal Parks Branch saw Fort Steele as a provincial concern, and the HSMBC repeatedly refused to take action.[61] The property was owned by the Province, and in 1956 Ottawa even transferred control of the HSMBC cairn and plaque to British Columbia. Even the RCMP agreed. Although the force requested the relocation of the HSMBC marker so as to centralize its commemoration of the fort, it too had ceded land to the Province by the end of the 1950s.[62]

Prompted by the possibility that proposed dam works on the Columbia River would flood the townsite, the provincial government began taking interest in restoring Fort Steele at the end of the decade. In 1948, a devastating flood on the Columbia had killed dozens of people and left thousands homeless in Oregon and Washington State. President Truman promised to create a water management authority for the Columbia to prevent such a catastrophe from happening again.[63] However, studies by the International Joint Commission took fifteen years to conclude and led to the signing of the Columbia River Treaty between Canada and the United States only in 1961.[64] Planning for Fort Steele's restoration was initiated in the state of uncertainty created by these negotiations. Yet, if the outcome of the Columbia River Treaty negotiations was uncertain, the BC government's experience with Barkerville assured it that historic reconstructions could draw tourist dollars into the provincial Interior.

In June 1960, the Barkerville Restoration Advisory Committee met to consider a proposal from Bill Mead, a California-based mining executive, for a Fort Steele restoration.[65] The following year, the Province established the Fort Steele Restoration Foundation, with deputy provincial secretary L.J. Wallace as president. Mead confidently informed Wallace that he should model the reconstruction on Rockefeller's Colonial Williamsburg or Ford's Greenfield Village. He also took it upon himself to meet with the builders of Disneyland on behalf of the foundation, and was pleased to report their enthusiasm for contributing to Fort Steele.[66] This idea must have startled provincial staff. Their aim was to balance the romance of the Sam Steele legend with the facts of history.[67] However, historical research and accuracy proved too slow for some interested observers. After a scathing editorial appeared in the *Cranbrook Courier*, Wallace was compelled to write its publisher, admonishing that "as in Barkerville, a true restoration and reconstruction is a slow process. This is made necessary because of the tremendous amount of research which must be done. It is our desire to do this on as authentic a basis as possible."[68]

When Fort Steele opened for visitors on 24 June 1967, it purported to represent a community that was "typical to the area during the period between 1890 and 1905."[69] The opening ceremony was brief, featuring the singing of "O Canada" and "God Save the Queen," as well as speeches from Harwood Steele, L.J. Wallace, and the premier. The town consisted of some forty structures on the original townsite between a provincial highway and the Kootenay River. As had become standard practice by 1967, each building told a particular story. The general store was supplied with oil lamps, tin pots, and provisions. The dentist's office was stocked with century-old dentistry equipment donated by Dr. King Grady of Vancouver. A replica stagecoach rumbled down the main street, and outside the town itself, next to the parking lot, visitors could ride a replica railway. The town was meant to be living, but as a *Calgary Herald* reporter lamented on opening day, the bottles in the saloon were only for show and the showgirls had left in the 1890s.[70]

Nonetheless, Fort Steele was an immediate success. The *Vancouver Sun* applauded the provincial government for demonstrating "respect for our heritage," noting that "it has certainly earned a hand with its imaginative restoration of Fort Steele in the East Kootenays."[71] It was a hit with travellers, too. In under a decade, attendance at the park, tucked away in a remote corner of the province, climbed from about 100,000 visitors in the inaugural year to nearly 300,000 by 1974. Half of all visitors were from British Columbia or Alberta, with Americans making up about 40 percent of the remainder. A survey conducted in 1975 found high levels of visitor satisfaction with the site, even if a third of respondents felt that more historical information could be provided.[72] The site used a variety of interpretive tools to provide visitors with information. Museum displays and signs were supplemented by brochures and, of course, craft demonstrations. However, the park had no costumed interpreters, and its experiment with a guided tour program for 1975 was a failure. Too many people preferred to come and go on their own schedule.

The 1975 survey reveals something of visitors' expectations for living history museums. They were free to wander the site as they pleased, without being directed by either a guide or an interpreter, and where they chose to spend their time allows glimpses of popular ideas about history. Despite Fort Steele's connection to the NWMP, only half of the visitors toured its police barracks. Many, fully 80 percent of them, preferred instead to take in demonstrations at the blacksmith's shop. Other popular venues

included the dentist's and doctor's offices, the general store, and the museum building, where, at least in 1975, exhibits focused on mining history and women's lives.[73] In other words, despite the efforts of planners to create a unique living museum, and despite its association with the celebrated Mountie, people expected to see a pioneer village in which pioneer skills were re-enacted by costumed interpreters. The tastes of mass tourism had come to dictate the presentation of the past.

8

The Great Tradition of
Western Empire

THE TRAVELLING PUBLIC'S preferences were not the only factors that living history museums took into account. In the years following the nationalistic celebrations of the Centennial of Confederation and the spectacle of Expo 67, Canadians felt confident that theirs really was a dominion "a mari usque ad mare." Many people sought out symbols that expressed this renewed sense of the nation as dynamic, energetic, and transcontinental. For many, the history of the fur trade perfectly captured this symbolism. Its image included many of the tropes of "Canadian" history and identity, and helped develop a popular nationalism. The fur trade fit with Canadians' long-held sense of themselves as connected to nature through canoeing and camping. It was a transcontinental enterprise. It was a multicultural enterprise. The connections might best be seen in the Centennial Voyageur Canoe Pageant, a three-month race over the summer of 1967 from the Rocky Mountains to Expo in which teams representing the provinces competed against each other. Avidly followed in the press and on television, the race helped popularize the trade as uniquely Canadian.[1]

Working the fur trade into living history sites and museums was equally popular. Yet, it could also prove challenging to curators and interpreters who wished to balance between historical research and popular expectations. Indeed, the ubiquity of fur trade images reinforced popular perceptions, supported by the works of Canada's leading historians, that the trade created Canada. However, the expectations that fur trade history would resemble boys' adventure tales tended to conflate the periods and places in which it had occurred despite efforts by museums to remain accurate. Case studies of Old Fort William and Fort Edmonton reveal how both the entertainment and educational mandates of living history museums could distort the past to conform to the popular tastes of fur trade nationalism.

Pure Canadiana

In July 1973, Queen Elizabeth II arrived for the first of her two summer trips to Canada. The second, at the end of the month, was to attend the meeting of the Commonwealth heads of government and was confined to Ottawa. But this first visit was more typical of a commemorative tour. Accompanied by Prince Philip, the queen visited Charlottetown for the centennial of Prince Edward Island's entry into Confederation. Later, she attended ceremonies in Saskatchewan and Alberta, marking the centennial of the creation of the RCMP. And on 3 July, in between breakfast in Charlottetown and dinner in Regina, she stopped at Thunder Bay at the western end of Lake Superior to inaugurate Old Fort William, Ontario's newest living history museum.

Old Fort William recreated a North West Company fur-trading post from the early nineteenth century. During the French regime, fur traders had conducted business in its vicinity and had built a small trading post. Following the Conquest, the British traders of the North West Company first preferred a site farther south in present-day Minnesota. Given the exceptional distance between the fur-bearing regions of the northwest and the company's headquarters in Montreal, the Nor'westers needed a large post to serve as a transshipment point, where goods from the east could be distributed to local traders and furs could be stored for the long trip back to Montreal. However, following the signing of Jay's Treaty in 1794, which established the border between Canada and the United States and mandated the withdrawal of British posts from American territory, the company was forced to move its operations. Perhaps Simon McTavish, one of its founders, remembered the old French route up the Kaministiquia River. There, in 1803 and under the leadership of McTavish's nephew William McGillivray, the company built a new fort. The post, which became one of the largest European settlements in the west, was named in 1807 for McGillivray, by then the company director. After serving as the company's western headquarters through much of the century, Fort William closed in the 1880s, its land transferred to the Canadian Pacific Railway. Over the years, the CPR tore down its walls and buildings. The last remaining structure, the stone store, was demolished in 1902, and with it vanished the physical connection to the lakehead's fur-trading past.

The idea to rebuild the fort can be dated to the 1930s. In 1938, Carson Piper's hardware store in the town of Fort William displayed a model of Fort Caministigoyan (or Kaministiquia), the original French trading post,

built in 1717 by Zacharie Robutel de la Nouë. Enhanced by photos from Piper's own collection and populated by Plasticine figures, the model caught the attention of passersby and inspired town leaders to call for a full-scale reconstruction as a "splendid drawing card for tourists."[2] With Ontario already paying to restore Fort Henry, residents of the lakehead felt they had every reason to expect similar treatment. Heady anticipation of provincial funding was reinforced by the minister of highways, who alluded to Fort Henry's doubling of tourist traffic into the Kingston area.[3] Yet, despite support from the Thunder Bay Historical Society and the local newspaper, as well as an endorsement from an American archaeologist, the plan seems to have fizzled out in 1939.

Twenty years later, inspired by a speech about the tourism potential of local history, Fort William residents banded together to form the Old Fort Restoration Committee. In his talk, tourism promoter W.H. Cranston drew connections to southern Ontario, where interest in pioneers was growing, and pointed out that pioneer village museums not only stimulated "archaeological preservation," but could be sold to tourists. "Such an attraction," Fort William's mayor learned, "is needed for Chippewa Park, to stimulate interest in the early history of the area, and to attract tourists."[4] Cranston, himself a member of the Ontario Archaeological and Historic Sites Board, was serious about using historic attractions to prompt economic growth. He was already involved with a reconstructed Wendat (Huron) village in Midland and later took a leadership role in urging the Province to reconstruct the seventeenth-century Jesuit mission Sainte-Marie among the Hurons.[5] The restoration committee took up Cranston's challenge and set about lobbying the provincial and federal governments for support. But the governments were reluctant to act, and a local plebiscite rejected the plan as too expensive.[6]

The reconstruction idea's fortunes began to change as the lakehead communities of Fort William and Port Arthur grew through the 1960s. It got a shot in the arm in 1965, when the local college in Port Arthur was elevated to degree-granting status as Lakehead University. Lakehead archaeology professor Kenneth Dawson began excavations at the CPR yards, in part as field work training for his students. With provincial support, Dawson and his students located some foundations, remains of palisade posts, and other evidence of North West Company activity, all of which renewed interest in the community's early history. Constituency politics may also have motivated the Province to act. The towns of Port

Arthur and Fort William were forcibly merged to create the city of Thunder Bay in 1969, despite local opposition (effective 1 January 1970). The area's Conservative MPP, Jim Jessiman, lobbied his own government to support the reconstruction to help soothe raw nerves. So, in January 1971, the Province announced that it would finance a $5 million full-scale reconstruction of what the minister of tourism called a "living, viable complex."[7] By the time the queen visited, just over two years later, work had concluded on three of the proposed forty-six buildings.

The opening ceremonies that July afternoon in 1973 were, to quote Martin O'Malley of the *Toronto Globe and Mail,* "a glorious multi-cultural afternoon, pure Canadiana."[8] A men's choir serenaded the royals with French and Scottish folk songs from the early nineteenth century. Ojibwa dancers weaved circles to the beat of the drums, and pipe bands performed for the queen and her consort. Demonstrations of traditional skills included splitting wood with an old broadaxe, as performed by a carpenter of Finnish descent, and paddling in birch bark canoes. The queen also received a gift of the "Fort William Bounty," a large box containing song sheets, a voyageur costume, a tin lantern, beaver skins, a twist of tobacco, and a British flag in the style of 1804. O'Malley could characterize birch bark canoes, voyageurs, and the mingling of French, British, and Aboriginal cultures as "pure Canadiana" because they all fit into one particular vision of Canadian identity that appealed to many Canadians in the late 1960s and early 1970s.

The Laurentian Thesis

Canada's identity, at least as it was popularly understood in the 1960s and 1970s, drew on historical concepts articulated in the Laurentian thesis, which was put forward by University of Toronto historian Donald Creighton in the 1930s. Creighton would certainly have rejected any connection between himself and the new nationalism of 1960s and 1970s English Canada, but nevertheless his belief in the east-west nation built from the pursuit of staples came to be reflected in many Canadian living history museums. Although English Canadians have not accorded Creighton the same attention that French Canadians lavished on Lionel Groulx, his influence on historical consciousness in anglophone Canada should not be underestimated. Like Groulx, Creighton was a flawed individual. Denounced as a racist and bigot by Charles Taylor in *Radical Tories,* he has also been exposed as a sexist by even a sympathetic biographer, Donald Wright.[9] Despite his faults, Creighton was a gifted writer

and a brilliant synthesizer of historical data. Moreover, "no English Canadian," mused Paul Romney at the outset of his long discussion of Canadian constitutional politics, "did more to shape his compatriots' sense of their past than Donald Creighton."[10]

As a young scholar, Creighton was deeply influenced by Harold Innis, his political economist colleague at the University of Toronto. Like Innis, he shifted the focus of Canadian history away from politics and the Constitution toward the environmental and economic determinants of Canadian national development. In the 1920s and 1930s, Innis had postulated a "staples thesis" of Canadian history, arguing that political development had depended on the exploitation of a series of natural resources. This was not Innis's innovation – he was himself influenced by colleagues such as economist W.A. Mackintosh. Even James Coyne of the Historic Sites and Monuments Board of Canada (HSMBC) anticipated these ideas in a 1929 speech, asserting that the fur trade had laid the pathways for modern transportation routes.[11] However, Innis was particularly fecund in his development of the idea, most notably in books such as *The Fur Trade in Canada,* published in 1930.[12] For Innis, Canadian development was driven by the export of "staple" natural products (first fish, then fur, timber, grains, and minerals) to the metropolitan economies of France and Britain. The manner in which each staple good was exploited for the benefit of the metropole structured patterns of settlement and political development in the hinterland. This metropolitan expansion into the hinterland locked Canada into a dependency on staples exportation, which in turn influenced later economic thinking about international development (the 1960s "dependency theory" can be traced from it). Within Canada, however, the differing requirements of staples exploitation also accounted for the differing patterns of regional settlement and the political development of the country. This geographical corollary to the staples thesis greatly influenced Creighton's thinking and helped him develop a "made-in-Canada" answer to the continentalist thinking of American historians who adhered to the frontier thesis of Frederick Jackson Turner.

The Laurentian thesis was Creighton's adaptation of the staples thesis. He saw Canada's history as the story of a domestic commercial empire centred on the St. Lawrence River and the Great Lakes basin. In this view, Canadian national and economic development emerged from the exploitation of the same series of staple products that had inspired Innis. However, Creighton credited a succession of great men, not abstract

economic forces, with building Canada. Their transcontinental pursuit of staples propelled them farther west along the continent's waterways. Fish drew merchants across the Atlantic, then furs drew explorers and traders farther into the interior. Later, settlement and grain farming brought populations into Upper Canada and farther west to the Prairies in the nineteenth century. For Creighton, the completion of the Canadian Pacific Railway in 1885 was the culmination of central Canada's transcontinental expansion and hegemony over northern North America. Given this, Creighton's understanding of Canadian development was profoundly anti-regionalist. His focus on the expansion of the Montreal merchants' control of hinterland economies played down the role of the various regions.

Largely consolidated by the 1940s, the Laurentian thesis became influential in Canadian historiography during the post-war years. Creighton's first masterwork, *The Commercial Empire of the St. Lawrence,* which narrated the tale of western staples expansion from the days of the post-Conquest fur traders to the final collapse of the British mercantile system in 1849, first appeared in 1937 as part of a Carnegie Foundation series on Canadian-American relations. It is Creighton's greatest elucidation of his argument that Canadian development was not artificial, but "a human achievement created in response to certain basic invitations and challenges of the new continent."[13] It linked together a natural "northern economy" in which the flag followed commerce. Published again in 1956 and in 1970 as *Empire of the St. Lawrence,* Creighton's book was essential reading in Canadian universities. It remains influential, although the reasons for its importance have changed, and the most recent edition appeared in 2002. Decade after decade, students of history encountered the Laurentian thesis in various guises in their undergraduate and graduate courses. Creighton himself taught a range of young historians, including Ramsay Cook, Craig Brown, Gerald Friesen, Margaret Prang, H.V. Nelles, Paul Rutherford, Jim Miller, and Ken McLaughlin, among many others who went on to prominent positions in the Canadian historical profession.

The Creighton-Innis interpretation of Canadian history did not go unchallenged. W.L. Morton, for one, took exception to its view of the west as nothing more than a supplement to central Canada, although he acknowledged that central designs had strongly affected western development. Writing in the *University of Toronto Quarterly* in 1946, Morton also called the Laurentian thesis tautological. Embracing instead a greater give-and-take between central and western Canada, Morton pointed out

that the Laurentian thesis served to normalize central Canada's political and economic dominance by presenting it as a natural historical development. It was an Ontario-centric vision of Canadian history that would be difficult to extend across the country. And yet, the development of open-air museums in post-war Canada's western provinces seemed to confirm just such a vision of national history. As David Neufeld argues, "not surprisingly, commemorations based on this historiographic representation of the country tended to emphasize the role of the expanding centre rather than the regions themselves."[14]

Certainly, the HSMBC had marked sites connected to the fur trade expansion of British and French imperialism. However, these earlier fur trade commemorations did not express the same enthusiasm that characterized the celebration of the fur trade at the time of the centennial. In the 1950s, Ottawa's acquisition and preservation of historic fur-trading sites, a program that began in the 1920s, expanded as more fur trade relics joined the country's inventory of heritage sites. In 1953, Jean Lesage, the federal minister of resources and development, wrote his Alberta counterpart about the possibility of sharing an estimated $400,000 to rebuild Fort Edmonton at its original location. According to Lesage, the fort was of national historical importance, but its development would primarily benefit Edmonton and Alberta tourism, and so the Province ought to contribute accordingly.[15] Ottawa had already commissioned a set of plans from Edmonton architect George MacDonald, who had identified the only appropriate spot for a reconstruction as the lawn of the Alberta legislature. Discussions continued throughout the decade, and public support was strong, but the prospect that a rebuilt frontier fort would spoil the view of the provincial capital's prized Beaux-Arts legislature, as well as the expense of maintaining it, no doubt contributed to Alberta's reluctance. By the early 1960s, with no alternative site available, the proposal had been abandoned.[16]

Similar official ambivalence faced Lower Fort Garry, which lay a few miles north of Winnipeg, Manitoba. The Hudson's Bay Company (HBC) had offered the fort to the federal Parks Branch in the 1920s, during its first foray into historic property acquisition. Ottawa turned down the offer, as it had earlier when the HBC ceased operating at the fort. However, with the assistance of a local country club, the HBC had maintained the fort as a sort of shrine to its fur-trading past. Lower Fort Garry, downriver from the original Fort Garry (and hence "lower"), had been an important supply depot for the company's traders and for the growing Red River

Fort Edmonton, beside the Alberta legislature, 1914 | Courtesy of Library
and Archives Canada, PA-011278

community. It was peripherally involved in the Red River and Northwest
Rebellions, and was the site for the signing of Treaty No. 1 in 1871, which
created Manitoba from territory ceded by a series of Ojibwa and Cree
chiefs. It had also served as a North-West Mounted Police (NWMP) facility.
And, from 1913 until its lease expired fifty years later, the fort was occupied
by the Manitoba Motor Country Club, which used its surrounding acreage
as a golf course.[17]

In 1955, popular historian Marjorie Wilkins Campbell complained that
Canada had failed to protect the material heritage of the fur trade, but
her criticism was not entirely fair.[18] In 1951, the Parks Branch had finally
taken an interest in revamping the fort as a historic park. Although its
development and interpretation waited until the 1960s, the acquisition
of Lower Fort Garry as well as the attempt at Fort Edmonton were part
of Ottawa's reorientation of its historic sites policies.[19] The federal gov-
ernment expanded its activities for a variety of reasons, and new sites
were not restricted to western Canadian trading posts. But certainly, this
movement helped spur the development of the Laurentian interpreta-
tion of Canada's history. In Saskatchewan, the old NWMP post at Fort
Battleford and the old rectory at Batoche became federal historic sites,

and acquisitions continued into the 1960s. Fort Walsh, rebuilt by the Mounties as an equestrian training facility in the 1940s, became a national historic site in 1968.[20] Ottawa again expressed some interest in developing Fort Edmonton in the late 1950s but eventually left that project to the provincial government.[21]

The Laurentian thesis of central expansion, or at least a version of it, thus played itself out across the western Canadian landscape. Historic plaques and post reconstructions offered material confirmation of the fur trade's historical significance and thus also of the Laurentian thesis's particular interpretation of history. But the Laurentian thesis also soothed anxieties about post-war continental integration by demonstrating Canada's independent historical trajectory. In an era of new economic nationalism and concern over continental integration that spurred the creation of foreign investment reviews and the nationalization of an oil company, the Laurentian thesis lent historiographical comfort to ideas of Canadian economic sovereignty and independence. Its argument that Canada was not an artificial creation that defied the north-south logic of continental geography encouraged nationalists. Its material evidence, even when wholly fabricated such as at Old Fort William, was a powerful reminder of one interpretation of Canadian identity.

Hinge of a Nation

In 1970, the Ontario government paid Toronto-based National Heritage Limited $28,500 to conduct a fifteen-week study on the historical significance of Old Fort William. The company's report, subtitled *Hinge of a Nation*, shaped planning for the reconstruction and its historical message. "Hinge of a nation" is a curious phrase to use for a provincial historic site. Yet, at the same time, its acceptance reveals something of the Ontario government's ideas about Canadian national identity. Under the premierships of John Robarts and later Bill Davis, Ontario had come to embrace the idea of a bilingual and multicultural Canada in which it led the federation. Together with his Quebec counterpart, Robarts pushed the federal government on such progressive issues as pension reform and health care, clearly articulating his view of central Canada's place in Confederation.[22]

On the surface, the decision to employ National Heritage seemed straightforward. Incorporated only the year before by William McCrea Pigott Jr., National Heritage had already begun to make a name for itself in the growing field of historical consultancy. During the early 1970s, it contracted work with clients ranging from the Ontario Northland

Transportation Commission, to the Manitoba Historical Society, to the Catholic Church. On the face of it, National Heritage looked like a good choice. It had arisen from the reorganization of a firm called Thompson, McCance and Pigott, which had been restoring churches since 1965.[23] And it looked every bit the part of a conscientious, competent, restoration venture. Like many other consulting companies that materialized to take advantage of the growth in government uses of history, National Heritage pulled researchers from the expanding PhD programs in history, whose graduates swelled the ranks of public historians and often went on to positions at universities. For its Old Fort William project, National Heritage employed young graduates Ronald Stagg, Norman Ball, and Michelle Greenwald, among others, and counted seventeen scholars among its senior advisers, including J.M.S. Careless, Morris Zaslow, Alan Gowans, and Fred Armstrong.[24]

As a result, *Fort William: Hinge of a Nation* is replete with the historiography of its day. It favoured, although only in passing, the decapitation thesis then raging in French-language historiography. Formulated by Montreal-based historians Maurice Séguin, Guy Frégault, and Michel Brunet, this theory argued that the Conquest had deprived Quebec of normal historical development because it had forced the colony's leadership, its wealthy merchants and its military and government officers, to leave the country. According to National Heritage, their departure "destroyed" the French fur trade but left a handy labour pool for its English replacement.[25] However, it was the Laurentian thesis that dominated the study. The report concluded its overview of the fur trade with an assessment that was reminiscent of *Empire of the St. Lawrence:*

> With the passage of time it has become possible to recognize that it was the Montreal fur traders who blazed the trail to be followed by the Canada of the late 19th and 20th centuries. It should be claimed first of all that they stand as the historic link between the French regime and modern times. They inherited the French [sic] in both trade and exploration. Men of the Company, as we have seen, charted a third of the continent.[26]

Fort William was not just a geographical hinge, sitting at the juncture between the metropole and the hinterland – it was also a hinge of Canada's historical development. As they pursued the overland route to the west, "time was to prove [the Nor'westers] right, in still another respect." The report continued: "The water route through Hudson's Bay was shown to

be the best possible for the fur trade, but for nothing else. When the Canadian West was colonized, it was reached by way of the old route followed by the great trade canoes from Montreal." Donald Creighton would have said it more eloquently, but hardly more succinctly. For National Heritage, Fort William was the linchpin in what Creighton had called the "great tradition of western empire."[27]

Fort William: Hinge of a Nation was more than historical reflection. The 109-page report (not counting indices, illustrations, and its bibliography) set out a justification for the reconstruction of Old Fort William, including financial considerations, planning assumptions, and, of course, construction plans.[28] On the strength of the report, National Heritage was awarded the contract to oversee the project, the Ontario government's third historic site recreation. Yet, almost immediately the company encountered criticism regarding its work, its methods, and its behaviour. The controversy was such that the firm had gone bankrupt by the summer of 1976, with debts of nearly $400,000. The *Toronto Globe and Mail* insinuated, with more than a hint of *schadenfreude*, that the Thunder Bay project had tarnished its reputation, making it impossible to find new clients.[29]

The first signs of trouble came with the announcement of the reconstruction itself. On 21 January 1971, Premier Robarts revealed that the Province would build a replica of Fort William near Thunder Bay. Alluding to his government's work at Sainte-Marie among the Hurons and Upper Canada Village, Robarts explained that "we have accomplished much in Ontario to emphasize our history and our heritage." The seventeenth and nineteenth centuries had been covered, but "a major gap in our program has been the 18th century dominated by the fur trade."[30] However, the fort was to be rebuilt, not at its original location near the mouth of the Kaministiquia River, but five or six miles upriver at a site known as Point de Meuron. Less than a month later, nine thousand local residents had signed a petition condemning the decision as undemocratic and demanding that the original site be used for the reconstruction. Professor Dawson was upset about the choice of Point de Meuron, as was the Thunder Bay Historical Society.

This was not a case of mere historical nitpicking. People had come to accept and even expect that reconstructions would be built on the exact site of the original and, where possible, over its original foundations. Port Royal had claimed to do just that. Louisbourg had clearly popularized the approach. Even the Ontario government made the claim at Sainte-Marie among the Hurons. Building on the original location was part of

the materiality and therefore the authenticity of the reconstruction. Lacking it, as Ronald Way had implied, the ability of the reconstruction "to inspire in the beholder a sense of the past" was diminished. Yet, Robarts himself had inspected the CPR rail yard, and the government had considered buying it before ruling it unacceptable. It had researched a number of locations before settling on Point de Meuron as the best option. Moreover, 9,000 signatures out of a population of more than 100,000 were not enough to sway the government, and the mayor of Fort William denounced the petition, implying that it reflected discontent over the forced amalgamation with Port Arthur and an imposed official town plan rather than any real concern with a tourist attraction.[31]

However, discontent and accusations of malfeasance plagued National Heritage. In 1974, *Toronto Globe and Mail* reporter Gerald McAuliffe began probing the deal between the Province and the firm. Tenders, it seemed, were never called. That spring, provincial Liberal leader Robert Nixon asked embarrassing questions in the legislature. In a speech in April, Nixon connected the scandal at Old Fort William to another tourism-related contract – awarded to the Tory-friendly firm Camp Associates for publicity work – that had been given without tender or competition.[32] In June, a Liberal MPP accused the government of destroying documents to avoid criticism of its work at Sainte-Marie.[33] Something in the Ministry of Tourism smelled distinctly rotten. The *Globe and Mail* led this charge against the government and singled out for scrutiny one of the founding directors of National Heritage, Ronald Atkey, who had been a Conservative Party MP in Ottawa since 1972. Atkey vigorously denied that graft was involved in the awarding of the contract to National Heritage, but the *Globe* dug deeper and discovered some interesting news. Besides Atkey, the firm's secretary-treasurer, Patrick O'Connor, was a Tory MP for Halton. And its vice-president for development had been Atkey's campaign manager and was a former aide to James Auld, Ontario's minister of tourism.[34]

In response to these revelations, Auld came out swinging. First, he accused McAuliffe of ducking interviews with him and therefore called into question the reporter's objectivity. He pointed out that the Old Fort William project had the support of the people of Thunder Bay and that recent articles in the *Toronto Star* and the *Globe and Mail* had contained inaccuracies and contradictions. Moreover, insinuations about the financial problems of Pigott's construction company were simply irrelevant to the Old Fort William contract. But most importantly, Auld insisted that

tenders had not been not called because there simply was no other Canadian firm that could do the work. Besides, under the terms of the contract, following an inspection for historical accuracy, the company was required to fix anything that was deemed inappropriate, at no further cost.[35] Regardless of any complaints, the people of Ontario would get a first-class, authentic reconstruction. The premier was less combative, announcing that the government would tender any future historic site contracts, should qualified companies compete for the work.[36] None of this resolved the scandal, but it faded away over the summer.

National Heritage also faced allegations about shoddy research. For a reconstruction project, this issue was particularly troubling because any disparagement of its authenticity threatened its legitimacy in the minds of tourists. Even as the Province announced the reconstruction and handed National Heritage control of its design, it also appointed an archaeological team from Lakehead University, under the supervision of Joyce Kleinfelder, to assist with the project. Kleinfelder's task was to work with Dawson's continuing archaeological excavations at the CPR yards. However, the partnership between the academics and the company was not a friendly one. National Heritage saw Lakehead University as a competitor and took a proprietary interest in its historical research, despite its own insistence on access to the archaeological data. In November 1971, Kleinfelder wrote the project administrator in Toronto to complain that National Heritage refused to share any information, echoing J.D. Herbert's concerns at Louisbourg that, "ideally, historic research should *precede* the archaeological research on the historic site," because only with this knowledge could archaeologists excavate intelligently.[37] Ultimately, however, Dawson weighed in to suggest that archaeology could not really serve the project. Although, as the only contact with the actual, physical site of the fort, the excavations were crucial to understanding, Dawson felt that they could not proceed quickly enough to assist the reconstruction project. At best, the dig could provide salvage work that would parallel the reconstruction. This, however, was a calculated risk worth taking. Moreover, discrepancies taught a valuable lesson, Dawson mused, about our ability to rebuild the past: "There will undoubtedly be differences between certain reconstruction details and archaeological evidence gathered after the fact – but is this not itself a worthwhile point to make in an historical reconstruction – the difference between what was really there and what various people from various backgrounds recorded was really there?"[38]

In a sense, Dawson was tearing down the assumptions about material evidence that had governed the reconstruction and living history movements. He called into question, not just the linkages between material reality and historical understanding, but also the conception of certainty that underwrote sites like Old Fort William and made them successful tourist attractions. He clearly believed that archaeology was a study of material reality ("what was really there"), whereas history was personal interpretation ("what people recorded"). However, as all reconstructions relied on interpretation (as did archaeological understanding, for that matter), he implied that they could never be correct. Although the suggestion passed almost without notice in 1971, for living history it was an ominous foreshadowing of a coming loss.

For National Heritage, research problems continued. A few years into the project, the company faced a revolt among its graduate student researchers that fed into the political imbroglio in the headlines of 1974. In the winter of 1972–73, a group of former employees approached J.M.S. Careless with their concerns regarding problems in the historical research and financial irregularities at National Heritage. According to them, untrained company executives were making judgments about historical data and thus affecting the reconstruction. Furthermore, bibliographies were padded, and despite its denials, the company was working only from secondary sources while citing primary source research, sins that fell under the broad label of "academic misconduct." Careless severed his connection with the project, and many researchers, such as Ronald Stagg, who was one of the malcontents, found themselves out of work when the company discovered that it lacked the funds to pay them.[39] Some of these allegations became part of the political attack against both the site and the company, and they prompted Jim Foulds, the NDP MPP for Port Arthur, to dismiss the project as the "Disneyland of the North."[40]

In many ways, the Disneyland label was a greater attack than the accusations of corruption. Even Joyce Kleinfelder was moved to defend the project's authenticity in the face of this charge. Ignoring her own objections that her work was not being used, as well as Dawson's suggestion that it did not matter, she wrote to the *Globe and Mail,* insisting that "to imply that the archeological research has been ignored is a falsehood which should be perpetuated no further."[41] The premier defended the site as "first class in terms of historical authenticity and the quality of work being done."[42] However, Ronald Way conceded that the reconstruction could not be authentic. National Heritage, which had touted his involvement

at the project in *Fort William: Hinge of a Nation,* glossed over his skepticism.[43] In a report commissioned in 1968 for Auld, Way prophetically wrote that "the best you could hope for would be a Disneyland-type mockup."[44] To adapt another historian's phrase, "hinge of a nation" had clearly become a bone of contention.[45]

Historical Systems Planning

No doubt stung by the ongoing mess at Old Fort William, Ontario began to work out policies to guide its standards for historic site development. In 1972, bureaucratic reorganization created the Historic Sites Branch to better co-ordinate and plan Ontario's historical resources, housed within the Division of Parks of the new Ministry of Natural Resources. In essence, the branch was an amalgamation of two programs: the tourism ministry's historic sites program (sites such as Sainte-Marie and Old Fort William) and the historical resources research and interpretation unit from the Parks Branch of the former Ministry of Lands and Forests. Within the Historic Sites Branch, a Historical Systems Group, including John Weiler, Theresa Baxter, Bill Russell, Chris Nokes, Tony Usher, and Victor Konrad, was created to develop the workings of a systems plan.[46] Eventually, they generated a plan with four key components: a topical organization of Ontario history; a historical resource research report format; a historical resources evaluation scheme; and a historical resources inventory. The inventory was obviously to be a work in progress. The evaluation scheme guided decisions on the suitability of developing historic sites, and the topical organization set some of the guidelines for the evaluation scheme. The systems plan reflected the degree to which the government believed that authenticity was measurable by technical expertise. In this light, Way's 1951 memo in which he suggested cashing in on history, as well as his methods of interpretation development, appeared almost quaint.

The systems plan was so Byzantine that only a seasoned bureaucrat could admire it or, for that matter, navigate its labyrinthine structure. However, its intent was to inject a degree of objectivity into the highly subjective process of selecting historic sites for development. The topical organization was ready for 1973. It was based on three "conceptual areas" of Ontario history: economic and social history; military history; and political history. Each conceptual area was subdivided into themes, which were then subdivided further. Evaluation criteria next had to be developed for each theme segment according to seven indicators: Historical

Significance, Cultural Phenomena, Interpretability, Scenic Value, Recreational Activities, Capability of the Land Base, and Accessibility. Each of these was assigned a score out of 100, which was built up in a complex manner. The indicators were subdivided into "sections" and given scores based on "variables" that were themselves divided into "facets." These variables and facets were evaluated on a 10-point scale, with 10 points being a perfect score. However, limitations were also built into the points system. Scores of 0, 1, 9, and 10 were never assigned. This produced a range of assessment from 2 to 8, a limitation that perhaps reflected the grading range used by history professors as they marked undergraduate essays. Scores were then added, divided by the total possible score, and multiplied by the weighted value of each indicator. The site's total score out of 100 was found by adding the scores of the seven indicators. A site needed to score above 60 for its development to be considered.[47]

As ridiculous as all this seems, it had a purpose. It was designed to minimize the subjectivity and value judgments that are inherent in assessing the historical importance and tourist viability of any given site, directing the evaluator to very specific discrete areas of the evaluation at a time. Thus, a Disneyland approach to assessing historical significance, based on personal taste, would be avoided. Even then, the evaluation scheme stressed that the raw scores were only a guideline: they did not oblige the government to act. Yet, if the focus on discrete individual aspects was intended to make the assessment more objective, the systems group recognized that any individual assessments remained subjective.

The topical organization – the arbiter of historical significance or 25 percent of the evaluation scheme – was perhaps the most significant subjective aspect. It provided a chronological and geographical survey of Ontario's history.[48] Its most complex conceptual area was economic and social history. It alone was subdivided into 11 themes and 115 theme segments. By contrast, the military area consisted of only 5 segments, as did the political area. These areas told the standard narrative of the progress of Canada to Confederation. Only in the economic and social area did the topical organization address the diversity of the province's history, as each theme was broken into chronological and regional segments. For instance, the theme of the Fur Trade and Fur Trade Communities was divided into 16 trade routes (styled segments in the document) organized by 3 historical periods: New France (1615–1760); Intense Competition (1760–1820); and the period of the Hudson's Bay Company (1820–1870s). In addition, segments were rated by historical significance. Only three

fur trade routes were rated in the most significant category: the Ottawa River–Georgian Bay trade route of New France, and two Lake Superior routes to the west used by the North West Company and the Hudson's Bay Company. In this process of designating the most significant trade routes or periods, the topical organization relied on the most famous historical studies of the fur trade. Thus, the most historically significant fur trade topics for Ontario followed a line mapped out by Donald Creighton in *The Commercial Empire of the Saint Lawrence* nearly four decades earlier. The systems plan, then, was an "objective" reinforcement of prevailing opinions.

Ronald Way's 1951 vision had tried to co-ordinate differing aspects of Ontario's historical development. The systems plan, particularly its topical organization, met the challenge of knitting together a broad, diverse understanding of provincial history by relying on a theory of national historical development. Recourse to the Laurentian thesis helped planners at the centre overcome the difficulty of accommodating the province's diverse regions in a single story. As much as this displaced many potential histories, it also helped Ontarians to imagine their provincial past as contiguous with Canada's national past. In this adaptation, Ontario, which constituted half of the Laurentian heartland, became the homeland of Confederation. The political and military areas in the topical organization helped to confirm this outlook. The topical organization thus suggested a progressive history in which present-day Ontario – and by extension, Canada – developed naturally. Thus, a history of regional expansion became normalized in the province as a common sense national history, with Ontario at its centre.

Pioneerland

The historical systems plan could do little to prevent the controversy that drove some to see Old Fort William's "pure Canadiana" as little more than a Disneyland sham. Fur trade history was particularly susceptible to this problem, in part because of its association with romantic notions of heroic voyageurs and an almost sublime struggle against a half continent of wilderness. It provided a uniquely Canadian counter to the American national myth of western expansion. However, like the American myth, the romance of the fur trade was constructed from only a partial history. More importantly, and more insidiously, it also lent itself to a Hollywood-style simplification, which was certainly the case for the reconstruction of Fort Edmonton, a project that involved many of the issues raised in

Thunder Bay. It was built nowhere near its "original" location and was also accused of confusing fantasy with fact. Moreover, it seemed to favour entertainment rather than education, having been inspired, in part, by a western-themed fairground exhibit.

Like many other historic attractions, the Fort Edmonton reconstruction was subject to a number of false starts. As early as 1911, when the remnants of the last Fort Edmonton were still standing, Emily Murphy, president of the Women's Canadian Club of Edmonton, proposed shoring up its surviving structures as a shrine to the city's pioneering past.[49] But despite this patriotic endorsement, the old fort was dismissed as an eyesore and dismantled. It was a victim of aesthetics, for its rough construction struck many as too primitive next to the new Beaux-Arts legislative building, with its classical and Egyptian influences. And so, a bit of Alberta's heritage was sacrificed to the ambitions of its capital city during the province's first decade. By the early 1920s, when the HSMBC considered marking the original fort with its standard plaque and cairn, its exact location had become a mystery.[50] Part of the problem was that the fur-trading companies had established a series of forts along the Saskatchewan River, many of which informally used the same or similar names. Repeated relocation and mergers of different posts was just as confusing for the fur trade companies as it was for later historical researchers. According to one researcher, the Hudson's Bay Company complained to the factor at Edmonton House, ordering him to "stop moving Fort Edmonton about, or adopt a new name for each location."[51]

Fort Edmonton's history began in 1795. That year, Angus Shaw, a North West Company trader based at Fort George on the North Saskatchewan River, decided to move operations farther upstream and outflank his HBC rivals. He ordered a post, Fort Augustus, to be built in the river flats across from the present-day suburb of Fort Saskatchewan. Competitors from the HBC, first William Tomison and then George Sutherland, established a nearby rival – Edmonton House – the following year, about where the Sturgeon River meets the North Saskatchewan. Although born in competition, the two posts were within sight of each other, which promoted co-operation for mutual security. Thus, Fort Augustus and Edmonton House were linked from their beginnings. Together, the rival traders moved their posts up and down the North Saskatchewan River. From their original locations, they were rebuilt in 1802 near today's 105th Street Bridge in downtown Edmonton's Rossdale neighbourhood. In 1810, both were relocated a hundred kilometres to the northeast, then back again

two years later when trading proved unprofitable. By the 1810s, the two "rival" posts were sharing a defensive palisade, and their co-operation was formalized in 1821, when the two companies merged. Further complicating the precise location of "Fort Edmonton," was the fact that chronic flooding problems prompted Chief Factor John Rowland to move the post one final time in 1830. This time, Fort Edmonton was built on the high ground overlooking the river, now occupied by a power-generating station.[52]

When the HSMBC decided to place its historic marker, it eventually settled on the site of Shaw's Fort Augustus.[53] However, early in the post-war years, the local chamber of commerce, as well as the Alberta Historical Society and the Northern Alberta Oldtimers' Association, began to press the federal government for a greater recognition of the forts' historical importance by rebuilding one of them.[54] Lesage's 1953 overture about cost sharing was a response to these pressures. However, although this effort had fizzled out by the early 1960s, centennial-era Canadian nationalism revived it. With money flowing into cultural projects by mid-decade, the people of Edmonton began to reconsider commemorating the founding of the provincial capital. Ideas ranged from small to grandiose, but most involved some evocation of the city's fur-trading pioneers. The Women's Canadian Club constructed a scale model of Fort Edmonton, a miniature version of its first proposal, and the *Edmonton Journal* recommended building a new provincial museum around a "Fort Edmonton" theme.[55] Most support fell behind a 1966 proposal by the Rotary Club that the City's Parks and Recreation Department build a replica Fort Edmonton to celebrate the centennial. This plan lay behind the eventual construction of today's Fort Edmonton Park.[56]

Before anyone could act on the Rotary Club's resolution, the image of Fort Edmonton veered in a new direction. Montreal had been awarded Canada's first category-one world's fair in 1962, and five years later, Expo 67, as the 1967 International and Universal Exposition was commonly known, opened its gates to the public. Unfortunately for Fort Edmonton Park, the shadow of Expo 67 hung over it. Planners for Expo had separated its more frivolous entertainments into a Disney-style amusement park called La Ronde. At La Ronde, various theme areas provided diverse kinds of amusements, based on the Disneyland model. Indeed, this theme park model had become standardized in the decade after Disneyland opened. La Ronde featured such theme areas as a safari jungle, a French Canadian village, and an Old West setting called Fort Edmonton-Pioneerland.

Fort Edmonton-Pioneerland at La Ronde, Expo 67 | Courtesy of Library
and Archives Canada, 1970-019 NPC

Pioneerland was exactly the model of historic reconstruction that horri-
fied the living history movement. To make it worse, it involved the
same City of Edmonton bureaucracy that would plan the "authentic"
reconstruction in Edmonton. For Edmonton's mayor, the Expo amuse-
ment park was a tremendous marketing opportunity for the city's tourist
trade. "We'll get our city publicized across Canada [and] we can adver-
tise Klondike Days," he enthused in January 1967.[57] Six months later, he
was satisfied that Pioneerland had accomplished "all it was supposed to
do for the city."[58]

Fort Edmonton-Pioneerland was a Klondike-themed amusement park
that consisted of an Old West main street lined with saloons, restaurants,
and cabaret shows. The stockade park resembled the set of a television
western, with the vivid atmosphere of a fantasy Wild West. Wake-Up
Jake's Saloon, modelled on its namesake at Barkerville, poured beer for
the thirsty, and the Golden Garter Saloon offered regular cancan shows
for the curious. Evening shows featured such events as jailbreaks from the
North-West Mounted Police lockup.[59] It was a blending of Hollywood
popular culture and historical reconstruction. The *Edmonton Journal*'s
reporter made the blend explicit, apparently oblivious to the contra-
diction. As he explained, the attraction boasted an "authentic pioneer

main street," populated by "the kind of person most often seen in television Westerns."[60] But despite the collective cringe expected among historical societies across the country, Pioneerland was a great success.[61]

Shortly after Expo closed, the City of Edmonton engaged Project Planning Associates to design its own Fort Edmonton reconstruction. The master plan laid out a story of historical progress, beginning with prehistory and working through the themes of "Indian, Fort, and Capital." The plan included a reconstructed Fort Edmonton, an Indian village, and other displays depicting the past, present, and projected future of the city. The areas would imply a story of progress by moving visitors chronologically from primeval prairie to the twentieth century, with the time periods clearly separated to avoid visual contamination. The fort itself was rebuilt to its 1850 state because the Big House, known as Rowland's Folly, was completed by then. A massive structure, Rowland's Folly incorporated an image of grandeur into the wilderness post. By 1969, the Rotarians had organized a Fort Edmonton Park Historical Foundation, financed by donations and the government, to oversee research and construction. By 1972, the project had cost over $1 million, and only continued government support allowed it to open in May 1974.[62]

Although every insistence was made that, unlike its Expo cousin, the project would be authentic, the spectre of Disneyland was inescapable. The American Wild West model had been shunned as antithetical to the historical fort, but the modern reconstruction continued along a consumerist theme. Not only did its displays emphasize trade or the exchange of consumer goods, but what made it attractive was directly linked to commercial entertainment. The park captured the dissonance inherent in constructing living history museums: most people rejected the Disneyland model in favour of an educational park that would teach important lessons about heritage, but they also expected it to be commercially viable. This Catch-22 was hardly unique to Fort Edmonton, but as the last major living history museum to open in Canada, it most clearly exposed the contradiction. The pejorative Disneyland label continued to follow Fort Edmonton through the 1970s and 1980s.

Fort Edmonton, Old Fort William, and the historical systems plan reveal competing aspects of living history as it moved into the 1970s. Old Fort William was based on historical and archaeological research, but it fell victim to political scandal and practical expediency. Its eventual form, as one Thunder Bay architect lamented, had forsaken "the environmental atmosphere of the historic period," leaving behind a "total disaster."[63] The

systems plan was a bureaucratic response that was intended to prevent exactly this occurrence. Designed to bring objectivity to the assessment of the significance of individual historic sites, it was shot through with subjective decisions that reinforced the prevailing interpretation of Canadian historical development. Yet, Kenneth Dawson belittled historical interpretation as not quite real, a notion that anticipated postmodernism's assault on certainty. Nevertheless, as Fort Edmonton and Old Fort William revealed, some degree of "authenticity" was essential to prevent a living history museum from becoming, in the words of so many, Disneyland North.

9

The Spirit of B & B

THE PROLIFERATION OF LIVING history museums across Canada also co-incided with the excitement of rapid social and political change in Quebec, known as the Quiet Revolution. The Quiet Revolution shook the confidence of anglophone Canada and provoked responses that challenged conceptions of Canadian national identity. Ottawa's reaction gave shape to a national mission in which history museums played an important role. The Fortress of Louisbourg was only one example of a federal recasting of history in support of national unity. In a bid to keep the country together, against the threat of Quebec separation and growing regional and ethnic antagonisms, federal and provincial governments turned to the past to frame a story of Canadian national identity. Living history practitioners thus responded in ways that wove new conceptions of national identity into their depictions of the past, reforming ideas about the place of French Canadians in Canadian history.

Federal attention to Quebec's historic character was not new in the 1960s. Fort Chambly, on the Richelieu River, was among the first forts that the Parks Branch acquired in 1922. The provincial government had also been active in preserving Quebec's built heritage, starting with the 1921 preservation of Louis-Joseph Papineau's mansion in Montebello.[1] Early the following year, the Province established its Historic Monuments Commission, which quickly developed an inventory of 177 provincial historic sites worthy of designation.[2] Indeed, in the years before the Second World War, provincial tourist promotion pivoted on Quebec's "historic character." The Historic Monuments Commission supported this image by selectively designating as historic particular styles of village architecture, and private entrepreneurs picked up on this leadership by designing resorts along the same lines.[3] For instance, drawing on the architectural histories of Ramsay Traquair, they designed the ski resorts of Mont-Tremblant to emulate the "typical" French Canadian village that

tourist literature highlighted. There were even plans to rebuild lost structures. During the Second World War, at the three hundredth anniversary of the founding of Montreal, the Abbé Albert Tessier spearheaded an idea to build a replica of Ville-Marie, the original French settlement at Montreal. To be modelled after Skansen, the Village-musée Ville-Marie was never realized.[4] Nevertheless, Quebec, like the rest of North America and long before the start of the Quiet Revolution, had already established its own approach to using history to attract tourists. This approach offered French-speaking Canadians alternatives to the living history model of anglophone North America. By contrast, although by the 1960s they often embraced commemorations of Canada's French past across the country, anglophone Canadians proved reluctant to embrace *living* interpretations of a French past outside Quebec.

Revolution, Quietly

To most observers, the Quiet Revolution looked revolutionary. As the provincial government rapidly expanded into new (for Quebec) fields of interest, the sudden overturning of stereotypes of the province and its people as backward and traditional provoked new questions about the future of Confederation. Finding an answer to the question "what does Quebec want?" gained urgency in the spring of 1963, when a radical movement for independence began a bombing campaign in Montreal, initiating a phase of terrorism in Canada. At about the same time, the newly elected federal Liberals accepted a challenge from the publisher of Montreal's influential *Le Devoir* newspaper and launched a royal commission into the status of Canada's two main linguistic groups. Co-chaired by *Le Devoir*'s André Laurendeau and the president of Carleton University, Davidson Dunton, the Royal Commission on Bilingualism and Biculturalism (B & B) roamed the country in 1964 and 1965. Its mandate was to investigate the state of Canadian bilingualism and to recommend steps to develop Confederation on the basis of an equal partnership between Canada's "two founding races." Members of the committee sat through endless town hall and open forum meetings in communities from coast to coast. They met with provincial premiers and advocacy groups, and heard everyday Canadians express their opinions on bilingualism and biculturalism. They waded through hundreds of briefs and digested the torrent of research reports produced by their own research team. The commission drafted an interim report in 1965, and its final report dribbled out in six volumes between 1967 and 1970. It was one of the most

far-ranging royal commissions in Canadian history, and its archives at Library and Archives Canada runs to over forty-five metres of shelf space for textual records alone.

The B & B Commission discussed neither living history nor tourism. Nevertheless, its spirit infused the interpretation of Canada's past that emerged in the 1960s and 1970s. The notion of two founding peoples and of coast-to-coast biculturalism held particular resonance in Ontario. Premier John Robarts personally endorsed the ideals of bilingualism and biculturalism. In 1965, he designated the province's main highway, the 401, the Macdonald-Cartier Freeway, as a symbol of Canadian partnership. And, in a speech given at Quebec City on 16 June 1963, he declared that his own view of Confederation was one of respect between two founding peoples.[5]

Naturally, not everyone subscribed to this interpretation of Canada's history. True, most Canadian newspapers mildly supported the B & B Commission and its mandate, although editorialists in Atlantic Canada and on the Prairies were more reticent than their Ontario counterparts.[6] But many people were hostile to the idea of coast-to-coast bilingualism. Even in Ontario, the antagonism was often palpable. In the diary he kept during the commission's work, Laurendeau characterized the anglophones of Windsor, Ontario, as close-minded: "To sum up, a majority of the English Canadians I met in Windsor refuse French outright, at least for Windsor and possibly for Canada."[7] Moreover, members of ethnic minority communities, particularly in English Canada, feared that biculturalism was a rejection of their contributions to Canadian cultural life. Many rallied against the commission and instead promoted unity in diversity and a vision of cultural pluralism.[8]

Donald Creighton was especially critical of the goal of national bilingualism, denouncing it in the mass media and through his historical scholarship. He described the B & B Commission as "an obviously partial and inadequate representation of the values and interests of English Canada."[9] As Donald Wright notes, Creighton formed his ideas during the 1920s and 1930s, and thus internalized the then dominant assumptions of English Canadian nationalism and Canadian federalism, which in turn guided his interpretation of Canadian history.[10] His assumptions led him to reject the very idea of bilingualism as an ahistorical intrusion on Canada's natural development. In the same breath, Creighton could point to the fur trade as a unifying feature of Canada's past and dismiss any enduring French-English co-operation. In *The Commercial Empire of the*

St. Lawrence, Creighton called the fur trade "the first and the last great continental enterprise in which British and French Canadians ever intimately participated."[11] Much later, in a series of 1960s articles as well as in his 1970 book *Canada's First Century,* Creighton argued that biculturalism itself was a myth. His reasoning might be summarized succinctly: the fathers of Confederation had never intended to extend French-language rights beyond Quebec, and therefore the British North America Act contained no declaration of a principle that Canada was to be a bilingual or bicultural nation.[12] It followed that the extension of French and Catholic rights, such as in the Manitoba Act of 1870 or the Northwest Territories Act of 1875, was anathema to the true objectives of the fathers of Confederation. The protections for French and Catholic schooling that were written into these pieces of legislation, according to Creighton, were forced upon the federal Parliament. Thus, it was only just that Manitoba and the territories rescinded these provisions in the 1890s at the urgings of the "warm-hearted" Orangeman D'Alton McCarthy.[13]

Creighton's younger colleagues backed the inclusive spirit of the B & B Commission. Ramsay Cook's repudiation of a "rigid, even intolerant, adherence to the letter of the British North America Act" was directed to jingoists at the time of the First World War but was equally a subtle denunciation of Creighton's established views. According to Cook, such a rigidity rejected "the essential spirit of Confederation."[14] More directly, Ralph Heintzman, then a doctoral student at York University, accused Creighton of selectively employing historical evidence to support his claims. Conceding that the fathers of Confederation had not entered into a bicultural compact to extend French and English from coast to coast, Heintzman nevertheless argued that a "spirit" of Confederation existed and was endorsed by all the fathers, including Sir John A. Macdonald. This spirit of generosity and compromise, according to Heintzman, was the unwritten compact that had been worked out by Upper and Lower Canadian politicians during the 1840s and 1850s, and it demanded that "those rights which French Canadians felt to be the minimum compatible with their national dignity and self-respect had to be readily and freely granted."[15] Thus, for Heintzman, Cook, and those who agreed with their historical perspective, the spirit of B & B was a natural extension of the spirit of Confederation.

On occasion, resentment over how the federal government applied this spirit of Confederation affected discussions at the nation's historic sites. Quebec historic sites become a major preoccupation for Ottawa as

the Quiet Revolution ran its course. In fact, Ottawa had moved to increase its historic site presence in Quebec when it amended the Historic Sites and Monuments Act in 1955 to increase French Canadian representation on the Historic Sites and Monuments Board of Canada (HSMBC) by adding a second Quebec member. The HSMBC had long been criticized from within for failing to recognize Canada's French past. In part, this problem was due to inconsistent representation from the province, but it also reflected a general sentiment in English Canada that interpreted the country's history through a British lens.[16] When the Massey Commission had criticized the board for inconsistent national coverage, it singled out the paucity of sites that it recognized in Saskatchewan. Quebec's member reacted furiously, by pointing out that Quebec had suffered a far greater neglect.[17] With the reorganization of its historical programming, Ottawa moved quickly to correct this imbalance. By the end of the 1960s, some thought the pendulum had swung too far. The *Toronto Globe and Mail* drew attention to an article in the spring-summer issue of *National Historic Parks News,* an internal Parks Branch newsletter, titled "Focus on Quebec." The issue provided a rough estimate of $5 million to be spent on fifteen historic parks in the province in 1971. Although the *Globe* reporter produced a different spending estimate, he did determine that capital spending on construction at historic parks was heavily slanted toward Quebec. Of nearly $3.5 million to be devoted to major projects, fully 79 percent was earmarked for the province, and over $.5 million of the remaining $700,000 was designated for further reconstruction work at Louisbourg. An unnamed spokesman for the branch pointed out that there was a "lot of catching up to do in Quebec" and that the government was using parks construction to aid areas struck by slow economic growth. Pressed, the spokesman also acknowledged a "determination by Ottawa to assert a greater federal presence in Quebec."[18] The *Globe* reporter snidely concluded that Quebec had thus achieved "its long-sought special status" and that "focus on Quebec" was indeed an appropriate title.

However, the spirit of B & B involved more than increasing the federal presence at Quebec's historic sites, and thus Canada's place in the interpretation of Quebec history. It also entailed employing historic sites in the rest of Canada. As with the B & B Commission itself, these developments were immediately controversial. When, in the summer of 1963, an *Ottawa Citizen* editorial proclaimed that the story of Upper Canada Village was connected to the history of French exploration, it provoked a flurry of angry letters. One, from R.C. Loucks, accused the newspaper of

"jump[ing] on the bilingual bandwagon," but most simply attempted to correct the paper's "misreading" of history.[19] In truth, the *Citizen*'s editorial had not misread the message of Upper Canada Village, but had instead wedged national unity issues into it: although Upper Canada Village commemorated the period long after the French regime, the settlement of the Loyalists owed a debt to French explorers who had opened the land for Europeans.[20] The *Citizen*'s claim was really just empty rhetoric. Nevertheless, it revealed the extent to which the spirit of B & B could inform interpretations of history, both among those who embraced it and those who rejected it. Language issues may also have contributed to the earlier collapse of a proposal to build a seigneurial village near Windsor, Ontario. The idea to create a replica eighteenth-century French settlement along the Detroit River, honouring the original European settlers of the area, was welcomed by Minister of Tourism James Auld in the legislature. But, although the minister endorsed the proposal, he committed no provincial funding, and local enthusiasm simply faded away.[21] Thus, an important precursor to Ontario's Loyalist settlers remained hidden in its touristic depiction of history.

The Cradle of Ontario History

The Fortress of Louisbourg was the most prominent expression of French history outside Quebec, and under Ronald Way it had been conscripted to the service of national unity. But the Government of Ontario was a significant partner to this mission. Premier Robarts did not just embrace the spirit of B & B – his government's tourism strategies helped promote recognition of francophone heritage outside Quebec. For example, it announced in 1964 that Sainte-Marie among the Hurons would be its third provincially controlled living history attraction. Like Upper Canada Village and Fort Henry before it, Sainte-Marie was intended to draw tourists to the province and therefore to be commercially viable. But whereas Fort Henry had been a restoration and Upper Canada Village was pure fantasy, Sainte-Marie was built on its own archaeological remains in the tradition of Harriette Taber Richardson's Port Royal reconstruction.

The original Sainte-Marie was a seventeenth-century Jesuit mission to the Wendat (or Huron) people, established in 1639 where the Wye River flows into Georgian Bay. It was the most important missionary and administrative centre for the Jesuit Order in the North American interior and was home to the eight Jesuit missionaries who were martyred during

the 1640s and later canonized as North American saints. Sainte-Marie protected the Jesuits and their allies when the Iroquois launched a war that overwhelmed the weaker Wendat Confederacy. Historians still disagree over what caused the destruction of Huronia, or what prompted the Iroquois to continue their offensive against other peoples living around the lower Great Lakes. However, by the spring and summer of 1649, the Wendat had been forced from their homeland. In the face of devastating losses, some Christian Wendat convinced the remaining Jesuits to abandon their mission at Sainte-Marie and flee. In the words of Father Paul Rageuneau, "we even applied the torch to the work of our own hands, lest the sacred House should furnish shelter to our impious enemy: and thus in a single day, and almost in a moment, we saw consumed our work of nearly ten years."[22]

For nearly two centuries, Europeans ignored this part of North America. Aboriginal peoples continued to make use of the land and rivers, with the Ojibwa pushing the Iroquois south of the Great Lakes in the 1680s. However, as the European fur trade expanded to the west, Europeans lost interest in the area between Georgian Bay and Lake Simcoe. British colonists arrived only in 1828. When they did, some recognized the ruins of Sainte-Marie as an "old French fort" and used its stones for their own houses and fences.[23] In 1844 and again in 1855, Jesuit priests visited the ruins, looking for the site where Jean de Brébeuf and Gabriel Lalemant were martyred.[24] The Jesuits celebrated the memory of the eight martyrs, and the search for their graves dominated historical interest in the area through the late nineteenth century and into the twentieth.

As part of the campaign to have the martyrs canonized, the Jesuits celebrated Mass at the ruins of Sainte-Marie in 1925. They then built the Martyrs' Shrine, a basilica overlooking the ruins, and four years later Pius XI conferred sainthood on the martyrs. Meanwhile, local residents continued to see the treeless fields around the Sainte-Marie ruins as an attractive picnic spot and an interesting setting for children's games. Then, in 1940, the Jesuits took another step toward reclaiming their heritage and bought the land where the ruins stood.[25] As early as 1947, they began to imagine a full-scale reconstruction and, to this end, invited archaeologists to dig. The first excavations were conducted by Kenneth Kidd and a team from the Royal Ontario Museum, but Wilfrid Jury undertook more elaborate excavations between 1948 and 1951. His work guided the eventual reconstruction.[26]

It was about this time that tourism promoter W.H. Cranston began to take interest. As he had elsewhere, Cranston saw historic sites as economic motors for the local economy. He had become convinced of the economic potential of tourism in the 1950s and joined the local tourist association. Working in association with Wilfrid Jury, he also opened a small museum in the form of a fantasy "Huron village" at Midland's Little Lake Park in 1956.[27] By his estimates, some 250,000 Catholic pilgrims visited the Martyrs' Shrine each year, and he recognized their commercial potential for Midland, the town that lay nearby. Indeed, Cranston hoped to make Simcoe County into a destination by using history to rebrand the area as "Huronia." A feature of the destination would be a living history replica of Sainte-Marie. As a well-connected Conservative Party organizer, Cranston had regular correspondence with senior Ontario cabinet ministers, and he used these opportunities to lobby for provincial involvement in developing Sainte-Marie. Finally, in 1964 the government established the Huronia Historical Development Council (HHDC) to advise the minister of tourism and publicity on the commercial potential of Simcoe County's historic attractions. Cranston naturally became president of the council and set about rebuilding Sainte-Marie.

In its brochures, the Sainte-Marie replica celebrated the original Jesuit mission as the cradle of Ontario history and presented itself as "an authentic, detailed reconstruction of Ontario's first European community."[28] Yet, despite this rhetoric, the heritage that the HHDC was hoping to appropriate for economic gain was really Catholic, Jesuit, and Wendat. Notwithstanding their approval of the project, senior cabinet ministers were anxious about its French and Catholic connotations. At a private meeting in the premier's office, Robarts met with James Auld, his minister of tourism, and Bill Davis, his minister of education. The three men were enthusiastic about the project, but they expressed some misgivings "concerning the ethnic and religious angle."[29] This potential for religious or ethnic tensions also weighed on the minds of HHDC members. In the 1960s, the population of Simcoe County was 23 percent Catholic, and just over 10 percent of its inhabitants claimed to be of "French" ethnicity, figures that roughly matched the province as a whole.[30] The district was not particularly "Orange," but these broad numbers hid local differences. For instance, in the 1840s a number of French Canadian families settled in the area around Penetanguishene, giving that township a stronger bilingual feel. Farther east, Rama Township was home to Anishinaabe reserves, created by the Williams Treaties of 1923. While overall

the county's demographics mirrored those of the province, these local dimensions left it susceptible to some ethnic and religious animosities. In June 1965, Bas Mason, the HHDC development consultant, warned Cranston about security risks at the site and asked to hire night guards. He was worried about accidental fires but also apprehensive about "wilful damage" from "a nut, marauding teenagers, an irrational anti-Catholic, and the fools who desecrate cemeteries and churches."[31] As the summer drew to a close, Mason again warned Cranston about Sainte-Marie's religious connection. He had heard Midland locals gripe about the almost daily coverage given Sainte-Marie by Cranston's newspaper, the *Midland Free Press*, and suspected a religious overtone to the resentment. Once again he advised reducing the emphasis on Catholicism in the site's publicity, as well as taking other steps to salve wounded religious sentiments. Such measures were especially necessary, given the Jesuits' plan to move their daily celebration of Mass from the Martyrs' Shrine to a proposed reconstruction of the Sainte-Marie chapel. Mason suggested opening the chapel to all-denominational services, which would require locating a cleric of the "right mindset."[32]

Yet, concerns about the narrow religious appeal of Sainte-Marie aside, Mason and Cranston were only too happy to direct their publicity toward a Catholic niche market. Mason wrote the leaders of North American Catholic associations and clubs, and suggested to secular tour operators that they might do the same. In more than one case, his pitch was explicit. Just after warning Cranston about the need to reduce religious emphases in their own publicity, Mason wrote Continental Trailways of Dallas, Texas, to suggest that Sainte-Marie might be "a sales attraction to students, scholars, educators, Roman Catholics and the public generally throughout the United States."[33]

For the provincial government, Sainte-Marie was part of its commitment to the spirit of B & B. After all, Sainte-Marie represented the French and Catholic origin of European settlement in Ontario, a fact that could help cement national unity. Even Mason recognized this value, listing the three objectives of the reconstruction as public education, an increase in tourism, and national unity. In a memo to Cranston, he mixed together these economic, political, and educational aspects. He suggested that the "improved relations between Quebec (and French language Canadians generally) and Ontario (and English language Canadians)" could be "the greatest benefit accruing from Ste. Marie ... not only from the revenue, which could be substantial from an almost untapped market, but from

the better relations on a people-to-people basis sparked by a common understanding and appreciation of a common heritage."[34] Father John L. Swain of the Jesuit Order concurred, hoping that the reconstruction would "make Canadians more appreciative of their common heritage and help to ease the tensions and strains of Canadian federation."[35]

Regardless of the reasons for developing Sainte-Marie, its connection to Ontario history had to be established if it were to be accepted as a part of the province's heritage. As Mason's memo suggested, French- and English-speaking Canadians had to be shown their common heritage. The difficulty lay in making Protestant, English-speaking Ontarians feel a connection between their own identities and an obscure French Catholic mission to the "savages." Yet, this link proved astonishingly easy to make. In a characterization that tapped into the province's "genesis complex," yet twisted its well-established public veneration of pioneers, Sainte-Marie was made to represent many of Ontario's historic firsts. Advertising pamphlets emphasized that the mission was the first European settlement in what would become Ontario, and the farthest outpost of "the whitemen" in North America. Thus, in this simplest of tests, it was a part of Ontario's heritage by virtue of a kind of racial geography. By building their mission on ground that would later become the province of Ontario, the Jesuit missionaries were founding modern Ontario, although they would never have thought in such terms. They erected its first European-style buildings, its first stone works, its first canal, its first Christian church, and its first hospital. They brought its first barnyard animals and many of its first European tools and artifacts. Historians might quibble that these accomplishments were ephemeral and that they had been abandoned for three hundred years, but this did not deter the HHDC. The seventeenth-century life of Sainte-Marie simply pushed back the origins of Ontario 150 years before the founding of Upper Canada. In heritage, nothing trumps "historic firsts." However, they inevitably involve selective readings of history's body of facts and a forgetting of contravening evidence. At Sainte-Marie, these firsts helped situate the Jesuit priests in a narrative of European conquest, even though Iroquois hostility had forced them to abandon the mission after only ten years. As it invited Ontarians to celebrate their Catholic precursors, the narrative supported at Sainte-Marie implicitly assigned Native peoples the role of the vanquished.[36]

In 1968, the Travel Research Branch of the tourism ministry conducted telephone surveys in Toronto and Midland to determine the degree of public knowledge about Sainte-Marie after five years of publicity.[37] The

survey was not particularly sophisticated, but its results were greatly dis-
appointing. Only 50 percent of the 324 Toronto respondents had heard
of Sainte-Marie. Far more of them knew about Upper Canada Village and
Fort Henry. Three-quarters of respondents in Toronto agreed that they
would like to spend "a day or more at each one of these sites," and nearly
85 percent felt that such sites "help to make us better Canadians." However,
when they were asked to choose which site they would recommend to a
twelve-year-old child as representative of Ontario's heritage, a distressing
pattern arose: only 12 percent picked Sainte-Marie as their first suggestion.
By contrast, 45 percent chose Upper Canada Village and 34 percent se-
lected Fort Henry. Indeed, when asked which they would recommend
last, fully 49 percent opted for Sainte-Marie. Virtually identical numbers
emerged when they were asked which site they would recommend to a
western Canadian or an American.[38] These results were borne out by
attendance figures. Despite being much farther from Toronto, Upper
Canada Village consistently drew many more visitors than Sainte-
Marie. Government officials worried that the public did not accept its
vision of Sainte-Marie as part of the province's heritage. Although the
branch put a positive spin on its report, these figures were especially
disappointing when two-thirds of visitors to the site claimed that it was
"much better than expected."[39] Ontarians, at least as far as Toronto resi-
dents were representative of them, preferred a myth of origins related to
the Loyalists, nineteenth-century pioneer settlement, and the War of 1812.
They did not connect with a seventeenth-century Jesuit mission.

B & B in Atlantic Canada

Language issues could both conceal and reveal aspects of Canada's history,
and controversies around language had a profound effect on the develop-
ment of many living history museums. On the Atlantic coast, the massive
reconstruction of Louisbourg seemed an ideal place to use history to
reinforce a new vision of national unity. Louisbourg itself represented
a very prominent relic of French history outside Quebec, which seemed
to accord nicely with the federal government's new commitment to pro-
moting bilingualism and biculturalism. Although the original mandate
of Louisbourg had little to do with B & B, Ronald Way seized on its spirit
when he recommended "that the message of restored Louisbourg should
be the story of progress of Canada's two major races from armed hostility
to their national partnership and unity in the Canada of today."[40] Indeed,
Way often insisted that his interest in living history and reconstructions

was rooted in his desire to promote national unity. His 1951 policy memo suggested fostering a new nationalism: "Some stress that they are French-Canadian, but all too few of us know what it is to be just plain Canadian and proud of it."[41] Of course, much of his work suggested an adhesion to a British concept of "just plain Canadian," but his attention to supporting national unity was ideal at Louisbourg.

To make Louisbourg accessible to French-speaking tourists, the park began hiring bilingual guides as soon as it opened. Six were on staff by the summer of 1970. Signs and pamphlets were also routinely printed in both languages.[42] And, although it made sense that French was prominent at a reconstructed French colonial seaport, staff nevertheless stressed that the sounds of French-speaking tourists added to its *historical* atmosphere. By speaking French, they enhanced the experience for other tourists by adding to that depth of experience sought by John Lunn. Although to Bill O'Shea, a fortress supervisor, "most" French Canadian visitors seemed to be bilingual, they preferred to speak their own language. "Legally they can speak whatever language they want," he said in an interview, but he himself would "like them to speak French in order to keep the French town atmosphere the Canada Parks Branch is trying to create here." O'Shea pushed the benefits for national unity even farther. Although visitors did not share their views with staff regarding "the bilingual-separatist struggle going on in Quebec," he could sense their "nationalistic pride" in finding a French historic site in a Scottish English province.[43]

Of course, O'Shea overlooked the possibility that many of the French-speaking visitors may have come from the prominent Acadian population of western Cape Breton Island. Indeed, the presence of Acadians in the Maritimes brought controversies over the spirit and policies of B & B to the east coast, particularly in New Brunswick. Language policies in that province were hotly contested and directly influenced living history. In 1969, alongside federal legislation, the New Brunswick government of Louis Robichaud passed an Official Language Act, declaring the province officially bilingual. The 1960 election of Robichaud had coincided not only with Quebec's Quiet Revolution, but also with a wider sense of Acadian heritage. Often styled the first Acadian premier of the province, Robichaud launched a series of initiatives to promote equality between its main linguistic groups. His government created an Equal Opportunities Program that was designed to reorganize the administration and

funding of school boards, primarily to increase opportunities for francophone communities. The 1970 election of a Conservative government did not alter this policy direction. In 1974, the government of Richard Hatfield adopted a recommendation to create parallel education administrations for the two languages, largely in response to demands from the province's Acadian community.[44]

Many New Brunswick anglophones pushed back, seeing the growth of francophone opportunities as the weakening of their own. Increased bilingualism, some imagined, would close access to jobs for unilingual New Brunswickers, making bilingualism in employment a particularly hot-button issue. In 1977, King's Landing Historical Settlement found itself caught up in the anti-bilingualism campaign of the Dominion of Canada English Speaking Association. Responding to advertisements for bilingual interpreters at the park, James Hall of the association wrote to complain that "this stipulation for employment is becoming all too frequent" in New Brunswick. He demanded that the ads be reissued without a requirement of bilingualism. He and his associates were particularly upset because "as residents of New Brunswick we are all well aware that in nearly ALL cases a bilingual person is a French person, thus discriminating against our unilingual English." Although he made no specific mention of the history depicted at King's Landing, Hall did insist that "there is no necessity for all employees to speak the French language" at King's Landing.[45] According to museum staff, King's Landing had trouble retaining bilingual employees, but with 20 percent of visitors being francophones, it saw bilingualism as an important objective.[46] Hall himself had no complaints about requiring two-language service at the province's other living history museum, the newly built Village historique Acadien.

On 28 June 1977, the Village historique Acadien opened its doors at Caraquet, New Brunswick. Acadian history had come to global attention through Longfellow's poem *Evangeline*, which gave the impression that the Acadians no longer existed. This view quickly became common sense knowledge as North Americans embraced Longfellow's story of romance and disappearance. Moreover, the deserted buildings and fields of the Dominion Atlantic Railway's Land of Evangeline in Grand Pré lent physical confirmation to that idea. The reality of Acadian history was much different. Although most Acadians had been deported from Nova Scotia and lived as refugees throughout Britain's mainland colonies, they were not passive victims, and exile did not destroy their culture. Historian Naomi

Griffiths argues that the consolidation of the Acadians as a people helped them survive the deportation and return home at the end of the Seven Years War. Despite a horrific death toll, loss of both property and political rights, and nine years of proscription, Acadian communities managed to sustain themselves. Many returned to Nova Scotia after 1764, when they were again permitted to own land in the colony. Instead of destroying the Acadian community, the deportation proved to be a source of power for the formation of Acadian identity in the nineteenth century.[47]

Arriving home, the Acadians discovered that their farms were now occupied by British settlers and that their newly restored property rights came with limitations. Forbidden to settle at their former centres of Grand Pré and Port Royal, many sought out new frontiers on Cape Breton Island and in what became the colony of New Brunswick. Through the nineteenth century, the Acadians of New Brunswick lived largely in isolation from the anglophone majority. After all, only in 1830 was the Test Act, which barred Catholics from holding public office, repealed. An Acadian was first elected to the provincial legislature sixteen years later. Economically, politically, and often geographically on the margins, New Brunswick's Acadians often lived as outsiders in their own homeland.

Outsider status did not prevent them from developing national ambitions. Like other communities of the late nineteenth century, they often turned to symbolic representations of national identity. In 1881, the first Acadian national convention met and declared 15 August, the feast of the assumption of the Virgin Mary, as the Acadian national day. At the second convention in 1884, Father Marcel-François Richard married the star of the Virgin to the French Tricolore to create the Acadian national flag.[48] And through the twentieth century, Acadians began to commemorate events from their local and national histories, culminating with the 1955 bicentennial of the deportation itself.[49] The success of the bicentennial inspired a drive for new cultural institutions. Around the same time, the Caraquet Chamber of Commerce was contemplating ways of drawing tourists to the remote Northumberland Strait coast of the province. It built a small museum with centennial funds in the 1960s and, among other plans for expansion, proposed a historic reconstruction along the lines of Port Royal or Grand Pré in Nova Scotia.[50] By 1969, this idea had developed into a reconstructed Acadian village, and the Acadian Village Committee was formed. The following year, at the request of the committee, the Province's Historic Sites Branch commissioned Peter John Stokes to report on the feasibility of interpreting Acadian history through

a village-style museum at Caraquet. Thus, the inspiration behind the Village historique Acadien brought together the optimism of the Acadian revival with the established post-war faith in tourism's potential to revive local economies.

Situating an Acadian history museum in Caraquet was in some ways a monument to the Acadian revival itself. Caraquet had been the scene of the violent climax of French-language suppression in the nineteenth century. In 1871, New Brunswick imposed a single public school system on Catholic families, denied public funding for denominational schools, and restricted education in French. To the province's Catholics, both Irish and Acadian, this law seemed to deny a right they had enjoyed in practice (if not in law) when New Brunswick joined Confederation. They took their protest to the federal government of Sir John A. Macdonald, which refused to overturn the provincial law. Its constitutionality was later upheld by the courts. However, some Catholics protested by refusing to pay their school taxes, and attempts by tax collectors to seize properties led to a riot in Caraquet. A few days later, further violence erupted when constables arrived to arrest suspected rioters, and two men were killed by gunfire.[51] It was a bloody affair in the province's history and certainly not one that 1970s New Brunswickers wanted to relive. Indeed, during the planning and construction of the Village historique Acadien, no one commented on the anniversary or the connections to the schools issue of a hundred years earlier, but no doubt many Acadians remembered.

Stokes visited Caraquet in early July 1970 and reported back to the director of research and development for the provincial Historical Resources Administration. His impressions were mixed. Over the course of a weekend, he had undertaken a "whirlwind tour" of the Caraquet area, a visit to the proposed village site, and an inspection of four buildings selected for the museum. He was particularly impressed with the natural setting and the architectural merits of the houses he saw: "The site proposed seems to have all the enchantments of remoteness, seclusion and a return to the natural. Some fascinating material has been recorded already, much of it particularly fascinating to the student of building technology and the architectural historian."[52] Yet, he remained cautious in his recommendations. He felt that the proposal was only preliminary and nowhere near ready for implementation. Further work was required to document the architectural history of the buildings and to solve site problems of access and services. Stokes recommended that more detailed arrangements be made to establish a competent organization to oversee

the research, construction, planning, and interpretation of the museum, none of which were yet prepared to his satisfaction.

Yet, even as Stokes urged caution, political imperatives lined up behind the project from a variety of sources. Since the early 1960s, the federal Liberals had been promising greater attention to Atlantic Canada's regional problems. Maritime leaders had begun to work together more closely in the mid-1950s, calling the first Atlantic premiers' conference and establishing the Atlantic Provinces Economic Council. Pushed by an alliance between New Brunswick's Robichaud and Nova Scotia's premier Robert Stanfield, the Pearson governments of the 1960s increased financial support for regional development. The regional development programs of the Diefenbaker era were expanded, and the Fund for Rural Economic Development (FRED) was established in 1966. Despite its name, FRED's mandate was broader than simple rural development. It was also intended to support programs in areas of social infrastructure. Attention to regional development in Atlantic Canada intensified after 1967, when Stanfield became the leader of the federal Conservatives. In 1969, Pierre Trudeau announced the creation of the Department of Regional Economic Expansion (DREE), headed by powerful Trudeau ally Jean Marchand and his influential deputy minister Tom Kent. Marchand and Kent had an expansive view of regional development, and they supplemented programs inherited from other departments with a comprehensive review of development policy. In short order, a new, decentralized approach to regional development became federal policy, which put significant power and resources in the hands of local officials in the regions and led to a "multi-dimensional approach" that called for federal-provincial co-operation and diversified the kinds of projects that could apply for DREE financial support.[53] Amendments to FRED compelled the Province to rush its decision to approve the Village historique Acadien only a month after Stokes had advised caution.[54]

If the Acadian village fit with the Trudeau government's regional development agenda, it also meshed nicely with its vision of Canadian bilingualism, and it especially highlighted minority official language groups. Indeed, the opening of the village coincided with important political events that had significant resonance in the offices of the Secretary of State for Multiculturalism. In October 1977, partly in reaction to the election of René Lévesque's separatist Parti québécois in the Quebec election of November 1976, and partly as a response to pressures from francophone minority groups outside Quebec, Ottawa announced

a 250 percent increase in funding for minority language groups.[55] The Caraquet project thus slotted into the Trudeau government's national unity agenda by highlighting the history of French Canada outside Quebec. Even its official English name, according to policy, was the French-language "Village historique Acadien," ironically in support of bilingualism. Indeed, one government official made this point directly when he argued (incorrectly) that "the project was never conceived as a Tourist attraction, but rather as a tangible way of paying tribute to our Acadian heritage and as an important educational tool in helping all New Brunswickers to better understand and appreciate that heritage."[56]

A central theme in the Acadian revival was the presumption that the Acadians were united by a tragic history.[57] In his feasibility report, Stokes had warned that the romanticization of this issue threatened to undermine the historical and educational value of the project as a whole. In his words, "the romantic trap of folklore" and the "sentimental embroidery of historical fact" distorted the real story. And, as he informed David Webber, the director of the provincial Historical Resources Administration, they "may well help to befuddle the mind."[58] But five years later, on a site visit to the partially built museum, Stokes changed his tune. He was impressed that the staff exhibited a "genuine attempt and desire to avoid false interpretations," and that buildings had been restored so that "the dignity of the whole has so far been remarkably well preserved."[59] Mason Wade, the leading American historian of French Canada, largely concurred. Although he maintained that the spacing of the houses was "out of character for an Acadian village, which is traditionally well nucleated," he agreed that great care and feeling for Acadian heritage had steered the interpretation.[60]

Despite intentions, the Acadian village was more successful as a community museum than as a tourist attraction. It never drew hordes of travellers to the remote Acadian Peninsula. Certainly, there was initial promise. Early media attention was positive from newspapers and magazines such as *Le Soleil, Le Devoir, Saturday Night,* and *Canadian Traveller.* Quebec's nationalist *Action nationale* even confidently predicted that 100,000 tourists would visit the museum every year.[61] The official opening was to be a national event, with invitations sent to the president of France, the prime minister, and the premiers of all the provinces, although some questioned the appropriateness of inviting René Lévesque.[62] Over a month after the museum opened for tourists, it was officially dedicated on the Acadian National Day (15 August). Combined with a music and

cultural festival, it was a celebration of Acadian culture. With one eye on Lévesque's recent election, Pierre Trudeau issued a statement that confirmed the importance his government attached to the Acadian revival: "The unity of this country is in fact tied more than ever to the future of French outside Quebec."[63] The Village historique Acadien was historical proof of the survival of French outside Quebec, built in three dimensions into the landscape. By implication, it too was tied to the unity of Canada. Yet, by the end of the decade, the provincial government lamented that even travelling New Brunswickers were largely unaware of this tourist attraction in their home province.[64]

Histoire Vivante?
The ironic outcome of this focus on national unity through biculturalism was the collective shrug with which francophone Quebecers met living history museums. Living history, at least in the guise familiar to the rest of North America, never caught on in Quebec. Certainly, there were early moments of enthusiasm. In 1964, a local historical society proposed developing a village museum in a municipal park in Bucherville. The proposal expired when it failed to win provincial support.[65] More promising was a venture in Chambly, a community some fifteen miles east of Montreal. The Village historique Jacques de Chambly was one of Canada's earliest post-war initiatives to build a living history pioneer village. The brainchild of Antoine Prévost, a Chambly antique collector and later a celebrated painter, it was named after the region's founding seigneur and was intended to preserve the architectural heritage of the Richelieu River valley in a "village that never existed."[66] In 1960, Prévost set up a foundation, the Société du village historique Jacques de Chambly, for the purpose of relocating and preserving some of the area's old houses and other structures. On 12 July 1962, Paul Gouin, the chairman of the provincial Historic Sites Commission (and the son of former premier Lomer Gouin) presided over the official opening of the Village historique Jacques de Chambly. Noting that the commission had already restored a number of old churches and houses in the area, Gouin nevertheless remarked that the village museum concept was something different. "The whole Richelieu valley is a history lesson," he told those assembled before a recently rebuilt stone house from St. Hubert, and so "the location of the historical village, in the centre of this region, could hardly be improved." But moreover, unlike the solitary restoration of a church, for example, the creation of a historic village would draw tourists, just like the pioneer

village museums of Ontario. The village would make "a wonderful attraction for tourists in an important historical region heretofore largely overlooked."[67] Of course, at the time of Gouin's speech, there were only three houses and some outbuildings on the two-hundred-acre village site. These buildings were filled with antique furnishings from both Prévost's collections and those of other dealers and collectors from as far away as Montreal. Plans were in place to add within five years a chapel, an inn, a school, a sawmill, a stockade, a convent, and a trading post, among other proposals. Thus, the village would be "complete" by 1967, the year of Canada's centennial and Expo.

At about the same time, the provincial government was examining alternative ways to preserve Quebec's historic character. Although Ottawa had taken the lead in the province, restoring Fort Chambly and Fort Lennox, and undertaking a massive renovation of Quebec City's gates and walls, the provincial government also promoted historic sites in the 1960s. A vastly more activist provincial state characterized the Quiet Revolution. For instance, the Province revived its Ministry of Education and inaugurated a Ministry of Cultural Affairs. Legislation passed in 1963 restructured the 1920s Historic Monuments Commission, giving it a wider mandate and specifically linking it to the Ministry of Cultural Affairs by appointing the minister as one of its seven commissioners. Moreover, the new law empowered the commission to recommend the establishment of historic districts and then, once created, to regulate renovations on any structures within the district. This power took precedence over any municipal by-laws.[68] This was a striking departure from the Province's pre-1960s approach, which had carefully guarded the rights of individual property owners. Historic districts, by contrast, represented a statist intrusion into the display of history, one intended to preserve the character of the built environment in a way that coexisted with modern life.

The government's decision to control the province's built environment emerged from concerns over the effects of urban renewal on Quebec City. The catalyst for action was protest over the building of a modern hospital wing to the city's Hôtel-Dieu hospital on the edge of the old walled town. Some Montrealers were also nervous about what the future held for their city's historic core. In 1961, Eric McLean, music critic for the *Montreal Star,* bought the dilapidated family home of Louis-Joseph Papineau on Bonsecours Street in the old city. McLean paid for its restoration, based on a sketch of 1885, and chronicled the work in the *Star.*[69] Spearheaded in part by McLean's efforts, city council decided to establish

a preservation committee for Old Montreal, which was authorized by the Province in the summer of 1962. The Jacques Viger Commission, named for Montreal's first mayor and chaired by Paul Gouin, recommended that the City preserve Old Montreal, an area covering roughly the walled town as it stood at the Conquest. The Historic Monuments Commission then declared Old Montreal a historic district in 1964, granting the Jacques Viger Commission authority to control property development.[70] Despite this, the law was applied so that the city's financial district, St. James Street, was largely unaffected, permitting the Banque Canadienne-française to erect a thirty-two-storey skyscraper, designed in the monolithic international style, in the heart of the historic area.

Historic districts were also established in the province's smaller towns, such as Sillery, Charlesbourg, and Beauport. But when the legislation was written, no one anticipated the suggestion that fantasy villages should be designated. Nevertheless, in the winter of 1964, the Corporation du village historique Jacques de Chambly asked the Historic Monuments Commission to declare the village, then only a handful of relocated buildings, a historic district. The corporation had important allies in Gouin and Chambly's representative in the provincial legislature, the highly influential cabinet minister Pierre Laporte. Despite some opposition on the commission, Gouin secured the historic district designation for a fictional village comprised of relocated and rebuilt structures that had been removed from their original environment. This was an unusual precedent and one that has never been repeated.[71]

Despite this protection, the Village historique Jacques de Chambly remained on shaky financial ground. A membership roll from May 1964 listed $81,840 in contributions from 703 subscribers to the village fund, divided between lifetime members and annual subscriptions. One-time payments from lifetime memberships had raised $62,000 from a group of forty-odd subscribers who contributed between $500 and $2,000 each. This group included some of Quebec's leading philanthropists, such as Hartland de Montarville Molson and members of the Birks, Bronfman, and Eaton families. Annual subscribers, on the other hand, pledged nearly $20,000 in 1963–64. The majority of donations, 399 of the total, were annual contributions of $10 each.[72] Even assuming that every annual member renewed each year, this revenue could never support an ambitious plan of reconstruction. Only a year after becoming a historic district, the village lost its provincial subsidy, and it became insolvent. Its major creditor, Montreal Trust, seized the property, after which the village sank

into abandon. The Maison St. Hubert that Gouin had opened only three years earlier became the property of the Quebec Ministry of Cultural Affairs. Threatened by the nearby excavation of a quarry, the historic properties around the Maison St. Hubert eventually fell into the hands of the municipal government. A second effort, christened the Village historique de Carignan, was launched toward the end of the 1980s, but it never fulfilled its promise of the early 1960s.[73]

Governments and private associations continued to restore and preserve specific historic structures, but the trend toward living history that swept English-speaking Canada in the 1960s and 1970s largely passed over Quebec. Elsewhere, the Province revealed an interest in developing the tourist potential of its resources. In the mid-1960s, the provincial government converted a pulp and paper ghost town, Val-Jalbert on Lac-Saint-Jean, into a recreational park to help attract tourists into the Saguenay region.[74] Val-Jalbert developed at the start of the twentieth century around a paper mill at the waterfalls near the mouth of the Ouiatchouan River. The town prospered and grew quickly, but its life was short. In 1927, the mill closed its doors and Val-Jalbert emptied as quickly as it had grown. The townsite itself became the property of the Quebec government in the 1940s, which, having little use for it, converted the empty buildings into a setting for camping at the start of the Quiet Revolution. Today it is managed by the Province's campgrounds company Sepaq, and although it is now a living history site, this development came only in the 1990s. Only one other pioneer village or living history museum opened in Quebec during the 1970s. Some hundred kilometres northeast of Chambly, in Drummondville, another non-profit corporation developed the Village québécois d'antan. It was designed for the Drummondville Chamber of Commerce by Claude Verrier, who was hired to research the history of a family of early Eastern Townships settlers and their ancestral home. The idea for a pioneer museum emerged from this research. The Village québécois d'antan, which opened in 1977 on the bank of the St. Francis River, depicts Eastern Townships life between 1810 and 1910.[75]

There are a number of possible reasons why francophone Quebeckers did not embrace the living history museum concept with the enthusiasm of their English Canadian compatriots. The pioneer village model, for instance, has only partial resonance for the settlement history of Quebec. Early settlement along the St. Lawrence Valley followed the linear, riparian pattern of the seigneurial system. Even as population densities increased in the eighteenth century, *habitant* farmers eschewed villages, preferring

to live on their farms. At the time of the British Conquest in the mid-eighteenth century, the St. Lawrence Valley was more properly one ribbon of settlement from Quebec City to Montreal. Village life was not the norm. Certainly, there were some villages in the French regime, but their development advanced only after 1815, multiplying tenfold between 1800 and 1850.[76] The pioneer village model for living history better captures the later migration away from the seigneurial lands of New France toward the north and the Eastern Townships, which explains why the Village québécois d'antan in the Townships is Quebec's only museum that follows the pioneer village tradition.

A second reason why Quebecers did not embrace living history could relate to its nationalist origins. Canada's living history movement sprang from the preservation of historic forts and fur trade posts, beginning with those developed by the federal Parks Branch in the 1920s. Much of this built heritage is associated with the record of British victory, often over the French. As the rise of living history coincided with the Quiet Revolution and the emergence of an assertive Québécois nationalism, it is perhaps not surprising that there was little appetite for bringing memories of past losses to life. The nationalist project of the Quiet Revolution involved setting that past aside and building a modern Quebec. However, it would be wrong to push this argument too far. The federal government began paying more attention to sites in Quebec, especially historic houses associated with George-Étienne Cartier and Wilfrid Laurier, in the 1960s and 1970s. And some military sites attracted even nationalist attention. Fort Chambly certainly had its champions. In Quebec City, the Plains of Abraham and the historic fortifications were cherished space, and in Montreal, the fort on Île Ste-Hélène was restored during the Great Depression. Converted to a museum in 1955, the Montreal Military Museum added summer re-enactments of drills of the Compagnies franches de la Marine and the Fraser Highlanders in the 1960s, funded by David Macdonald Stewart, the Scottish-born heir of the Macdonald Tobacco fortune.

Moreover, Quebec was attuned to the economic and regional development potential of heritage tourism. Quebec City had been trading on its historic character since at least the 1830s.[77] In the post-war years, especially after the start of the Quiet Revolution, the provincial government became more involved in the management of this economic sector. Alongside its interests in hydroelectricity, steel, and finance, it played a significant role in directing local museums. Prior to that, local museum momentum in

Quebec did not compare to the pioneer movement that materialized in the local historical societies and conservation authorities of Ontario. Early in the Quiet Revolution, the government announced plans to increase the number of local museums to promote the study of history, a program that expanded after the 1976 election of the Parti québécois (PQ). A 1940 survey identified only thirty-one historic museums in Quebec.[78] By 1968, twenty-eight new cultural institutions had opened across the province, and their numbers continued to grow over the next two decades. After 1972, when the federal government also allocated $10 million to museums in Quebec, their number rose from 125 to over 380 by the mid-1990s. The PQ government stressed accessibility and a "new museology," which had at its root the preservation of Quebec's cultural heritage for public use.[79] Thus, whereas the living history movement, as characterized by the pioneer village model, had its roots in local historical societies and an amateur tradition of museum display, museums in Quebec looked to the leadership of the Ministry of Cultural Affairs and state funding.[80]

Under state guidance, local museums in Quebec soon came to espouse an alternative model to living history: the ecomuseum. Established in France at the end of the 1960s, the ecomuseum model spread across Europe, supported by the International Council of Museums. It reached Quebec by 1979, with the opening of the Écomusée Haute-Beauce near St. Hilaire. Precise definitions vary, but an ecomuseum can be understood as a local museum of many buildings spread over a significant territory that interprets human life in tandem with local geography, ecology, and botany. Most importantly, in its classical definition, an ecomuseum is jointly controlled by an institution and a local community. It is a model that can incorporate living history museums, and indeed Skansen's directors have now adopted it. However, its impact in Canada was not felt until the 1980s and 1990s.

Conclusion

What message about Canadian dualism – the spirit of B & B – did living history sites send to Canadians and foreign tourists? There is no easy answer to this question. Like most museums built to represent the past, those displaying French Canadian heritage outside Quebec placed a premium on historical accuracy. They were planned with sincerity and an honest effort at honing a positive message. One might quibble with specific decisions in the design, interpretation, or displays at a particular museum, as Mason Wade did at Caraquet. However, if we look only at six

of the most popular sites representing a French heritage outside Quebec, the message is not unlike the one imagined by nineteenth-century imperialists as they groped for a way to reconcile the French past with Canada's imperial present. Indeed, the oldest representations of French heritage outside Quebec, Port Royal and Grand Pré, were planned and developed by people who reached adulthood before the First World War.

The overwhelming message that living history museums teach about French Canada is one of loss. Certainly, Grand Pré, steeped in the myth of Evangeline, presents a tragic story of a people overcome by developments. A similar case might be made for the short-lived Jesuit mission at Sainte-Marie. It had been destroyed in advance of an Iroquois attack, although its survivors eventually escaped to the relative security of life near Quebec City. Even the Port Royal reconstruction, built in the 1930s as a monument to the founding of European civilization in North America, conveyed, in its own way, a message of the disappearance of the French. Throughout the 1960s and 1970s, when other historic sites were being populated by costumed interpreters and animators, visitors to Port Royal could walk its uninhabited rooms. The silence suggested that Champlain and company had simply disappeared. Louisbourg, despite Ronald Way's insistence that it represented the coming together of Canada's "two founding peoples," was also a site of conquest, as J.D. Herbert pointed out. In his award-winning tales of Louisbourg, former park researcher Christopher Moore summed up its human legacy with telling prose:

> Some of the Louisbourg exiles eventually became the founders of France's foothold on the fishery, the little colony of Saint-Pierre and Miquelon. Some went out to Louisiana, the Caribbean, South America, even the Far East. Others stayed in France to find new careers in the port cities or to subsist on royal pensions. Some died in the French Revolution, some thrived in it, and slowly they rejoined the mainstream of French society.[81]

The absence of the phrase "some went to Quebec" is striking. Only Ontario's Old Fort William could lay claim to depicting French and English Canadians working together to build Canada, although the founder of the Laurentian thesis would have disputed the conclusion. The message of living history outside Quebec during the era of B & B was one of conflict, not cohabitation.

10

People and Place

In October 1971, shortly after the Royal Commission on Bilingualism and Biculturalism (B & B Commission) finished its work, Pierre Trudeau stood in the House of Commons and announced a program of grants, studies, and cultural incentives aimed at supporting Canada's various ethnic communities:

> It was the view of the royal commission, shared by the government and, I am sure, by all Canadians, that there cannot be one cultural policy for Canadians of British and French origin, another for the original peoples and yet a third for all others. For although there are two official languages, there is no official culture, nor does any ethnic group take precedence over any other. No citizen or group of citizens is other than Canadian, and all should be treated fairly.

Continuing on this theme, the prime minister announced a new cultural policy for the country: "A policy of multiculturalism within a bilingual framework commends itself to the government as the most suitable means of assuring the cultural freedom of Canadians."[1] Within two years, this policy had been enshrined at Canada's newest living history museum, Old Fort William, whose 1973 opening ceremonies were pronounced a multicultural afternoon of "pure Canadiana."

Multiculturalism thus wound its way into Canada's living history museums, although often with mixed results. More crucially, some people seized on living history as a means to tell the stories of their own communities and assert their place in Canada's history. At first, these efforts fell prey to the popular culture expectations that were typical of tourist industry promotions. Yet, as case studies of Ukrainian and Mennonite Canadians on the Prairies and Scots in the Maritimes reveal, living history museums could be more than tourist attractions. They also had the potential to be archives of community memories.

A Policy for All Canadians

As a government policy, multiculturalism emerged directly from the fourth volume of the B & B Commission's final report. Titled *The Cultural Contribution of the Other Ethnic Groups* and published only in 1969, the volume was an afterthought. There is no doubt that the commission politicized ethnic minority organizations. Commenting on obstacles to its work, its co-chair André Laurendeau noted that, as far as western Canada was concerned, support for multiculturalism was the chief objection to entrenching equality between French and English:

> First and foremost this means the reality of "ethnic groups" who, strangely enough, seem to believe that to grant something to French is to take something away from them, or at the very least to create an unjust situation: for if they accept to a great extent the necessity of losing their languages, why shouldn't everyone in Canada have to do so?[2]

Laurendeau was clearly dismayed that people saw French Canadians as just another ethnic group instead of a distinct and founding Canadian society. As Volume 4 proclaimed, even multiculturalism was to be considered within the framework of the host English- and French-speaking societies, according to the terms of reference that established the commission. The report explicitly denied the existence of multiculturalism as a "third force" in Canadian politics, but it nevertheless recognized the desirability of incorporating minority languages and cultures into national life and national policy.[3] To this end, the commission made sixteen specific recommendations for cultural institutions, such as the CRTC, CBC, universities, and the National Film Board, to include, publicize, research, or better finance programs to support the cultural contributions of "other ethnic groups."[4]

A considerable mythology has developed around the initiation of multiculturalism as federal policy by Trudeau's declaration in the House of Commons. It is often heralded (and occasionally condemned) as the beginning of official multiculturalism and the creation of a vast bureaucracy devoted to supporting folk dances and food festivals across the country.[5] Actually, Trudeau only proclaimed the creation of a program of grants, commissioned studies, and cultural incentives. In fact, as Opposition leader Robert Stanfield pointed out, all the government announced was a general principle in support of multiculturalism within a bilingual country and that "resources permitting," it might find ways to

assist cultural groups. This was a broad recognition of Canada's cultural diversity, and after noting that many of the B & B Commission's recommendations had already been developed into existing programs, the prime minister placed responsibility for refining the policy with the Citizenship Branch of the Department of the Secretary of State.[6] In this way, two years after the appearance of Volume 4, Ottawa came to accept the general principle of multiculturalism.

However, though Trudeau's initial statement was vague enough to endorse many types of support, the 1972 general election convinced the Liberals to use multiculturalism in a more partisan manner. The election reduced the Liberals to a slim plurality of seats, largely at the expense of the Progressive Conservatives. Official bilingualism was one feature of the party's campaign that weakened its public support, at least outside Quebec, and following the election the government decided to stress its more popular multicultural policy. A Liberal MP of Polish descent, Stanley Haidasz, was named minister of state for multiculturalism, even as the program itself remained in the Citizenship Branch. That one government program was given its own minister suggests the importance that the Trudeau administration now attached to the multiculturalism file. Another indication was its budget. In May 1973, Haidasz announced funding increases for multiculturalism programs from $4 million to $10 million.[7]

Over the subsequent decade, multiculturalism program funding continued to escalate. Spending was spread out over nine subprograms, including Canadian Identities (song and dance), Ethnic Group Liaison, Ethnic Press Analysis Service, Immigrant Orientation, Multicultural Centres, Multiculturalism Studies Program, and Non-official Languages Teaching Aids. Multicultural museums received only a pittance of this program funding. In the 1974–75 fiscal year, only 6 of 640 grants, amounting to less than $25,000, went directly to museums, although they may have benefitted indirectly from the 39 grants to cultural centres or the 264 grants for festivals and folk dancing.[8] Multiculturalism program funding is clearly not sufficient to explain the opening of living history exhibits of minority groups. Nevertheless, in the era of official multiculturalism, a culture that valued ethnic minority identities helped some groups to build living museums that told of their story in Canada's history. And certainly, this culture of inclusion helped build the case for funding support from other government programs at the federal and provincial levels. As the spirit of B & B had influenced some living museums, the spirit of multiculturalism encouraged the emergence of others.

A Mosaic of the Folk

In fact, the celebration of multiculturalism began long before Trudeau announced his response to Volume 4. Multi-ethnic celebrations, such as Toronto's Caravan (established 1969) or Winnipeg's Folklorama (1970), were contemporaries of the work of the B & B Commission. Multiculturalism in living history – at least as expressed through depictions of minority cultures in the museum displays – also has a pedigree reaching back to the early years of the movement. The folk dances seen at Fort York in 1934 were repeated elsewhere during the post-war years. And some museums sought to establish "ethnic" displays in their permanent exhibits. For instance, although some five thousand Chinese had moved to Barkerville shortly after the first Cariboo gold strike died down, the early promotional pamphlets for Barkerville made no mention of this. Gradually, however, officials began to recognize the need to tell the whole history of the town. In 1957, the secretary of a Chinese Freemason lodge wrote to the BC deputy provincial secretary L.J. Wallace to ask about the possibility of restoring the Chinese Masonic Lodge in Barkerville, which he believed was the first of its kind in Canada.[9] However, efforts at inclusion often drew on stereotypical images. At Burnaby's Heritage Village Museum, original plans included developing a Chinese herbalist exhibit. This was achieved by mid-decade, when the contents of the Way Sang Yuen Wat Kee shop from Victoria were set up in a newly built replica store in Burnaby.[10] At Barkerville, Cockfield Brown's 1965 scripts for radio advertisements featured the town's "Chinese gambling house" as an attraction for tourists.[11] And two years prior, while encouraging L.J. Wallace to develop the Barkerville ads, Gordon Hilker also suggested an expansion of its tourist service and entertainments:

> I also feel we should take another look at starting a *Chinese laundry*. All this needs is a small cabin and elementary equipment. Here is a chance to involve Bill Hong in active participation which might have far reaching results in other ways. This would provide a genuine service to hard-pressed campers although I think we would have to estimate a loss of around fifteen hundred dollars on the season even assuming Hong can arrange for two Chinese who will work the kind of hours necessary.[12]

It is hard to imagine tourists taking a greater appreciation of the lives of Chinese Canadians from such an exhibit.

Much of Canada's support for multiculturalism stems from a mythologized understanding of the immigrant experience, especially the immigration boom and "open door" policy of the Laurier governments in the early twentieth century. Many people believe that the country was built by an unprecedented (and unrepeated) wave of immigration, and thus in this view official recognition of ethnic diversity is warranted. In his classic discussion of multiculturalism, Howard Palmer characterized Canada's approach to integrating non-British immigrants before the 1920s as Anglo-conformity. As he explained it, Anglo-conformity was more than just an insistence on assimilation to British values and traditions. Built into its assumptions was a belief in a hierarchy of races, with those closest to the British situated at the top of the hierarchy. At the opposite end were the allegedly inassimilable races, which would need to be barred from Canada. All the major books on immigration in this period, works including *Strangers within Our Gates, The Education of the New-Canadian, Handbook for New Canadians,* and *A Study in Canadian Immigration,* despite their many differences, shared these assumptions of Anglo-conformity.[13] However, in the 1920s, some thinkers began to speculate about new approaches to immigrant assimilation. Growing concerns over nativism following the First World War led a new generation of writers to argue that assimilation was a two-way street that was producing a new Canadian type. Although it was not always clearly distinguished from Anglo-conformity, these writers imagined a new society evolving from the "contributions" of various cultural groups. Moreover, in the late 1920s, alongside these nascent ideas of assimilation, some writers began to accept notions of cultural pluralism.[14]

Peter Henshaw argues that the Scottish novelist and statesman John Buchan, also known as Canada's fifteenth governor-general, Lord Tweedsmuir, brought a multicultural sensibility with him when he came to Canada in the fall of 1935. During his time in Canada, Tweedsmuir repeatedly stressed the value of cultural diversity within the British Empire, something that Henshaw attributes to his two years of diplomatic service in South Africa.[15] More conventionally, the origins of multicultural sensibilities are connected to the growth of interest in folk culture that spread across the country during the early decades of the century. Initially the preoccupation of "scientific" collectors such as Franz Boas and Marius Barbeau, folk music, art, and customs had also become popular entertainment by the 1920s. Under the guidance of its publicity agent, J. Murray

Gibbon, the Canadian Pacific Railway sponsored a series of sixteen folk and music festivals between 1927 and 1931. Although their primary goal was to fill CPR hotels during the off-season, these festivals were instrumental in introducing Canadians to the Old World costumes, song, and dance of Canada's ethnic minorities. The CPR's competitor, the Canadian National Railways (CN), likewise encouraged an acceptance of diversity, and its promotions underscored its own role in assimilating Canada's multi-ethnic population. Yet, while its programs blithely assumed the superiority of Anglo-Canadian culture, and relied heavily on stereotypes of Ukrainians, Poles, Hungarians, and Jews, they also highlighted the suitability of such people to life in Canada.[16] Moreover, Gibbon's book *Canadian Mosaic* suggested a new way of looking at immigrant groups. By seeing each culture as tiles in a mosaic, Gibbon suggested that each one retained its own distinctiveness while also contributing to a larger pattern of national culture.[17]

To be sure, both the CPR and CN had commercial motives for promoting a form of multiculturalism, or at least multi-ethnic immigration. Immigration schemes in the interwar years relied on Anglo-Canadians' conceptions of ethnic acceptability, unofficially classifying migrants as "preferred," "non-preferred," and "special permit." Although this terminology did not appear in official documentation, Brian Osborne asserts that correspondence between bureaucrats was awash with it. However, the railways were anxious to increase passenger traffic on their extensive prairie lines, and the "non-preferred" migrants from eastern and central Europe offered the only viable source of passengers. The railways thus used their publicity campaigns, each in their own way, to combat the xenophobic tendencies of mainstream Canada.[18] Although both companies acted primarily to protect their own commercial interests, equally both were committed to promoting culturally diverse immigration.

During the Second World War, ideas such as Gibbon's were woven into government propaganda. Shortly after the war broke out, the newly created Bureau of Public Information (BPI) sought to mobilize Canadians without resorting to the demonizing of "enemy aliens" that had characterized First World War propaganda. At the same time, concerned that foreign subversive elements might undermine the patriotism of ethnic minorities in the country, the BPI and its successors promoted cross-cultural understanding. Watson Kirkconnell's booklet *Canadians All: A Primer of Canadian National Unity*, issued in 1941 by the Director of Public

Information, was the best-known example of the campaign. Linked to a series of radio broadcasts, the book was illustrated with still shots from the National Film Board's 1940 *The Peoples of Canada*.[19] Ostensibly, the film was intended to remind viewers that Canada was a blend of many peoples, but its parade of "traditional" costumes and dances recreated the folk-festival image of non-British ethnicity and quaint cultures. The National Film Board followed it up with wartime titles such as *Ukrainian Dance* (1943), *Poland on the Prairies* (1944), *Habitant Arts and Crafts* (1944), *New Scotland* (1943), and *Polish Dance* (1944). Wartime propaganda produced a filmic version of the ethnographic folk festival. Folk festivals and demonstrations of folk cultures continued to express these simplified ideas of cultural pluralism through the post-war years.

Multiculturalism can be distinguished from ideas such as pluralism and diversity. In its colloquial sense, the word refers to the value of diversity. In its stricter sense, multiculturalism as elaborated by the Secretary of State after 1971 established relationships between the state and specific ethnic communities through their civil society organizations. It thus further legitimized ethnicity as a category of Canadian society, which was later entrenched in section 27 of the Charter of Rights and Freedoms, and in the Multiculturalism Act of 1988. More importantly, multiculturalism backed away from some of the implications of B & B in that it rejected the notion of an official culture. Although the Official Languages Act of 1969 had implemented the B & B Commission's recommendation to establish French and English as Canada's official languages, the policy of multiculturalism defended the equality of all cultural groups in Canada. In the Commons, Trudeau insisted that "there is no official culture, nor does any ethnic group take precedence over any other."[20] But underlying both the official and the colloquial forms of multiculturalism is a historical premise. Multiculturalism recognizes the fundamental importance of migration to the historical development of Canada and holds all migrant groups, defined in ethnic terms, as equal.

More importantly, multiculturalism in its colloquial sense was embraced by many Canadians, especially those of neither British nor French ancestry, long before the B & B Commission began wrestling with the realities of cultural diversity. This understanding of multiculturalism confirmed people's sense of their own identity and their families' place in Canadian life. Moreover, post-war Canada became increasingly multi-ethnic, especially during the 1970s after the Immigration Act was amended to aid the

arrival of people who had once been considered inassimilable. Collo-quial multiculturalism thus offered confirmation of Canada as a nation of migrants.

Migration is a difficult topic to interpret at a living history museum. It is the process of the movement of people, as individuals, families, or oc-casionally in masses, around the globe and through time. Living history museums, as a product of their efforts to portray authentic settings, do not easily depict mobility and the passage of time. Their displays are nor-mally confined to a specific time period because doing otherwise would expose them to accusations of anachronisms. Moreover, built into the landscape, they present an almost timeless sense of the past as interpret-ers repeatedly perform the same period tasks. Their exhibits present domestic stability, not a history of upheaval and migration. This is not to suggest that museum programs ignored migration as a subject. However, the look and feel of the past that they portray stressed daily life in a specific time and place.

Living History on the Prairies

During the hearings of the B & B Commission, Ukrainian Canadians led the fight to expand national cultural identity beyond a narrow British-French conception.[21] Given their lengthy history of activism, it is perhaps not surprising that Ukrainian cultural organizations were well positioned to build aspects of their material heritage into the Canadian landscape. Ukrainian Canadians had long been involved in collecting artifacts of material culture and amassing them in museums. In the years before the Second World War, many became sensitized to their cultural survival, and thus they welcomed opportunities to nurture Ukrainian cultural and political identity.[22] The first collecting, early in the twentieth century, was related to folk drama groups that needed props. Gradually, however, Ukrainians incorporated their folk culture into mainstream displays of dance and handicrafts, including Gibbon's CPR festivals.[23] These initia-tives spurred government involvement in collecting Ukrainian folk artifacts, such as the efforts by the Museum of Man under the direction of Marius Barbeau.

Agitation against the perception that the B & B Commission had ignored so-called third-force minorities propelled the Ukrainian cultural groups into the political limelight during the late 1960s. However, activism in-volved more than just lobbying the government. It also produced a series of initiatives to promote Ukrainian Canadian culture. The Canadian

Institute of Ukrainian Studies was organized at the University of Alberta in 1976, which helped support the publication of books about Ukrainian Canadians as well as articles through its own *Journal of Ukrainian Studies*. This was not a feature confined to Ukrainian Canadians. Ethnic studies, and especially ethnic group history, flourished in the 1970s. In part, this was related to broader historiographical trends, promoting social history over the older political story of nation building. But it was also a direct result of specific post-1971 policies to fund multiculturalism and of the more generalized "spirit" of multiculturalism that pervaded Canada in the decade. As Howard Palmer notes, "pressure from increasingly articulate central and eastern European minorities" pried loose funds to provide research grants for the study of Canadian ethnicities. It helped establish academic journals, such as *Canadian Ethnic Studies,* and it stimulated the development of organizations such as the Mennonite History Society of Canada, the Jewish History Society of Canada, and, of course, the Canadian Institute of Ukrainian Studies.[24]

In 1971–72, some Albertans of Ukrainian descent banded together to build a pioneer village to preserve their heritage. Like many other private initiatives, they organized themselves into an association – the Ukrainian Cultural Heritage Society – and sought out threatened artifacts. Armed with a $177,000 federal grant, they began building the Ukrainian Cultural Heritage Village at the eastern entrance to Elk Island National Park, forty kilometres east of Edmonton.[25] By 1974, they had relocated or erected eighteen buildings at the site.[26] Their aim was to recreate the rural experience of the Ukrainian migrants from Galicia and Bukovyna who settled in east-central Alberta. But at first, the buildings served primarily as galleries for traditional museum displays. Moreover, the displays were typical of popular culture imaginations of western Canada and TV images of the American west. This began to change with increasing professionalization, brought about, in part, by government attention to multiculturalism. In 1975, the provincial Department of Culture and Multiculturalism assumed control of the village and, although remaining true to the original idea, sought to redesign its message. Advised by a newly created Ukrainian Cultural Village Advisory Board, comprised of members of local cultural organizations, local government officials, and the provincial MLA, the Province revamped the museum to more carefully reflect the settlement history of Alberta. During this process, it also paid closer attention to the authenticity of the buildings themselves, altering and remodelling reconstructed examples or replacing them with more historically accurate

replicas. This concern for accuracy fed into a research program that studied landscaping, townsites, settlement patterns, and farm layouts typical of Ukrainian migrant communities of the early twentieth century.[27]

After half a decade of study, the Province undertook a major capital development program in 1981. The new message aimed to recreate "the full breadth of lifestyle experienced by the residents of east central Alberta prior to 1930."[28] In the renewed museum, buildings were reimagined from structures that housed galleries to an integral part of the story being told. Different types of buildings were then incorporated into the story of Ukrainian settlement in Canada and served to represent the typical architecture of townsites, rural communities, and farms in various stages of development before the Great Depression. Buildings were moved around the site to spots that better provided a setting for the display of material culture.[29] The addition of first-person animation brought the past to life and transferred the museum into the living history category during the 1980s.

The Mennonite Heritage Village Museum at Steinbach, Manitoba, followed a similar pattern, in part because Mennonites and Ukrainians simultaneously developed strategies to create a place for themselves in the broader Prairie society.[30] The museum commemorates the Mennonite migration to North America that began in 1874, when pacifist Mennonites left the Russian Empire to avoid compulsory military service. Canada, and especially the Prairie provinces, was attractive because of its flexible policies on landholding, which permitted block and village settlements, as opposed to the American preference for individual homesteads. Many Mennonites settled near Steinbach, southeast of the developing city of Winnipeg. By the 1930s and 1940s, a number of people sought to establish a Mennonite Historical Society to help preserve their heritage. However, a formal Mennonite Historical Society of Manitoba organized itself only following the Second World War, first in 1953 and then at a second meeting in 1958. Among its first objectives was the establishment of a Mennonite museum and heritage centre to hold artifacts and documents relevant to Canadian Mennonites. By 1964, this centre had become the Mennonite Heritage Village Museum, which opened to the public in 1967.[31]

This museum was more than an expression of colloquial multiculturalism. It was also part of a significant shift within the Canadian Mennonite community toward greater engagement with mainstream Canada. Anabaptist Mennonite tradition had long maintained a separation between

the brethren and other Canadians. However, in the post-war years, particularly during the 1960s and 1970s, Mennonites moved from rural enclaves into the modern and urban environments of Canada. In Manitoba, the process of becoming part of the wider provincial community involved new publications, broadening Mennonite education, and establishing new cultural institutions.[32] This transformation was neither easy nor uncontroversial. The Anabaptist Mennonite tradition, like those of many religious groups without centralized leadership, was fragmented and splintered. However, a majority of Mennonites embraced greater integration and sought ways to stake a place for themselves in Canadian society. For instance, radio station CFAM was established in Altona, Manitoba, and although it was not strictly a Mennonite station, it adopted the tradition of Prairie radio-evangelicalism to promote a more pluralistic Mennonite message.[33]

Recasting memories of the Mennonite experience in Canada was part of this strategy of integration and the reformulation of Mennonite identity. For instance, on the heels of a similar transformation in the United States, which produced a four-volume history *The Mennonite Experience in America* in the mid-1960s, the Ontario and Manitoba Mennonite Historical Societies combined to commission their own Canadian history. Frank H. Epp, then an Ottawa pastor, was selected to write the first volume, which appeared in time for the 1974 centennial of the Mennonite arrival in Manitoba.[34] Epp's history, *Mennonites in Canada,* was only one of a flood of commemorative books published in conjunction with the centennial. The Mennonite Heritage Village Museum also played a role in the centennial. In 1969, CFAM followed a broadcast of one of Arnold Dyck's popular Low German comic plays with a special program about the museum and its collections. Later, historian Gerhard Ens made use of the radio to broadcast a series on the migrations of the Russian Mennonites as a special commemoration of the centennial.[35] Otto Klassen's film *Prairie Pioneers* linked the centennial of the Mennonite arrival to other special events in the province, including a royal visit in 1970 and a Thanksgiving celebration. Simply holding the centennial celebrations was itself a tactic of integration. Its commemorative plaque, placed inside the Manitoba legislative building in December 1974, depicts a farm family, father, mother, and son, gazing the length of a freshly ploughed field toward (presumably) their homestead. Although the plaque expressly identified the arrival of the Mennonites, its depiction of rural Manitoba would have been acceptable

to many rural communities. Its image of prosperity and progress, which would have resonated across the province, was given physical proof at the heritage village. A living history museum helped Mennonites reimagine their place in Canada's cultural mosaic, within the context of Trudeau-era multiculturalism.[36]

Both the Ukrainian and Mennonite villages invoked the image of the "pioneer" as a means to stake legitimacy in multicultural Canada. Already proven popular at Canada's living history museums, it played a similar role in both the Prairies and Ontario. It provided legitimacy. It helped construct a myth of origins and borrowed from the "man-versus-nature" ethos. The commemorative plaque in the Manitoba legislature states simply, "We came. We toiled. God blessed." Thus, the Mennonite and Ukrainian village museums contributed to the telling of a multicultural past by proclaiming that the Mennonites and Ukrainians were among the first settlers, the pioneers who built a modern Canada. In anticipation of the centennial, the Mennonite Historical Society gathered stories of pioneer life over the course of 1972 and 1973, and published them in 1975.[37] However, as Jean Friesen points out, the pioneer image is a bland, populist, and neutral version of the past. It surfaces at summer folk festivals, such as Winnipeg's Folklorama, and at the Pioneer Days festival held every August at the Mennonite Heritage Village Museum in Steinbach.[38]

As if on cue, the Mennonite Heritage Village also released its first pamphlet guidebook – *Mennonite Village Museum* – in 1975. That spring, some seven thousand children visited the site on school trips, a demonstration of the museum's popularity. Revised and expanded in 1979, and again several times during the 1980s, the guidebook told the story of the arrival of the first Mennonites from Russia. And the museum continued to grow, with the addition of a semlin (sod house) and log house in time for Pioneer Days in the summer of 1979.[39] Although it tried to explain the distinctiveness of the Mennonites and their beliefs, *Mennonite Village Museum*'s account of settlement was much like that of other pioneer village museums. Its focus on nineteenth-century material culture, which did not set apart the Mennonites in the nineteenth century, helped ease distinctions between the Mennonite past and that of mainstream Canada. What was unique was the distinctive architecture and the Low German language, which was highlighted by the glossary of the 1984 edition of the booklet. Not everyone was happy with the folked-up version of Mennonite history. To some, its emphasis on ethnicity and material culture seemed to lead away from spiritual renewal, which Frank Epp insisted should be

the goal of remembering the past.[40] Nevertheless, the portrayal of the Mennonite past at the Steinbach village fit well with the spirit of multiculturalism. It added to the prairie landscape three-dimensional proof of the pioneering contributions of "ethnic" Canadians.

Memories of Place

Another museum that benefitted from government benevolence through programs celebrating multiculturalism (as well as promoting regional development) was the Nova Scotia Highland Village Museum. It was a dream of Nova Scotia's long-serving Liberal premier Angus L. Macdonald. While attending the 1938 British Empire Exhibition in Glasgow, Macdonald had seen a mock-up of a Hebridean village. For an additional fee, visitors could escape the exhibition's triumphant modernity and slip back to the simpler times of a Highland *clachan*. Modelled on a similar display at the Glasgow Exhibition of 1911, the clachan combined the real with the imaginary, the authentic with the false. It was a classic fairground folk village. Peopled by Gaelic-speaking Highlanders, it offered displays of household tasks undertaken in reproduced cottages from across the Hebrides, set around a meandering brook that disappeared into a painted backdrop of a generic Highland loch. The clachan was a controversial addition to the show, with many critics complaining that its anachronistic, primitive, and pre-industrial caricature distracted from the modernist theme of Scotland's progress, which underpinned the fair.[41] Yet, despite the criticism, it was popular, and over 1.5 million visitors paid the supplement to have a look. Macdonald was enthralled and dreamed of building a copy in Nova Scotia as part of his plan to promote Scottish-themed tourist attractions in the province.[42] However, although it sprang from Macdonald's fertile imagination, the Highland Village Museum owed more to the politics of regional development and multiculturalism of the 1970s.[43]

World events put Macdonald's dream on hold, as he moved from Halifax to Ottawa to serve in the wartime cabinet of Mackenzie King. After returning to Nova Scotia as premier, he called a meeting in Halifax in 1953 to discuss the possibility of building a clachan or *shieling* on Cape Breton Island. There was already a "lone shieling," a single replica settler's croft, constructed in 1942 in the newly opened Cape Breton Highlands National Park. Essentially an empty house, it was one of the early attractions placed in the park.[44] Macdonald's scheme was to be a grander tourist draw than a single cabin. He envisioned a full Highland village, almost exactly as he had seen in Glasgow. However, he did not live to see the realization of his

dream: he died in his sleep in April 1954, a few days after suffering a heart attack.

The other men at the 1953 meeting, C.I.N. MacLeod and W.L. Fillmore, carried the plan forward. After Macdonald's death, his seat in the legislature was draped in Clanranald tartan and sprigs of heather adorned his desk. It seemed a fitting tribute to a man who had loved his Scottish heritage, but MacLeod and Fillmore wanted something grander. They turned his hopes for the Highland Village Museum into an unofficial memorial. They secured blueprints for the 1938 Glasgow clachan from its architect and presented them to the Nova Scotia Association of Scottish Societies in 1954.[45] The following year, the association itself made a formal request to the Province that it fund six initiatives to promote Scottish-themed tourism in Nova Scotia, the first of which was "the establishment of a Highland Village at a place with a recognized Scottish environment."[46]

Despite many protests from rival communities, including a strong argument for Pictou, where the *Hector* had disembarked 189 Scottish settlers in 1773, organizers fixed early on a Cape Breton site for the museum – Hector's Point, near the village of Iona.[47] Centrally located on Cape Breton Island, this site offered a number of justifications. It was sufficiently inland to lure tourists off the beaten track, which was a major imperative of official interest in the project, and there was a convenient parcel of land for sale.[48] It was also close to the birthplace of Angus L. Macdonald. Like many living history museums, the Highland Village project was designed to connect the economic benefits of post-war tourism with the education of citizens. Not only would it promote Nova Scotia's Scottish image to tourists, it would also ingrain it in the personal identities of residents. As Fillmore explained, "the highland village should not only be looked upon as a tourist attraction. There are many other advantages too long to go into here, one of which is to incorporate the educational angle."[49] The village would be a tangible link to life in Scotland and physical evidence, if admittedly manufactured, of the transatlantic transfer of Scottish culture to the New World.

The highlight of the reconstruction was the Tigh Dubh, or Highland Blackhouse. In MacLeod's plan for the village, it was the first structure to be built.[50] In his view, a "typical blackhouse" was a rough stone structure with a sod roof. The interior, at least at Hector's Point, was divided into three rooms. Usually, a blackhouse had just one door and no windows, except perhaps for a hole in the ceiling above the main living quarters. In the central room, a single fire pit burned peat for warmth, and the

smoke was vented, without benefit of a chimney, through the opening in the roof. The floor was earthen.[51] This was a stereotype of primitive living that fit nicely with twentieth-century imaginations. Although such housing was common in the Outer Hebrides early in the nineteenth century, when many of the Clearance migrants left the Highlands, it significantly underplayed the development of Scotland and presented the Highlands as a romanticized place removed from history. The inclusion of the Tigh Dubh, situated near the entrance to the museum, connected Nova Scotia's Scottish ethnicity to a primitive world separated from the challenges of twentieth-century modernity. It implied a connection between old and new Scotlands. Most obviously, the structure spoke to the ethnic origins of Nova Scotians. It connected them to their ancestral homes in the Highlands and Islands of Scotland, and it emphasized commonness. This was the root of the Cape Breton Highland culture that the village sought to memorialize. Yet, the Tigh Dubh also represented a boundary. It separated life in the Old Country from the conditions of the new one. It pointed to a heritage, but not one that persisted in the New World. It represented a way of life left behind in Scotland.

The quick building of the Tigh Dubh was a false start, and little more was accomplished before the early 1970s. MacLeod and Fillmore incorporated a Highland Village Society (HVS), and local boards of trade and tourist associations exchanged notes on what the museum could accomplish for the local economy. But little in the way of construction was carried out. The HVS, a voluntary organization, relied on the free time and donations of residents in an economically depressed region of the country. The same collapse of the Cape Breton steel and coal industries that had spurred Ottawa's involvement at Louisbourg hampered fundraising and dampened prospects for this new and untested endeavour. In 1962, the HVS organized Highland Village Day, a gathering of pipe bands for concerts on the first Saturday in August. Until the 1970s, this was its main fundraising mechanism, and it never produced sufficient revenue to carry out the full construction. After a small exhibition building opened in 1966, the museum operated on a budget assembled from gifts, minor donations, and the proceeds of its annual festival. This financial insecurity really changed only in the years that followed the federal government's direct involvement in the coal industry. In the mid-1960s, the Dominion Steel and Coal Corporation abruptly announced that it was abandoning the coal-mining business, prompting Ottawa to appoint yet another royal commission to investigate Cape Breton's coal-mining industry. The Donald

Commission recommended that Ottawa assume responsibility for the mines through the creation of a Crown corporation, the Cape Breton Development Corporation (Devco) in 1967. At first, Devco concentrated on running the nationalized coal mines, but its mandate also included weaning the region's economy off coal and planning for economic diversification. Particularly after Liberal Party strategist Tom Kent took charge, Devco's efforts involved stimulating tourism resources on the island. By the early 1970s, it had embarked on a policy of small grassroots enterprises linked to Cape Breton's natural resources and the service economy as the path to diversification.[52] The Highland Village Museum was a natural fit for this local, small-scale kind of development assistance, and Devco's construction of a motel next door enhanced the synergy. By 1974, Devco's grant to the museum had grown to more than $60,000. Although Devco never underwrote the entire venture or took an ownership stake, its support permitted sufficient stability to develop the village.[53]

The original plan had called for replicating the Highland village seen at the Glasgow exhibition. However, the next generation of planners turned this idea into a commemoration of their own particular history in the New World. Crafted with the help of Barry Diamond of the Technical Division of the provincial Department of Industry and Development, 1971's master plan helped steer the museum in a new direction.[54] Instead of a series of Highland cottages, the village would represent the stages of material improvement that the Scots had undergone once they reached Canada, although elements of Highland primitiveness remained in the finished product. New buildings were added gradually over the first half of the 1970s. As at other living history museums, some were period structures moved from original locations and others were new constructions modelled on the styles of the past. By 1975, when expansion halted, the museum had eleven of its planned twenty-six buildings in place and was hosting between ten and twelve thousand visitors a year.[55] What was less typical of living history museums was the deliberate reference to historical change. The village was laid out so that visitors moved more or less clockwise through the decades of the nineteenth century. From the Tigh Dubh, they progressed to a log house of 1810, the centre chimney house of 1829, the central hallway house and school of 1865, and the 1920s general store. The message of progress was clear. As the generations passed, each built better and larger homes, formal educational institutions appeared, and eventually, by the 1920s, so did a commercial complex.

Conclusion

The cultural communities that designed living history museums intended to move beyond the happy folklore of food and dance festivals. Thus, the Highland Village, the Mennonite Heritage Village, and the Ukrainian Heritage Village were planned as expressions of community identity as much as they were intended to attract tourists and educate the public. As expressions of community life, they relied on donations from community members to fill out their displays of furniture, decorations, domestic wares, and tools. Many Cape Bretoners felt connected to the Highland Village and trusted it with their family heirlooms, and probably with their old junk as well. There is no handy list of donations to the museum, as artifacts began arriving at Hector's Point before there was much of an organization to properly collect, let alone catalogue, them. By 1964, the museum had gathered nearly eight hundred objects from across Nova Scotia, with an estimated value of nearly $5,000.[56] In 1968, the HVS reported on its holdings to the provincial Department of Trade and Industry. Prefacing a general description of the collection, the curator offered this observation: "The contents of the Museum are made up [of] primitive tools used by the early settlers after they came to this country from Scotland ... With very few exception[s] the articles in it were donated chiefly from Victoria and Cape Breton Counties."[57] This collection was an archive of local and personal memories that commemorated the life and labour of past generations. These material traces of the past were memory prompts that helped people define their identity as Nova Scotian Scots. They linked their family histories with Scottishness, as proclaimed by the Highland Village Museum. Similar stories built the collections of the Ukrainian and Mennonite Heritage Villages.

With their emphasis on community participation, these museums resemble the ecomuseum model that became popular in Europe by the end of the 1970s. Indeed, in 1991–92, the Ukrainian Heritage Village was incorporated into the Kalyna Country Ecomuseum, twenty thousand square kilometres of nature and historical interpretation centres spread around east-central Alberta. Like living history museums, ecomuseums broke the mould of the traditional museum by literally expanding their displays beyond the four walls of their buildings.[58] Their development was led by Georges Henri Rivière and Hugues de Varine, two of the founders of the International Council of Museums, who laid out an inclusive and ethnographic vision for local museums. The first ecomuseum, the Maison des

techniques et traditions ouessantines, opened in July 1968 on the Île de Ouessant, a windswept, rocky island famous for its lighthouses and flocks of dwarf black sheep, twenty kilometres off the coast of Brittany. It consisted of three houses, a windmill, and the surrounding countryside, on the surface closely resembling the Canadian living history model.

Rivière and de Varine believed that ecomuseums should emphasize ecology and the environment. However, in the ecomuseum world, "environment" is not restricted to ecology and biology, but also includes human land uses.[59] Moreover, as the rural environment of France was transformed during the second half of the twentieth century, as in much of the industrialized world, the preservation of rural places became an increasingly urgent concern for some museum professionals. Combined with imperatives to develop faltering local economies, the preservation of local identities prompted new experiments in museum structure and mission toward the end of the 1960s.[60] Indeed, Rivière also brought to the model his deep roots in French ethnography and an interest in interpreting human history through artifacts. Definitions worked out during the 1970s developed principles of community participation that became central to his "evolutive" or flexible definition in which an ecomuseum is an institution operated jointly by a public authority (the state) and a local community: "It is a mirror in which the local population views itself to discover its own image ... It is an expression of man and nature. It situates man in his natural environment. It portrays nature in its wilderness, but also as adapted by traditional and industrial society in their own image."[61] Rivière went on to emphasize the diversity with which expressions of the passage of time and interpretations of the uses of space might combine, so that, although the Ukrainian, Mennonite, and Highland Villages were not planned as ecomuseums, they exhibit the same inspiration and sensibility that made ecomuseums appealing.

This brief comparison suggests that the ecomuseum model presents an alternative for the portrayal of a society's history. For Rivière and de Varine, the ecomuseum was at once a research centre, an interpretation centre, and an educational facility that addressed the human and natural past of a particular region. If it were to flourish, it must acquire local participation and local consent. In this sense, it is better characterized as neither an amateur museum nor a local museum, but as a participatory one that invokes both popular consent and scientific expertise. Connected to concerns about local economic development, using tourism's potential to draw investment and employment into the countryside, the ecomuseum

sounds strikingly similar in goals to English Canada's living history museums, especially those dedicated to particular local or ethnic communities. However, ecomuseums are not living history museums in the same sense. Although they can involve elements of living history, such as demonstrations of and participation in traditional forms of rural work, these are not necessary to the model. Examined from the other side, it is possible to see living history museums as a subset of ecomuseums. As Peter Davis and others suggest, ecomuseums are museums of local distinctiveness and archives of place. Their individuality, rooted in local environments, conserves primarily memories of place.[62]

The museums discussed in this chapter also reveal some ways in which living history museums failed to achieve inclusiveness. Efforts to include ethnic minorities often diluted their stories or consigned them to stereotypical portrayals that would probably have reinforced discriminatory attitudes. The solution of organizing ethnic community histories in distinct museums, although it involved organic participation by community members, ironically mirrors some of the earlier practices of ethnology. By separating a cultural group's historical development into its own enclave, these museums repeated the "othering" practices of early-twentieth-century ethnologists. Similarly, interpreters in traditional costumes recalled the colourfully dressed performers of the CPR folk dance shows. The continuity should not be overstated. With their emphases on material culture and everyday life, these museums offered portrayals of lifestyles that closely resembled the "mainstream" communities depicted at other pioneer village museums. And they played important roles in supporting cultural life for Canadian communities. Since the 1960s, ethnic folk festivals have become increasingly significant for the development of Ukrainian music, and the Ukrainian village provided an outlet for contemporary cultural expression.[63] Similarly, the Nova Scotia Highland Village became a centre for nurturing Gaelic culture on Cape Breton Island. However, these were expressions of culture that reflected the spirit and aspirations of modern multiculturalism as much as they represented the histories of Ukrainian, Mennonite, and Scottish Canadians.

11
Genuine Indians

ETHNOLOGICAL DISPLAYS OF Aboriginal artifacts were central exhibits in the first North American museums. Yet ironically, living history museums of the 1960s largely excluded Canada's First Nations from the stories they told. The silence was not absolute. Many museums planned some reference to the Aboriginal past that preceded European settlement. In the 1940s, the Fort Langley museum displayed "Indian tools," as well as photographs of Native people, two totem poles, baskets, arrowheads, and wooden implements.[1] These were the static museum displays of ethnologists and anthropologists that reinforced the "otherness" of Native peoples and emphasized their separation from the history of European explorers and settlers. Likewise, when Canadians built replica "Indian villages," they did not animate them to create living museums. The normal practice, where such replicas existed, was to create an Aboriginal ghost town. In 1956, W.H. Cranston built a replica Wendat village in Midland, Ontario, based on some of Wilfrid Jury's archaeological excavations. At Doon Pioneer Village in Ontario, the original plan included "Indian Habitations" near, but not in, the settler village. Calgary's Heritage Park likewise had an "Indian village" of empty "teepees," erected beside the main village in 1964.[2] Some museums actually rejected the idea of incorporating indigenous peoples into their interpretation programs. King's Landing staff opposed as anachronistic the idea of including an "Indian encampment" in its Loyalist village setting, although George MacBeath, the deputy minister, suggested that the Province build a replica of Fort Meductic, a fortified eighteenth-century Maliseet village farther up the Saint John River.[3] Across the country, depictions of indigenous people at living history museums were sporadic and often idiosyncratic. Moreover, they reflected the prevailing beliefs of white, middle-class Canadians about Native people.

In 1965, Fort Chambly came under criticism for its depiction of Native people, and the parks service responded by planning amendments to its

information booklet to deal with "the role of Indians more accurately."[4] The exact nature of the complaint is not clear in the documentary evidence but neither is the meaning of the word "accurately." Even at places where one might expect to find First Nations history, it was often absent. A 1968 survey of visitors to Sainte-Marie among the Hurons recorded public astonishment at the absence of Wendat at the site. Some suggested the addition of "statues of Indians" or of more "Indian relics" to tell the story of the "lost Huron nation." At least one respondent thought that the museum should hire "genuine Indians in full costume" to make Aboriginal history come alive.[5] As the final chapter in this book reveals, living history museums left much to be desired when it came to portraying (or failing to portray) Aboriginal people. Yet, although the living history movement often borrowed from antiquated ideas of ethnology and early anthropology, it suggested ways for Native people to seize control of the depictions of their history. Nevertheless, it also raised questions about just what "genuine" meant when applied to First Nations histories.

The Vanishing Indian

Through much of the twentieth century, North Americans were convinced that Native peoples were doomed to extinction. Particularly in the United States, ideas about "Indians" had changed during the nineteenth century. Whereas once they were feared adversaries, America's Anglo elites saw them as tamed and unthreatening by the century's end. Thus, they could be recast, at least symbolically, as the first Americans, though Native peoples themselves did not benefit from this changed perception. For Americans, it was conditioned by a fundamental crisis in national identity, triggered by non-white immigration. Aboriginality was as much about defining "true" Americans, in opposition to the latest migrants, as it was about finding a place in American society for First Nations.[6] Indeed, the "first Americans" were expected to wither away. Compared to the glorious future that Americans imagined for themselves, the culture, artifacts, and history of Native peoples looked meagre. They were, paradoxically, seen as societies without history, yet consigned to history. Lacking in architectural accomplishments comparable to those of European societies, they had left behind few great ruins or physical legacies to inspire romantic imaginations of a forgotten history.

Canadians largely concurred with this American view. Indeed, it was the "fact" of their imminent demise that made Native people such attractive subjects for artistic portrayal. Painters from Paul Kane to Emily Carr and

others depicted a vanishing culture and sometimes imagined themselves saving it, if only symbolically, from extinction.[7] Marius Barbeau bewailed the plight of Canada's Native populations. Their culture, he lamented, had been reduced by popular entertainments to mere caricature, and his anthropological evidence convinced him of their inevitable disappearance from the continent. But many others saw this as no real loss. Stephen Leacock neatly encapsulated the standard view that North America's Native peoples existed in a Stone-Age or pre-civilized state. Their passing was not something to regret, but a necessary step for civilization in North America.[8]

By contrast, collecting artifacts from cultures on the verge of extinction fed North American interest in folklore and ethnology, and Aboriginal imagery was popular. Through the twentieth century, many may have believed that the actual people were vanishing, but this only strengthened the appeal of what Daniel Francis so aptly calls the "imaginary Indian." Often depicted through an ahistorical assemblege of cultural forms, the imaginary Indian characteristically wore the elaborate ceremonial dress of the Plains peoples, which many Canadians believed to be "typical" of all Native peoples. It was a racial discourse, created and directed by the descendants of the colonial powers in the New World. European exhibits of the Plains-inspired paintings and costumes of the American artist George Catlin of the 1840s, coupled with illustrations in the more scientific works of Maximilien Philipp, prince of Wied-Neuwied, generated a European expectation for particular images of North American peoples. This image was fortified by coverage of the American Plains wars and the phenomenal success of Buffalo Bill's Wild West Show, so that by 1900 the image of the Indian in buckskin and war bonnet had become standardized.[9] Stereotyping could sometimes be well meaning. Archie Belaney, an English immigrant from Hastings, combined various tropes and clichés to invent an Aboriginal identity for himself. As Grey Owl, Belaney advocated conservation and respect for nature by "playing Indian" for middle-class audiences that were eager to believe their own stereotypes about Native people. Hollywood and television westerns marketed the image further as North Americans were inundated with commercial uses of Indian images. Stylized, or stereotypical, depictions of Aboriginal people were used as branding tools, selling everything from tobacco to motorcycles. Even a small shopping centre in Toronto, the Don Mills Centre, used an "authentic Indian village and Indian tribal dancers" to lure shoppers to its annual "western days" sale in the 1960s.[10]

Indian images could be used in numerous ways. For instance, Sharon Wall's discussion of antimodernism at Ontario summer camps highlights the allegedly therapeutic value that some people attached to letting their children "go Native," if only for a few hours at a time. Playing Indian offered middle-class children an intense emotional experience. Although this seemed to run counter to the professional advice on properly socializing children, it was acceptable in the context of summer camp because Indian culture was seen as close to the natural world and thus healthy.[11] Here, in a nutshell, was the hypocrisy of the Indian image laid bare. The image was employed to legitimize and market modern social practices and goods, yet the actual people were consigned to another, more primitive and static existence in the past. While the travelling public may have desired "authentic" or "genuine" Indians, public historians had difficulty managing the contradictory impulses that this entailed.

Indian Troubles

Not everyone agreed that Aboriginal history was adequately covered by erecting a few "teepees" at pioneer villages. No sooner had the Ontario government announced plans to rebuild Sainte-Marie among the Hurons than scholars rallied against it. W.H. Cranston complained to the deputy minister of tourism that an archaeologist from the University of Toronto, J. Norman Emerson, was belittling the project. Emerson was concerned that its senior archaeological adviser was Wilfrid Jury, whom he dismissed as an amateur. He suggested involving professional archaeologists from the Royal Ontario Museum, the University of Toronto, the federal Historic Sites and Monuments Board, and the National Museum, and he felt that final authority should be placed in the hands of the Archaeological and Historic Sites Board of Ontario. The minister of tourism tersely replied that the board was already involved in the project.[12] However, the board's role was largely restricted to the involvement of its chairman, W.H. Cranston, as Sainte-Marie's champion.

A number of factors played into this dispute, and J. Norman Emerson was not someone to be ignored. He had studied at the Universities of Toronto and Chicago, and had been appointed to Toronto's Anthropology Department in 1946 to create an archaeology program. Emerson is often considered the first scholar to develop a serious program for archaeological training in Canada, and he was a founder of both the Ontario Archaeological Society (1951) and the Canadian Archaeological Association

(1968).[13] His doctoral research examined Wendat archaeology, and he was understandably uneasy with the government's choice of an amateur to shape public perceptions about Sainte-Marie. Simply put, Emerson did not trust Jury, whose findings never appeared in accredited scholarly journals. Jury did more than confirm this mistrust when he rushed out a reprint of his book in 1965, without taking into account the new evidence uncovered since its initial publication a decade earlier. It was for this reason, at least in part, that Emerson wanted to involve professional archaeologists and anthropologists in the research. He understandably wanted to get it right.

More importantly, Emerson did not accept Jury's theories. He disagreed with Jury's claim that a canal ran through the mission, what Cranston called the "locked waterway," as well as the size and placement of almost the whole of the Sainte-Marie excavation. Many people might dismiss these reservations as academic quibbles, but they are important issues. Uncertain of how to interpret the dispute, the editor of the *Orillia Packet and Times* seized on the part that he could understand to criticize Sainte-Marie:

> In archaeological circles, no doubt, this is a serious matter; to the general public, it is unlikely to stir much feeling. For the main thing which most people here in Orillia, Midland, and Huronia generally are anxious to see is a development of their great historical sites; the differences of opinions between locations of walls and accuracy of detail is largely a matter of academic interest. Certainly it is difficult for any layman to pass an opinion on the conflicting claims.

It certainly is difficult for laymen to pass an opinion on such matters, and raising the issue was possibly the newspaper's subtle dig at Jury's credentials. Nonetheless, the editor proceeded to offer his own opinion, proclaiming Jury's theories "absurd," based on the "most rudimentary military knowledge." He concluded with this advice: "Yet regardless of errors or imaginings, the important thing from a tourist point of view is to have the fort re-built. But it would surely be as well for the accuracy of these matters to be checked while yet there is time, so that the fort could be as much like the original as possible."[14]

In some ways, Jury invited this kind of criticism. He was quick to take offence when challenged and refused to engage in scholarly debate, preferring to restrict his contact to amateur historical societies. He was largely self-taught and his doctorate only honorary. Consequently, he was

not respected by professional archaeologists. Thus, many academics were outraged when the *Packet and Times* claimed that the government intended to place Emerson's research with the University of Toronto under the supervision of Jury and the University of Western Ontario. Not surprisingly, such a suggestion, however false, infuriated professional archaeologists and anthropologists. Emerson mustered near unanimous support at a March 1964 meeting of the Northeastern Anthropological Association in Hamilton and pointed to "widespread concern" about the project and Jury's involvement with it.[15] Even W.H. Cranston confessed that Jury's reputation was questionable and had nearly kept him out of the project.[16]

Emerson's own research was at what he had identified as Cahiagué, one of the largest and most important of the early-seventeenth-century Wendat villages. He had linked the site with Cahiagué as early as 1951 and had established a field school there by 1961. This site was near Orillia, and so the attention to the Sainte-Marie excavations near Midland, only about thirty miles away, naturally inflamed festering municipal jealousies. The *Packet and Times* clearly misinterpreted the situation in March 1964, when it denounced a proposal to build a replica Cahiagué at Midland instead of Orillia. In fact, there was no plan at all for Cahiagué. "We were a little alarmed," announced the president of the Orillia Historical Society, "that Cahiagué, like Brigadoon, had suddenly disappeared overnight."[17] The *Packet and Times* quickly allied itself with Emerson, and the feud simmered through the spring and summer of 1964. In this dispute, academic concerns became confused with political ones. The contest pitted the interests of Orillia against those of Midland, the second- and third-largest towns in Simcoe County. Midland, with a population of about ten thousand in the 1960s, was considerably smaller than Orillia's sixteen thousand, although both were dwarfed by Barrie. Cranston, a prominent Midland booster, was not well liked in Orillia. Likewise, the Huronia Historic Sites and Tourist Association ridiculed both Orillia's city council and its chamber of commerce, claiming that neither had paid its dues and so deserved no input on tourism matters. Jim Lamb, the editor of the *Packet and Times*, was unrelenting, complaining that "the so-called historic sites grow like mushrooms around Midland but Cahiagué, perhaps the most significant site in Huronia, lies dormant."[18] Cranston himself felt that this was simply a case of "everybody gets everything but me," and to some extent he was right.[19] Lamb saw a connection between the lack of development at Cahiagué and the lack of a cloverleaf interchange at Highway 11 and West

Street, a major east-west axis in Orillia. He also advanced a more conspira-
torial explanation, noting that the premier, John Robarts, was a graduate
of Western. Lamb thought it curious that the Province would follow the
lead of the University of Western Ontario and its "questionable" archae-
ologist, Dr. Wilfrid Jury.[20]

Cranston worried that the criticism of his friend was unfair and that
Emerson and Lamb, among others, had simply launched an unfortunate
personal vendetta against Jury. Sainte-Marie, he repeatedly noted, was of
international significance, whereas Cahiagué was not really of interest,
even to the majority of Orillians. Of course, Emerson did not help his
own credibility by coupling his complaints about Jury and the Sainte-
Marie reconstruction with a request to have his own funding increased
from $5,000 a year to $25,000. This would finance a summer archaeo-
logical school for high-school students, something that Jury also had in
mind for Sainte-Marie.[21] Eventually, Emerson fell out with his supporters
at Orillia. He had arranged some funding for his summer school through
the local chamber of commerce, but after a single season he was accused
of losing interest. The students did not help, either. Some had been caught
breaking into barns, cutting wood on private property, and otherwise
misbehaving while under Emerson's tutelage. Moreover, there was a mis-
understanding about money between the professor and the chamber of
commerce. Cranston could barely contain his glee when he informed the
minister that Emerson had moved on to other projects.[22]

However, it would be inaccurate to attribute Emerson's reservations
solely to a rather minor squabble of egos. Although Cranston insisted that
his concerns were "a fair bit off base in nearly every respect and certainly
not supported," the minister of tourism asked to see them in writing.[23]
Cranston, of course, lacked the expertise to make such an assessment.
Moreover, the evidence he worked from was entirely supplied by Wilfrid
and Elsie Jury. Still, a few months later, he had to admit that Emerson had
some valid points, though he would not say so directly to the archaeolo-
gist. Instead, in February 1966, nearly two years after Emerson first raised
his concerns, the minister of tourism informed him that his questions had
been "fully examined" and that the matter was now closed. He then pro-
ceeded to lecture Emerson on the difficulties of archaeological science.
The problem, as he explained to the distinguished archaeologist, was
that archaeology was complex and its evidence often obscured by subse-
quent land uses as well as earlier excavations. Surprisingly, Emerson swal-
lowed this insult to his credentials and informed the minister, somewhat

sardonically, that he looked forward to reading the answers to his questions in subsequent scholarly publications.[24] And while Cranston patted himself on the back for having rid himself of an irksome complaint, he had not simply "called Emerson's bluff" as he put it when he suggested that the premier phone the president of the University of Toronto to "gag" him.[25] Nor, for that matter, had he heard the last of J. Norman Emerson.

Emerson's concerns were legitimate. He felt that Jury had significantly overstated the size of Sainte-Marie. In so doing, he had seriously overestimated its importance, especially when compared to the much larger Cahiagué. Why, he wondered, should a mission that housed a handful of Jesuits for only ten years overshadow a village of perhaps 2,500 people? Moreover, his excavations had established that Cahiagué was not simply one big village, but twinned fortified villages six hundred feet apart, a discovery that had important implications for 1960s understandings about Wendat defence and social organization.[26] Jury and Cranston had thus misunderstood contemporary archaeology and had misconstrued the past. They had elevated the importance of the French missionaries above that of the society to which they attended. But more crucially, they had constructed the physical evidence that supported their view of the past.

Through the remainder of the decade, Emerson continued to advocate for recognition of the Cahiagué site. In 1966, he was commissioned to report on it to the federal Parks Branch as well as the provincial Archaeological and Historic Sites Board. But he received little federal encouragement when, in 1969, he called for Cahiagué to be named a national historic site.[27] Like the provincial government, Ottawa remained unconvinced that Emerson had located the real Cahiagué and refused to act without confirmation. Although many scholars accepted Emerson's findings and conclusions, a government archaeologist felt that he had not proved his case. For Emerson's site to be Cahiagué, its two sections, which he had interpreted as twinned villages, would need to have been occupied simultaneously. John H. Rick felt that the evidence for simultaneous occupation of the two villages was insufficient and that they might have been two entirely separate settlements.[28] As the new decade began, the federal government, through the inertia of the Historic Sites and Monuments Board, gave every sign that it would not take action.[29]

With Ottawa declining to participate and the Province dragging its feet, leadership for developing the Cahiagué site fell to the Orillia Chamber of Commerce, supported by the *Packet and Times*. Twenty years earlier,

the chamber had purchased land near the village of Warminster, where Emerson had conducted his excavations and, according to the newspaper, authenticated the site by the "most exacting process known to man."[30] Meanwhile, a reorganization of the provincial government had transferred the Huronia Historical Parks section of the former Department of Tourism and Information to the Ministry of Natural Resources, Division of Parks, Historic Sites Branch. Around 1970, the government had bought some land adjacent to the chamber of commerce site, presumably to protect archaeological relics from prospectors. By the summer of 1973, the local MPP, Gordon Smith, learned that, while there were no specific plans for Cahiagué, the Parks Division was consolidating its holdings and synthesizing the many research reports that scholars had produced since 1946. The next year, Allen Tyyksä, a protégé of Emerson, could confidently envision the Province developing an educational program at Cahiagué around a full-scale reconstruction to teach about archaeology, cultural contact, and the environment.[31]

The brief optimism quickly evaporated. Although a government press release of September 1974 claimed that the site had been subjected to a two-year review under the Province's systems plan and had been found "significant," little was done. The government built a fence and set up directional signs on the nearby highway, but little else. Indeed, the systems plan had undermined the prospects for Cahiagué. As the systems report concluded, curio seekers had made off with many of its relics during the decades of archaeological attention, leaving very little to conserve. Despite finding connections to no less than six of its themes, the review scored Cahiagué at 57.6 out of 100 overall. Anything over 50 percent was considered suitable for development, but 57.6 was only a "fair" score.[32] With limited resources for developing sites, "fair" was not good enough and unlikely to warrant action. In the end, Cranston put the final nail in Cahiagué's coffin when he convinced the government, under the guise of protecting the site from further loss of artifacts, to remove the directional signs from the highway.[33]

"For an Audience of Indians"

In 1968, the same year that it surveyed visitors to Sainte-Marie, the Ontario government dispatched Ronald Way on a clandestine visit to the Six Nations Indian Reserve near Brantford. The mission was prompted by comments from Opposition leader Robert Nixon, who proposed that Ontario Tourism and the Six Nations Council act together to better

promote local tourism and thus enhance the financial position of the reserve.[34] It also followed on an unrealized proposal from five years earlier in which the City of Brantford had planned to build a campsite on the reserve, where "tourists could come and spend a week living as the Indians did."[35] Way, who grew up in the time of Grey Owl, shared that era's views of Aboriginal peoples, and how the "Indians lived." His attitude toward the Native peoples of North America was paternalistic at best, and this was reflected in his findings and his report back to the government. He argued that any efforts to develop historic properties on Canada's reserves could be carried out only with the "complete agreement and cooperation of the Federal authorities." He apparently saw no real need to secure permission from the Six Nations to develop their communities as "historic properties" for tourism. To prevent anyone from discovering his true purpose, he arrived at Brantford with his wife, Taffy, not as a senior consultant for heritage tourism development, but as a casual visitor who was curious about the Native way of life.

The Ways convinced a local man, in their words a "chief," to escort them to a ceremonial longhouse and to provide a tour of the reserve. Although not permitted to take photographs inside the longhouse, they were later treated to an "Indian pageant," explaining the origins of the Six Nations Confederacy, a presentation that, according to Taffy Way, "seemed to drag." She was also disappointed that the show was performed "by Indians for an audience of Indians." For the Ways, this was a terrible waste of development potential. They were shocked to learn that the band council was not interested in acquiring government aid to improve either the performance or the reserve's tourism potential. When Way remarked that the government could help promote the reserve to tourists, he was politely told that its involvement "would probably wind up with the Indians getting less in the end than we do now." His suggestion that provincial aid could help restore a rundown longhouse was met with similar resistance. The band had already rejected that idea. In the eyes of the Ways, the band took a curiously proprietary attitude toward its own heritage. Struck by this recalcitrance, Way recommended that, for the time being, the Province should avoid attempts to develop the Six Nations Reserve as a tourist attraction.

However, should such a plan become government policy, Way reluctantly made two recommendations. The first, demonstrating his own deafness in listening to his informants, was for a greater elaboration and expansion of the annual pageant on the history of the confederacy. The

second was the reconstruction of the original 1785 Mohawk village along the lines of Sainte-Marie among the Hurons. There would be no overlap with the Midland project, he assured the minister. For one thing, they would address very different periods in Ontario history, the mid-seventeenth and late-eighteenth centuries. As well, they would explore relations between different peoples: Sainte-Marie focused on the French and the Wendat, whereas Brantford dealt with the English and the Iroquois. Moreover, and here Way showed his astuteness in interpreting the messages of the province's historic properties, despite Robert Nixon's claims in the legislature, Sainte-Marie was not a glorification of the Wendat. It was, he bluntly stated, really a memorial to the Jesuits "and their heroic endeavours to spread Christianity in the New World."

The Ways were not unsympathetic to the plight of Canada's Aboriginal peoples; nor were they unaware of the complexity of the problem at hand – the economic development of an impoverished reserve. But their suggestions were steeped in the stereotypes and the paternalistic and often dismissive attitude of 1960s mainstream Canadian society. Way was certain that the Iroquois reserve at Deseronto in eastern Ontario more greatly needed an infusion of cash than the Six Nations Reserve. Politically, he recognized that Brantford was the safer choice and an easier sell to the voting public and visiting tourists because of its association with the Loyalist chief Joseph Brant. But Deseronto, he suggested, had a stronger historical connection to the Loyalists. Although he felt that Deseronto was unlikely to reject government aid, and though he himself admitted that he might be suffering from "an Indian-behind-every-tree syndrome," Way felt that the potential for controversy warned against taking action. Although something needed to be done, "and soon," he concluded that the Province was not well placed to intervene in the contentious federal issue of Native poverty, and did not need to get involved. Indeed, "Mrs. Way and I have almost come to the conclusion," he noted, "that no two Indians, let alone two experts on Indian affairs, are presently in agreement as to the remedy for their all-too-obvious handicaps and disadvantages."[36]

Perhaps ironically, the Ways were at the forefront of a shift in attitudes about Aboriginal history at Canada's historic sites. By the 1970s, anthropologists had considerably excised from their work the worst stereotyping of the nineteenth century. Although James W. St. G. Walker complained in 1971 that few historians seemed to consider Native peoples worthy of serious study, scholars from other disciplines were hard at work proving

W.H. Cranston's reconstructed Huron village, Little Lake Park, Midland, 1958 |
Source: RG 65-35-3, Image I0005577, Ontario Archives

him wrong.[37] Important scholarly works had recast European-Aboriginal
relations and Aboriginal histories by the end of the decade.[38] More
emerged in the 1980s as "Native History" began to assume a more central
place in North American scholarship. In tandem with these develop-
ments, museum exhibitions began to change, reflecting increased confi-
dence and activism among Aboriginal people themselves. The watershed
mark for museum exhibits was probably the opening of the Indians of
Canada Pavilion at Expo 67, which initiated an anti-colonial critique of
standard museum narratives of Aboriginal history. The pavilion's displays
framed a revisionist history that refuted official narratives set down by
government policy, academic texts, and more than a century of museum
exhibits. Although most visitors probably failed to grasp its implicit
challenge, the Indians of Canada Pavilion, alongside the founding of the
American Indian Movement in the United States, marked the start of a
new approach to Aboriginal rights.[39]

Archaeological excavations also contributed to a new educational sens-
ibility. Certainly, many stereotypes persisted. In his 1973 survey of Canadian

museums, Archie Key described the summer program at Midland's Huronia Village as "demonstrations of the daily primitive life of the Hurons."[40] At about the same time, the Prince Edward Island Heritage Foundation proposed a living history museum to teach children about the island's rural past. However, should the anticipated working farm and agricultural village become boring, the children would be able to pass through a "jungle" to play in an adjacent "cowboy setting and Red Indian village." This would be a place free of teachers and interpretation, where, despite the obvious anachronism of cowboys and Indians on the North-umberland Strait, "they can dress up in typical costumes and really play the part of wild west adventure."[41] However, most 1970s museums were careful to pay closer attention to the growing archaeological and anthropo-logical research in their depictions of the Aboriginal past. In Ontario, excavations at the Lawson site near London and Crawford Lake near Milton eventually led to reconstructions of pre-contact Iroquoian villages to serve as teaching facilities for school field trips. The federal government even built a few longhouses at Cartier-Brébeuf Historic Park in Quebec City, evoking the memory of Stadacona, the village near Jacques Cartier's winter camp of 1535–36. Teachers could thus give three-dimensional demonstra-tions of pre-contact agriculture and architecture, and tell stories that explained religious beliefs, social life, and culture in an approximately authentic atmosphere. These displays may have been educational, but they remained lifeless museum pieces. They had none of the dynamism or "living" components of most pioneer village museums. In part, this may have reflected growing uneasiness with the legacies of "playing Indian" and nervousness about how the politically active Aboriginal or-ganizations of the 1970s and 1980s might react. Tellingly, none of these reconstructed villages and longhouses involved Native people in their planning or construction until fairly recently.[42]

Colonial Stories

As living history museums began integrating Native stories into their in-terpretations, the fur trade, which had been intimately connected to the story of Canadian nationhood by the Laurentian thesis, seemed a natural fit. The fur trade was a crucial nexus of contact between cultures, by its very definition bringing them together at sites of exchange. This inclusion was not seamless or based on equality. At Lower Fort Garry in the 1960s, interpretations of Cree and Ojibwa history were accorded lesser significance than re-enactments of the factor's garden parties and typical

living history demonstrations such as blacksmithing. When the program later developed into a full-scale animation of the 1850s–60s life of the fort, the interpretation concentrated on the senior officers and their wives.[43] Ironically, the focus on contact between cultures implicitly relegated First Nations to supporting roles in the development of European Canada. Even in an atmosphere of greater respect for Native peoples and Aboriginal history, living history museums continued to stress stories that reinforced colonialism and reflected mainstream beliefs.

At the 1974 dedication ceremony for Fort Edmonton, intercultural contact was made explicit. The event included costumed First Nations men riding into the fort wearing full feather headdresses and buckskin suits adorned with beaded patterns. Marked by a single cannon salute, this peaceful encounter obscured and yet hinted at the more contentious relations between the Hudson's Bay Company and the Plains people, such as in 1807 when a group of Kainai (Blood) warriors razed the original Forts Edmonton and Augustus. Moreover, by casting First Nations as support to traders in the construction of Fort Edmonton, the "foundation" of the modern capital city, and of European settlement in northern Alberta, the museum fell into a pattern that was well established in the early 1970s. Its program treated Native peoples as the ancillary cast in a British nation-building project. Still, it would be unfair to suggest, as one author has, that the Native workers who helped build the reconstructed Fort Edmonton were also "unrecognized."[44] A 1974 photo essay book published by the Fort Edmonton Reconstruction Project explicitly linked Metis labourers to the history of the fort: "We look into the Fort Edmonton Journals and find the names of the men working in the Fort in the 1830s. Yet in the 1972 Big House reconstruction crew, a majority of whom were Métis, we find the same names recurring."[45]

At Old Fort William, park historians also worked to incorporate Ojibwa stories into their interpretations. When the queen attended its official opening in 1973, Native performers danced in ceremonial costumes for Her Majesty's entertainment, and over the years official literature played up the importance of Native peoples to the Nor'wester success in the fur trade. "Fort William was people," one pamphlet explained, "and you will experience how they created a fur trade society – a blend of native and European cultures."[46] Old Fort William was set up to portray the original fort as a meeting place of diverse cultures. On one side of the grounds, visitors could explore an Indian camp and "witness rare Ojibwa arts, such as cedar bark weaving." At the opposite end of the park, they might "lend

an ear to voyageur songs and tales. And in between these two encampments explore the functioning community of the North West Company which, during the Great Rendezvous, often numbered 2000 people."[47] Another pamphlet pronounced on "the profound effect of Canada's native people on the fur trade and thus on shaping the nation."[48] *Fort William: Hinge of a Nation,* Old Fort William's founding document, had connected the significance of the historical fort to the fur trade and therefore the reconstruction was compelled to put First Nations near the centre of its story.

More often, museums incorporated specific "Indian tales" into their background stories. At Fort Steele, relations between white settlers and Aboriginal people should have been central to interpretation. After all, confrontation between the Ktunaxa and settlers at Galbraith's Ferry was the trigger that brought Sam Steele to British Columbia and thus secured the community's association with the legendary Mountie. More than anything else, it was this association that gave the Fort Steele restoration project legitimacy and credibility with tourists. Yet, the Fort Steele museum preferred to direct visitors to the Wild Horse Theatre for the "Gay Nineties Extravaganza" or to Dunrobin, the 1895 steam locomotive operating on a toy-train loop of track.[49] Figures from a 1975 visitor survey reinforced these priorities, as the theatre and the train were the most popular exhibits. Only 6 percent of respondents requested more information about Aboriginal people.[50]

Indeed, Fort Steele dismissed its founding moment in a manner that conformed to Hollywood ideas about savage Indians. Perhaps this was not surprising. As the museum's own literature explained, the restoration was meant to create a community "typical to the area during the period from 1890 to 1905," after the subjugation of the Aboriginal population. Yet, it also claimed to tell the story of the 1860s gold rush and the "period of Indian unrest that brought Steele and the NWMP D Division" to British Columbia in 1887. "Where space permits," the museum pledged to discuss the archaeology and anthropology of the pre-gold-rush period as well. Clearly, the emphasis in the 1960s and 1970s was on Caucasian conquest of the BC Interior. Where the confrontation with the Ktunaxa appeared at any length, it served only to reinforce the greatness of Sam Steele. For instance, one pamphlet identified his arrival as the "first significant change" at Galbraith's Ferry and credited Ktunaxa leader Isadore in a backhanded way: "A Kootenay Indian named Kapula was jailed at Wild Horse, charged with the murder two years before of two white miners.

Kapula was forcibly released from jail by Chief Isadore of the Kootenay Indians in defiance of the white man's law." "In defiance of the white man's law" was a crucial phrase. Although the pamphlet acknowledged ongoing land claim disputes, its version of events clearly marked the Aboriginals of East Kootenay as lawless and even murderous. Steele was called in to re-establish peace: "Within a year, Steele had firmly and fairly settled differences with Chief Isadore and restored peace to East Kootenay."[51] This was the Sam Steele of myth at work. Here was a man who dealt "firmly and fairly" with lawlessness, instilling peace, order, and good government wherever he went. Aboriginal people at Fort Steele served only as a foil to demonstrate the superiority of the "white man." This stereotypical depiction of Native people dates, not from the museum's opening in 1967, before the American Indian Movement had begun to transform attitudes, but from 1979.

Still, a shift in public attitudes brought new interpretations to the museums. From the end of the 1970s into the 1980s, many museums updated their Aboriginal programs, taking into account developments in scholarly understandings of Native history. Not surprisingly, some of the most thorough efforts to integrate these new perspectives occurred at Louisbourg, the museum with the greatest resources. By the end of 1977, working with the Union of Nova Scotia Indians, researchers at Louisbourg had started to look for evidence of contact between the French city and the Mi'kmaq people. Acknowledging that park priorities had created a bias in Louisbourg's collections that restricted its ability to illustrate Native topics, researcher Eric Krause began contacting other museums, looking for documents to corroborate oral evidence. The intention was to produce an exhibit that brought the Mi'kmaq experience into the foreground.[52] Other museums similarly updated aspects of their presentations. In 1986, prompted by complaints to the Human Rights Commission, Sainte-Marie among the Hurons amended its introductory video depicting "savage" Iroquois. Changes continued as Aboriginal affairs became more prescient public issues in subsequent years, but only in the 1990s did living history museums broadly incorporate Aboriginal interpreters and perspectives.[53]

Despite the sincerity of these reinterpretations, they continued the colonization of Aboriginal culture in many ways. The manner in which the museums incorporated First Nations stories drew on Euro-Canadian perceptions of accommodation through pluralism. The addition of Aboriginal stories simply inserted one more culture into the narrative of the national march toward the modern incarnation of multicultural Canada.

By slotting the Native past more fully into the account of European settle-ment, these displays inadvertently reinforced the subordinate role of First Nations to national history, although usually recast as a supportive role. The decisions to incorporate Aboriginal representations into public his-tory sites may have been taken with contemporary political and social motivations in mind, yet one observer notes that twenty-first-century visitors still prefer the Indian stereotype – hair braided, face painted, arms folded stoically across the chest – which reflects the continued exclu-sion of "genuine Indians" from public history.[54] Perhaps it is a no-win situation.

The Breath of Our Grandfathers

The dilemma that living history museums faced often stemmed from their original purpose as museums of European settlement and exploration. Incorporating Native history into existing exhibits, even living ones, without fundamentally recasting the whole site might always be doomed to tokenism. Moreover, decisions to add Native displays often came just as governments began to shrink museum budgets in the late 1970s and early 1980s. Available resources simply would not support the reimagina-tion of entire museums. However, a few living history museums began, not as representations of European history in North America, but as expressions of community. One of these – 'Ksan Historical Village – originated in a Euro-Canadian concern for the "vanishing" people of the Pacific coast, but in a reversal of historical colonization, it became a living expression of Aboriginal culture.

Sitting at the confluence of the Bulkley and Skeena Rivers, near Hazelton in northern British Columbia, 'Ksan Historical Village occupies the place where the Gitxsan village of Gitanmaax once stood. When it opened in 1970, 'Ksan was unique among North American museums.[55] Unlike other living history or open-air museums, it did not preserve crafts, ceremonies, and a way of life that had been supplanted by technological and cultural change. 'Ksan was not a relic hall, even a living one in which artifacts and practices of the past were displayed, performed, and contextualized by animators in period costume who attempted to recreate their social and cultural contexts. Instead, it was a place of cultural revival. At 'Ksan, trad-itional ceremonies and art forms maintain their social and cultural content because they remain potent in the culture of the Gitxsan. It might even be argued that the Gitxsan have been advanced by the building of the village. Although it tended to overshadow other local Aboriginal sites,

'Ksan represented a kind of cultural revival in which the techniques of living history helped to build a more organic connection with the lives of the community's ancestors. As a museum, it pushed the idea of cultural revival farther by being a part of Gitxsan culture, rather than simply preserving it.[56]

For much of the nineteenth and twentieth centuries, the myth of the vanishing Indian dominated perceptions of Pacific coast cultures. Borrowed from central Canada and applied to the clearly populous peoples of British Columbia, the myth became a trope. Emily Carr's paintings were inspired, in part, by her own convictions on the matter.[57] Federal policy was even designed to speed the demise of First Nations culture by banning traditional customs and ceremonies, most notably the potlatch. Alarmed by an expansion of the potlatch, missionaries, Indian agents, and some Christian Indians lobbied the federal government to abolish it. Ottawa obliged in 1884 with an amendment to the Indian Act. Further acts curtailing Native practices and Native cultures followed, so that the "decline" of Native culture later lamented by some anthropologists, ethnologists, and other Euro-Canadian observers was partly of their own making.[58]

In the 1920s, when anthropologists from the National Museum visited the Skeena River region, they confirmed the decline of the Gitxsan people. Marius Barbeau arrived first in 1920, departing Ottawa only a month after he wrapped up a Montreal concert series of French Canadian folk songs. Reaching Hazelton on Dominion Day, he stayed seven months in the heart of Gitxsan country, some 285 kilometres northeast of Prince Rupert. Barbeau believed that the area had once been the centre of a vibrant culture, symbolized by one of the richest stands of totem poles ever erected. Sadly, he noted, they had fallen into decay, the victims of natural rot following the banning of the potlatch and the vandalism of the overly zealous followers of Christian missionaries.[59] Between 1923 and 1925, Barbeau returned to British Columbia, accompanied by colleagues Harlan Smith and Diamond Jenness. The trio recorded over sixty Gitxsan songs and took extensive linguistic notes. They sent more than four hundred photographs back to Ottawa to expand the museum's collections and looked into the state of standing totem poles, hoping possibly to preserve them.[60] Smith took the lead in the totem pole project and negotiated with local chiefs to overcome widespread suspicions of the government's intentions. In 1925, the museum, along with the Department of Indian Affairs and the Canadian National Railways (CN), agreed to a multi-year program to document and restore some sixteen poles in the

Skeena Valley.[61] The railway recognized that its rail line snaked through the best surviving clusters of poles and quickly calculated the tourism potential for restoration. Moreover, acknowledging that totem poles lost much of their interest when moved, CN recommended restoring them in situ.[62] Despite the fact that the restoration work was intended to preserve the relics of a lost, or at least dying, culture, it provoked a cultural revival among the Gitxsan.

On the surface, this revival originated from outside the Gitxsan community. Even as museums anticipated the imminent death of Native art, they accorded it "Canadian" status. Although categorized as "primitive" art, examples of Native carvings were sent to the National Gallery for display in the mid-1920s and were included in an exhibition of Canadian art held in Paris in 1927, interspersed with works by the Group of Seven and Emily Carr.[63] However, of greater importance was the organic "revival" that emerged among the Gitxsan themselves. Ethnographic evidence collected by the museum indicates that Gitxsan culture was not as moribund as 1920s researchers imagined. Barbeau had previously reversed his assessment of the vitality of Huron-Wyandot culture near Quebec City, so perhaps it should not be surprising that he later acknowledged the same for the Pacific Northwest. Indeed, by the 1940s, Barbeau corrected his earlier argument and accepted that the culture had not died, but seemed to be flourishing anew.[64]

As a testament to this, between 1929 and 1952, local artists restored another eleven poles along the Skeena and raised seventeen new ones. This built on the twenty-five poles that Barbeau reported had been raised during the first quarter of the twentieth century. Along the Skeena, relative isolation from Euro-Canadian civilization had long permitted the Gitxsan to preserve their culture, and at least fourteen carvers were still active in the mid-1920s.[65] Although many old practices were outlawed, they continued in new guises, and potlatches persisted despite prosecution by the RCMP after 1921; Barbeau even attended one.[66] The economic collapse of the 1930s, and its consequent strain on government finances, reduced the zeal of law enforcement and left greater openings for banned customs to endure. The surreptitious potlatches of the 1920s thus became overt in the decade that followed, as did other traditional practices, which in turn helped renew interest in pole carving.[67]

By the 1950s, the Skeena totem poles had become mainstream features of BC tourism promotion. Indeed, British Columbia had become reliant

on Aboriginal imagery in its promotional campaigns. In Vancouver, the Totem-Land Society was established in 1950, with financial support from the Greater Vancouver Tourist Association, to urge the expanded use of totem pole imagery in the promotion of the province and its largest city. In 1964, the society even attempted to have its slogan – Totem-Land – replace "Beautiful BC" on provincial licence plates. In the intervening years, not solely because of the Totem-Land Society, totem poles featured prominently in conventional advertising and in the lower-order branding of letterheads, envelopes, invoices, and packing slips. And, although some Aboriginal leaders decried the practice, the raising of new totem poles – obviously stripped of their original cultural significance – was a common feature of new tourist site developments around the province.[68] The ongoing restoration of the Skeena poles fit perfectly with this advertising strategy. As the premier was informed in the early 1960s, tourists heading to Alaska cited totem poles as the single greatest attraction along the route.[69]

At about the same time, local entrepreneurs and community leaders began searching for totem-related attractions to supplement the hunting and fishing tourist trade of northern British Columbia. In the Hazelton area, this was not new. Proposals for a local museum to display Native artwork may date from before the 1920s. It is also possible that Barbeau suggested it during his visits. He had been interested in using Native art to promote tourism on the northwest coast and once proposed building a resort at Temlaham, an abandoned village that he wove into a series of stories in 1928's *The Downfall of Temlaham*.[70] However, although some private individuals displayed their collections from time to time, no museum was built until the student council of the Hazelton Amalgamated School held a boxing match to raise funds for glass-fronted display cases in 1952. The "museum" was then set up in the local library, itself erected only a few years earlier and attached to the new school building.

The little library museum set a precedent for the drive that eventually produced the 'Ksan open-air museum two decades later. During his visits to British Columbia, Barbeau often called at the Hazelton home of his cousin, where he probably also met his cousin's daughter-in-law Margaret (Polly) Sargent. During the 1950s, Polly Sargent was a driving force behind the construction of a more elaborate museum in Hazelton. She had helped organize the library museum, and she ran the Inlander Hotel with her husband, Bill Sargent. When the Village of Hazelton, population 432, was

incorporated in 1952, Sargent was elected chair of the village commission, a post she held until 1969. Thus, she personified the links between commercial interest in tourism and civic community spirit, as well as representing a direct connection to the early study of the Gitxsan people through her relationship to Marius Barbeau.[71] Moreover, she took the lead in developing what became the Skeena Treasure House.

With the 1958 centennial of British Columbia approaching, provincial funds became available for local projects like Hazelton's museum. The village's Library Association, established in the late 1940s to oversee the new library, also approached the federal government to support building a "replica of a potlatch house" on the municipal dock.[72] Although the minister showed interest and the Parks Branch was expanding its historic reconstruction activities in the 1950s, Ottawa eventually balked, and the scheme was reduced to a single historic marker on the Hazelton dock, once the head of navigation on the Skeena River. Indeed, in his correspondence with the minister, the local MP implied that navigation history was more important than Native culture.[73] But the Library Association was not satisfied and pushed ahead with its BC centennial project. Sargent's more robust plan called for a replica of "an ancient Indian Ceremonial House" to be built by the river. Alongside a plaque marking the names of the riverboats, their captains, and the dates they plied the Skeena, the attraction would include a new totem pole and another pair of Aboriginal houses. The main attraction would be the Skeena Treasure House, which would contain Native artifacts and artwork.[74] The full project would thus have linked European and Native uses of the Skeena River and its valley.

Despite this early emphasis on navigation, the appeal to Native culture was central to winning support for the Skeena Treasure House. The BC centennial program provided forty cents per capita funding for unincorporated communities like Hazelton, but the fact that 1,200 Native people lived in the area increased Hazelton's grant, which, added to community contributions, brought in $5,500 to start the program. Admittedly, Native participation was only nominal at the outset. The initial reaction from Native bands was mixed and in some cases hostile. For obvious reasons, the Gitxsan had little incentive to trust non-Native superintendence of their cultural artifacts, and some bristled at the prospect of yet another museum exhibit of their culture. In part to alleviate fears that displays would depict a dying culture, the museum was named a "treasure house," as an indication of a continuing and living culture. Surviving documents

do not confirm it, but this step was probably the origin of 'Ksan's eventual sharing of authority over its display of Gitxsan material culture. However, continued opposition persisted among the Gitxsan, as did a reasonable fear that the products of their culture were once again being expropriated.[75]

Construction of the Treasure House began in 1958, on a site conveniently close to the Sargents' Inlander Hotel on the bank of the Skeena River. By 1960, Hazelton's centennial committee had become the Skeena Treasure House Association, which managed the collections until the 1970 opening of 'Ksan itself. Crucially, the association board and executive encouraged the participation of representatives of Native and non-Native communities. Gradually, more Native leaders were drawn into the venture, and they brought more artists with them.[76] By the mid-1960s, the idea of expanding the Treasure House into a full village was under discussion in Hazelton. No doubt the success of Barkerville, as both a museum and a tourist attraction to an economically challenged region, inspired some of this discussion. Another possible catalyst was a plan to build a replica Haida village in Victoria's Thunderbird Park.[77] Although the Victoria scheme was never realized, the idea of a village museum of Native culture, and the promise of increased tourism, would have been tantalizing for Polly Sargent, who was both a civic leader and the proprietor of a tourism-dependent business. However, with so many living history projects being built in Canada during the 1960s, a specific inspiration was unnecessary. Like the other living history museums, 'Ksan was part of the new common sense regarding history education and the way in which past communities should be portrayed.

In February 1967, Dudley Little, the MLA for Skeena, rose in the legislature to propose that the government support a village museum at Hazelton. Borrowing the Aboriginal name for the Skeena River, he suggested that it be called Old 'Ksan. With the closing of the local sawmill, Little surmised, Hazelton qualified for support for regional economic development, as envisioned by the 1961 creation of the federal-provincial Agricultural and Rural Development Agency. Hazelton's village council pledged $36,000 for building 'Ksan and eventually convinced the senior levels of government to make matching grants. By March, a 'Ksan agreement had been established and funding secured.[78] Construction on four communal houses and a carving house began in 1968. The village started to receive visitors in 1969, although the official opening was not held until the summer of 1970. In the early 1970s, visitors to 'Ksan could wander

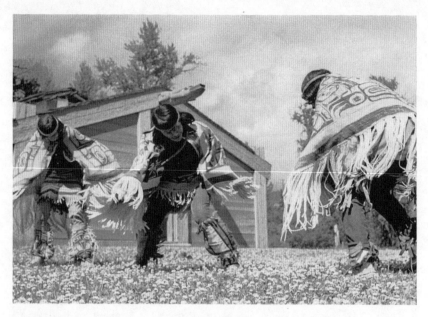

Youth dancers wearing chilkat blankets at 'Ksan Historical Village | Image
courtesy The Bill Reid Centre at Simon Fraser University. Photo by Dr. George F.
MacDonald, 1972.

through the Frog House of the Distant Past to see how the Gitxsan of the
pre-contact period had produced a rich material culture from the natural
environment. In the Wolf House of the Grandfathers, they might learn
how people adapted to the arrival of the Europeans and their trade goods.
In 1970, the European trade goods were laid out as if in preparation for
a potlatch. The layout was suggestive of other museum approaches to
Aboriginal history, fitting Aboriginal life into pre- and post-contact periods.
However, unlike other museums, 'Ksan did not portray a culture of the
past. Three of the houses, the Fireweed House of Treasures, the Today
House of the Arts, and the Carving House of All Times, displayed carvings
and paintings as part of the fabric of contemporary Gitxsan culture. In
the latter two houses, artists might be caught at work on their carvings,
whereas the Fireweed House displayed the regalia of local chiefs. "Insured
against loss by fire or theft," the museum's first brochure assured its read-
ers, these irreplaceable items were ready to be worn by their owners at a
feast or festival.[79] Plans were in place to perform songs and dances to help
animate the replica village.

Perhaps unknowingly, that first brochure positioned 'Ksan as both a
museum that housed valuable relics *and* a cultural centre that served

contemporary artists. Scholars have argued that Aboriginal peoples used a number of strategies to adapt to colonialism. Whereas missionaries and Indian agents might have decried as "inauthentic" the pursuit of waged labour or Western finery (while simultaneously attempting to stamp out undesirable "authentic" practices), Aboriginal people reinforced their own cultures by adapting the new circumstances that Europeans brought with them. For instance, the Kwakwaka'wakw (or Kwakiutl) famously modified their traditional dances for tourists at the Chicago World's Fair. At home, they used the material wealth they gained from cannery work to enhance their status at illegal potlatches, much to the chagrin of missionaries and government agents.[80] In the same way, 'Ksan revealed how the Gitxsan could live with the past but in the present. In 1971, 'Ksan launched its own historical project, recording the community's rich oral history, songs, and legends.[81] As the recorders and their informants came from the same community, this project not only enjoyed greater access than outsider anthropologists would have, but used modern technology to preserve storytelling, a traditional means to safeguard and pass on Native culture. The museum artifacts similarly straddled the line between modern and traditional. Insurance policies protected the treasured regalia against loss. Modern carvers demonstrated traditional skills that were not lost, but adapted. And tourists could purchase them, knowing that "the 'Ksan Trademark guarantees the workmanship and authenticity of each article."[82] As a further integration of 'Ksan into the tourist economy, a modern campsite was built next to the village, equipped with water, sewage, and electrical connections.

Conclusion

'Ksan as it existed in the 1970s was not a utopian marriage of modern tourism, European settlers, and Aboriginal culture. It was a joint project of the 'Ksan Association and the provincial government, with assistance from the federal government. And it had obviously been planned and designed as a point of contact between the local Aboriginal community and the descendants of North America's colonial settlers. It even stimulated an artistic revival and pointedly showcased Native "art" instead of anthropological artifacts.[83] Of course, it did not remake colonialism or alter relations between Natives and whites. It was not accessible enough in the 1970s to play a major role in tourism or to have a significant influence on other living history museums. Situated in northern British Columbia, where the summer tourist season is short, and despite convenient access

to the Yellowhead Highway, it was far too remote from the Alaska Highway to attract sizable numbers of visitors. Nevertheless, the early days of 'Ksan point to possibilities for rethinking living history.

'Ksan suggests a way for living history to be brought into the lives of present-day people. Unlike the pioneer villages of Ontario, the fur trade posts of the Prairies, or the military forts of the Maritimes, it attempted to connect past and present in a functional manner. For tourists, it was a recreation of a traditional Aboriginal village, a relic of the past. However, local people saw it as an affirmation of the continuing role of traditional culture in modern Aboriginal life. Perhaps some tourists even absorbed that lesson. They would not have learned it in a pioneer recreation. No matter how much other living history museums attempted to recreate the lived environment of the past, they nevertheless involved, to paraphrase Ronald Way, crossing a drawbridge from the present to the past. They existed, often purposefully, apart from the present. To visit King's Landing or Upper Canada Village was meant to evoke a journey back in time. These were artificial villages and known to be so.

What made 'Ksan innovative in the 1970s was its early adoption of "shared authority," a term that had yet to be coined. The concept of shared authority was popularized in 1990 in a book by oral historian Michael Frisch, and it quickly captured the imaginations of museum curators and technicians.[84] In museum work, it refers to the process by which groups and individuals are invited to share their views and experiences in the design of exhibits. In Canada, sharing authority gathered strength following some disastrous exhibits in the 1990s. Bringing constituent groups into discussions about how *their* history is presented in a public setting, the theory posits, would help strip museums of paternalism and colonialism. 'Ksan's early history suggests ways to change how communities and museums might tell stories. It drew together the Gitxsan past and the lived experience of the present, and displayed them as one.

Conclusion
The Limits of Time Travel

TIME TRAVEL, AS A MODEL for presenting the past, does not lend itself to sharing authority. Speaking to a meeting of the Canadian Historical Association in 1950, Ronald Way imagined that he had the power to transport people to the past. Teaching the history of a battle on the very ground where it was fought, he argued, was a powerful stimulus to the feeling of authenticity. The materiality of the physical surroundings reduced the effort of imagination necessary to secure a sense of the past to the point where virtually anyone could accomplish it. However, he continued, "the stimulus is even greater when, by crossing the antique drawbridge of a fort, the visitor finds himself, to all appearances, among the authentic surrounding of another age."[1] He first applied this lesson at Fort Henry in the 1930s, then exported it to other living history museums following the Second World War. In these efforts, Way relied on his professional expertise and that of like-minded curators to construct and interpret physical replicas of past environments. However, this model of interpretation is a paternalistic one that relies on the authoritative voice of the historian to manufacture an authentic experience for tourists and other visitors.

Time travel has been a dream since at least the days of H.G. Wells. In his classic 1895 novel *The Time Machine,* Wells depicted an Englishman's journey to witness the future of humanity and the eventual death of the Earth itself. At 800,000 years into the future, the protagonist encountered a culture divided between the beautiful but lethargic Eloi and the hideous Morlocks, and tried to interpret their world through his Victorian eyes. In a similar fashion, modern tourists work from their own cultural contexts to interpret the worlds presented at living history museums. However, unlike the *Time Machine* character, they are aided by the builders of the living history worlds, who construct and thus frame the interpretation according to shared sets of cultural values. The world of living history thus

involves judgments that are mutually and doubly reinforcing. The interpreters create the perception of the past for visitors, who observe it through the very same cultural expectations.

At the same time, museum interpretation shifts with the culture of the interpreters and their audiences. Early examples of living history museums relied on the truth statements embedded in the use of material artifacts to validate their claims to authenticity. The materiality of the buildings, the use of artifacts (instead of their mere display), and the performance of past chores by real, living people gave contemporary verification to interpretive statements about vanished ways of life. You could touch it and you could see it in action – therefore, it had to be true. However, this conviction in the value of the artifact broke apart in the poststructuralist understandings that penetrated the academic world after the 1970s and subsequently wound their way into museum work. New ideas about knowledge and truth embraced multiplicity and plurality, nibbling away at the straightforward association between artifact and understanding that the Victorian museum had built up. Kenneth Dawson prophetically drew attention to the fallacy of the connection between materiality and historical interpretation at Old Fort William. Although he continued to believe that artifacts proved what "really" happened, he acknowledged that the interpretation of history would always be subjective. In the 1980s, dramatic changes in the ways that artifacts were understood, and the recognition that curating could affect the meaning of material things, shifted the goal of interpretation. Prompted as well by specific crises in museum work, such as the unexpected uproar around the Glenbow Museum's *The Spirit Sings* exhibit, museologists began to emphasize the mutability of historical interpretation.[2] At historic sites and living history museums, the holistic thinking that influenced the mid-century conservation movement took on new meanings. In the 1980s, interpretation saw a new approach to rooting out the fundamental significance of historic places that recognized their multiple layers of meaning. This approach explicitly privileged cultural pluralism by acknowledging that there is no single or correct way to interpret a site.[3]

This dynamic is most clearly seen through the changing interpretation of Aboriginal histories at living history museums. Originally, most museums emphasized the establishment of colonial culture in ways that shunted Native peoples to the margins. The exception of 'Ksan notwithstanding, Aboriginal history appeared at living history museums in the 1960s and 1970s as external to both the project of nation building and the lives of

contemporary Canadians. At Sainte-Marie among the Hurons, interpretation shifted in the 1980s and 1990s, with the result that the museum now depicts seventeenth-century missionary life as a partnership between the Wendat people and the Jesuits. This interpretation contains an element of truth, but it nevertheless represents an aspirational vision rooted in contemporary politics and postcolonial sensibilities. This is an observation that Laura Peers corroborates. Native interpretation programming began at Sainte-Marie in 1982, and both discussion and material displays emphasize the Jesuits' dependency on the Wendat for survival. For instance, large quantities of dried corn in the mission stores remind visitors of where the mission's food supply originated.[4]

Yet, if this change in interpretive strategy has been under way for more than three decades, why have so many contemporary scholars continued to decry the conservatism, simplification, and Disneyfication of history at living history museums? This book suggests that the answer to this question lies in the histories of the museums themselves. The organization of the museum as an institution was part of the construction of an understanding of the world in which people function both as historical agents and the interpreters of historical action. Living history museums mirror this dual function as both interpreters of the past and as the products of cultural activity.[5] Although time travel remains the "sustaining fiction" of the living history museum, the illusion is never complete. According to Graeme Davison, this is because the "illusionists" want to show off their skills and impress visitors with their technical expertise.[6] Popular media coverage of Canada's museums, often written by museum researchers themselves, regularly dwelled on the technical expertise employed to recreate the past material environment, suggesting that it was an aid to the experience of authenticity. This reliance on expertise is a feature of the culture of modernity. Yet, equally, the illusion is never complete, because museums market themselves as tourist attractions. As such, they often cross the hypothetical line that divides entertainment from education and draw attention to their connections to the less "pure" tourist venues of theme parks and midways. More crucially, the illusion is never complete, because visitors, whether as tourists or children on school trips, know that they are suspending their daily routines when they arrive. Schoolchildren know that the museum visit is a departure from the classroom routine, and they embrace its opportunities for something new. Arriving as tourists, visitors also imagine themselves on hiatus from their everyday obligations. Whereas these breaks from the ordinary might

seem to support the illusion of travelling to the past, they also reinforce the fact that the break is not "real life." Yet, if the illusion of time travel ultimately fails, the historical arguments presented by living history museums were often convincing. Although most museums have moved away from the idea that the truth is found in the physical artifact, their interpretations remain pinned down by materiality.

Simply put, living history museums are built things. As much as they change the landscape to create evidence for their interpretations, they are limited by the very landscape that they themselves have manufactured. Once their time-specific ideas regarding the appearance of the past are made tangible in their physical layout, buildings, exhibits, and artifacts, subsequent adjustments become problematic. Moreover, the historiography of Canada's past began to shift at precisely the time when governments, facing budget shortfalls and economic restructuring, began to curtail their financial support of museums. For instance, saddled with debt and unable to tap into the public purse, Ontario's Westfield Pioneer Village closed its doors in 1984. Other museums struggled simply to survive, let alone to adapt to changes in historiography and interpretation.

The Four Rs

Living history museums have typically used four methods or models – restoration, relocation, reconstruction, and replication – sometimes mixing two or more together at one site. Each offers its own unique challenges and problems to overcome. Each has its own merits and advantages. However, all four reveal something of the artificiality of the living history museum and its depiction of past ways of life. Equally, each model reveals how the builders of these museums struggled to manufacture authenticity within the artificial past that they developed.

The restoration of old forts and houses was the first step toward the development of the living history museum. These relics of the past were often a locale's oldest architectural artifacts. Yet, restoring them to their historic condition often involved altering them in meaningful ways. Canada's restorations never entailed the large-scale manipulations of past architectural form, as seen in Europe during the nineteenth century. Much of Europe's historic architecture was invented by restoration architects of the Victorian era, such as the remodelling of Paris's Notre-Dame Cathedral or the renovation of Edinburgh Castle to make its Renaissance features appear more medieval.[7] The Canadian restoration of historic forts worked within the bounds of what was possible. Often, such as at Fort

York, urban encroachment made their wholesale reconstruction impossible. Subsequent land uses had superimposed the modern world over the foundations of historic ruins.

Relocation offered different challenges to the construction of authenticity. Pioneer village museums in particular relied on relocation to add legitimacy to their invented spaces. This often involved the painstaking cataloguing and labelling of every component of a structure, dismantling it piece by piece, transporting the parts, and reassembling them in their original condition. The Peter Prince House at Heritage Park was moved in this manner in 1967. It was cut in half, and its twenty-five thousand bricks were removed before it was transported from downtown Calgary to the museum.[8] However, moving a building from one locale to another extracts it from its original context. The proposal to remove Wolford Chapel to Upper Canada Village reveals one danger of this practice. Had the chapel been accepted, it would have significantly altered the intended message of the village museum and drawn an unwanted connection between different historical and geographical contexts. Upper Canada was not England, and it followed architectural traditions of its own. Moreover, Confederation-era Upper Canada was not the same as the colony founded by Sir John Graves Simcoe nearly eighty years earlier. To juxtapose them, as some suggested, would have opened the museum to the charge of anachronism. In most cases, however, relocation was not viewed as controversial, in part because many people saw value in the saving or preserving of historic buildings. Still, as long as they remained in their original location, buildings were part of a historic landscape; once they were ensconced in a new pioneer village home, they became part of a fantasy environment.

Reconstruction or replication posed their own problems. Creating an exact replica of a past material environment is beyond human ability, even when it relies on archaeological data and the use of original foundations. No amount of research, historical or archaeological, can resurrect the material and cultural depth of a past society in its entirety. As C.W. Jefferys, Ronald Way, W.H. Cranston, and others discovered, reconstructions inevitably involved guesswork, approximation, and a heavy reliance on comparison and "reasonable probability." They were, as so many builders proclaimed, as authentic *as possible*. Although they depended on their connection to the record of the material past, in the end, they were nothing more than attempts at building replicas. In a 1979 guide pamphlet, Fort Steele acknowledged that it was not restored, but built new. Indeed, despite

its attention to detail and the thorough historical and archaeological research that underpinned it, Louisbourg remained a fantasy of the past. This simple fact was acknowledged in the travel journalism that promoted the site to tourists. And yet, reconstructions also depended heavily on their claims to authenticity.

Connections

So many people were willing to embrace the version of the past on display at living history museums in part because they provided tangible, material proof of what they expected the past to be like. They allowed travel into history, but like many package tours, they did so in ways that obscured the undesirable aspects of the place. For middle-class Canadians of the mid-twentieth century, living history museums replicated a comfortable domesticity in which historical men and women played roles that were strikingly similar to modern ones. Modern material comforts aside, middle-class, suburban families would have felt at home in the past recreated by Black Creek Pioneer Village, Upper Canada Village, and their imitators around the country. It was a past grounded in the post-war values of their own world.

Yet, despite the social stability that living history museums represented, mid-century Canadians could also take comfort in the progressive values that their historical messages enshrined. Although only some Canadians welcomed the spirit of bilingualism and biculturalism, they could point to evidence of its historical veracity in the (admittedly invented) physical evidence of Sainte-Marie among the Hurons or the Village historique Acadien. These museums were three-dimensional representations of a bicultural past that some people used to promote a particular vision of Canadian national unity. Others endorsed the promise of multiculturalism and helped construct a tourist landscape that confirmed a multicultural view of Canada's national development. Although some dismissed multiculturalism as a simplification of cultural pluralism, amounting to little more than folk-festival performances of ethnic costume, dance, and cuisine, others saw it as a way to rebuild historical environments. Living history museums had recreated the pioneer and military pasts of Canada – why not use them to foster understanding of other past cultures? Thus, living history museums sometimes contributed to the promise of a unified national identity.

Unfortunately, this connection to the cultural values of the 1960s and 1970s also sowed the seeds of inauthenticity. The commercial entertainment

complex that dominated North American popular culture inundated people's perceptions of the "authentic" past and threatened the success of living history as a model for education. The Wild West of Hollywood and the tame west of Disneyland-style theme parks left their mark on living history. Not only Fort Edmonton, but other museums countered, adopted, and assimilated this aspect of popular culture. However, commercialism was not the greatest threat to their authenticity. Rather, their greatest challenge was their own material reality and the dissonance between it and changing cultural values.

The material environment that the mid-twentieth century constructed to represent what people thought about the eighteenth or nineteenth centuries is, however invented, still physical. The historical research that guided the design of buildings might later be discovered to be flawed. Wilfrid Jury's extrapolations from the archaeological evidence at Sainte-Marie are but one case in point. He believed that a canal had wound through the mission, so the reconstruction was equipped with one. However, what inspired Jury to imagine a canal is now thought to have been a series of ditches, and his interpretation is no longer accepted. Obviously, Sainte-Marie cannot be rebuilt simply to adapt to new theories, so the museum's literature dodges the question of accuracy and authenticity by inviting visitors to speculate on the real nature of the canal: "In both the North Court and South Court, archaeological evidence of a water system has been documented. Was it a moat, a source of fresh water, a canoe access, a locked waterway, a millrun or something else? There is still much speculation about how it was originally used."[9] Elsewhere, the inability to change the built environment injects an element of dissonance into interpretation programs. Many modern observers of living history museums have noted this issue but confused it for simple anachronism. However, the dissonance is more than simply discrepancy and incongruity. It represents a fundamental component of heritage's negotiated authenticity, and it results from disagreement over what is on display. In one sense, dissonance reflects discrepancies between interpretations of the past, and thus it reveals the contest to enshrine those artifacts or elements that comprise our heritage. It can be generated in many ways, but in living history museums today it often emerges from the incongruity of the historiographical interpretation with the built museum environment.[10]

Canada in the twenty-first century is culturally different from the Canada of the mid-twentieth century. It is demographically more diverse and culturally more tolerant and open. Twenty-first-century expectations no

longer match the tourist tastes that most living history museums were built to gratify. Yet, even as interpretations changed, the museums remained tied to their own pasts and presents. David Lowenthal notes wryly that staff at Colonial Williamsburg looked suspiciously at the supposed "authenticity" of their museum fifty years earlier and confidently claimed to have gotten it right in the 1990s. All the same, contemporary pieties weighed on their interpretations of African American slaves at Williamsburg, even banishing references to watermelons as racist stereotyping, despite their presence in crop records.[11] The Fort Henry Guard is now multicultural and coeducational, although this has raised other accusations of anachronism. The Chinese displays at Barkerville no longer depict the worst stereotyping of the 1950s and 1960s. Yet, as Laura Peers observes, it is difficult to portray postcolonial histories in an environment that was built on the assumptions of colonialism.[12] It is even more problematic when the environment was built, not just on colonial assumptions, but to teach those assumptions. In other words, the values of the mid-twentieth century are fixed onto the landscape, but they have not been as securely fixed in Canadian identity.

The Future of the Past

Living history museums are now themselves historic relics. Their reconstructed buildings are now forty or fifty years old, and their relocated ones have stood on their new foundations for generations. As much as they represent the history of pioneer times, the French regime, or the fur trade, they are the creations of the mid-twentieth century. Thus, it is not surprising that, like many other products of post-war modernity, they have fallen into disuse or have been repurposed for new functions. The controversial medieval fair at Upper Canada Village is but one example of this shift in usage. Westfield Pioneer Village, reopened in 1994, served as the setting for the popular Anne of Green Gables television program, its nineteenth-century Upper Canadian farm buildings standing in for Prince Edward Island in the early twentieth century. Fort York is now used as a site for art installations, particularly for the annual Nuit Blanche exhibits. In the summer of 2014, Upper Canada Village hosted a food festival and farmers' market, drawing on commonly held beliefs about the organic food movement's connection to the "natural" farming of the pioneers. It sparked no controversy.

There are many ways to live with the past that do not rely on the time travel illusion. Many museums have espoused the ecomuseum model,

introduced to Canada in the late 1970s and the 1980s. However, English and French Canadian ecomuseums are often differing concepts. In English Canada, they have become associated with heritage districts, and they borrow from a wider range of influences, including England's rural heritage protective associations. There are now many heritage districts in Canada, including the Cowichan and Chemainus Valleys Ecomuseum in British Columbia, Ontario's Manitoulin Island Heritage Region, and the Labrador Straits Heritage Region. However, this concept is not without its drawbacks. There is no straightforward definition of either an eco-museum or a heritage region.[13] Because of their focus on local heritage, ecomuseums often emphasize the ecological and cultural distinctiveness of individual regions, making it difficult to interpret history in ways that give meaning to national and transnational connections. Moreover, eco-museums tend to concentrate on rural environments, inadvertently dividing the heritage district from the modern, urban world. Thus, like living history museums, ecomuseums reproduce the traditional museum's separation of daily life from history.

Urban heritage districts, on the other hand, integrate the built environment bequeathed to the present with modern urban developments. Urban heritage preservation has grown beyond its 1960s roots in Montreal and Quebec City, and has now been adopted from Vancouver's Gastown and Granville Island to Barrington Street in Halifax. However, although it helps conserve aspects of the architectural past, it can do little to inform modern residents and visitors about an area's human history. Ottawa's Byward Market is a case in point. Middle-class residents and tourists eat, drink, and shop in the market, mostly oblivious to its displaced history as a working-class neighbourhood.[14] Moreover, the practice of historic preservation is inherently selective. It reflects value judgments about what is worthy of retention and what is not, and it imposes economic judgments on the uses of urban space that can perversely threaten the vibrancy of a neighbourhood.

In making a selective use of the past, heritage preservation is not alone. Ecomuseums similarly represent choices about the nature of a locale's ecological and cultural background, just as living history museums made choices about how to interpret the past. Indeed, all representations of the past, whether in historical monographs or in three-dimensional museum exhibits, epitomize choices made by people who are bounded by their own culture and times. As such, they reflect the world in which their creators lived and worked. They are artifacts of their times as much

as, and perhaps more than, they are representations of history. Living history museums need to learn to embrace this simple fact of their own creation. If the past is to have a future at living history museums, it must reflect contemporary culture, but in a way that does not simply graft more "tolerant" and "inclusive" attitudes onto an artificial environment built to reflect another age's values. They must find ways to reveal history as a process and must also insert themselves into that process. Without that sense of historical change, they are not really statements of *living* history.

Notes

Introduction: Living History Time Machines

1 Harry Needham, "Changes to Historic Village are Misguided, Damaging," *Ottawa Citizen*, 17 June 2009, A15.

2 "Village Park Falling on Hard Times," *Ottawa Citizen*, 1 June 2009, B3.

3 Dan Gonczol, "Surely You Joust," *Ottawa Citizen*, 14 June 2009, A1.

4 Needham, "Changes to Historic Village," *Ottawa Citizen*, 17 June 2009, A15.

5 Beryl W. Way, "Upper Canada Village," *Canadian Geographical Journal* 62, 6 (June 1961): 219.

6 "Press Kit," n.d., file 4, RG 5-54, Administrative Records of the St. Lawrence Parks Commission, Ontario Archives (OA), Toronto.

7 Alan Gordon, "Heritage and Authenticity: The Case of Ontario's Saint-Marie-among-the-Hurons," *Canadian Historical Review* 85, 3 (September 2004): 514, 526.

8 James Buzard, *The Beaten Track: European Tourism, Literature, and the Ways to Culture, 1800–1918* (Oxford: Oxford University Press, 1993).

9 The literature on tourism is too vast to summarize here. See, as an introduction, Louis Turner and John Ash, *The Golden Hordes: International Tourism and the Pleasure Periphery* (London: Constable, 1975); Valene Smith, ed., *Hosts and Guests: The Anthropology of Tourism* (Philadelphia: University of Pennsylvania Press, 1977); Maxine Feifer, *Going Places: The Ways of the Tourist from Imperial Rome to the Present Day* (London: Macmillan, 1985); John A. Jakle, *The Tourist: Travel in Twentieth-Century North America* (Lincoln: University of Nebraska Press, 1985); Earl Spencer Pomeroy, *In Search of the Golden West: The Tourist in Western America* (Lincoln: University of Nebraska Press, 1990); Hal K. Rotham, *Devil's Bargains: Inventing Tourism in the Twentieth-Century American West* (Lawrence: University of Kansas Press, 1998); Erve Chambers, *Native Tours: The Anthropology of Travel and Tourism* (Prospect Heights: Waveland Press, 2000); and Valene Smith and Maryann Brent, eds., *Hosts and Guests Revisited: Tourism Issues of the 21st Century* (New York: Cognizant Communication, 2001). Canadian scholars have increasingly turned to the history of tourism. Some of the most significant titles are E.J. Hart, *The Selling of Canada: The CPR and the Beginnings of Canadian Tourism* (Banff: Altitude, 1983); Patricia Jasen, *Wild Things: Nature, Culture, and Tourism in Ontario, 1790–1914* (Toronto: University of Toronto Press, 1995); Karen Dubinsky, *The Second Greatest Disappointment: Honeymooning and Tourism at Niagara Falls* (New Brunswick, NJ: Rutgers University Press, 1999); Michael Dawson, *Selling British Columbia: Tourism and Consumer Culture, 1890–1970* (Vancouver: UBC Press, 2004); Cecilia Morgan, *'A Happy Holiday': English Canadians and Transatlantic Tourism, 1870–1930* (Toronto: University of Toronto Press, 2008); and Ian McKay and Robin Bates, *In the Province of History: The Making of the Public Past in Twentieth-Century Nova Scotia* (Montreal and Kingston: McGill-Queen's University Press, 2010).

10 See, for example, David Lowenthal, *The Past Is a Foreign Country* (Cambridge: Cambridge University Press, 1985); David Lowenthal, *The Heritage Crusade and the Spoils of History* (Cambridge: Cambridge University Press, 1998); Dean MacCannell, *The Tourist: A New Theory of the Leisure Class* (New York: Schocken, 1976); Raphael Samuel, *Theatres of Memory*, vol. 1 (London: Verso, 1994); and John Urry, *The Tourist Gaze: Leisure and Travel in Contemporary Societies* (London: Sage, 1990).

11 McKay and Bates, *In the Province of History*.

12 Samuel, *Theatres of Memory*, 1:179.

13 Richard Gassan, *The Birth of American Tourism: New York, the Hudson Valley, and American Culture, 1790-1830* (Amherst: University of Massachusetts Press, 2008), 70–72.

14 Richard Gassan, "The First American Tourist Guidebooks: Authorship and the Print Culture of the 1820s," *Book History* 8, 1 (2005): 52. A third form of travel literature, the gazetteer, was also common in the nineteenth century.

15 James Buzard, "The Grand Tour and After (1660-1840)," in *The Cambridge Companion to Travel Writing*, ed. Peter Hulme and Tim Youngs (Cambridge: Cambridge University Press, 2002), 48–49; Alan Gordon, "What to See and How to See It: Tourists, Residents, and the Beginnings of the Walking Tour in Nineteenth-Century Quebec City," *Journal of Tourism History* 6, 1 (2014): 81–82.

16 Rudy Koshar, "What Ought to Be Seen: Tourists' Guidebooks and National Identities in Modern Germany and Europe," *Journal of Contemporary History* 33, 3 (July 1998): 326.

17 D.A.L. MacDonald, "Sun and ... Snow," *Montreal Gazette*, 10 November 1956, 21. The *Gazette*'s regular travel page, "Holiday and Travel" first appeared in *Montreal Gazette*, 16 October 1954, 29.

18 Richard K. Popp, *The Holiday Makers: Magazines, Advertising, and Mass Tourism in Postwar America* (Baton Rouge: Louisiana State University Press, 2012), 36, 49–50.

19 Hervé Gagnon, "Pierre Chasseur et l'émergence de la muséologie scientific au Québec, 1824-36," *Canadian Historical Review* 75, 2 (1994): 205–38; Brian Young, *The Making and Unmaking of a University Museum: The McCord, 1921-1996* (Montreal and Kingston: McGill-Queen's University Press, 2000); Lianne McTavish, *Defining the Modern Museum: A Case Study in the Challenges of Exchange* (Toronto: University of Toronto Press, 2013); Christy Vodden and Ian Dyck, *A World Inside: A 150-Year History of the Canadian Museum of Civilization* (Gatineau: Canadian Museum of Civilization, 2005), 24. Archie F. Key, *Beyond Four Walls: The Origins and Development of Canadian Museums* (Toronto: McClelland and Stewart, 1973), is primarily a list of institutions that were in operation during the early 1970s.

20 Michelle Hamilton, *Collections and Objections: Aboriginal Material Culture in Southern Ontario, 1791-1914* (Montreal and Kingston: McGill-Queen's University Press, 2010), 11.

21 Cecilia Morgan, *Creating Colonial Pasts: History, Memory, and Commemoration in Southern Ontario, 1860-1980* (Toronto: University of Toronto Press, 2015), 32–33.

22 Jay Anderson, *Time Machines: The World of Living History* (Nashville: American Association for State and Local History, 1984); Jay Anderson, ed., *A Living History Reader*, vol. 1, *Museums* (Nashville: American Association for State and Local History, 1991).

23 Tony Bennett, "Museums and 'the People,'" in *The Museum Time Machine*, ed. Robert Lumley (New York: Routledge, 1988), 64–74. See also Tony Bennett, *The Birth of the Museum: History, Theory, Politics* (New York: Routledge, 1995), 110–14.

24 Scott Magelssen, *Living History Museums: Undoing History through Performance* (Lanham: Scarecrow Press, 2007).

25 Richard Handler and Eric Gable, *The New History in an Old Museum: Creating the Past at Colonial Williamsburg* (Durham: Duke University Press, 1997).

26 Warren Leon and Margaret Piatt, "Living-History Museums," in *History Museums in the United States: A Critical Assessment,* ed. Warren Leon and Roy Rosenzweig (Urbana: University of Illinois Press, 1989), 64–97.

27 Carla Corbin, "Representations of an Imagined Past: Fairground Heritage Villages," *International Journal of Heritage Studies* 8, 3 (2002): 225–45; Linda Young, "Villages That Never Were: The Museum Village as a Heritage Genre," *International Journal of Heritage Studies* 12, 4 (2006): 321–38; Jillian M. Rickly-Boyd, "Through the Magic of Authentic Reproduction: Tourists' Perceptions of Authenticity in a Pioneer Village," *Journal of Heritage Tourism* 7, 2 (May 2012): 127–44.

28 Mary Tivy, "Museums, Visitors and the Reconstruction of the Past in Ontario," *Material History Review* 37 (Spring 1993): 35–51.

29 Terry MacLean, "The Making of Public History: A Comparative Study of Skansen Open Air Museum, Sweden; Colonial Williamsburg, Virginia; and the Fortress of Louisbourg National Historic Site, Nova Scotia," *Material History Review* 47 (Spring 1998): 30.

30 Karen Wall, "'A Sliver of the True Fort': Imagining Fort Edmonton, 1911–2011," *Journal of Heritage Tourism* 6, 2 (2011): 109–28.

31 Laura Peers, *Playing Ourselves: Interpreting Native Histories at Historic Reconstructions* (Lanham, MD: AltaMira, 2007). See also her "Playing Ourselves: First Nations and Native American Interpreters at Living History Sites," *Public Historian* 21, 4 (Autumn 1999): 39–59.

32 Pamela Peacock, "Interpreting a Past: Presenting Gender History at Living History Sites in Ontario" (PhD diss., History, Queen's University, 2011).

33 "Village Park Falling on Hard Times," *Ottawa Citizen,* 1 June 2009, B3.

34 Gordon Waitt, "Consuming Heritage: Perceived Historical Authenticity," *Annals of Tourism Research* 27, 4 (2000): 836.

35 Maura Troester, "Roadside Retroscape: History and the Marketing of Tourism in the Middle of Nowhere," in *Time, Space, and the Market: Retroscapes Rising,* ed. Stephen Brown and John F. Sherry (Armonk, NY: M.E. Sharpe, 2003), 115–40.

36 Mike Crang, "Magic Kingdom or a Quixotic Quest for Authenticity?" *Annals of Tourism Research* 23, 2 (1996): 428.

37 Richard Handler and William Saxton, "Dyssimulation: Reflexivity, Narrative, and the Quest for Authenticity in 'Living History,'" *Cultural Anthropology* 3, 3 (August 1988): 243.

38 Yaniv Poria, Richard Butler, and David Airey, "The Case of Heritage Tourism," *Annals of Tourism Research* 30, 1 (2003): 239.

39 Handler and Saxton, "Dyssimulation: Reflexivity," 250 (emphasis in original).

40 Amy M. Tyson, "Crafting Emotional Comfort: Interpreting the Painful Past at Living History Museums in the New Economy," *Museum and Society* 6, 3 (November 2008): 246–62.

41 Thomas Schlereth, "It Wasn't That Simple," *Museum News* 56 (January-February 1978): 36–41.

42 Waitt, "Consuming Heritage," 836.

43 Philip Massolin, *Canadian Intellectuals, the Tory Tradition, and the Challenge of Modernity, 1939-1970* (Toronto: University of Toronto Press, 2001), 3.

44 Hillel Schwartz, *The Culture of the Copy: Striking Likenesses, Unreasonable Facsimiles* (1996; repr., New York: Zone Books, 2014).

45 Massolin, *Canadian Intellectuals,* 4.
46 Zygmunt Bauman, *Liquid Modernity* (Cambridge: Polity Press, 2000).
47 See Ian McKay, *Reasoning Otherwise: Leftists and the People's Enlightenment in Canada, 1890-1920* (Toronto: Between the Lines, 2008), 17–21, 350.

Chapter 1: History on Display

1 Nicholas Zook, *Museum Villages, U.S.A.* (Barre, MA: Barre, 1971). See also Jay Anderson, *The Living History Sourcebook* (Washington, DC: American Association for State and Local History, 1985).
2 Sten Rentzhog, "What I Learnt from Writing the History of Open Air Museums," in *On the Future of Open Air Museums,* ed. Inger Jensen and Henrik Zipsane (Östersund: Jamtli förlag, 2008), 11–12.
3 Ibid., 10–12; Andrew Robertson, "Live Interpretation," in *Heritage Interpretation,* ed. Alison Hems and Marion Blockley (New York: Routledge, 2006), 42.
4 Chris Caple, *Conservation Skills: Judgement, Method, and Decision Making* (New York: Routledge, 2000), 46–47.
5 Ken Arnold, *Cabinets for the Curious: Looking Back at Early English Museums* (Aldershot: Ashgate, 2006), 14.
6 On the array of displayed artifacts and the wonderment they produced, see Horst Bredekamp, *The Lure of Antiquity and the Cult of the Machine: The Kunstkammer and the Evolution of Nature, Art, and Technology* (Princeton: M. Wiener, 1995); and Patrick Mauriès, *Cabinets of Curiosities* (London: Thames and Hudson, 2002).
7 Bredekamp, *The Lure of Antiquity,* 163.
8 Carla Yanni, *Nature's Museums: Victorian Science and the Architecture of Display* (Baltimore: Johns Hopkins University Press, 1999), 23.
9 Arnold, *Cabinets for the Curious,* 21–23.
10 Paula Findlen, *Possessing Nature: Museums, Collecting, and Scientific Culture in Early Modern Italy* (Berkeley: University of California Press, 1994), 242–46.
11 Arnold, *Cabinets for the Curious,* 137–38; Kenneth Hudson, *A Social History of Museums: What the Visitors Thought* (London: Macmillan, 1975), 4–5.
12 Tony Bennett, *The Birth of the Museum: History, Theory, Politics* (New York: Routledge, 1995), 37.
13 Arthur MacGregor, "Sloane, Sir Hans, Baronet (1660–1753)," *Oxford Dictionary of National Biography* (Oxford: Oxford University Press, 2004), http://dx.doi.org/10.1093/ref:odnb/25730.
14 Hudson, *A Social History of Museums,* 9–10. See also A.E. Gunther, "The Royal Society and the Foundation of the British Museum, 1753-1781," *Notes and Records of the Royal Society* 33, 2 (1979): 207–16.
15 Holger Hoock, "Reforming Culture: National Art Institutions in the Age of Reform," in *Rethinking the Age of Reform: Britain, 1780-1850,* ed. A. Burns and J. Innes (Cambridge: Cambridge University Press, 2003), 259–60.
16 Neil Chambers, *Joseph Banks and the British Museum* (London: Pickering and Chatto, 2007), 17. See also Holger Hoock, "The British State and the Anglo-French War over Antiquities," *Historical Journal* (Cambridge, UK) 50, 1 (2007): 49–72.
17 For an extended discussion of imperialism in museums, see John MacKenzie, *Museums and Empire: Natural History, Human Culture, and Colonial Identities* (Manchester: Manchester University Press, 2009).
18 Chambers, *Joseph Banks,* 121–27.

19 Edward Miller, *That Noble Cabinet: A History of the British Museum* (Athens: Ohio University Press, 1974), 211–13. Hawkins resigned in 1860.

20 Joel J. Orosz, *Curators and Culture: The Museum Movement in America* (Tuscaloosa: University of Alabama Press, 2002), 8–9, 50.

21 Whitfield Bell, *Patriot-Improvers: Biographical Sketches of Members of the American Philosophical Society* (Philadelphia: American Philosophical Society, 1997), 504–7.

22 Orosz, *Curators and Culture*, 33. The funds that Pennsylvania awarded him were in worthless colonial scrip.

23 Andrea Dennett, *Weird and Wonderful: The Dime Museum in America* (New York: New York University Press, 1997), 10–12.

24 Charles Sellers, *Mr. Peale's Museum: Charles Willson Peale and the First Popular Museum of Natural Science and Art* (New York: Norton, 1980), 12.

25 Orosz, *Curators and Culture*, 41–43.

26 Dennett, *Weird and Wonderful*, 147.

27 Robert Bogdan, *Freak Show: Presenting Human Oddities for Amusement and Profit* (Chicago: University of Chicago Press, 1988), 29. See also Dennett, *Weird and Wonderful*, 12–13.

28 Sellers, *Mr. Peale's Museum*, 42.

29 Ibid., 28.

30 Dennett, *Weird and Wonderful*, 14–15.

31 Ibid., 14.

32 Bogdan, *Freak Show*, 28.

33 Karen Smith, "Community Libraries," in *The History of the Book in Canada*, vol. 1, *Beginnings to 1840*, ed. P.L. Fleming, Gilles Gallichan, and Yvan Lamonde (Toronto: University of Toronto Press, 2004), 145.

34 Archie F. Key, *Beyond Four Walls: The Origins and Development of Canadian Museums* (Toronto: McClelland and Stewart, 1973), 107.

35 J. Lynne Teather, "Museum-Making in Canada (to 1972)," *Muse* (Columbia) 9–10 (Summer-Fall 1992): 22. On the history of early Canadian museums, see Randall F. Miller, "Gesner's Museum of Natural History, an Early Canadian Geological Collection," *Geoscience Canada* 34, 1 (2007): 37–48; J. Lynne Teather, "'Delighting the Eye and Mending the Heart': Canadian Proprietary Museums of the Early Nineteenth Century," *Ontario History* 94, 1 (Spring 2002): 49–77; and Leighann C. Neilson, "The Development of Marketing in the Canadian Museum Community, 1840-1989," *Journal of Macromarketing* 23, 1 (June 2003): 17–22.

36 Raymond Duchesne, "Delvecchio, Thomas (Tommaso)," DCB Online. http://www.biographi.ca/en/bio/delvecchio_thomas_6E.html. See also Cyril Simard, *Patrimoine muséologique au Québec: Repères chronologiques* (Quebec City: Ministère des Affaires culturelles, 1992), 17–19.

37 *Canadian Spectator* (Montreal), 21 August 1824.

38 Teather, "Museum-Making in Canada," 22.

39 Hervé Gagnon, "Pierre Chasseur et l'émergence de la muséologie scientific au Québec, 1824-36," *Canadian Historical Review* 75, 2 (1994): 208.

40 Amable Berthelot, "Dissertation sur le canon de bronze trouvé en 1826 ...," Quebec Literary and Historical Society, *Transactions* 2 (1830): 198.

41 Raymond Duchesne, "Chasseur, Pierre," DCB Online. http://www.biographi.ca/en/bio/chasseur_pierre_7E.html.

42 Orosz, *Curators and Culture*, 111. Orosz notes a third strategy of returning to a members-only, elite institution.

43 M.H. Dunlop, "Curiosities Too Numerous to Mention: Early Regionalism and Cincinnati's Western Museum," *American Quarterly* 36, 4 (Autumn 1984): 524–48.

44 Orosz, *Curators and Culture*, 130–33.

45 Ottilie Assing, *Radical Passion: Ottilie Assing's Reports from America and Letters to Frederick Douglas*, ed. Christoph Lohmann (New York: Peter Lang, 1999), 121.

46 Bogdan, *Freak Show*, 32–37.

47 Susan Sheets-Pyenson, *Cathedrals of Science: The Development of Colonial Natural History Museums during the Late Nineteenth Century* (Montreal and Kingston: McGill-Queen's University Press, 1988), 9.

48 See Orosz, *Curators and Culture*, 8–9, for the most succinct statement of his argument.

49 On the early days of the Smithsonian, see Sally Gregory Kohlstedt, "History in a Natural History Museum: George Brown Goode and the Smithsonian Institution," *Public Historian* 10, 2 (Spring 1988): 7–26; Kenneth Hafertepe, *America's Castle: The Evolution of the Smithsonian Building and Its Institution, 1840-1878* (Washington, DC: Smithsonian Institution Press, 1984); and Curtis M. Hinsley, *Scientists and Savages: The Smithsonian Institution and the Development of American Anthropology, 1846-1910* (Washington, DC: Smithsonian Institution Press, 1981).

50 Gagnon, "Pierre Chasseur," 234–35.

51 John C. Carter, "Ryerson, Hodgins, and Boyle: Early Innovators in Ontario School Museums," *Ontario History* 86, 2 (June 1994): 123.

52 Suzanne Zeller and Gale Avrith-Wakeam, "Dawson, George Mercer," DCB Online. http://www.biographi.ca/en/bio/dawson_george_mercer_13E.html.

53 Sheets-Pyenson, *Cathedrals of Science*, 55–58.

54 Christy Vodden and Ian Dyck, *A World Inside: A 150-Year History of the Canadian Museum of Civilization* (Gatineau: Canadian Museum of Civilization, 2005), 19.

55 Steven Conn, *Museums and American Intellectual Life, 1876–1926* (Chicago: University of Chicago Press, 1998), 79. See also David K. Van Keuren, "Cabinets and Cultures: Victorian Anthropology and the Museum Context," *Journal of the History of Behavioral Science* 25, 1 (January 1989): 26–39.

56 Key, *Beyond Four Walls*, 126–28; Vodden and Dyck, *A World Inside*, 24.

57 Andrew Nurse, "Tradition and Modernity: The Cultural Work of Marius Barbeau" (PhD diss., History, Queen's University, 1997), 1. Nurse was quoting from Laurence Nowry's 1965 interview with Barbeau.

58 I.J. Katz, "Marius Barbeau, 1883-1969," *Ethnomusicology* 14, 1 (January 1970): 129.

59 Laurence Nowry, *Man of Mana: Marius Barbeau* (Toronto: NC Press, 1995), 141–42.

60 Ernest Gagnon, *Chansons populaires du Canada* (Quebec City, 1865).

61 Vodden and Dyck, *A World Inside*, 39.

62 Edward N. Kaufman, "The Architectural Museum from World's Fair to Restoration Village," in *Museum Studies: An Anthology of Contexts*, ed. Bettina Carbonell (Malden, MA: Blackwell, 2004), 275.

63 John Findling, *Chicago's Great World's Fairs* (Manchester: Manchester University Press, 1994), 124–29; Robert W. Rydell, *All the World's a Fair: Visions of Empire at American International Expositions, 1876-1916* (Chicago: University of Chicago Press, 2013), 40–41.

64 Conn, *Museums and American Intellectual Life*, 111.

65 Robert W. Rydell, "World Fair and Museums," in *A Companion to Museum Studies*, ed. Sharon Macdonald (Oxford: Blackwell, 2006), 140.

66 Conn, *Museums and American Intellectual Life*, 102–12.

67 Nurse, "Tradition and Modernity," 14–17; Patrick H. Butler, "Past, Present, and Future: The Place of the House Museum in the Museum Community," in *Interpreting Historic House Museums,* ed. Jessica Donnelly (Walnut Creek, CA: AltaMira, 2002), 18–42.

68 Ian McKay, *The Quest of the Folk: Antimodernism and Cultural Selection in Twentieth-Century Nova Scotia* (Montreal and Kingston: McGill-Queen's University Press, 1994), 18–19.

69 Alan Gordon, *Making Public Pasts: The Contested Terrain of Montreal's Public Memories, 1891-1930* (Montreal and Kingston: McGill-Queen's University Press, 2001), 46–47.

70 Lynda Jessup, "Marius Barbeau and Early Ethnographic Cinema," in *Around and about Marius Barbeau: Modeling Twentieth-Century Culture,* ed. Andrew Nurse, Gordon Smith, and Lynda Jessup (Gatineau: Canadian Museum of Civilization, 2008), 269–304.

71 McKay, *Quest of the Folk,* 33–34.

72 Sten Rentzhog, *Open Air Museums: The History and Future of a Visionary Idea* (Stockholm/Östersund: Carlssons/Jamtli, 2007), 4. See, for example, James L. Lindgren "A Spirit That Fires the Imagination: Historic Preservation and Cultural Regeneration in Virginia and New England, 1850-1950," in *Giving Preservation a History: Histories of Historic Preservation in the United States,* ed. Max Page and Randall Mason (New York: Routledge, 2004), 123; and Scott Magelssen, "Performing Practices of [Living] Open-Air Museums (and a New Look at 'Skansen' in American Living History Discourse)," *Theater History Studies* 24 (June 2004): 125–49.

73 Rentzhog, *Open Air Museums,* 48–50.

74 Paul Oliver, "Re-presenting and Representing the Vernacular: The Open Air Museum," in *Consuming Tradition, Manufacturing Heritage: Global Norms and Urban Forms in the Age of Tourism,* ed. Nezar Al Sayad (New York: Routledge, 2001), 193.

75 Edward P. Alexander, *Museum Masters: Their Museums and Their Influence* (Lanham, MD: AltaMira, 1983), 241–44.

76 Michael Conan, "The Fiddler's Indecorous Nostalgia," in *Theme Park Landscapes,* ed. Terence G. Young and Robert B. Riley (Washington, DC: Dumbarton Oaks, 2002), 98.

77 Rentzhog, *Open Air Museums,* 4.

78 Alexander, *Museum Masters,* 8

79 Bruno Giberti, *Designing the Centennial: A History of the 1876 International Exhibition in Philadelphia* (Lexington: University Press of Kentucky, 2002), 145; Alexander, *Museum Masters,* 249.

80 Debra Reid, "What Can We Learn from the History of Our Museums?" in *On the Future of Open Air Museums,* ed. Inger Jensen and Henrik Zipsane (Östersund: Jamtli förlag, 2008), 33–34.

81 Conan, "The Fiddler's Indecorous Nostalgia," 100; Edward P. Alexander, *Museums in Motion: An Introduction to the History and Functions of Museums* (Nashville: American Association for State and Local History, 1979), 122; Reid, "What Can We Learn," 34.

82 Oliver, "Re-presenting and Representing," 192–93.

83 Rentzhog, *Open Air Museums,* 39–40.

84 Warren Leon and Margaret Piatt, "Living-History Museums," in *History Museums in the United States: A Critical Assessment,* ed. Warren Leon and Roy Rosenzweig (Urbana: University of Illinois Press, 1989), 65.

85 Orosz, *Curators and Culture,* 182.

86 Patricia West, *Domesticating History: The Political Origins of America's House Museums* (Washington, DC: Smithsonian Institution Press, 1999), 2.

87 Barry Schwartz, "George Washington and the Whig Conception of Heroic Leadership," *American Sociological Review* 48, 1 (February 1983): 18–33. See also Barry Schwartz, "Social Change and Collective Memory: The Democratization of George Washington," *American Sociological Review* 56, 2 (April 1991): 221–36.

88 Kaufman, "The Architectural Museum," 284.

89 Lindgren, "A Spirit That Fires the Imagination," 109.

90 Everett is best known for his two-hour speech at the opening of the Gettysburg National Cemetery. His speech was followed by the far, far briefer and far more eloquent Gettysburg Address of Abraham Lincoln.

91 West, *Domesticating History*, 6–37. See also Alexander, *Museum Masters*, 177–204.

92 Lindgren, "A Spirit That Fires the Imagination," 109.

93 Butler, "Past, Present, and Future," 24; Kaufman, "The Architectural Museum," 284.

94 Antiquarian and Numismatic Society of Montreal, Minute Books, 17 March 1891, Antiquarian and Numismatic Society fonds, Musée du Château de Ramezay, Montreal. See also R.W. McLachlan, "How the Chateau de Ramezay Was Saved," *Canadian Antiquarian and Numismatic Journal* 2nd Series 3, 3/4 (May 1894): 109–21; and Nicole Cloutier, "Château de Ramezay," in *Les Chemins de la mémoire: Monuments et sites historiques du Québec*, ed. Paul-Louis Martin and Jean Lavoie (Quebec City: Publications du Québec, 1990), 2:38–40.

95 Adelaide Lynch-Staunton to F.H.H. Williamson, 16 October 1938, RG 84, Records of Parks Canada, vol. 1356, HS9–30, Library and Archives Canada, Ottawa.

96 Laurence Coleman, *Historic House Museums* (Washington, DC: American Association of Museums, 1933).

97 Patrick Wright, *On Living in an Old Country: The National Past in Contemporary Britain* (London: Verso, 1985), 50–53.

98 George Humphrey Yetter, *Williamsburg before and after: The Rebirth of Virginia's Colonial Capital* (Williamsburg: Colonial Williamsburg, 1988), 49–52; Conn, *Museums and American Intellectual Life*, 155.

99 Raymond B. Fosdick, *John D. Rockefeller Jr.: A Portrait* (New York: Harper, 1956), 356–57.

100 Richard Handler and Eric Gable, *The New History in an Old Museum: Creating the Past at Colonial Williamsburg* (Durham: Duke University Press, 1997), 33–34.

101 Michael Wallace, "Visiting the Past: History Museums in the United States," in *A Living History Reader*, ed. Jay Anderson (Nashville: American Association for State and Local History, 1991), 190. See also Lindgren, "A Spirit That Fires the Imagination," 121.

102 John D. Rockefeller Jr., "The Genesis of the Williamsburg Restoration," *National Geographic Magazine*, April 1937, 401.

103 Cary Carson, "Living Museums of Everyman's History," *Harvard Magazine* 83 (July-August 1981): 25–26.

104 Wallace, "Visiting the Past," 190.

105 Conn, *Museums and American Intellectual Life*, 155.

106 Ibid., 154–60.

Chapter 2: The Foundations of Living History in Canada

1 Carl Benn, *Historic Fort York, 1793-1993* (Toronto: Natural Heritage/Natural History, 1993), 79–81.

2 This story can be followed in much greater detail in Gerald Killan, "The First Old Fort York Preservation Movement, 1905-1909: An Episode in the History of the Ontario Historical Society," *Ontario History* 64, 3 (September 1972): 162–80.

3 Keith Walden, *Becoming Modern in Toronto: The Industrial Exhibition and the Shaping of a Late Victorian Culture* (Toronto: University of Toronto Press, 1997), 242–43.
4 Benn, *Historic Fort York*, 145. See also E.J. Hathaway, "The Story of the Old Fort at Toronto," *OHS Annual Report* 25 (1929): 356. The slaughterhouse finally closed in 2014.
5 "Save the Old Fort," *Toronto Globe*, 4 October 1905, 6.
6 "Old Fort a Sacred Trust Which Should Be Preserved," *Toronto Evening News*, 9 October 1905, 4.
7 "President's Remarks," *Annual Report of the Ontario Historical Society 1910* (Toronto: Ontario Historical Society, 1910), 18; see also Killan, "First Old Fort York," 178–79.
8 Benn, *Historic Fort York*, 148; Hathaway, "The Story of the Old Fort," 356. The streetcar line was eventually built during the First World War, in the process destroying some of the fort's outlying 1830s structures.
9 "Resolutions Adopted," *Annual Report of the Ontario Historical Society 1905 and 1906* (Toronto: Ontario Historical Society, 1906), 43.
10 "President's Remarks," *OHS Annual Report 1910*, 18.
11 W.W. Cory to Eugene Fiset, 10 July 1920, RG 84, Records of the Canadian Parks Service, vol. 1048, FB2, Library and Archives Canada (LAC), Ottawa.
12 "The Preservation of Places of Scenic and Historic Interest," *Proceedings and Transactions of the Royal Society of Canada* 2nd Series 7 (1901): xxi.
13 See H.V. Nelles, *The Art of Nation-Building: Pageantry and Spectacle at Quebec's Tercentenary* (Toronto: University of Toronto Press, 2000); and Ronald Rudin, *Founding Fathers: The Celebration of Champlain and Laval in the Streets of Quebec, 1878-1908* (Toronto: University of Toronto Press, 2003).
14 C.J. Taylor, *Negotiating the Past: The Making of Canada's National Historic Parks and Sites* (Montreal and Kingston: McGill-Queen's University Press, 1990), 23–25. The HLA survived for about a decade and was folded into the Canadian Historical Association in 1920. Its papers are found at Library and Archives Canada, MG 28 I52.
15 Beckles Willson, "Louisbourg To-Morrow," *Canadian Magazine* 42, 4 (February 1914): 359.
16 The French spelling "Louisbourg" was abandoned for an anglicized Louisburg by British colonists. Following the building of the Fortress of Louisbourg National Historic Park, the spelling was changed back to the French original.
17 Willson, "Louisbourg To-Morrow," 352.
18 R. Murray and J.S. McLennan, "Cape Breton," in *Picturesque Canada*, ed. George Munro Grant (Toronto, 1882), 2:846.
19 This incident, as well as other early commemorative efforts, is covered in A.J.B. Johnston, "Preserving History: The Commemoration of 18th Century Louisbourg, 1895-1940," *Acadiensis* 12, 2 (Spring 1983): 53–80.
20 "Obituaries: David Joseph Kennelly," *Monthly Notices of the Royal Astronomical Society* 68, 4 (February 1908): 237–38.
21 F.H.H. Williamson, "Report on Investigation of Historic Sites in Maritime Provinces, December 1919," RG 84, vol. 1189, HS6, LAC.
22 Johnston, "Preserving History," 63.
23 See Carl Berger, *The Sense of Power: Late Nineteenth Century Imperialists in Canada* (Toronto: University of Toronto Press, 1971).
24 John G. Bourinot, "Cape Breton and Its Memorials of the French Régime," *Royal Society of Canada Proceedings and Transactions* 9 (1891): 173–343.
25 Taylor, *Negotiating the Past*, 19.

26 Ibid., 20.

27 Ibid., 211.

28 Canada, National and Historic Parks Branch, *Fort Anne National Historic Park* (Ottawa: Queen's Printer, 1967), n.p.

29 J.B. Harkin to L.M. Fortier, 1 February 1917, RG 84, vol. 1041, FA2, LAC; see also Taylor, *Negotiating the Past*, 16–17.

30 J.B. Harkin to J.G. Mitchell, 25 February 1919, RG 84, vol. 1041, FA2, LAC.

31 C.C. Avard to F.H.H. Williamson, 13 May 1920, RG 84, vol. 1048, FB2, LAC.

32 Shannon Ricketts, "Cultural Selection and National Identity: Establishing Historic Sites in a National Framework, 1920-1939," *Public Historian* 18, 3 (Summer 1996): 26.

33 Henry A. Miers and S.F. Markham, *A Report on the Museums of Canada* (Edinburgh: Constable, 1932), 51.

34 Janet Foster, *Working for Wildlife: The Beginning of Preservation in Canada* (Toronto: University of Toronto Press, 1998), 79; Leslie Belle, *Parks for Profit* (Montreal: Harvest House, 1987), 63.

35 E.J. Hart, *J.B. Harkin: Father of Canada's National Parks* (Edmonton: University of Alberta Press, 2010), 141–42.

36 Taylor, *Negotiating the Past*, 55–56.

37 W. Crowe to R.E. Harris, 18 May 1923, RG 84, vol. 1095, LAC.

38 Taylor, *Negotiating the Past*, 77–78.

39 Canada, *Debates of the House of Commons* (12 June 1929), 3648. See also Taylor, *Negotiating the Past*, 78–85.

40 J.B. Harkin to R.A. Gibson, 11 April 1929, RG 84, vol. 1096, LAC.

41 E.R. Forbes, "The 1930s: Depression and Retrenchment," in *The Atlantic Provinces in Confederation,* ed. E.R. Forbes and Del Muise (Toronto: University of Toronto Press, 1993), 296. See also Taylor, *Negotiating the Past*, 80–82.

42 Taylor, *Negotiating the Past*, 106.

43 Terry MacLean, *Louisbourg Heritage: From Ruins to Reconstruction* (Sydney: UCCB Press, 1995), 17.

44 Hart, *J.B. Harkin*, 430.

45 Michael Dawson, *Selling British Columbia: Tourism and Consumer Culture, 1890-1970* (Vancouver: UBC Press, 2004), 78, 92.

46 Kenneth Norrie and Douglas Owram, *A History of the Canadian Economy,* 2nd ed. (Toronto: Harcourt Brace, 1996), 358.

47 Canada, Senate, *Report and Proceedings of the Special Committee on Tourist Traffic* (Ottawa, 1934), ix-xiv.

48 "Appendix A," in *Minutes of Proceedings of the Council of the Corporation of the City of Toronto, 1931* (Toronto: Carswell, 1932), 1150, 1686.

49 "Old Uniforms Vie With 1934 Precision," *Toronto Star,* 25 May 1934, 4; "50,000 In Ward 8 Celebrate Centenary," *Toronto Star,* 25 May 1934, 5.

50 "Centennial Outlay Will Provide Work Is Mayor's Opinion," *Toronto Globe,* 6 October 1933, 1.

51 "Progress Report Submitted to His Worship the Mayor and the Members of the Board of Control by the General Committee and the Director of the Toronto Centennial 1934," 4. F 1086, Toronto Centennial Collection, Ontario Archives, Toronto.

52 *Canadian Annual Review* (1937–38): 215.

53 William Lyon Mackenzie King diary, 1 August 1938, 766, MG 26 J13, W.L.M. King Papers, Diary Series, LAC.

54 *Ottawa Journal,* 24 July 1924; see also A.A. Pinard to J.B. Harkin, 13 November 1924, RG 84, vol. 1312, HS8–12, LAC.

55 W.J. Brown to Charles Stewart, 17 September 1928, RG 84, vol. 1312, HS8–12, LAC.

56 "Contract to Restore Fort Henry is Let," *Kingston Whig-Standard,* 15 July 1934, 1. On McQueston, see Joan Coutu, "Vehicles of Nationalism: Defining Canada in the 1930s," *Journal of Canadian Studies/Revue d'études Canadiennes* 37, 1 (2002): 180–203.

57 "Fort Henry will be Officially Open to the Public Saturday," *Kingston Whig-Standard,* 31 July 1936, 3.

58 R.L. Way, *Ontario's Niagara Parks: A History,* 2nd ed. (Toronto: Niagara Parks Commission, 1960), 227.

59 R.L. Way, "Old Fort Henry: The Citadel of Upper Canada," *Canadian Geographical Journal* 40 (April 1950): 169.

60 C.W. Jefferys, "The Reconstruction of the Port Royal Habitation, 1605-13," *Canadian Historical Review* 20, 4 (December 1939): 369–70.

61 Barbara M. Schmeisser, "The Port Royal Habitation – A 'Politically Correct' Reconstruction?" *Collections of the Royal Nova Scotia Historical Society* 44 (1996): 42.

62 J.B. Harkin to J.C. Webster, 25 August 1924, RG 84, vol. 1805, PR2, LAC.

63 F.H.H. Williamson to L.M. Fortier, 31 January 1931, RG 84, vol. 1041, FA2, LAC.

64 L.M. Fortier to Philippe Roy, 23 September 1932, RG 84, vol. 1041, FA2, LAC.

65 *Halifax Chronicle,* 29 September 1932, clipping in RG 84, vol. 1041, FA2, LAC. See also L.M. Fortier to J.B. Harkin, 20 September 1932, RG 84, vol. 1041, FA2, LAC.

66 Paul E. Prieur, "Richardson, Harriette Taber Collection," MG 30 B92, Finding Aid 393, 1979, I, LAC.

67 Harvard College, *Harvard Class of 1897: 25th Anniversary Report* (Cambridge, MA: Riverside Press, 1922), 6:454; "Miss Richardson Engaged to Marry," *New York Times,* 14 June 1930, 24; "Other Weddings," *New York Times,* 26 October 1930, N5. George Randall, *Taber Genealogy: Descendants of Thomas, Son of Philip Taber* (New Bedford: Viking Press, 1924).

68 H.P. Biggar, ed., *The Works of Samuel de Champlain in Six Volumes: 1615-1618* (Toronto: Champlain Society, 1929). On the influence of the publication of Champlain's *Works,* see Taylor, *Negotiating the Past,* 68.

69 "Celebrates Birth of Drama in America," *New York Times,* 3 August 1926, 12.

70 Harriette Taber Richardson, "Circular," 22 April 1928, MG 30 B92, LAC.

71 In calling her organization the Hundred Associates, Richardson borrowed the name of a French fur trading company established in 1627 to support colonization at Quebec, long after Champlain had abandoned Port Royal.

72 L.M. Fortier to H.T. Richardson, 23 November 1928, Correspondence, MG 30 B92, LAC.

73 J.B. Harkin to J.C. Webster, 25 July 1936, RG 84, vol. 1041, FA2, LAC.

74 J.B. Harkin to E.A. Pickering, 21 August 1936, RG 84, vol. 1805, PR2, LAC.

75 E.K. Eaton to E.F. Surveyer, 17 June 1937, RG 84, vol. 1805, PR2, LAC; Adrien Huguet to Harriette Taber Richardson, 2 June 1938, MG 30 B92, LAC; Jefferys, "The Reconstruction," 371.

76 Brian S. Osborne, "The Kindling Touch of Imagination: Charles William Jefferys and Canadian Identity," in *A Few Acres of Snow: Literary and Artistic Images of Canada,* ed. Paul Simpson-Housley and Glen Norcliffe (Toronto: Dundurn, 1992), 33–37.

77 W.D. Cromarty to J.M. Wardle, 20 September 1938, RG 84, vol. 130, PR28, LAC. See also C.W. Jefferys, "The Visual Reconstruction of History," *Canadian Historical Review* 17, 3 (September 1936): 249–65.

78 Jefferys's sketches of how he thought Port Royal should look were on file in the Parks Branch from 1927, meaning he was hired to oversee the authenticity of his own imaginative creation. See RG 84, vol. 1805, PR2, LAC. See also C.W. Jefferys to L.M. Fortier, 2 November 1928, Correspondence: C.W. Jefferys, MG 30 B92, LAC.

79 C.T. Currelly to F.H.H. Williamson, 12 August 1938, RG 84, vol. 130, PR28, LAC.

80 C.C. Pinkney to T.S. Mills, 18 October 1938, RG 84, vol. 131, PR28, LAC.

81 C.C. Pinkney to T.S. Mills, 12 October 1938, RG 84, vol. 131, PR28, LAC.

82 C.C. Pinkney to T.S. Mills, 18 October 1938, RG 84, vol. 131, PR28, LAC.

83 T.S. Mills to J.M. Wardle, 31 October 1938, RG 84, vol. 131, PR28, LAC.

84 Harriette Taber Richardson to Kenneth Harris, 28 November 1938, MG 30 B92, Correspondence 1937/38, LAC.

85 Harriette Taber Richardson to Julius Tuttle, 2 December 1938, MG 30 B92, Correspondence 1937/38, LAC.

86 Harriette Taber Richardson to W.F. Ganong, 7 December 1938, MG 30 B92, Correspondence 1937/38, LAC.

87 Harriette Taber Richardson to Winfred Overholser, 2 December 1938, MG 30 B92, Correspondence 1937/38, LAC.

88 C. Coatsworth Pinkney to Harriette Taber Richardson, 3 and 25 June 1939, MG 30 B92, Correspondence: C. Coatsworth Pinkney, LAC.

89 K.D. Harris, "Report, 11 October 1938," RG 84, vol. 131, PR28, LAC.

90 C.W. Jefferys to K.D. Harris, 3 December and 10 October 1938, RG 84, vol. 131, PR28, LAC.

91 C.W. Jefferys to K.D. Harris, 3 and 10 December 1938, RG 84, vol. 131, PR28, LAC.

92 C.W. Jefferys to K.D. Harris, 19 February 1939, RG 84, vol. 131, PR28, LAC.

93 C.W. Jefferys to F.H.H. Williamson, 13 September 1938, RG 84, vol. 131, PR28, LAC.

94 C.W. Jefferys to K.D. Harris, 19 February 1939, RG 84, vol. 131, PR28, LAC.

95 Ramsay Traquair to T.S. Mills, 5 October 1939, RG 84, vol. 132, PR28, LAC.

96 Ramsay Traquair to K.D. Harris, 8 February 1939, RG 84, vol. 131, PR28, LAC.

97 C.W. Jefferys to K.D. Harris, 1 June 1939, RG 84, vol. 131, PR28, LAC.

98 K.D. Harris to C.W. Jefferys, 30 May 1939, RG 84, vol. 131, PR28, LAC.

99 Jefferys, "The Reconstruction," 377.

100 Dick Snell, "He Makes a Present of Our Past," *Imperial Oil Review* 48 (June 1964): 26.

101 "Prime Minister of Canada Officially Declared Fort Henry Open to the Public," *Kingston Whig-Standard*, 2 August 1938, 3.

102 "Pageant Will be Tribute to City's History," *Kingston Whig-Standard*, 23 July 1938, 2; "Kingston Will Soon be All Decked Out in Its Gayest," *Kingston Whig-Standard*, 25 July 1938, 1.

103 "Centenary Celebration is Launched with Perfect Weather and Fine Program," *Kingston Whig-Standard*, 30 July 1938, 29.

104 Snell, "He Makes a Present," 26.

Chapter 3: Tourism and History

1 Michael Wallace, "Mickey Mouse History: Portraying the Past at Disney World," in *History Museums in the United States: A Critical Assessment*, ed. Warren Leon and Roy Rosenzweig (Urbana: University of Illinois Press, 1989), 159–63.

2 Judith Adams, *The American Amusement Park Industry: A History of Technology and Thrills* (Boston: Twayne, 1991), 21; R.B. Nye, "Eight Ways of Looking at an Amusement Park," *Journal of Popular Culture* 15, 1 (1981): 65.

3 Scott A. Lukas, *Theme Park* (London: Reaktion Books, 2008), 38.

4 S. Anton Clavé, *The Global Theme Park Industry* (Wallingford: CABI, 2007), 14–15.

5 Lukas, *Theme Park*, 80. See also Raymond M. Weinstein, "Disneyland and Coney Island: Reflections on the Evolution of the Modern Amusement Park," *Journal of Popular Culture* 26, 1 (1992): 131–64.

6 Alan Bryman, *The Disneyization of Society* (London: Sage, 2004), 35. See also Lukas, *Theme Park*, 74–79.

7 Ian McKay and Robin Bates, *In the Province of History: The Making of the Public Past in Twentieth-Century Nova Scotia* (Montreal and Kingston: McGill-Queen's University Press, 2010), 77–129, covers this in greater detail.

8 See Ella Cork, "Memo to Historical Committee of the Canadian Tourism Association," June 1950, Historic Sites Advisory Council Papers, MG 20, vol. 933, Nova Scotia and Archives Record Management (NSARM), Halifax.

9 Nicole Neatby, "Meeting of Minds: North American Travel Writers and Government Tourist Publicity in Quebec, 1920-1955," *Histoire Sociale/Social History* 36, 72 (2003): 465–95; Alan Gordon, *Making Public Pasts: The Contested Terrain of Montreal's Public Memories, 1891-1930* (Montreal and Kingston: McGill-Queen's University Press, 2001), 64–71.

10 Ian McKay, "History and the Tourist Gaze: The Politics of Commemoration in Nova Scotia, 1935-1964," *Acadiensis* 22, 2 (Spring 1993): 102–38.

11 Michael Boudreau, "'A Rare and Unusual Treat of Historical Significance': The 1923 Hector Celebration and the Political Economy of the Past," *Journal of Canadian Studies/ Revue d'études Canadiennes* 28, 4 (1993–94): 28–48.

12 Warren James Belasco, *Americans on the Road: From Autocamp to Motel, 1910-1945* (Cambridge, MA: MIT Press, 1979), 72.

13 Gerald Bloomfield, Murdo MacPherson, and David Neufeld, "The Growth of Road and Air Transport," in *Historical Atlas of Canada*, vol. 3, *Addressing the Twentieth Century*, edited by Donald Kerr and Deryk W. Holdsworth (Toronto: University of Toronto Press, 1990), plate 53.

14 Kenneth Norrie and Douglas Owram, *A History of the Canadian Economy*, 2nd ed. (Toronto: Harcourt Brace, 1996), 327.

15 Donald Finlay Davis, *Conspicuous Production: Automobiles and Elites in Detroit, 1899-1930* (Philadelphia: Temple University Press, 1988); Ronald Edsforth, *Class Conflict and Cultural Consensus: The Making of a Mass Consumer Society in Flint, Michigan* (New Brunswick, NJ: Rutgers University Press, 1987), 13–15; John B. Rae, *The Road and the Car in American Life* (Cambridge, MA: MIT Press, 1971), 34–35; Belasco, *Americans on the Road*, 71–74; James Flink, *The Car Culture* (Cambridge, MA: MIT Press, 1975), 31.

16 "Commission Named to Build Highway," *Toronto Globe*, 19 September 1914, 6. On patronage in the hiring practices, see Alan Gordon, "Patronage, Etiquette, and the Science of Connection: Edmund Bristol and Political Management, 1911-1921," *Canadian Historical Review* 80, 1 (March 1999): 25.

17 Robert Prévost, *Trois siècles de tourisme au Québec* (Sillery: Septentrion, 2000), 90.

18 John A. Jakle, *The Tourist: Travel in Twentieth-Century North America* (Lincoln: University of Nebraska Press, 1985), 127.

19 Edward MacDonald, *If You're Stronghearted: Prince Edward Island in the Twentieth Century* (Charlottetown: Prince Edward Island Museum and Heritage Foundation, 2000), 71–73.

20 Cole Harris, *The Resettlement of British Columbia: Essays on Colonialism and Geographical Change* (Vancouver: UBC Press, 1997), 223. See also his "Moving Amid the Mountains, 1870-1930," *BC Studies* 58 (1983): 27–30.

21 Foster Dulles, *America Learns to Play: A History of Popular Recreation, 1607-1940* (New York: D. Appleton-Century, 1940), 319.

22 Quoted in Alan MacEachern, *Natural Selections: National Parks in Atlantic Canada, 1935-1970* (Montreal and Kingston: McGill-Queen's University Press, 2001), 37.

23 Thomas Weiss, "Tourism in America before World War II," *Journal of Economic History* 64, 2 (June 2004): 317.

24 Rae, *The Road and the Car*, 137–38. See also Cotton Seiler, *Republic of Drivers: A Cultural History of Automobility in America* (Chicago: University of Chicago Press, 2008), 105–28.

25 Kathleen Morgan Drowne and Patrick Huber, *The 1920s* (Westport: Greenwood, 2004), 253–54.

26 Jakle, *The Tourist*, 147. See also his *The Visual Elements of Landscape* (Amherst: University of Massachusetts Press, 1987), 69–74.

27 Catherine Gudis, *Buyways: Billboards, Automobiles and the American Landscape* (Florence, KY: Routledge, 2004), 66.

28 Sally Henderson, *Billboard Art* (San Francisco: Chronicle Books, 1980), 35.

29 Gudis, *Buyways*, 62–63.

30 Canada, Royal Commission on Canada's Economic Prospects, *The Canadian Automotive Industry* (Hull: Cloutier, 1956), 24, Table XI.

31 F.H. Leacey, *Historical Statistics of Canada*, 2nd ed., Series T147–194 (Ottawa: Statistics Canada, 1983).

32 Richard Harris, *Creeping Conformity: How Canada Became Suburban, 1900-1960* (Toronto: University of Toronto Press, 2004), 162–63.

33 Jean Barman, *The West beyond the West: A History of British Columbia*, rev. ed. (Toronto: University of Toronto Press, 1996), 263, 279–82; Michael Dawson, *Selling British Columbia: Tourism and Consumer Culture, 1890-1970* (Vancouver: UBC Press, 2004), 190.

34 Bloomfield, MacPherson, and Neufeld, "The Growth of Road and Air Transport."

35 Michael L. Berger, *The Automobile in American History and Culture* (Westport: Greenwood, 2001), xxii.

36 See Lizabeth Cohen, *A Consumer's Republic: The Politics of Mass Consumption in Postwar America* (New York: Vintage Books, 2004).

37 Steve Penfold, "Selling by the Carload: The Early Years of Fast Food in Canada," in *Creating Postwar Canada: Community, Diversity, and Dissent, 1945-75*, ed. Magda Fahrni and Robert Rutherdale (Vancouver: UBC Press, 2008), 169.

38 Ester Reiter, "Life in a Fast Food Factory," in *Canadian Working-Class History: Selected Readings*, ed. Laurel Sefton MacDowell and Ian Radforth (Toronto: Canadian Scholars' Press, 2006), 427.

39 Steve Penfold, *The Donut: A Canadian History* (Toronto: University of Toronto Press, 2008), 64–65.

40 John A. Jakle, Keith A. Sculle, and Jefferson S. Rogers, *The Motel in America* (Baltimore: Johns Hopkins University Press, 2002), 131–34.

41 Ibid., 175. See also Kemmons Wilson, *Half Luck and Half Brains: The Kemmons Wilson, Holiday Inn Story* (Nashville: Hambleton Hill, 1996).

42· Jakle, Sculle, and Rogers, *The Motel*, 45.

43 Karen Dubinsky, *The Second Greatest Disappointment: Honeymooning and Tourism at Niagara Falls* (New Brunswick, NJ: Rutgers University Press, 1999), 178.

44 W.H. Cranston to Peter Klopchic, 4 March 1968, RG 5-46, General Correspondence Files, Travel Research Branch, Ministry of Tourism and Information, Ontario Archives

(OA), Toronto. See also Report 28, "A Study of U.S. Visitors to Ontario Gas Stations, 1967," RG 5-48, Ministry of Tourism and Information, Reports, OA.

45 L.J. Crampon, "Tourist Research – A Recent Development at the Universities," *Journal of Marketing* 20, 1 (July 1955): 28.

46 D.B. Wallace, "Tourist Trade Attracts Veterans," *Canadian Business*, February 1946, 68.

47 Cindy S. Aron, *Working at Play: A History of Vacations in the United States* (New York: Oxford University Press, 1999), 247–49.

48 Gary Cross, *Time and Money: The Making of Consumer Culture* (New York: Routledge, 1993), 95–96; Jakle, *The Tourist*, 185.

49 Royal Commission on Economic Union, cited in Craig Heron and Steve Penfold, *The Workers' Festival: A History of Labour Day in Canada* (Toronto: University of Toronto Press, 2005), 326.

50 L.J. Crampon, "Additional Thoughts on Obtaining Tourist Data," *Journal of Marketing* 21, 1 (July 1956): 81. See also Robert E. Waugh, "Increasing the Validity and Reliability of Tourist Data," *Journal of Marketing* 20, 3 (January 1956): 286–88.

51 "Japanese Look to Air Travel for Quick Tourist Trade Boost," *Toronto Globe and Mail*, 29 September 1949, 19.

52 Norrie and Owram, *A History of the Canadian Economy*, 411.

53 Alisa Apostle, "The Display of a Tourist Nation: Canada in Government Film, 1945–1959," *Journal of the Canadian Historical Association* 12, 1 (2001): 185.

54 "Tourist Freedom Factor for Peace, Says St. Laurent," *Toronto Globe and Mail*, 14 September 1949, 15.

55 Michael Dawson, "'Travel Strengthens America'? Tourism Promotion in the United States during the Second World War," *Journal of Tourism History* 3, 3 (2011): 217–36.

56 Dawson, *Selling British Columbia*, 120–30.

57 J. Frank Beaman, "Editorial: In Pursuit of Happiness," *Holiday*, April 1946, 3.

58 "Tourist Freedom Factor for Peace, Says St. Laurent," *Toronto Globe and Mail*, 14 September 1949, 15.

59 J.A. Hume, "Charges Small Group Hurts Tourist Trade," *Ottawa Citizen*, 2 October 1947, 30.

60 Apostle, "The Display of a Tourist Nation," 187, 195.

61 Edwin G. Nourse, "Ideal and Working Concepts of Full Employment," *American Economic Review* 47, 2 (May 1957): 109. Nourse was the first chairman of the Council of Economic Advisors, which was established in 1946 to advise the president of the United States.

62 Apostle, "The Display of a Tourist Nation," 189.

63 Prévost, *Trois siècles de tourisme*, 97–98.

64 Stephen Papson, "Spuriousness and Tourism: Politics of Two Canadian Provincial Governments," *Annals of Tourism Research* 8, 2 (1981): 220–35.

65 Dawson, *Selling British Columbia*, 178.

66 Ontario, Ministry of Tourism and Information, *Annual Report* 23 (1969): 1.

67 Paul Litt, *The Muses, the Masses, and the Massey Commission* (Toronto: University of Toronto Press, 1992), 113–15, 247–48.

68 W.E. Greening, "Canada's Historic Sites," *Queen's Quarterly* 59, 1 (Spring 1952): 431.

69 Canada, Royal Commission on National Development in the Arts, Letters and Sciences, *Report: Royal Commission on National Development in the Arts, Letters and Sciences, 1949-1951* (Ottawa: E. Cloutier, 1951), 123 (hereafter Massey Report).

70 D.C. Harvey to Col. Childe, 17 September 1951, RG 84, vol. 1183, HS2, Library and Archives Canada (LAC), Ottawa; C.J. Taylor, *Negotiating the Past: The Making of Canada's*

National Historic Parks and Sites (Montreal and Kingston: McGill-Queen's University Press, 1990), 133–35.

71 Massey Report, 92.

72 R.L. Way, "Ontario's Historic Sites," memorandum to Leslie Frost, 15 August 1951, RG 5-54, Administrative Records of the St. Lawrence Parks Commission, OA.

73 Ibid.

74 Ronald Way, "Historical Restorations," *Canadian Historical Association Annual Report* 29 (1950): 59.

75 J.D. Herbert to C.T. Smith, 21 August 1963, RG 84, vol. 1156, GP2, LAC.

76 J.C. McCuaig to Jean Lesage, 14 March 1955, RG 84, vol. 1156, GP2, LAC.

77 R.H. Winters to J.G. Diefenbaker, 15 June 1950, RG 84, vol. 979, BA2, LAC.

78 Taylor, *Negotiating the Past,* 145.

79 Archibald Day to C.M. Drury, 2 June 1950, RG 84, vol. 1160, HC28, LAC.

80 Canada, National and Historic Parks Branch, *The Halifax Citadel: National Historic Site* (Ottawa: Information Canada, 1973), 9.

81 W.C. Borrett to C.G. Childe, 17 June 1952, RG 84, vol. 1160, HC28, LAC.

82 J. Smart to C.G. Childe, 27 September 1951; and G.V.F Weir to E.A. Gurnet, 30 August 1951, RG 84, vol. 1160, HC28, LAC.

83 Walter Dinsdale, "Rededication of the Old Town Clock: The Citadel Hill of Halifax, 20 October 1962," RG 84, vol. 1165, HC109-1, LAC.

84 J.R.B. Coleman to H.A. Johnson, 25 September 1964, RG 84, vol. 1165, HC118, LAC.

85 McKay and Bates, *In the Province of History,* 342.

86 W.E. Greening, "Canada's Historic Sites: A Neglected Source of Tourist Revenue," *Canadian Banker* 67 (Winter 1960): 58–67.

87 D.F. McOuat and Peter Klopchic, "The Historical Significance of Niagara and Its Potential as a Tourist Attraction," 1966, RG 5-4, Minister's Correspondence, Department of Travel and Publicity, OA.

88 Ontario, Department of Travel and Publicity, *Annual Report of the Department of Travel and Publicity* 11 (1957): 7.

89 Keats, Peat, Marwick, and Company, Consultants, "The Economic Significance of Tourism in Canada: Summary Report, 1969," RG 5-30, reports and publications files of the Deputy Minister of Tourism and Information, OA.

90 *Fort William Times-Journal,* 7 April 1971. clipping in Old Fort William Collection, Thunder Bay Museum, Thunder Bay.

91 J.D. Herbert, "The Economic Impact of Historical Attractions: A Report Prepared for the Canadian Conference on Historical Resources," box 5, MS 2009, Margaret A. Ormsby fonds, BC Archives, Victoria.

92 Government of Ontario, *Annual Report for the Department of Travel and Publicity for the Year 1963* 17 (1963): 1.

93 Peter Klopchic to W.H. Cranston, 8 March 1968, RG 5-46, OA. See also Report 28, "A Study of U.S. Visitors to Ontario Gas Stations, 1967," RG 5-48, Ministry of Tourism and Information, Reports, OA.

94 Jakle, *The Tourist,* 176–82.

95 Bloomfield, MacPherson, and Neufeld, "The Growth of Road and Air Transport."

96 Jafar Jafari, *Encyclopedia of Tourism* (New York: Routledge, 2000), 389; John Swarbrooke and Susan Horner, *Consumer Behaviour in Tourism* (Boston: Butterworth-Heinemann, 1999), 21. For an account of Mexico's rise as an American tourist destination, see Dennis Merrill, *Negotiating Paradise: U.S. Tourism and Empire in Twentieth Century Latin America* (Chapel Hill: University of North Carolina Press, 2009), 65–102.

97 "Tourists Prefer Historical Europe," *Toronto Financial Post,* 23 September 1972, J14.
98 "Portrait of Aviation Appraised as Erratic," *Toronto Globe and Mail,* 29 December 1955, 4. TCA was not permitted to fly to London until 1961.
99 "Any Friend of Ghoulash Can't Be All Bad," *Life,* 17 April 1964, 4.
100 Peter Klopchic, "Tourist Industry Problems – 1970s," May 1967, RG 5-30, AO.
101 "Tourists Prefer Historical Europe," *Toronto Financial Post,* 23 September 1972, J14.
102 J.R.B. Coleman to H.A. Johnson, 25 September 1964, RG 84, vol. 1165, HC118, LAC.
103 Joel J. Orosz, *Curators and Culture: The Museum Movement in America* (Tuscaloosa: University of Alabama Press, 2002), 8–9.
104 P.H. Schonenbach to J.I. Nicol, 7 October 1966, RG 84, vol. 118, FLO108, LAC.
105 Tony Bennett, *The Birth of the Museum: History, Theory, Politics* (New York: Routledge, 1995), 157.
106 J.R.B. Coleman to H.A. Johnson, 25 September 1964, RG 84, vol. 1165, HC118, LAC. Emphasis added.
107 Walter Dinsdale, "Rededication of the Old Town Clock: The Citadel Hill of Halifax, 20 October 1962," RG 84 vol. 1165, HC109-1, LAC.

Chapter 4: Pioneer Days

1 Alex Henderson, "Vacation Peak Needs Stretch," *Toronto Star,* 2 January 1960, 12.
2 Mary K Nolan, "History on the Move," *Hamilton Spectator,* 19 July 2004, G04.
3 Transcript of Evidence, Montreal Sessions, 458B, in Canada, Royal Commission on National Development in the Arts, Letters and Sciences, *Report: Royal Commission on National Development in the Arts, Letters and Sciences, 1949-1951* (Ottawa: Edmond Cloutier, 1951), 94 (hereafter Massey Report).
4 "Fort York Wins a Modern Battle," *Ontario History* 51, 1 (Winter 1959): 22.
5 Shirley McManus, *History of the Toronto Civic Historical Committee and the Toronto Historical Board, 1949-1985* (Toronto: Toronto Historical Board, 1986), 4–5.
6 Some of these letters are collected in MU 3209, York Pioneer and Historical Society fonds, F 1143, Ontario Archives (OA), Toronto.
7 "Expressway Poll," *Toronto Globe and Mail,* 28 November 1958, 19.
8 G.F.G. Stanley to Nathan Phillips, 19 March 1958, York Pioneer and Historical Society fonds, F 1143, OA.
9 "Fort York Wins a Modern Battle," 22.
10 Toronto Civic Historical Committee, Minutes, 2 July 1958, York Pioneer and Historical Society fonds, F 1143, OA.
11 Steve Penfold, "'Are We to Go Literally to the Hot Dogs?' Parking Lots, Drive-Ins, and the Critique of Progress in Toronto's Suburbs, 1965–1975," *Urban History Review/Revue d'histoire urbaine* 33, 1 (2004): 22–23.
12 "Standardized – Like Anthills," *Toronto Globe and Mail,* 11 July 1946, 6. According to the *Toronto Telegram,* the situation had not improved by the end of the 1950s. "Report on 'Dull' Suburbs Fails to Stir Reeves," *Toronto Telegram,* 2 June 1960, 3.
13 Richard Harris, *Creeping Conformity: How Canada Became Suburban, 1900-1960* (Toronto: University of Toronto Press, 2004), 141.
14 James T. Lemon, *Liberal Dreams and Nature's Limits: Great Cities of North America since 1600* (Toronto: Oxford University Press, 1996), 275.
15 *Maclean's Magazine,* 24 May 1958, front cover.
16 Blodwen Davies, "History at the Grassroots," *Bulletin of the Canadian Museums Association* 7, 4 (December 1954): 8–12.

17 Norman High, "A Point of View of History," *Waterloo Historical Society Annual Report* (Kitchener: Waterloo Historical Society, 1960), 33.

18 Royce McGillivray, "Local History as a Form of Popular Culture in Ontario," *New York History* 65, 4 (October 1984): 371.

19 See T.J.J. Lears, *No Place of Grace: Antimodernism and the Transformation of American Culture, 1880-1920* (New York: Pantheon, 1981); Ian McKay, *The Quest of the Folk: Antimodernism and Cultural Selection in Twentieth-Century Nova Scotia* (Montreal and Kingston: McGill-Queen's University Press, 1994), 30–44; and Alan Gordon, *Making Public Pasts: The Contested Terrain of Montreal's Public Memories, 1891-1930* (Montreal and Kingston: McGill-Queen's University Press, 2001), 13–16.

20 Sharon Wall, *The Nurture of Nature: Childhood, Antimodernism, and Ontario Summer Camps, 1920-55* (Vancouver: UBC Press, 2009).

21 Paul Litt, "Pliant Clio and Immutable Texts: The Historiography of a Historical Marking Program," *Public Historian* 19, 4 (Fall 1997): 16.

22 Mary Tivy, "Museums, Visitors and the Reconstruction of the Past in Ontario," *Material History Review* 37 (Spring 1993): 37.

23 John Henry Haines Root, *Memoirs from 1908 to 1982 of John Henry Haines Root* (Grand Valley: Star and Vidette Printing, 1982), 38.

24 Ontario, *Debates of the Legislative Assembly* (24 March 1954), 763.

25 The 1932 act created the Grand River Conservation Commission, modelled on the New Deal Tennessee Valley Authority. In 1948, a separate Grand Valley Conservation Authority was established. The two agencies merged to become the present Grand River Conservation Authority in 1966. See Dan Shrubsole, "The Grand River Conservation Commission: History, Activities, and Implications for Water Management," *Canadian Geographer* 36, 3 (1992): 221–36.

26 John C. Carter, "Ontario Conservation Authorities: Their Heritage Resources and Museums," *Ontario History* 44, 1 (Spring 2002): 11; *Conservation Authorities Act*, 10 Geo. VI, c. 11.

27 Danielle Robinson and Ken Cruikshank, "Hurricane Hazel: Disaster Relief, Politics, and Society in Canada, 1954-55," *Journal of Canadian Studies/Revue d'études Canadiennes* 40, 1 (Winter 2006): 40–41.

28 Carter, "Ontario Conservation Authorities," 11–12.

29 Sheila A. Johnson, "History of Fanshawe Village," 1, Fanshawe Pioneer Village, Corporate Archives, London, Ontario. See also Ruth Home, "A Master Plan to Prepare for Canada's Centenary," *Ontario History* 53, 3 (September 1961): 178.

30 *Moira Valley Conservation Report* (Toronto: Planning and Development, 1950), 28–29.

31 *Don Valley Conservation Report* (Toronto: Planning and Development, 1950), iv.

32 Dorothy Duncan, *Pioneer Village: Black Creek Conservation Area* (North York: Metro Toronto and Region Conservation Authority, 1964), n.p.

33 The original conservation authorities were the Humber Valley Conservation Authority, the Etobicoke-Mimico Conservation Authority, the Don Valley Conservation Authority, and the Rouge, Duffin, Highland, and Petticoat Conservation Authority.

34 *An Act to Amend the Conservation Authorities Act*, 4–5 Elizabeth II, c. 9. The bill received Royal Assent on 28 March 1956. *Journals of the Legislative Assembly (1955-56)* vol. 40 (Toronto: Baptist Johnston, 1956), 90, 152. See also Bill McLean, *Paths to the Living City: The Story of the Toronto and Region Conservation Authority* (Toronto: Toronto and Region Conservation Authority, 1984).

35 At times, the persistence of this amateur tradition infuriated "professional" or professionalizing museologists, such as Andrew Taylor, the first curator of Doon Pioneer Village. Nevertheless, the amateur drive helped sustain them.

36 On the professionalization of history, see Donald Wright, *The Professionalization of History in English Canada* (Toronto: University of Toronto Press, 2005). Cecilia Morgan reveals how one vocational curator, Janet Carnochan, was at the vanguard of museum practice early in the twentieth century. See Cecilia Morgan, *Creating Colonial Pasts: History, Memory, and Commemoration in Southern Ontario, 1860-1980* (Toronto: University of Toronto Press, 2015), 16–33.

37 "Eligibility for Membership," *Canadian Museums Association Bulletin* 1, 1 (April 1948): 3.

38 Carl Eugen Guthe and Grace M. Guthe, *The Canadian Museum Movement* (Ottawa: Canadian Museums Association, 1958), 16.

39 Gerald Killan, *Preserving Ontario's Heritage: A History of the Ontario Historical Society* (Toronto: Ontario Historical Society, 1976), 234–35.

40 Dorothy Drever, "The Museums Section: An Account of Its Beginning," *Ontario History* 53, 3 (September 1961): 153–55.

41 Richard Handler and Eric Gable, *The New History in an Old Museum: Creating the Past at Colonial Williamsburg* (Durham: Duke University Press, 1997), 182.

42 Massey Report, 95.

43 Carl Eugen Guthe, "The Museum as Social Instrument," *Ontario History* 53, 3 (September 1961): 171.

44 Mary Tivy, "The Local History Museum in Ontario: An Intellectual History, 1851–1985" (PhD diss., History, University of Waterloo, 2006), 164–69.

45 A.E. Broome to the Mayor and Council, City of Kitchener, 27 April 1953, Ontario Pioneer Community Foundation fonds, box 3, Waterloo Historical Society – Correspondence, Waterloo Region Curatorial Services, Kitchener.

46 Ibid.

47 "Pioneer Village Plan Gets Support, Agriculture Minister 'Eager,'" *Kitchener-Waterloo Record*, 4 November 1953.

48 "Brief to the Honourable S.F. Thomas," in *Waterloo Historical Society Annual Report* (Kitchener: Waterloo Historical Society, 1953), 31–39.

49 Tivy, "The Local History Museum," 150–52.

50 "Enthusiast for Museums, Planned Six," *Toronto Globe and Mail*, 5 November 1965, 50.

51 "Picturesque Flashback Into Guelph's Early Days," *Guelph Daily Mercury*, 29 January 1954, 3.

52 See, for instance, John Root to Ernest Young, 17 January 1953; and John Root to Leslie Frost, 21 September 1953, RG 3-23, Premier Leslie M. Frost, General Correspondence, box 2, OA.

53 "The Annual Meeting," *Ontario History* 46, 2 (Spring 1954): 188.

54 Tivy, "The Local History Museum," 153.

55 The surveys of the Huron Road were supervised by Deputy Provincial Surveyor John McDonald, who was also responsible for laying out the streets of Guelph and Goderich according to Galt's plans. Robert C. Lee, *The Canada Company and the Huron Tract, 1826-1853: Personalities, Profits and Politics* (Toronto: Natural Heritage/Natural History, 2004), 252n38.

56 "Brief to the Honourable S.F. Thomas," 31–39.

57 "Glimpse Into Bygone Days," *Guelph Daily Mercury*, 20 June 1960, 4.

58 "Expert's Advice: Start Pioneer Village Without Outside Aid," *Kitchener-Waterloo Record*, 6 November 1954; "City Gives $5,000 for Pioneer Village," *Kitchener-Waterloo Record*, 7 December 1954. Wilfrid Jury's first name is often misspelled as "Wilfred." However, in his own publications, and on the London public school that bears his name, the spelling is Wilfrid.

59 "Pioneer Body Chooses its First Officers," *Kitchener-Waterloo Record*, 9 December 1954.

60 *Grand Valley Conservation Report* (Toronto: Planning and Development, 1954), 126–28; see also Carter, "Ontario Conservation Authorities," 13–14.

61 "Historic Houses To Be Restored," *Toronto Globe and Mail*, 18 December 1958, 2.

62 "Pioneer Body Names First Paid Official," *Kitchener Waterloo Record*, 31 August 1957. See also Andrew Taylor to A.E. Broome, 5 March 1957, Ontario Pioneer Community Foundation fonds, box 38, Waterloo Region Curatorial Services, Kitchener.

63 Louis C. Jones, "The Cooperstown Idea: History for Everyman," *American Heritage* 1, 3 (Spring 1951): 32.

64 Andrew Taylor, "The Ontario Pioneer Community – An Outdoor Museum," *Ontario History* 50, 1 (Winter 1958): 13–14.

65 Andrew Taylor to Oliver Wright, 1 March 1960; and OPCF, Minutes, 1 March 1960, Doon Pioneer Village fonds, Waterloo Region Curatorial Services; see also "Pioneer Village Man Quits," *Kitchener-Waterloo Record*, 2 March 1960.

66 See OPCF, Minutes, 29 August 1961, Doon Pioneer Village fonds, Waterloo Region Curatorial Services.

67 "Pioneer Village Rises Near Kitchener," *Toronto Star*, 16 June 1960, 5; "2,500 Pioneer Village Items Displayed at Opening Event," *Kitchener-Waterloo Record*, 16 June 1960. As late as 1978, a consultant complained that no clear plan had ever been implemented at Doon and that new donations simply added more "tangle." P.J. Stokes, "Doon Pioneer Village: A Preliminary Report, 1 February 1978," box 2, OPCF fonds, Waterloo Region Curatorial Services.

68 "Grand Conservation Authority," *Our Valley* 6, 1 (Winter 1960): 27.

69 Howard Groh to Ann Wilcox, 27 September 1966, Correspondence 1966, OPCF fonds, Waterloo Region Curatorial Services.

70 Robert J. Pearce, *Stories of (Pre) History: The Jury Family Legacies* (London: London Museum of Archaeology, 2003), 8–10.

71 Michelle Hamilton, *Collections and Objections: Aboriginal Material Culture in Southern Ontario, 1791-1914* (Montreal and Kingston: McGill-Queen's University Press, 2010), 37.

72 Michael Baker, *100 Fascinating Londoners* (Toronto: James Lorimer, 2005), 80–81.

73 UTRCA Executive Committee, Minutes, 22 April 1958, UTRCA Library, London. See also Archie F. Key, *Beyond Four Walls: The Origins and Development of Canadian Museums* (Toronto: McClelland and Stewart, 1973), 242.

74 *Stratford Beacon-Herald*, 27 June 1959, cited in Tammy Coleman, "Wilfrid Jury's Vision for Fanshawe Pioneer Village" (November 2004), 6, Fanshawe Pioneer Village Records, London, Ontario.

75 W.W. Jury, "Pioneer Life in Models," *Western Ontario Historical Notes* 1, 1 (1942): 10–11.

76 UTRCA, *Twenty Years of Conservation on the Upper Thames Watershed, 1947-1967* (Stratford: Beacon-Herald Press, n.d.), 74.

77 Fanshawe Pioneer Village, *A Commemorative Look at the Creation of a Village: Celebrating Forty Years of History* (London: Upper Thames River Conservation Authority, 1996), n.p.

78 UTRCA, *Twenty Years of Conservation*, 76–78.

79 "Pioneer Festival Highlights Early Days," *Toronto Star*, 29 September 1958, 22.

80 MTRCA, "Brief to the Province of Ontario, 1966," Pioneer Village Papers, Toronto Public Library, Toronto.

81 MTRCA, Minutes of Historical Advisory Board, 1 May 1964, City of Toronto Archives, Toronto.

82 Quoted in McLean, *Paths to the Living City*, 138.

83 MTRCA, Minutes of Historical Advisory Board, 1 May 1964, City of Toronto Archives.

84 "Metro Toronto & Region," *Our Valley* 6, 2 (Summer 1960): 33.

85 Toronto Public Library, "North York Heritage Scrapbooks: Black Creek Pioneer Village," vol. 1, uncredited newspaper clipping (likely *Weston Times and Guide*). See also "Modern Kitchen – 1816," *Toronto Telegram*, 2 June 1960, 4.

86 Vera E. Burns, "Heritage Park," *Canadian Collector* 11, 4 (January-February 1976): 63.

87 Sylvia Harnden, "A Brief History of Heritage Park Historical Village," rev. ed. (2005), 4–5, Heritage Park Collection, Heritage Park, Calgary.

88 Vera Burns, "Manuscript, Chapter 2," n.p., Heritage Park Collection, Heritage Park.

89 "William Pratt," *Calgary Herald*, 20 June 2008, http://www.canada.com/story.html?id= 4bdc3179-faf0-45d5-b403-d6a383fd0aca.

90 Vera Burns, "Manuscript, Chapter 1," n.p., Heritage Park Collection, Heritage Park.

91 Heritage Park Society, Board Minutes, 18 June 1964, Heritage Park Collection, Heritage Park.

92 Vera Burns, "Manuscript, Chapter 1," n.p., Heritage Park Collection, Heritage Park. The display items were probably Barkerville-themed advertisements, which were then popular in British Columbia.

93 Vera Burns, "Manuscript, Chapter 5," n.p., Heritage Park Collection, Heritage Park; George Sidney, dir., *The Harvey Girls* (Burbank: MGM Grand, 1946). For more on how the Harvey Company itself manipulated history to market its restaurant chain, see Marta Weigle, "From Desert to Disney World: The Santa Fe Railway and the Fred Harvey Company Display the Indian Southwest," *Journal of Anthropological Research* 45, 1 (Spring 1989): 115–37.

94 Heritage Park Society, Board Minutes, 19 November 1964; Heritage Park, "Report of Public Service Committee, October 1964," Heritage Park Collection, Heritage Park.

95 J.D. Francis, *What Is Heritage Park?* (Calgary: Heritage Park, 1972), 4. See also Vera Burns, "Manuscript, Chapter 1," n.p., Heritage Park Collection, Heritage Park.

96 Heritage Park, *Annual Report for the Fiscal Year Ending 1964* (Calgary: Heritage Park Society, 1964), n.p.

97 Red Cathcart to J. Scammon, 5 May 1964, box 2, file 16, M203 John G. "Red" Cathcart fonds, Glenbow Museum Archives, Calgary.

98 Heritage Park, "Report of Public Service Committee, October 1964," Heritage Park Society, Board Minutes, 19 November 1964, Heritage Park Collection, Heritage Park.

99 Heritage Park, *Annual Report for the Fiscal Year Ending 1978* (Calgary: Heritage Park Society, 1978), n.p.

100 Heritage Park, *Annual Report for the Fiscal Year ending 1979* (Calgary: Heritage Park Society, 1979), n.p.

101 Michael Webb, "Master Plan Prepared for the Heritage Park Society, August 1979," 4, Heritage Park Collection, Heritage Park.

102 Ibid., 3.

Chapter 5: A Sense of the Past

1 J.L. Granatstein, *Yankee Go Home: Canadians and Anti-Americanism* (Toronto: Harper-Collins, 1996), 149–50.

2 Hydro-Electric Power Commission of Ontario, press release, 26 July 1958, RG 5-54, Administrative Records of the St. Lawrence Parks Commission, Ontario Archives (OA), Toronto.

3 Daniel Macfarlane, *Negotiating a River: Canada, the US, and the Creation of the St. Lawrence Seaway* (Vancouver: UBC Press, 2014), 139–49.

4 Gerald Killan, *Preserving Ontario's Heritage: A History of the Ontario Historical Society* (Toronto: Ontario Historical Society, 1976), 238–39.

5 Barrie Zwicker, "Village Opening Termed Washout," *Toronto Globe and Mail,* 26 June 1961, 1.

6 A.E. Bunnell to W.M. Nickle, 8 October 1958 (emphasis in original), RG 5-54, OA.

7 "Press Kit," n.d., RG 5-54, OA.

8 Ontario–St. Lawrence Development Commission, *Annual Report* (Morrisburg, ON, Ontario-St. Lawrence Development Commission, 1961), 12–13.

9 Ronald Way, "Historical Restorations," *Canadian Historical Association Annual Report* 29 (1950): 62.

10 R.L. Way, "Old Fort Henry: The Citadel of Upper Canada," *Canadian Geographical Journal* 40 (April 1950): 169.

11 Ronald Way to G.H. Challies, 20 October 1959, RG 5-54, OA.

12 Ronald Way, "Memo on Interview with F. Spinney, Director of Sturbridge Village, September 6, 1958," RG 5-54, OA.

13 Ronald Way, "Memo on Interview with F. Spinney," 6 September 1958, RG 5-54, OA.

14 Cited in Arnold Edinborough, "Living History in Ontario," *Saturday Night,* June 1964, 28.

15 Ronald Way, "Memo on Interview with F. Spinney," 6 September 1958, RG 5-54, OA.

16 John H. Herbst, "Historic Houses," in *History Museums in the United States: A Critical Assessment,* ed. Warren Leon and Roy Rosenzweig (Urbana: University of Illinois Press, 1989), 99.

17 W.M. Nickle to John Hall Stewart, 18 May 1960, RG 5-54, OA.

18 G.H. Challies to R.W. Macaulay, 1 December 1961, RG 5-54, OA. The Historic Sites and Monuments Board of Canada declared the house a site of national historical importance in 1961. Parks Canada acquired it in 1971.

19 Ronald Way to Executive Committee, 8 October 1959, RG 5-55, OA.

20 Later investigations revealed that the house was not built until after her death. Mary Jane Charters, "The House that Died a Slow Death," *Ottawa Citizen,* 25 March 1978, 95.

21 Robert Beck to W.M. Nickle, 8 December 1959, RG 5-55, OA. The house was dismantled and moved to a barn near Gananoque for storage. Unfortunately, on 31 May 1975, fire destroyed both the barn and the house stored inside it. Charters, "Slow Death," *Ottawa Citizen,* 25 March 1978, 95.

22 Adamson's career can be followed in the Anthony Adamson and Marion MacRae fonds, McMaster University Archives, Hamilton. He also wrote an early proposal for Upper Canada Village. See Anthony Adamson, *A Report on a Plan for the Development of the Major Park in the Park System Under Construction for the Ontario-St. Lawrence Development Commission* (Morrisburg, ON, Ontario-St. Lawrence Development Commission, 1957).

23 "Memo RE: Control of Upper Canada Village Restoration," n.d. (spring 1958), RG 5-54, OA.

24 Way, "Historical Restorations," 61–62.

25 See Norman Knowles, *Inventing the Loyalists: The Ontario Loyalist Tradition and the Creation of Useable Pasts* (Toronto: University of Toronto Press, 1997).

26 Donald Creighton to George Challies, 11 June 1959, RG 5-54, OA.

27 W.M. Nickle to James Auld, 21 August 1958, RG 5-54, OA.

28 H.F. Crown to J.S.P. Armstrong, 3 January 1962, RG 5-54, OA.

29 *Toronto Globe and Mail,* 10 January 1962 (overseas edition) clipping in RG 5-54, OA.

30 Cited in J.S.P. Armstrong, "Memorandum on Wolford Chapel," n.d. (probably 1961), RG 5-54, OA.

31 Floyd Chalmers to J.S.P. Armstrong, 22 May 1958, RG 5-54, OA.

32 Paul A. Bator, *Ontario's Heritage: A Celebration of Conservation* (Toronto: Ontario Heritage Foundation, 1997), 14.

33 Roger Graham, *Old Man Ontario: Leslie Frost* (Toronto: University of Toronto Press, 1990), 248.

34 G.H. Challies to James Auld, 12 December 1961, RG 5-54, OA.

35 James Auld to R.W. MacAuley, 15 December 1961, RG 5-54, OA.

36 H.F. Crown to R.W. MacAuley, 20 December 1961, RG 5-54, OA.

37 "N.B. Power Participation in the Realization of the Historical Village at King's Landing" (1976), n.p., file D5/8, RS 173, Mactaquac Development Project Records, Provincial Archives of New Brunswick (PANB), Fredericton.

38 R.T. Shawcross to Douglas Hough, 20 December 1966, King's Landing Historical Settlement fonds (KLHS), Douglas Hough file, King's Landing Historical Settlement Corporate Archives (KLHSCA), Fredericton.

39 See *Community Improvement Corporation Act,* 14 Elizabeth II, c. 2, assented 3 April 1965.

40 J. Lorne Mcguigan to R.B. Hatfield, 3 December 1971, RS 310, PANB.

41 "$4,400 Bid for Historic Verandah," *Ottawa Citizen,* 14 November 1962, 14; Peter John Stokes, Curriculum Vitae, Research Peter John Stokes Research, KLHS, KLHSCA. Stokes passed away in July 2013 at the age of eighty-seven. Lori Fazari, "Architect Peter John Stokes brought heritage to life," *Toronto Globe and Mail,* 8 November 2013, http:// www.theglobeandmail.com/arts/art-and-architecture/architect-peter-john-stokes -brought-heritage-to-life/article15363043/.

42 Paul Litt, "The Apotheosis of the Apothecary: Retailing and Consuming the Meaning of a Historic Site," *Journal of the Canadian Historical Association* 10, 1 (1999): 304.

43 Peter John Stokes to R.C. Ballance, 12 March 1966, Site Selection File, KLHS, KLHSCA.

44 E.W. Sansom to R.C. Ballance, 2 September 1965, Mactaquac Historical Project File, KLHS, KLHSCA.

45 E.W. Sansom to R.C. Ballance, 14 October 1965; and R.C. Ballance to E.W. Sansom, 8 September 1965, Mactaquac Historical Project File, KLHS, KLHSCA.

46 R.T. Shawcross to George MacBeath, 20 November 1967, Mactaquac Historical Project File; and QED Services, "King's Landing – Prince Williams Highway Report," 5, KLHS, KLHSCA.

47 Acres Research and Planning, "Conceptual Plan: Mactaquac Historical Complex" (Fredericton and Toronto, 1967), 1, KLHS, KLHSCA.

48 See Fernand Ouellet, "La modernisation de l'historiographie et l'émergence de l'histoire sociale," *Recherches sociographiques* 26, 1–2 (1985): 11–83. See also Margaret Conrad, "A Brief Survey of Canadian Historiography," in *New Possibilities for the Past: Shaping History Education in Canada,* ed. Penney Clark (Vancouver: UBC Press, 2011), 33–54.

49 E.F. Eaton to J.P. Wohler, 21 September 1970, Recommendations File, KLHS, KLHSCA.

50 R.C. Ballance to W.W. Meldrum, 2 February 1968, Administration File, KLHS, KLHSCA.

51 "Nine Resigned at King's Landing in Past Year," *Fredericton Daily Gleaner,* 21 September 1971; "Resignations Another Problem for Premier Hatfield," *Fredericton Daily Gleaner,*

22 September 1971; *Fredericton Telegraph-Journal,* 22 September 1971, clipping in RS310, G1k-1, PANB.

52 "Historical Resources Administration Notes for Minister," 11 March 1971, RS310, G1a-11, PANB.

53 William H. Bradford, "Letter to the Editor on King's Landing: Its Problems, Its Management, Its Future," *Fredericton Daily Gleaner,* 12 October 1971.

54 See "Museum Appoints Educationist," *Ottawa Citizen,* 26 November 1966, 24. For Wohler's obituary, see "John Wohler," *Ottawa Citizen,* 21 March 2009, http://www. legacy.com/obituaries/ottawacitizen/obituary.aspx?n=john-wohler&pid=125316758 &fhid=7311.

55 Ronald Way to Executive Committee, 8 October 1959, RG 5-55, OA.

56 J.P. Wohler to George MacBeath, 10 February 1971 (emphasis in original), KLHS, KLHSCA.

57 "Believes Authentic London Pioneer Village to be Among Top Community Attractions," *London Free Press,* 23 April 1958, 7; "Early June Opening Seen for Pioneer Village," *London Free Press,* 22 April 1959, 1.

58 Quoted in Tammy Coleman, "Wilfrid Jury's Vision for Fanshawe Pioneer Village" (November 2004), 9, Fanshawe Pioneer Village Records, London, Ontario.

59 Ontario Pioneer Community Foundation (OPCF), Report of the Annual Meeting, January 1977, OPCF fonds, Waterloo Region Curatorial Services, Kitchener.

60 Elmer Sager to J.L. Carroll, 21 August 1962 (emphasis in original), RG 5-54, OA.

61 Beryl W. Way, "Upper Canada Village," *Canadian Geographical Journal* 62, 6 (June 1961): 219.

62 R.A. O'Brien, "Upper Canada Village Is Making Our History Live Again," *Canadian Comment* (October 1961): 19.

63 Jenny Kidd, "Performing the Knowing Archive: Heritage Performance and Authenticity," *International Journal of Heritage Studies* 17, 1 (January 2011): 24.

64 Michael Webb, "Master Plan Prepared for the Heritage Park Society, August 1979," 45, Heritage Park Collection, Heritage Park, Calgary.

65 Stacey Roth, *Past into Present: Effective Techniques for First Person Historical Interpretation* (Chapel Hill: University of North Carolina Press, 1998), 3; see also Mike Crang, "Magic Kingdom or a Quixotic Quest for Authenticity?" *Annals of Tourism Research* 23, 2 (1996): 429; for the counter argument, see S. Ketchum and J. Pietschman, "Costumed Interpretation: Magic or Mistake?" *Interpretive Sourcebook: Proceedings of the 1995 National Interpreters' Workshop* (Fort Collins: National Association of Interpreters, 1995), 29. Scott Magelssen argues that third-person interpretation is more "historiographically responsible" than the first-person approach. Scott Magelssen, "Living History Museums and the Construction of the Real through Performance," *Theatre Survey* 45, 1 (May 2004): 69. As early as 1897, the Dutch archaeologist Sophus Muller ridiculed animation at open-air museums as pantomime and falsehood. Cited in Sten Rentzhog, *Open Air Museums: The History and Future of a Visionary Idea* (Stockholm/Östersund: Carlssons/Jamtli, 2007), 30.

66 E. Fronk, "Historic Costuming: When Appearance Is Everything," *Legacy* 8, 4 (1997): 21.

67 Jacob Spelt, *Urban Development in South-Central Ontario* (Assen: Van Gorcum, 1965), 140. Spelt's work was originally published in 1955.

68 These museums were selected to provide a proportional cross-section of pioneer villages. Six were in Ontario, three in the Maritimes, and three in western Canada. They were chosen for their size and the availability of documents to confirm their exhibits. By the mid-1970s, all had interpretation programs that involved costumed interpreters.

The museums are Doon Pioneer Village, Upper Canada Village, Fanshawe Village, Westfield Pioneer Village, Black Creek Pioneer Village, Lang Pioneer Village, Sherbrooke Village, King's Landing Historical Settlement, Orwell Corner, Barkerville, Fort Steele, and Heritage Park.

69 Gail MacMillan, "Restoring a Working Farm," *Atlantic Advocate* 65 (November 1974): 44; Julie V. Watson, "Horses and Handlers at King's Landing," *Atlantic Advocate* 68 (September 1979): 26–27.

70 Generations of observers and scholars have overestimated the importance of property ownership in Upper Canada. As much as 43% of Upper Canada's rural population were tenants in 1848. See Catharine Anne Wilson, *Tenants in Time: Family Strategies, Land, and Liberalism in Upper Canada, 1799-1871* (Montreal and Kingston: McGill-Queen's University Press, 2009), 7, 54.

71 Darrell Butler et al., "Interpretation 1977: Interpretation Recommendations," Interpretation Recommendations File, KLHS, KLHSCA.

72 Heritage Park Society, *Annual Report for the Fiscal Year Ending 1968* (Calgary: Heritage Park Society, 1968), n.p.

73 Heritage Park Society, *Heritage Park, Calgary, Alberta, Canada: The Original West Rediscovered* (Calgary: Heritage Park Society, likely 1969).

74 See, for example, *Toronto Globe and Mail,* 19 May 1961, 11.

75 "This House is Not a Home It's a Space Age Palace," *Toronto Star,* 2 April 1964, 21.

76 "The Royal" advertisement, *Toronto Globe and Mail,* 20 November 1964, 8.

77 Dorothy Duncan, *Pioneer Village: Black Creek Conservation Area* (North York: Metro Toronto and Region Conservation Authority, 1964), 13.

78 Douglas McCalla, "'Retailing in the Countryside': Upper Canadian General Stores in the Mid-Nineteenth Century," *Business and Economic History* 26, 2 (1997): 400. McCalla has extended this dicussion in *Consumers in the Bush: Shopping in Rural Upper Canada* (Montreal: McGill-Queen's University Press, 2015).

79 "Visitor's Survey, 1969 Black Creek Pioneer Village," box 83, file 17.7, RG 5-34, Correspondence of the Executive Director of the Tourist Promotion and Information Branch, OA.

80 Duncan, *Pioneer Village,* 13.

81 Beatrice Craig, *Backwoods Consumers and Homespun Capitalists: The Rise of a Market Culture in Eastern Canada* (Toronto: University of Toronto Press,) 113.

82 See, for example, "Booklet on Pioneer Village Published," *Enterprise,* 15 April 1964.

83 Metro Toronto and Region Conservation Authority (MTRCA), "Brief to the Province of Ontario" (September 1962), Pioneer Village Papers, Toronto Public Library, Toronto.

84 See, for example, Dorothy Duncan, *Black Creek Pioneer Village Recipes* (Downsview: Metro Toronto and Region Conservation Authority, 1980).

85 Anne Wanstall, "Hot from a Woodstove," *Toronto Star,* 27 June 1966, 45. On suburban domesticity, see Valerie Korinek, *Roughing It in the Suburbs: Reading Chatelaine Magazine in the Fifties and Sixties* (Toronto: University of Toronto Press, 2000).

86 Gary Lautens, "Pioneer Living 1963 Style," *Toronto Star,* 6 August 1963, 21.

87 "Pioneer Village Gets Old School," *Toronto Star,* 20 June 1960, 8; "Hundred Years Ago Today Recreated in Pioneer Village," *Toronto Globe and Mail,* 22 May 1961, 17.

88 James T. Lemon, *Toronto since 1918: An Illustrated History* (Toronto: J. Lorimer, 1985), 136.

89 Ken Osborne, "Teaching History in the Schools: A Canadian Debate," *Journal of Curriculum Studies* 35, 5 (2003): 590.

90 "Metro Toronto & Region," *Our Valley* 6, 2 (Summer 1960): 35; MTRCA, Minutes of Historical Advisory Board, 1 May 1964, City of Toronto Archives, Toronto.

91 MTRCA, Minutes of Historical Advisory Board, 1 May 1964, City of Toronto Archives.

92 Darrell Butler, "Education Report: 9 October 1979," RS 244, King's Landing Corporation Records, PANB.

93 "Why Make a Field Trip to King's Landing Historical Settlement," RS 244, King's Landing Corporation Records, PANB.

94 Charles Henry Foss, "King's Landing Historical Settlement, New Brunswick, Canada," *Antiques* 65, 6 (June 1979): 1218.

95 King's Landing Corporation, "Syllabus of Programs for Schools," 4, School Programs, RS 244, King's Landing Corporation Records, PANB.

96 King's Landing Corporation, "Fall 1978 Program," School Programs, RS 244, King's Landing Corporation Records, PANB.

97 Sue Pritchard, "Our Trip to Upper Canada Village," 10 April 1962, RG 5-55, AO. See also *Brockville Recorder and Times,* 17 July 1962.

98 "Children Play in Pioneer Settings," *Toronto Globe and Mail,* 20 June 1963, 23.

99 "Pioneer Toys to Delight Tykes of Today," *Toronto Star,* 19 April 1962, 21. The Dalziel Barn is the name of the original Humber Valley Conservation Authority Pioneer Museum. The barn was originally built on the farm of Johannes Schmidt in 1809, who sold the farm to John Dalziel in 1828. See also Harry Symons, *Playthings of Yesterday: Harry Symons Introduces the Percy Band Collection* (Toronto: Ryerson, 1963).

100 Duncan, *Pioneer Village,* 19.

Chapter 6: Louisbourg and the Quest for Authenticity

1 Ian McKay, *The Quest of the Folk: Antimodernism and Cultural Selection in Twentieth-Century Nova Scotia* (Montreal and Kingston: McGill-Queen's University Press, 1994), 33.

2 John Myer, "Rand Report on Coal Offers New Concept," *Montreal Gazette,* 27 September 1960, 10.

3 C.J. Taylor, *Negotiating the Past: The Making of Canada's National Historic Parks and Sites* (Montreal and Kingston: McGill-Queen's University Press, 1990), 185–86.

4 Ivan C. Rand, *Report of Royal Commission on Coal* (Ottawa: Roger Duhamel, 1960), 47.

5 Ibid., 53.

6 J.D. Herbert to J.R.B. Coleman, 10 January 1961, RG 84, vol. 1122, FLO318, Library and Archives Canada (LAC), Ottawa.

7 Louisbourg Museum, Report of the Advisory Committee, RG 84, vol. 1122, FLO318, LAC.

8 Terry MacLean, *Louisbourg Heritage: From Ruins to Reconstruction* (Sydney: UCCB Press, 1995), 18.

9 Katharine McLennan to National Parks Bureau, 23 July 1941, RG 84, vol. 1122, FLO318, LAC.

10 MacLean, *Louisbourg Heritage,* 17.

11 "Jane Cunningham Weds," *New York Times,* 30 August 1914, 15; "Louisbourg Fortress Museum Regains 700-year-old Portrait," *Montreal Gazette,* 30 April 1955, 4. See also Ralph White, *Litchfield: Images of America* (Charleston: Arcadia, 2011), 94.

12 Norman Fee to Maurice Lamontagne, 30 April 1955, RG 84, vol. 1122, FLO318, LAC.

13 Maurice Lamontagne to Albert Almon, 10 May 1955, RG 84, vol. 1122, FLO318, LAC.

14 Rand, *Report of Royal Commission on Coal,* 47.

15 Taylor, *Negotiating the Past,* 171–72.

16 Ibid., 141–43.

17 "Planning Considerations: The Historic Parks – Maritimes," 17–25 May 1960, RG 84, vol. 1441, HS28, LAC.

18 "Draft Memo to Cabinet," 24 February 1961, RG 84, vol. 1102, FLO28, LAC.
19 J.D. Herbert, "Proposals concerning the Restoration of the Fortress of Louisbourg, 22 April 1960," RG 84, vol. 1102, FLO28, LAC.
20 See Alan Gordon, *The Hero and the Historians: Historiography and the Uses of Jacques Cartier* (Vancouver: UBC Press, 2010), 151–56; and Alan Gordon, "Heroes, History, and Two Nationalisms: Jacques Cartier," *Journal of the Canadian Historical Association* 10, 1 (1999): 99–100.
21 Norman Robinson to G.L. Scott, 12 May 1960, RG 84, vol. 1102, FLO28, LAC.
22 E.A. Côté to Alvin Hamilton, 26 February 1959, RG 84, vol. 1102, FLO28, LAC.
23 John Fortier, *Fortress of Louisbourg* (Toronto: Oxford University Press, 1979), 14.
24 H.F. Crown to W.M. Nickle, 18 September 1961, RG 5-54, Ontario Archives (OA), Toronto.
25 Ronald Way to J.R.B. Coleman, 30 April 1962 (emphasis in original), RG 84, vol. 1124, FLO320-7, LAC.
26 Ronald Way, "Recommendations concerning the Louisbourg Restoration Project," RG 84, vol. 1124, FLO320-7, LAC.
27 Ronald Way to J.R.B. Coleman, 30 April 1962, RG 84, vol. 1124, FLO320-7, LAC.
28 Bruce Fry, "Designing the Past at Fortress Louisbourg," in *The Reconstructed Past: Reconstructions in the Public Interpretation of Archaeology and History*, ed. John Jameson (Walnut Creek, CA: AltaMira, 2004), 212. See also MacLean, *Louisbourg Heritage*, 30.
29 Ronald Way to J.R.B. Coleman, 8 February 1962, RG 84, vol. 1124, FLO320-5, LAC.
30 Ronald Way to J.R.B. Coleman, 8 October 1962, RG 84, vol. 1124, FLO320-7, LAC.
31 Fry, "Designing the Past," 202.
32 Edward Larrabee, *Archaeological Research at the Fortress of Louisbourg, 1961-1965*, Canadian Historic Sites: Occasional Papers in Archaeology and History 2 (Ottawa: Indian Affairs and Northern Development, 1971), 13.
33 Ronald Way to J.R.B. Coleman, 8 October 1962, RG 84, vol. 1124, FLO320-7, LAC.
34 MacLean, *Louisbourg Heritage*, 31.
35 Larrabee, "Archaeological Research," 13.
36 Ibid., 14.
37 Ronald Way to J.I. Nicol, 24 July 1964, RG 84, vol. 118, FLO108, LAC.
38 A.D. Perry, "Reuse of Original Stones," 15 September 1966, RG 84, vol. 118, FLO108, LAC.
39 F.J. Thorpe to A.D. Perry, 9 October 1963, RG 84, vol. 1124, FLO320-7, LAC.
40 Ronald Way to J.R.B. Coleman, 24 April 1962, RG 84, vol. 1124, FLO320-7, LAC.
41 Ronald Way to J.R.B. Coleman, 30 July 1963, RG 84, vol. 1124, FLO320-7, LAC.
42 Ronald Way and Beryl Way, "Preliminary Report on Recent Trip to France," 2 January 1962, Ronald Lawrence Way fonds, box 2, Queen's University Archives, Kingston.
43 Ibid.
44 Peter Collins to J.D. Herbert, 24 January 1963; Peter Collins to C.M. Drury, 28 January 1963; and C.M. Drury to Peter Collins, 9 February 1963, RG 84, vol. 1112, FLO56-3, LAC.
45 More information on Hancock and Project Planning Associates can be found in the Macklin L. Hancock – Project Planning Associates Ltd. fonds, University of Guelph Archives and Special Collections, Guelph.
46 Eric Krause, "The Fortress of Louisbourg Archives: The First Twenty-Five Years," *Archivaria* 26 (Summer 1988): 139. Krause has long maintained an online database of Louisbourg research reports at http://www.krausehouse.ca/krause/Louisbourg

Institute.html. The Louisbourg Institute at Cape Breton University also holds digital copies of many of the early Louisbourg research reports.

47 Ronald Way and Beryl Way, "Preliminary Report on Recent Trip to France," 2 January 1962, Ronald Lawrence Way fonds, box 2, Queen's University Archives.

48 Ronald Way and Beryl Way, "Report of General Consultants: Louisbourg Project," 18 March 1963, Ronald Lawrence Way fonds, box 2, Queen's University Archives.

49 Ibid.

50 J.R.B. Coleman to E.A. Côté, 1 March 1963, RG 84, vol. 1441, FLO28, LAC.

51 Ronald Way and Beryl Way, "Report of General Consultants: Louisbourg Project," 18 March 1963, Ronald Lawrence Way fonds, box 2, Queen's University Archives.

52 G.E. Mortimore, "The New Battle of Louisbourg," *Globe Magazine,* 5 December 1964, 16.

53 Ronald Way to J.I. Nicol, 24 July 1964, RG 84, vol. 118, FLO108, LAC.

54 J.I. Nicol to H.A. Johnson, 9 November 1966, RG 84, vol. 118, FLO108, LAC.

55 P.H. Schonenbach to J.I. Nicol, 7 October 1966, RG 84, vol. 118, FLO108, LAC.

56 Ronald Way to J.R.B. Coleman, 8 October 1962, RG 84, vol. 1124, FLO320-7, LAC.

57 Ronald Way to J.I. Nicol, 14 June 1966, RG 84, vol. 1126, FLO321-1, LAC.

58 Carmen Bickerton, "Ronald Way, 1908-1978," *Historical Papers* (Canadian Historical Association) 13 (1978): 247.

59 MacLean, *Louisbourg Heritage,* 61–62.

60 Taylor, *Negotiating the Past,* 184.

61 On the creation of the Louisbourg Archives and their transfer to Cape Breton through the 1970s and 1980s, see Krause, "The Fortress of Louisbourg Archives," 137–48. See also Fortier, *Fortress of Louisbourg,* 16.

62 Ronald Way to J.I. Nicol, 14 June 1966, RG 84, vol. 1126, FLO321-1, LAC.

63 John Sweeny to A.J.H. Richardson, 29 January 1956, RG 84, vol. 1122, FLO318, LAC.

64 R.A. Peters to J. Smart, 11 March 1942; and W.D. Cromarty to J. Smart, 15 June 1942, RG 84, vol. 1122, FLO318, LAC.

65 Alex Storm, "Seaweed and Gold: The Discovery of the Ill-Fated Chameau, 1961-1971," in *The Island: New Perspectives on Cape Breton History, 1713-1990,* ed. Kenneth Donovan (Fredericton/Sydney: Acadiensis Press/University College of Cape Breton Press, 1990), 221–22. This chapter is reprinted in Alex Storm, *Seaweed and Gold: True Canadian Treasure Hunting Adventures* (Louisbourg: privately printed, 2002), and is available online at http://www.seaweedandgold.com.

66 H.S. Goldberg to Russell Harper, 31 August 1961, RG 84, vol. 1122, FLO318, LAC.

67 Storm, "Seaweed and Gold," 233–40.

68 J.D. Herbert to Maurice Lamontagne, 23 June 1965, RG 84, vol. 1124, FLO320-5, LAC.

69 "Wreck Yields $700,000, Divers Say," *Toronto Globe and Mail,* 5 April 1966, 9.

70 R.P. Malis, "Memorandum RE: Sunken Treasures," 6 April 1966, RG 84, vol. 1124, FLO320-5, LAC.

71 A.D. Perry to A.D. Johnson, 12 August 1965, RG 84, vol. 1124, FLO320-5, LAC.

72 The Supreme Court delivered its ruling on 28 June 1971. *Blundon et al. v. Alexander Storm,* [1972] S.C.R. 135. Alex Storm, "Seaweed and Gold," 242.

73 Kenneth Donovan, "Editor's Postscript," in Donovan, *The Island,* 242.

74 Hugh A. MacDonald to Jean Lesage, 8 February 1956, RG 84, vol. 1126, FLO325, LAC. See also Jean Lesage to Hugh A. MacDonald, 22 February 1956, RG 84, vol. 1126, FLO325, LAC.

75 J.D. Herbert, "Proposals concerning the Restoration of the Fortress of Louisbourg, 22 April 1960," RG 84, vol. 1102, FLO28, LAC.

76 Fry, "Designing the Past," 203.
77 H.A. Johnson, "Louisbourg: Interpretive Program," RG 84, vol. 118, FLO108, LAC.
78 John Lunn, "Interpretation at the Fortress of Louisbourg," March 1968, RG 84, vol. 118, FLO108, LAC.
79 B.C. Bickerton to F.J. Thorpe, 3 February 1966, Jean Palardy fonds, vol. 4, MG 30 D395, LAC.
80 J.E. Savage to J.R.B. Coleman, 24 August 1965, RG 84, vol. 1101, FLO28, LAC.
81 H.A. Johnson, "Louisbourg: Interpretive Program, 17 September 1965," RG 84, vol. 118, FLO108, LAC.
82 Ed Payn, "Rebirth of a Fortress," *Atlantic Advocate* 65, 22 (April 1975): 22.
83 J.D. Herbert to Jean Palardy, 8 January 1962, Jean Palardy fonds, vol. 4, MG 30 D395, LAC.
84 B.C. Bickerton to R.L. Way, 19 February 1965; and B.C. Bickerton to Jean Palardy, 9 July 1965, Jean Palardy fonds, vol. 4, MG 30 D395, LAC. See also MacLean, *Louisbourg Heritage*, 71–73.
85 F.J. Thorpe to Jean Palardy, 6 February 1964; and Jean Palardy to R.L. Way, 24 October 1965, Jean Palardy fonds, vol. 4, MG 30 D395, LAC.
86 B.C. Bickerton to R.T. Flanagan, 6 August 1965, Jean Palardy fonds, vol. 4 MG D395, LAC.
87 Ronald Way to J.I. Nicol, 13 March 1966, Jean Palardy fonds, vol. 4, MG 30 D395, LAC.
88 Du Quesnel was an unremarkable governor. See Blaine Adams, "Le Prévost Duquesnel (Du Quesnel), Jean-Baptiste-Louis," *Dictionary of Canadian Biography,* http://www.biographi.ca/en/bio/le_prevost_duquesnel_jean_baptiste_louis_3E.html. On the *Inventaire après décès,* see Louis Lavallée, "Les archives notariales et l'histoire sociale de la Nouvelle France," *Revue d'histoire de l'Amérique française* 28, 3 (December 1974): 385–403.
89 MacLean, *Louisbourg Heritage,* 110.
90 Ronald Way to J.I. Nicol, 13 March 1966, Jean Palardy fonds, vol. 4, MG 30 D395, LAC.
91 John Lunn, "Louisbourg After 1966: A Personal View," n.d., n.p., RG 84, vol. 1101, FLO28, LAC.
92 John Lunn, "Interpretation at the Fortress of Louisbourg" (March 1968), n.p., RG 84 vol. 118, FLO108, LAC.
93 Ibid.
94 E.A. Côté to John Turner, 26 November 1964; and J.R.B. Coleman to E.A. Price, 23 March 1965, RG 84, vol. 1122, FLO318, LAC.
95 Tony Price to John Turner, 26 March 1965, RG 84, vol. 1101, FLO28, LAC.
96 Tony Price to C.R. Bickerton, 17 March 1965; and Tony Price to John Turner, 8 March 1965, RG 84, vol. 1122, FLO318, LAC.
97 Price died on 28 September 2002. C.B., "Legacy of Tony Price Goes Far beyond Family Ties," *Quebec Heritage News* 2, 1 (November 2002): 8.
98 E.A. Côté to J.R.B. Coleman, 7 January 1965, RG 84, vol. 1122, FLO318, LAC.
99 H.M. Van der Putten, "Reception Centre and Satellite Units Functional Analysis," June 1966, 12 (emphasis in original), RG 84, vol. 118, FLO108, LAC.
100 "Fort Louisbourg Gets $12 Million Facelift," *Toronto Star,* 4 May 1963, 19.
101 *Saskatoon Star-Phoenix,* 13 September 1969.
102 T.A. Crowley, "Louisbourg," *Toronto Globe and Mail,* 10 September 1971, 6.
103 Claribel Gesner, "A Town out of Time," *Atlantic Advocate* 60 (August 1970): 38.

104 "Radio Tonight," *Toronto Star,* 15 April 1967, 28.
105 "Fortress of Louisbourg: A Major Reconstruction Program Has Put New Life Into the Famous Old French Fort," *Calgary Herald,* 12 September 1969, 12.
106 Doris Megill, "Louisbourg: The Ill-Fated Fortress," *Canadian Geographical Journal* 83 (October 1971): 125.
107 John Lunn, "The Emerging Touchstone: Louisbourg," *Canadian Antiques* 7 (January-February 1972): 37.
108 Dan Proudfoot, "A Fortress Rising," *Imperial Oil Review* 60, 3 (March 1976): 15–16.
109 Silver Donald Cameron, "Astonishing Louisbourg: French Canada in 1744 Recreated – For $25 Million," *Saturday Night,* June 1980, 45.
110 Ibid., 47.
111 "Louisbourg Gets Visitors It Doesn't Want," *Toronto Star,* 16 July 1966, 13.
112 Canada, *Debates of the House of Commons* (30 October 1969), 281.
113 MacLean, *Louisbourg Heritage,* 121.
114 John Lunn, "Memorandum," 24 November 1966, RG 84, vol. 1119, FLO121, LAC.

Chapter 7: Fur and Gold

1 Frank Howard to J.R.B. Coleman, 20 February 1967, RG 84, vol. 1415, HS10-115, Library and Archives Canada (LAC), Ottawa.
2 C.J. Taylor, *Negotiating the Past: The Making of Canada's National Historic Parks and Sites* (Montreal and Kingston: McGill-Queen's University Press, 1990), 157.
3 For an alternative perspective on BC museums, including some that were not built, see Ben Bradley, "By the Road: Fordism, Automobility, and Landscape Experience in the British Columbia Interior, 1920-1970" (PhD diss., History, Queen's University, 2012).
4 E.E. Rich, *The Fur Trade and the Northwest to 1857* (Toronto: McClelland and Stewart, 1967), 271–75.
5 Cole Harris, *The Resettlement of British Columbia: Essays on Colonialism and Geographical Change* (Vancouver: UBC Press, 1997), 77–78.
6 Jean Barman, *The West beyond the West: A History of British Columbia,* rev. ed. (Toronto: University of Toronto Press, 1996), 53.
7 G.P.V. Akrigg, "The Fraser River Gold Rush," in W.H. Matthews et al., *The Fraser's History, from Glaciers to Early Settlements* (Burnaby: Burnaby Historical Society, 1981), 32.
8 Elizabeth Furniss, *The Burden of History: Colonialism and the Frontier Myth in a Rural Canadian Community* (Vancouver: UBC Press, 1999), 65.
9 *Fort Langley National Historic Park* (Ottawa: Queen's Printer, 1960), 14.
10 See Forrest Pass, "The Wondrous Story and Traditions of the Country: The Native Sons of British Columbia and the Role of Myth in the Formation of an Urban Middle Class," *BC Studies* 151 (Autumn 2006): 9–15.
11 Archie F. Key, *Beyond Four Walls: The Origins and Development of Canadian Museums* (Toronto: McClelland and Stewart, 1973), 303.
12 Stephen Tomblin, "W.A.C. Bennett and Province Building in British Columbia," *BC Studies* 85 (Spring 1990): 45–61.
13 Forrest Pass, "Pacific Dominion: British Columbia and the Making of Canadian Nationalism, 1858-1958" (PhD diss., History, University of Western Ontario, 2009), 431.
14 Mia Reimers, "'BC at Its Most Sparkling, Colourful Best': Post-war Province Building through Centennial Celebrations" (PhD diss., History, University of Victoria, 2007), 38.
15 George Young to J. Forsyth, 17 July 1923, MS 2763, British Columbia Historical Association fonds, box 12, Fort Langley Correspondence, BC Archives, Victoria.

16 F.W. Howay to J.B. Harkin, 3 November 1926; and HSMBC Minutes, May 1926, RG 84, vol. 130, FLA28, LAC.

17 "Notes and Comments," *British Columbia Historical Quarterly* 11, 1 (January 1947): 60.

18 W.D. Cromarty to J. Smart, 19 October 1944; and Walter Sage to W.D. Cromarty, 2 January 1945, RG 84, vol. 130, FLA28, LAC.

19 Leonard Greenwood to W.A.C. Bennett, 26 September 1953, GR 1738, Provincial Archives of British Columbia Records, box 54, file 4, Fort Langley Restoration Society, BC Archives.

20 W.E. Ireland to W.A.C. Bennett, 12 January 1954, GR 1738, box 54, file 4, Fort Langley Restoration Society, BC Archives.

21 W.E. Ireland to W.A.C. Bennett, 26 August 1955, GR 1738, box 54, file 4, Fort Langley Restoration Society, BC Archives.

22 R.G. Robertson to W.D. Black, 30 November 1956, GR 1738, box 55, file 2, Fort Langley Restoration Society, BC Archives.

23 A.E. Roberts to T.C. Fenton, 22 May 1957, RG 84, vol. 1083, FLA109-1, LAC.

24 These arguments can be followed in GR 1738, box 54, file 3, BC Archives. See especially E.A. Côté to W.E. Ireland, 19 September 1957.

25 See "Princess Visits Fort Langley," *Vancouver Sun*, 23 July 1958, 8. For the televised speeches of Bennett and Princess Margaret, see "Fort Langley, the Birthplace of B.C., 100 Years Later," CBC Digital Archives, http://www.cbc.ca/archives/entry/fort-langley -the-birthplace-of-bc-100-years-later.

26 National Historic Parks, *Fort Langley National Historic Park* (Ottawa: Queen's Printer, 1958), 7.

27 "Barkerville Reason B.C.'s Canadian," *Vancouver Sun*, 3 August 1956, 2.

28 Pass, "Pacific Dominion," 437.

29 Ibid., 436.

30 British Columbia, Centennial Committee, *British Columbia Official Centennial Record, 1858-1958: A Century of Progress* (Vancouver: Evergreen Press, 1957), 40–52, 107–14.

31 Reimers, "'BC at Its Most Sparkling,'" 160. See also Bradley, "By the Road," 520–22.

32 Furniss, *The Burden of History*, 187–88.

33 C.P. Lyons, "Report on Barkerville 1958," n.d.; and Barkerville Restoration Advisory Committee, Minutes, 13 March 1958, GR 1738, box 181, file 1, BC Archives; C.P. Lyons to L.J. Wallace, 20 July 1960, GR 1738, Provincial Archives of British Columbia Records, box 181, file 5, BC Archives.

34 L.J. Wallace to Basil Nixon, 23 September 1958, GR 1738, box 181, file 5, BC Archives.

35 C.P. Lyons to L.J. Wallace, 30 April 1959, GR 1738, box 181, file 5, BC Archives.

36 C.P. Lyons to H.G. McWilliams, 6 December 1962, GR 1738, box 181, file 7, BC Archives.

37 Bennett Metcalfe, "Our Oldest Gold Rush City Lures Travellers to Cariboo," *Toronto Financial Post*, 21 July 1962, 12.

38 Barkerville Restoration Advisory Committee and Department of Recreation and Conservation, "Barkerville Historical Park: Gold Capital of B.C." (Victoria, B.C., Barkerville Restoration Advisory Committee, 1959), n.p.

39 Alastair Kerr, "The Restoration of Historic Barkerville," *Canadian Collector* 11, 3 (May-June 1976): 50.

40 Bennett Metcalfe, "Oldest Gold Rush City," *Toronto Financial Post*, 21 July 1962, 12.

41 Michael Collins, *Barkerville Historic Park, Visitor Use Study* (Victoria: Department of Recreation and Travel Industry, 1976), 48.

42 J.M. Morrison to E.F. Fox, 22 June 1965, GR 1661, British Columbia Provincial Secretary Records, box 17, file 7, BC Archives.

43 L.J. Wallace to W.M. Guild, 20 June 1962, GR 1661, box 18, file 2, BC Archives.

44 See, for instance, *Seattle Post-Intelligencer,* 28 October 1962, clipping in GR 1661, British Columbia Provincial Secretary Records, box 17, file 4, BC Archives. See also Larry Meyer, "Billy Barker's Town," *Westways* April 1963, 11–12.

45 Werner T. Allen, dir., *A Day of Fun in the Historical Town of Barkerville* (Victoria: Barkerville Restoration Advisory Committee, 1963). The narrator was James M. Bogyo. The film can be seen on YouTube at https://www.youtube.com/watch?v=QoGnN_xqiWg.

46 Barkerville Restoration Advisory Committee, Minutes, 13 August 1962, GR 1738, box 181, file 2, BC Archives.

47 H.G. McWilliams to L.J. Wallace, 21 October 1964, GR 1661, box 17, file 2, Barkerville Correspondence, BC Archives.

48 Barkerville Restoration Advisory Committee, Minutes, 1 March 1972, GR 1738, box 181, file 2, BC Archives.

49 Fred Bas to L.J. Wallace, 24 August 1964, GR 1661, box 17, file 3, BC Archives.

50 Franklin Jones to L.J. Wallace, 12 May 1965; and L.J. Wallace to H.M. Matthews, 13 May 1965, GR 1661, box 17, file 1, BC Archives.

51 Gordon Hilker, "A Plan to Activate Barkerville," 19 August 1961, GR 1738, box 181, file 6, BC Archives. See also L.J. Wallace to W.E. Ireland, 24 August 1961, GR 1738, box 181, file 6, BC Archives.

52 Collins, *Barkerville Historic Park,* 34.

53 Ray E. Pettit to L.J. Wallace, 5 August 1964, GR 1738, box 181, file 7, BC Archives.

54 Collins, *Barkerville Historic Park,* 6.

55 Roderick Charles Macleod, "Steele, Sir Samuel Benfield," DCB Online, http://www.biographi.ca/en/bio/steele_samuel_benfield_14E.html.

56 Robin Fisher, "Isadore," DCB Online, http://www.biographi.ca/en/bio/isadore_12E.html.

57 Michael Dawson, "That Nice Red Coat Goes to My Head Like Champagne: Gender, Antimodernism, and the Mountie Image, 1880-1960," *Journal of Canadian Studies/Revue d'études Canadiennes* 32, 3 (1997): 119–39.

58 Macleod, "Steele, Sir Samuel Benfield."

59 J.B. Harkin to J.M. Wardle, 5 July 1928, RG 84, vol. 1392, HS10-28, LAC.

60 Harwood Steele to Noel Robinson, 8 May 1951, RG 84, vol. 1392, HS10-28, LAC.

61 E.A. Côté to J.H.T. Poudrette, 6 January 1960, RG 84, vol. 1392, HS10-28, LAC.

62 J.D. Herbert to Bayard Iverson, 27 April 1962, RG 84, vol. 1392, HS10-28, LAC.

63 See "Truman Seeks Vast 'TVA' Project for the Columbia River System," *New York Times,* 25 January 1949, 1.

64 E.R. Peterson to O.T. Fuller, 22 December 1959, RG 84, vol. 1392, HS10-28, LAC.

65 Barkerville Restoration Advisory Committee, Minutes, 8 June 1960, file 3, box 1, GR 1738, BC Archives.

66 Bill Mead to E.C. Westwood, 11 October 1960; and Bill Mead to L.J. Wallace, 30 December 1960, GR 1661, Records of the British Columbia Provincial Secretary, BC Archives.

67 See, for example, "Fort Steele No. 2: East Kootenay in the 1880s," Dossiers of Historical Material, GR 318, Records of the BC Ministry of Recreation and Conservation, Parks Branch, BC Archives.

68 *Cranbrook Courier,* 17 July 1963, clipping in GR 1738, box 55, file 7, BC Archives. L.J. Wallace to Ron Powell, 25 July 1963, GR 1661, Records of the British Columbia Provincial Secretary, BC Archives.

69 *A Guide to Fort Steele Historic Park* (Victoria: British Columbia Ministry of Recreation and Conservation, Parks Branch, 1978), 5.

70 Bob Hage, "British Columbia Ghost Town Reborn," *Calgary Herald*, 26 June 1967, 36.

71 Langley Pioneer Fete Gets Started Tonight," *Vancouver Sun*, 27 June 1967, 29.

72 Michael Collins, *Fort Steele Historic Park Visitor Use Survey* (Victoria: Department of Recreation and Travel Industry, 1976), 3–4.

73 Ibid., 51–56.

Chapter 8: The Great Tradition of Western Empire

1 Misao Dean, "The Centennial Voyageur Canoe Pageant as Historical Re-enactment," *Journal of Canadian Studies/Revue d'études Canadiennes* 40, 3 (2006): 43–67.

2 *Fort William Times-Journal,* 5 July 1938, clipping in Old Fort William Collection, Thunder Bay Museum (TBM), Thunder Bay.

3 *Fort William Times-Journal,* 6 February 1939 and *Fort William Times-Journal,* 15 February 1939, clippings in Old Fort William Collection, TBM.

4 S.H. Blake to J.O. Booth, 29 August 1960, Old Fort William Collection, TBM.

5 "Meeting Plans Promotion of History for Tourists," *Toronto Financial Post,* 1 October 1960, 9.

6 *Fort William Times-Journal,* 17 December 1960, clipping in Old Fort William Collection, TBM. See also S.H. Blake to John Diefenbaker, 14 April 1960; J.H. Herbert to S.H. Blake, 24 June 1960; and Leslie Frost to S.H. Blake, 29 March 1961, Old Fort William Collection, TBM.

7 *Fort William Times-Journal,* 21 January 1971, clipping in Old Fort William Collection, TBM.

8 Hastily Improvised Ceremony: Brief Thunder Bay Visit Provides Much Fun for Royal Couple," *Toronto Globe and Mail,* 4 July 1973, 1.

9 Charles Taylor, *Radical Tories: The Conservative Tradition in Canada* (Toronto: Anansi, 1982), 22–23; Donald Wright, *The Professionalization of History in English Canada* (Toronto: University of Toronto Press, 2005), 118. See also Donald Wright, *Donald Creighton: A Life in History* (Toronto: University of Toronto Press, 2015).

10 Paul Romney, *Getting It Wrong: How Canadians Forgot Their Past and Imperilled Confederation* (Toronto: University of Toronto Press, 1999), 7.

11 M.B. Payne and C.J. Taylor, "Western Canadian Fur Trade Sites and the Iconography of Public Memory," *Manitoba History* 46 (2003): 3.

12 Harold Adams Innis, *The Fur Trade in Canada: An Introduction to Canadian Economic History* (New Haven: Yale University Press, 1930).

13 Donald G. Creighton, *The Commercial Empire of the St. Lawrence* (Toronto: Ryerson, 1937), 88.

14 David Neufeld, "Parks Canada and the Commemoration of the North: History and Heritage," in *Northern Visions: New Perspectives on the North in Canadian History,* ed. Kerry Margaret Abel and Kenneth Coates (Toronto: University of Toronto Press, 2001), 51.

15 Jean Lesage to A.J. Hooke, 30 September 1953, RG 84, vol. 1412, HS10-99, Library and Archives Canada (LAC), Ottawa.

16 Richard Second to Walter Dinsdale, 20 November 1962, RG 84, vol. 1412, HS10-99, LAC. See also *Edmonton Journal,* 24 September 1955 and *Edmonton Journal,* 5 March 1957, clippings in RG 84, vol. 1412, HS10-99, LAC.

17 J. Thompson to W.J. Roche, 24 December 1922; and Mgr. Antoine d'Eschambault to W.D. Cromarty, 6 May 1948, RG 84, vol. 1070, FG2, LAC.

18 Marjorie Wilkins Campbell, "So Little Sentiment," *Saturday Night*, 14 May 1955, 44.

19 J.D. Herbert to Enid Malloy, 18 December 1962, RG 84, vol. 1075, FG109, LAC.

20 Alison Wylie, *Thinking from Things: Essays in the Philosophy of Archaeology* (Berkeley: University of California Press, 2002), x-xi.

21 *Edmonton Journal*, 5 March 1957, clipping in RG 84, vol. 1412, HS10-99, LAC.

22 Penny Bryden, "The Ontario-Quebec Axis: Postwar Strategies in Intergovernmental Negotiations," in *Ontario Since Confederation: A Reader*, ed. E.-A. Montigny and Lori Chambers (Toronto: University of Toronto Press, 2000), 381–408.

23 *Thunder Bay Chronicle-Journal*, 6 February 1974, clipping in Old Fort William Collection, TBM.

24 National Heritage Limited, "Outline for a Study of the Reconstruction of Fort William, 1970," RG 47-64, Historic Sites Branch, Correspondence on Historical Resources in Provincial Parks, box 1, Ontario Archives (OA), Toronto.

25 *Fort William: Hinge of a Nation* (Toronto: National Heritage, 1970), 5.

26 Ibid., 29.

27 Creighton, *Commercial Empire*, 119.

28 "Memo: Construction of Old Fort William Historic Park," RG 47-64, box 1, OA.

29 "Company That Built Thunder Bay Park Owes $396,000, Folds," *Toronto Globe and Mail*, 1 July 1976, 35.

30 *Fort William Times-Journal*, 21 January 1971, clipping in Old Fort William Collection, TBM.

31 *Fort William Times-Journal*, 18 February 1971 and *Fort William Times-Journal*, 12 March 1971, clippings in Old Fort William Collection, TBM.

32 "Nixon Cites Abuses, Lack of Competition in Awarding of Government Advertising," *Toronto Globe and Mail*, 6 April 1974, 4.

33 *Debates of the Legislative Assembly of Ontario* (10 June 1974), 3028.

34 "Another Ontario Contract Without Tenders – $10 Million to Build Fort," *Toronto Globe and Mail*, 4 February 1974, 1.

35 "Auld Claims to Find 10 Errors in Stories on Fort Contract," *Toronto Globe and Mail*, 9 February 1974, 5; "Fort William Deal Reports Misleading, Distorted, Auld Says," *Toronto Star*, 9 February 1974, 3; "Criticism of Fort Job Discounted," *Windsor Star*, 9 February 1974. See also "Statement by Hon. James Auld on Old Fort William," RG 47-64, box 1, OA.

36 "Will Favor Tenders for the Restoration of Provincial Historic Sites, Davis Says," *Toronto Globe and Mail*, 15 February 1974, 31.

37 Joyce Kleinfelder to R.J. Richardson, 8 November 1971 (emphasis in original), RG 47-64, box 2, OA. See also W.M. Pigott to R.J. Richardson, 11 November 1971, RG 47-64, box 2, OA.

38 K.C.A. Dawson and Joyce Kleinfelder to R.J. Richardson, 19 November 1971, RG 47-64, box 2, OA.

39 J.W. Keenan to deputy minister of natural resources, 18 December 1972, RG 47-64, box 1, OA. See also "Another Ontario Contract Without Tenders – $10 Million to Build Fort," *Toronto Globe and Mail*, 4 February 1974, 1.

40 Quoted in Jean Morrison, *Superior-Rendezvous-Place: Fort William in the Canadian Fur Trade* (Toronto: Natural Heritage Books, 2001), 133.

41 Joyce Kleinfelder, "Old Fort William," *Toronto Globe and Mail*, 25 February 1974, 6. Contrast with her complaint that little of her work was being used. Donald MacLeod to R.G. Bowes, 1 December 1972, RG 47-64, box 1, OA.

42 "Will Favor Tenders for the Restoration of Provincial Historic Sites, Davis Says," *Toronto Globe and Mail,* 15 February 1974, 31.

43 *Fort William: Hinge of a* Nation, i.

44 Way's comment was widely published. See for example "Davis Promised Fort Won't Be Disneyland," *Ottawa Citizen,* 14 February 1974, 16.

45 Claire Campbell, "Hinge of a Nation or Bone of Contention: The Battle over Reconstructing Old Fort William" (paper presented to the 86th Annual Meeting of the Canadian Historical Association, University of Saskatchewan, Saskatoon, 28 May 2007).

46 "Historic Sites Branch Projects and the Historical Systems Plan," n.d., RG 47-64, box 5, OA.

47 "Historical Resources Evaluation Scheme," 1972; and G. Brian Woolsey to J.R. Sloan, 16 November 1972, RG 47-64, box 1, OA. The seven indicators were weighted as follows: Historical Significance (25 percent); Cultural Phenomena (20 percent); Interpretability (10 percent); Scenic Value (5 percent); Recreational Activities (10 percent); Capability of the Land Base (15 percent); and Accessibility (15 percent).

48 This section is based on Ontario, Historic Sites Branch, *A Topical Organization of Ontario History* (Toronto: Historic Sites Branch, Division of Parks, 1973).

49 See Karen Wall, "Fort Edmonton Mall: Heritage, Community and Commerce" (PhD diss., Physical Education and Sport Studies, University of Alberta 1998), 40.

50 J.N. Wallace to F.W. Howay, 17 November 1923, RG 84, vol. 1390, HS10-32, LAC.

51 Quoted in George Heath MacDonald, *Fort Augustus-Edmonton: Northwest Rails and Traffic* (Edmonton: Douglas Printing, 1954), 31.

52 A fairly succinct account of the moves of Fort Edmonton is found in W.D. Clark, *Fort Edmonton: Development of a Fur Trade Centre,* Museum and Archives Notes 4 (Edmonton: Queen's Printer for Alberta, 1971), 1–3.

53 "Cairn Commemorates Civilization's Advent to this Territory," *Edmonton Journal,* 9 August 1927, 1.

54 M.H. Long to W.D. Cromarty, 5 January 1949, RG 84, vol. 1390, HS10-32, LAC.

55 "Fort Edmonton Museum," *Edmonton Journal,* 23 June 1964, 4.

56 Fort Edmonton Park Historical Foundation, *Annual Report 1978* (Edmonton: Fort Edmonton Park Historical Foundation, 1978), 2.

57 "City Expo Plans Set Says Mayor," *Edmonton Journal,* 16 January 1967, 7.

58 "City's Expo Fort Reaping Rewards," *Edmonton Journal,* 19 June 1967, 28.

59 Nich Auf der Maur, "After Dark, Two Places – Le Village and Fort Edmonton," *Montreal Gazette,* 28 April 1967, D9.

60 "Fort Edmonton Proves Big Hit," *Edmonton Journal,* 15 April 1967, 15.

61 "Fort Edmonton, A Success," *Edmonton Journal,* 21 September 1967, 13.

62 Project Planning Associates Ltd., *Fort Edmonton Park Proposed Master Plan for the City of Edmonton, Alberta* (Toronto: Project Planning Associates, 1968). See also Wall, "Fort Edmonton Mall," 48–49.

63 *Thunder Bay Chronicle-Journal,* 17 November 1978, clipping in Old Fort William Collection, TBM.

Chapter 9: The Spirit of B & B

1 See "Le Manoir Montebello en Musée," *La Patrie* (Montreal), 25 August 1921, 2; and Béatrice Chassé, "Manoir Louis-Joseph Papineau," in *Les Chemins de la mémoire,* ed. Paul Louis Martin and Jean Lavoie (Quebec City: Publications du Québec, 1990), 2:510.

2 Pierre-Georges Roy, "Inventaire des monuments historiques," *Bulletin des recherches historiques* 30, 1 (January 1924): 3–13; and "Les Monuments commémoratifs de la province de Québec," *Bulletin des recherches historiques* 30, 2 (February 1924): 33–38.

3 Lucie K. Morisset, "Une conte patrimonial: l'invention du village canadien," *British Journal of Canadian Studies* 24, 2 (2011): 133–34. On Quebec tourist promotion, see Nicole Neatby, "Meeting of Minds: North American Travel Writers and Government Tourist Publicity in Quebec, 1920-1955," *Histoire Sociale/Social History* 36, 72 (2003): 465–95; James Murton, "La 'Normandie du Nouveau Monde': la société Canada Steamship Lines, l'antimodernisme et la promotion du Québec ancien," *Revue d'histoire de l'Amérique française* 55, 1 (2001): 3–44; and Alan Gordon, "What to See and How to See It: Tourists, Residents, and the Beginnings of the Walking Tour in Nineteenth-Century Quebec City," *Journal of Tourism History* 6, 1 (2014): 74-90.

4 Lucie K. Morisset, "L'identité québécoise naturalisée: La fiction architecturale de la montagne Tremblante," in *L'imaginaire géographique: Perspectives, pratiques et devenirs*, ed. Mario Bédard, Jean-Pierre Augustin, and Richard Desnoilles (Quebec City: Presses de l'Université du Québec, 2012), 142–44.

5 A.K. McDougall, *John P. Robarts: His Life and Government* (Toronto: University of Toronto Press, 1986), 197–200.

6 José Igartua, *The Other Quiet Revolution: National Identities in English Canada, 1945-71* (Vancouver: UBC Press, 2006), 103, 194–95, 197–201.

7 André Laurendeau, *Diary of André Laurendeau: Written during the Royal Commission on Bilingualism and Biculturalism, 1964-67*, trans. Patricia Smart (Toronto: Lorimer, 1991), 94.

8 Michael Temilini, "Multicultural Rights, Multicultural Virtues: A History of Multiculturalism in Canada," in *Multiculturalism and the Canadian Constitution*, ed. Stephen Tierney (Vancouver: UBC Press, 2007), 53.

9 Donald G. Creighton, *Canada's First Century* (Toronto: Macmillan, 1970), 336.

10 Donald Wright, "Donald Creighton and the French Fact, 1920s-1970s," *Journal of the Canadian Historical Association* 6, 1 (1995): 247.

11 Donald G. Creighton, *The Commercial Empire of the St. Lawrence* (Toronto: Ryerson, 1937), 33.

12 Creighton, *Canada's First Century*, 11–12.

13 Ibid., 73–74.

14 Ramsay Cook, "The Meaning of Confederation," in *Watching Quebec: Selected Essays*, ed. Ramsay Cook (Montreal and Kingston: McGill-Queen's University Press, 2005), 167.

15 Ralph Heintzman, "The Spirit of Confederation: Professor Creighton, Biculturalism, and the Use of History," *Canadian Historical Review* 52, 3 (September 1971): 268.

16 Alan Gordon, *Making Public Pasts: The Contested Terrain of Montreal's Public Memories, 1891-1930* (Montreal and Kingston: McGill-Queen's University Press, 2001), 61.

17 E.F. Surveyer to C.G. Childe, 20 September 1951, RG 84, vol. 1183, HS2, Library and Archives Canada (LAC), Ottawa. On Ottawa's reorganization of its historical programming, see C.J. Taylor, *Negotiating the Past: The Making of Canada's National Historic Parks and Sites* (Montreal and Kingston: McGill-Queen's University Press, 1990), 151–53. Of 388 HSMBC tablets erected across Canada by 1950, 58 were in Nova Scotia, 46 in New Brunswick, 119 in Ontario, and only 70 in Quebec.

18 Thomas Claridge, "Federal Publication Says $5 Million On Way: Quebec Historic Sites Slated for Largest Share of Grants," *Toronto Globe and Mail*, 10 June 1971, 8.

19 "Chevrier Makes Historical Point," *Ottawa Citizen*, 12 July 1963, 40; Martin Wyeth, "Upper Canada Village," *Ottawa Citizen*, 16 July 1963, 6.

20 "The Early French Explorers," *Ottawa Citizen*, 10 July 1963, 6.
21 Bill Prager, "Hopes Faint for Area Seigniory Village," *Windsor Star*, 16 April 1964, 5.
22 R.G. Thwaites, ed., *The Jesuit Relations and Allied Documents* (Cleveland: Burrows Brothers, 1896–1901), 35:23.
23 "Letter of Pierre Chazelle, Dated 31 October 1844," *Martyrs' Shrine Message*, June 1944, 12–24.
24 A.E. Jones, "Old Huronia," in Ontario Bureau of Archives, *Fifth Annual Report* (Toronto: King's Printer, 1909), 10; Wilfrid Jury, *Sainte-Marie among the Hurons* (Toronto: Oxford University Press, 1954), 6.
25 John Craig, *Simcoe County: The Recent Past* (Barrie: County of Simcoe, 1977), 28–31.
26 Kenneth Kidd, *The Excavation of Ste. Marie I* (Toronto: University of Toronto Press, 1949); Jury, *Sainte-Marie among the Hurons*.
27 Robert J. Pearce, *Stories of (Pre) History: The Jury Family Legacies* (London: London Museum of Archaeology, 2003), 21.
28 *Sainte-Marie among the Hurons: An Authentic, Detailed Reconstruction of Ontario's First European Community Where Lived Six of North America's Eight Martyr Saints* (Toronto: Ministry of Tourism and Information, 1967).
29 James Auld to W.H. Cranston, 30 December 1963, RG 5-4, Department of Tourism and Publicity, Minister's Correspondence, Ontario Archives (OA), Toronto.
30 The province as a whole was 30.0 percent Catholic, with 10.4 percent claiming French ethnicity. Government of Canada, Ninth Census of Canada (1961), *Bulletin SP-2 – Population: Ethnic Groups* (Ottawa: Dominion Bureau of Statistics, 1961), 66 and *Bulletin SP-3 – Population: Religious Denominations* (Ottawa: Dominion Bureau of Statistics, 1961), 68.
31 Bas Mason to W.H. Cranston, 26 June 1965, RG 5-53, Huronia Historical Development Council, General Files, OA.
32 Bas Mason to W.H. Cranston, 4 September 1965, RG 5-53, OA.
33 Bas Mason to Ed Smith, 16 September 1965. , RG 5-53, OA.
34 Bas Mason to W.H. Cranston, 18 January 1965, RG 5-53, OA.
35 Quoted in Bas Mason to G.E. Moore, 8 June 1965, RG 5-53, OA.
36 Raphael Samuel, "Continuous National History," in *Patriotism: The Making and Unmaking of British National Identity*, ed. Raphael Samuel (New York: Routledge, 1989), 1:9–17.
37 Report 39, "Awareness of Attitudes to Sainte-Marie among the Hurons and other Ontario Historic Sites" (November 1968), RG 5-48, OA.
38 These questions were not asked of Midland residents.
39 "Project 39: Tables and Worksheets," General Correspondence File, Travel Research Branch, file 25.17, RG 5-46, OA.
40 Ronald Way, "Recommendations concerning the Louisbourg Restoration Project," RG 84, vol. 1124, FLO320-7, LAC.
41 Ronald Way, "Ontario's Historic Sites," memorandum to Leslie Frost, 15 August 1951, RG 5-54, OA.
42 Claribel Gesner, "A Town out of Time," *Atlantic Advocate* 60 (August 1970): 38.
43 C.C. (Sandy) MacDonald, "Louisbourg," *Atlantic Advocate* 70 (June 1980): 20.
44 See especially Matthew Hayday, *Bilingual Today, United Tomorrow: Official Languages in Education and Canadian Federalism* (Montreal and Kingston: McGill-Queen's University Press, 2007), 81–85.
45 James Hall to King's Landing, 15 February 1977, RS 310, Historic Sites Branch Records, Subseries G, Gla-2, Provincial Archives of New Brunswick (PANB), Fredericton.

46　Darryl Butler to Lillianne Ferguson, 2 December 1977, RS 310, Historic Sites Branch Records, Subseries G, Gla-2, PANB.

47　Naomi Griffiths, *From Migrant to Acadian: A North American Border People, 1604-1755* (Montreal and Kingston: McGill-Queen's University Press, 2004), 463.

48　André Magord, *The Quest for Autonomy in Acadia* (Brussels: Peter Lang, 2008), 62.

49　For an overview of the 1955 celebrations in Nova Scotia, see Caroline-Isabelle Caron, "Se souvenir de l'Acadie d'antan: Représentations du passé historique dans le cadre de célébrations commémoratives locales en Nouvelle-Écosse au milieu du XXe siècle," *Acadiensis* 27, 2 (Spring 2007): 55–71.

50　Martin Légère to Elizabeth Lowry, 24 September 1965, MG 28 I70, Canadian Centenary Council fonds, vol. 130, LAC. See also Archie F. Key, *Beyond Four Walls: The Origins and Development of Canadian Museums* (Toronto: McClelland and Stewart, 1973), 199.

51　See G.F.G. Stanley, "The Caraquet Riots of 1875," *Acadiensis* 2, 1 (Autumn 1972): 21–38.

52　Peter John Stokes, "Confidential Report Re: The Caraquet Project, 13 July 1970," RS 310, Subseries G, G2x-17, PANB.

53　Robert Harley McGee, *Getting It Right: Regional Development in Canada* (Kingston and Montreal: McGill-Queen's University Press, 1992), 14, 34–39; Della Stanley, "The 1960s," in *The Atlantic Provinces in Confederation*, ed. E.R. Forbes and Del Muise (Toronto: University of Toronto Press, 1993), 422–30.

54　George MacBeath to W.W. Meldrum, 14 August 1970, RS 310, Subseries G, G2x-38, PANB.

55　Leslie A. Pal, *Interests of State: The Politics of Language, Multiculturalism, and Feminism in Canada* (Montreal and Kingston: McGill-Queen's University Press, 1993), 132.

56　Michael O'Rourke to Cecile Blanchard, 3 September 1976, RS 310, Historic Sites Branch, Subseries G, G2a-2, PANB.

57　W.F. Brundage, *Where These Memories Grow: History, Memory, and Southern Identity* (Chapel Hill: University of North Carolina Press, 2000), 273–74.

58　Peter John Stokes, "Confidential Report RE: The Caraquet Project" (July 1970), RS 310, Subseries G, G2x-17, PANB.

59　Peter John Stokes, "Memorandum on the Acadian Village, April 1975," RS 310, G2x-37, PANB.

60　Mason Wade, "Memorandum on King's Landing and Le Village Acadien," n.d. (probably summer 1978), RS 310, Subseries G, Gla-8, PANB.

61　Martin-J. Légère, "La situation économique des Acadiens du Nouveau-Brunswick," *Action nationale* 47, 3–4 (novembre-décembre 1977): 236.

62　"Procès-verbaux, 2me rencontre comité organisateur de l'ouverture oficielle du VHA," 17 November 1976, RS 310, Subseries G, G2b, PANB.

63　"PM Lauds Acadians' Role," *Toronto Globe and Mail*, 15 August 1977, 1.

64　Douglas Cole to T. Michael O'Rourke, 15 November 1979, RS 310, Subseries G, Glk4, PANB.

65　Alain Gelly, Louise Brunelle-Lavoie, and Corneliu Kirjan, *La Passion du patrimoine: La Commission des biens culturels du Québec, 1922-1994* (Sillery: Septentrion, 1995), 137.

66　Paul-Henri Hudon, "Le Village historique de Carignan: Du rêve à la réalité," *Cahiers de la seigneurie de Chambly* 30 (September 2006): 35. The quotation is from Alice J. Turnham, "At Chambly – Quebec Historical Village," *Montreal Gazette*, 21 July 1962, 6.

67　"Historical Chambly Village Shaping Up Well," *St.-Jean News and Eastern Townships Advocate*, 19 July 1962, 16.

68 Gelly, Brunelle-Lavoie, and Kirjan, *La Passion du patrimoine*, 130–31.

69 Jean-Claude Marsan, "La préservation du patrimoine urbain," in Martin and Lavoie, *Les Chemins de la mémoire*, 2:1–12. McLean later became president of the Jacques Viger Commission.

70 "Passé, présent, et futur," *Le Petit Journal* (Montreal), 1 March 1964, A14; see also Gelly, Brunelle-Lavoie, and Kirjan, *La Passion du patrimoine*, 131–32.

71 Gelly, Brunelle-Lavoie, and Kirjan, *La Passion du patrimoine*, 137–39.

72 "Village historique Jacques de Chambly, 31 May 1964," box 20, file 32, MG 31 A1, James Charles Bonar fonds, LAC.

73 Hudon, "Le Village historique de Carignan," 36–37. The historic district designation was repealed in 2009. *Gazette officielle du Québec*, partie 2, Lois et règlements (16 September 2009), 4715.

74 "Saguenay Attracts Tourists," *Toronto Globe and Mail*, 9 November 1963, 24.

75 Jocelyn Fournier and Guy Gauthier, *Drummondville* (Drummondville: Société historique du centre de Québec, 1987), 102.

76 Serge Courville, *Entre ville et campagne: l'essor du village dans les seigneuries du Bas-Canada* (Quebec City: Presses de l'Université Laval, 1990), 242.

77 See J.I. Little, "'Like a Fragment of the Old World': The Historical Regression of Quebec City in Travel Narratives and Tourist Guidebooks, 1776–1913," *Urban History Review/Revue d'Histoire Urbaine* 40, 2 (2012): 15–27; and Gordon, "What to See and How to See It," 74–90.

78 Gwendolen M. Kidd, "Historical Museums in Canada," *Canadian Historical Review* 21, 3 (September 1940): 285–97.

79 Dorothy Duncan, "From Mausoleums to Malls: What's Next?" *Ontario History* 86, 2 (June 1994): 116; Brian Young, *The Making and Unmaking of a University Museum: The McCord, 1921-1996* (Montreal and Kingston: McGill-Queen's University Press, 2000), 119–20; Key, *Beyond Four Walls*, 207. See also Ministère de la culture et communications, *Le réseau muséal québécois Énoncé d'orientations: S'ouvrir sur le monde* (Quebec City: Ministère de la culture et communications, 1994), 21.

80 There are a number of working mills and artisanal shops in Quebec that preserve and re-enact past fabrication and labour practices. Many of these date from a later period than is covered in this book and follow a different model. See Cyril Simard, *Économuséologie: Comment rentabiliser une entreprise culturelle* (Montreal: Centre éducatif et culturel, 1989); and Saskia Cousin, "Un brin de culture, une once d'économie: écomusée et economusée," *Publics et musées* 17, 1 (2000): 115–35. An economusée should not be confused with an écomusée.

81 Christopher Moore, *Louisbourg Portraits: Life in an Eighteenth-Century Garrison Town* (Toronto: Macmillan, 1982), 284.

Chapter 10: People and Place

1 Canada, *Debates of the House of Commons* (8 October 1971), 8545.

2 André Laurendeau, *Diary of André Laurendeau: Written during the Royal Commission on Bilingualism and Biculturalism, 1964-67*, trans. Patricia Smart (Toronto: Lorimer, 1991), 47.

3 Royal Commission on Bilingualism and Biculturalism, *Report of the Royal Commission on Bilingualism and Biculturalism*, vol. 4, *The Cultural Contribution of the Other Ethnic Groups* (Ottawa: Supply and Services Canada, 1969), 3–10.

4 Ibid., 228–30. The first two recommendations called for greater citizen equality and anti-discrimination policies.

5 For a particularly scathing indictment of multiculturalism, see Richard J.F. Day, *Multiculturalism and the History of Canadian Diversity* (Toronto: University of Toronto Press, 2000), 187–90.

6 Canada, *Debates of the House of Commons* (8 October 1971), 8546.

7 Leslie A. Pal, *Interests of State: The Politics of Language, Multiculturalism, and Feminism in Canada* (Montreal and Kingston: McGill-Queen's University Press, 1993), 115–19.

8 Ibid., 192.

9 Henry Lim to L.J. Wallace, 8 October 1957, box 181, file 5, GR-1738, BC Archives, Victoria.

10 John Adams, "A Chinese Herbalist in British Columbia," *Canadian Collector* 11, 3 (May-June 1976): 63.

11 J.M. Morrison to E.F. Fox, 22 June 1965, box 17, file 7, GR-1661, BC Archives.

12 Gordon Hilker to L.J. Wallace, 8 October 1963 (emphasis in original), 87-486-156, file 1-2.30, BC Archives.

13 J.S. Woodsworth, *Strangers within Our Gates; or, Coming Canadians* (Toronto: F.C. Stephenson, 1909); J.T.M. Anderson, *The Education of the New-Canadian: A Treatise on Canada's Greatest Educational Problem* (London: J.M. Dent, 1918); Alfred Fitzpatrick, *Handbook for New Canadians* (Toronto: Ryerson, 1919); William George Smith, *A Study in Canadian Immigration* (Toronto: Ryerson, 1920).

14 Second Canadian Conference on Multiculturalism, *Conference Report: Multiculturalism as State Policy* (Ottawa: Canadian Consultative Council on Multiculturalism, 1976).

15 Peter Henshaw, "John Buchan and the British Imperial Origins of Canadian Multiculturalism," in *Canadas of the Mind: The Making and Unmaking of Canadian Nationalisms in the Twentieth Century*, ed. Norman Hillmer and Adam Chapnik (Montreal and Kingston: McGill-Queen's University Press, 2007), 191–213.

16 Brian S. Osborne, "Constructing the State, Managing the Corporation, Transforming the Individual: Photography, Immigration, and the Canadian National Railways, 1925-1930," in *Picturing Place: Photography and the Geographical Imagination*, ed. Joan Schwartz and James Ryan (New York: I.B. Taurus, 2003), 178–82.

17 J. Murray Gibbon, *The Canadian Mosaic: The Making of a Northern Nation* (Toronto: McClelland and Stewart, 1938).

18 Brian S. Osborne, "'Non-Preferred' People: Inter-War Ukrainian Immigration to Canada," in *Canada's Ukrainians: Negotiating an Identity*, ed. Lubomyr Y. Luciuk and Stella M. Hryniuk (Toronto: University of Toronto Press, 1991), 81–102.

19 N.F. Dreisziger, "The Rise of a Bureaucracy for Multiculturalism: The Origins of the Nationalities Branch," in *On Guard for Thee: War Ethnicity and the Canadian State, 1939-1945*, ed. Norman Hillmer, B.S. Kordan, and L.Y. Luciuk (Ottawa: Canadian Committee for the History of the Second World War, 1988), 6–9. See also W.R. Young, "Building Citizenship: English Canada and Propaganda during the Second World War," *Journal of Canadian Studies/Revue d'études Canadiennes* 16, 3–4 (1981): 121–32.

20 Canada, *Debates of the House of Commons* (8 October 1971), 8545.

21 Frances Swyripa, *Ukrainian Canadians: A Survey of Their Portrayal in English-Language Works* (Edmonton: University of Alberta Press, 1978), 88.

22 Osborne, "'Non-Preferred' People," 83.

23 See Stuart Henderson, "'While There Is Still Time ...': J. Murray Gibbon and the Spectacle of Difference in Three CPR Folk Festivals, 1928–1931," *Journal of Canadian Studies/Revue d'études Canadiennes* 39, 1 (2005): 139–74; and Janet C. McNaughton, "John Murray Gibbon and the Inter-War Folk Festivals," *Canadian Folklore Canadien* 3, 1 (1981): 67–73.

24 Howard Palmer, "Canadian Immigration and Ethnic History in the 1970s and 1980s," *International Migration Review* 15, 3 (Autumn 1981): 473–74.

25 Archie F. Key, *Beyond Four Walls: The Origins and Development of Canadian Museums* (Toronto: McClelland and Stewart, 1973), 298.

26 Friends of the Ukrainian Cultural Heritage Village, *Ukrainian Cultural Heritage Village* (Edmonton: Alberta Culture and Multiculturalism, 1989), 4.

27 Radomir B. Bilash, "Collecting Material Culture: Alberta's Ukrainian Cultural Heritage Village," in *Visible Symbols: Cultural Expression among Canada's Ukrainians*, ed. Manoly Lupul (Edmonton: Canadian Institute of Ukrainian Studies, University of Alberta, 1984), 19.

28 Friends of the Ukrainian Cultural Heritage Village, *Ukrainian Cultural Heritage Village*, 4.

29 Bilash, "Collecting Material Culture," 19.

30 Jean Friesen, "Heritage: The Manitoba Experience," *Prairie Forum* 15, 2 (1990): 208.

31 Conrad Stoerz, "Gerhard Ens: Historian, Minister and Educator," *Mennonite Historian* 37, 1 (March 2011): 2.

32 Friesen, "Heritage," 209.

33 Jeremy Wiebe, "A Different Kind of Station: Radio Southern Manitoba and the Reformulation of Mennonite Identity, 1957-1977" (master's thesis, History, University of Manitoba, 2008), 1–2.

34 T.D. Regehr, *Mennonites in Canada, 1939-1970: A People Transformed* (Toronto: University of Toronto Press, 1996), ix.

35 Wiebe, "A Different Kind of Station," 95.

36 Don Kroeker, "Manitoba Mennonite Archives and Canadian Mennonite Collective Memory" (master's thesis, Archival Studies, University of Manitoba, 2000), 57. See also Otto Klassen, dir. *Prairie Pioneers: The Mennonites of Manitoba (1874-1974)* (Winnipeg: Otto Klassen Film Productions, 1974 and 2008), VHS.

37 Regehr, *Mennonites in Canada*, 415.

38 Friesen, "Heritage," 209.

39 "Museum Village News," *Mennonite Historian* 5, 2 (June 1979): 3.

40 Cited in Kroeker, "Manitoba Mennonite Archives," 57–58.

41 Perilla Kinchin and Juliet Kinchin, *Glasgow's Great Exhibitions: 1888, 1901, 1911, 1938, 1988* (Oxford: White Cockade, 1988), 156–57; Bob Crampsey, *The Empire Exhibition of 1938* (Edinburgh: Mainstream, 1988), 49–50.

42 Ian McKay, "Tartanism Triumphant: The Construction of Scottishness in Nova Scotia, 1933-1954," *Acadiensis* 21, 2 (Spring 1992): 5–47.

43 A longer account of the Highland Village Museum can be found in Alan Gordon, "The Highland Heart in Nova Scotia: Imagination, Memory, and the Nova Scotia Highland Village Museum," in *Placing Memory and Remembering Place in Canada: Local Acts of Remembering*, ed. John Walsh and James Opp (Vancouver: UBC Press, 2010), 107–29.

44 Alan MacEachern, *Natural Selections: National Parks in Atlantic Canada, 1935-1970* (Montreal and Kingston: McGill-Queen's University Press, 2001), 48–53.

45 Colin Sinclair to W.L. Fillmore, 14 June 1954, Nova Scotia Highland Village Society Records, Nova Scotia Highland Village Museum (NSHVM), Iona, Nova Scotia.

46 H.M. Macdonald, "A Submission of the Nova Scotia Association of Scottish Societies to the Premier and Members of the Nova Scotia Government," 3 May 1955, NSHVM.

47 Hector's Point was named after a local settler, not the ship that had become symbolic of the origins of the Scottish settlement. In 1923, the Province used the 150th anniversary of the *Hector*'s arrival to gauge the potential of history as a promotional vehicle for tourism. See Michael Boudreau, "'A Rare and Unusual Treat of Historical

Significance': The 1923 Hector Celebration and the Political Economy of the Past," *Journal of Canadian Studies/Revue d'études Canadiennes* 28, 4 (1993–94): 28–48.
48 Earl Clark to C.I.N. MacLeod, 13 January 1955, NSHVM.
49 W.L. Fillmore to Earl Clark, 17 January 1955, MG 20, vol. 933, H Nova Scotia Historic Sites Advisory Council fonds, Nova Scotia and Archives Record Management (NSARM), Halifax.
50 *Weekly Cape Bretoner,* 7 September 1957.
51 C.I.N. MacLeod, "The Hebridean 'Tigh Dubh,'" NSHVM. See also Hayden Lorimer, "Ways of Seeing the Scottish Highlands: Marginality, Authenticity, and the Curious Case of the Hebridean Blackhouse," *Journal of Historical Geography* 25, 4 (1990): 517–33.
52 James P. Bickerton, *Nova Scotia, Ottawa, and the Politics of Regional Development* (Toronto: University of Toronto Press, 1990), 249. See also Tom Kent, "The Cape Breton Development Corporation: One Canadian Case of Planning on the Spot," in *Canadians and Regional Economic Development at Home and in the Third World,* ed. Benjamin Higgins and Donald Savoie (Moncton: Canadian Institute for Research on Regional Development, 1988), 87–116.
53 "Report on Highland Village, Iona," February 1975, RG 66, Nova Scotia Department of Tourism, vol. 621, NSARM. The Highland Village Inn is still in operation.
54 Barry Diamond to R.C. MacNeil, 8 October 1971, NSHVM.
55 Rick Young to Jean Ross, 13 August 1975, RG 66, vol. 621, NSARM.
56 "Report on Highland Village, Iona," February 1975, RG 66, vol. 621, NSARM.
57 S.R. MacNeil to S.R. Fraser, 3 February 1968, NSHVM.
58 See Dominique Poulot, "Identity as Self-Discovery: The Ecomuseum in France," in *Museum Culture: Histories, Discourses, Spectacles,* ed. Daniel J. Sherman and Irit Rogoff (Minneapolis: University of Minnesota Press, 1994), 67.
59 Peter Davis, "Places, Cultural Touchstones, and the Ecomuseum," in *Heritage, Museums and Galleries: An Introductory Reader,* ed. Gerard Corsane (London: Routledge, 2005), 365–66.
60 Xerardo Pereiro Pérez, "Ecomuseums, Cultural Heritage, Development, and Cultural Tourism in the North of Portugal," in *Cultural Tourism: Global and Local Perspectives,* ed. Greg Richard (New York: Haworth Hospitality Press, 2007), 195–97.
61 Georges Henri Rivière, "Définition évolutive de l'écomusée," *Museum International (Edition Française)* 37, 4 (1985): 182.
62 Gerard Corsane, Peter Davis, and Donatella Murtes, "Place, Local Distinctiveness, and Local Identity: Ecomuseum Approaches in Europe and Asia," in *Heritage and Identity: Engagement and Dissemination in the Contemporary World,* ed. Marta Anico and Elsa Peralta (London: Routledge, 2009), 47–62; see also Davis, "Places, Cultural Touchstones, and the Ecomuseum," 367–68.
63 Brian A. Cherwick, "Polkas on the Prairies: Ukrainian Music and the Construction of Identity" (PhD diss., Modern Languages and Cultural Studies, Music, University of Alberta, 1999), 61.

Chapter 11: Genuine Indians
1 W.D. Cromarty to J. Smart, 19 October 1944, RG 84, vol. 130, FLA 28, Library and Archives Canada (LAC), Ottawa.
2 A.E. Broome to the Mayor and Council, City of Kitchener, 27 April 1953, Ontario Pioneer Community Foundation fonds, box 3, Waterloo Historical Society –

Correspondence, Waterloo Region Curatorial Services, Kitchener; "Report of the Public Service Committee, October 1964," Heritage Park Society, Board Minutes, 19 November 1964, Heritage Park Collection, Heritage Park, Calgary.

3 George MacBeath, "Mactaquac Historical Program Interim Report II, 2 February 1967," King's Landing Historical Settlement fonds, Acres Research and Planning File, King's Landing Historical Settlement Corporate Archives, Fredericton.

4 Arthur Laing to Kahn Tineataorn, 20 September 1965, RG 84, vol. 1069, FC113-200, LAC.

5 "Project 39 SMH – Visitors' Comments," file 25.18, General Correspondence, RG 5-46, Ontario Archives (OA), Toronto.

6 Alan Trachtenberg, *Shades of Hiawatha: Staging Indians, Making Americans, 1880-1930* (New York: Hill and Wang, 2004), xxii.

7 Daniel Francis, *The Imaginary Indian: The Image of the Indian in Canadian Culture* (Vancouver: Arsenal Pulp Press, 2011), 54–55.

8 Stephen Leacock, *The Dawn of Canadian History* (Toronto: Glasgow, Brook, 1921), 44.

9 John Ewers, "The Emergence of the Plains Indian as the Symbol of the North American Indian," in *Smithsonian Institution Annual Report, 1964* (Washington, DC: Smithsonian Institution, 1965), 531–44. See also Robert Berkhofer, *The White Man's Indian: Images of the American Indian from Columbus to the Present* (New York: A.A. Knopf, 1978); John M. Coward, *The Newspaper Indian: Native American Identity in the Press, 1820-90* (Chicago: University of Chicago Press, 1999); Christian F. Feest, "Europe's Indians," *Society* 27, 4 (May-June 1990): 46–51; and Kevin Meethan, "Touring the Other: Buffalo Bill's Wild West in Europe," *Journal of Tourism History* 2, 2 (August 2010): 117–32.

10 "Western Days" advertisement, *Scarborough Mirror*, 24 July 1963, 16.

11 Sharon Wall, *The Nurture of Nature: Childhood, Antimodernism, and Ontario Summer Camps, 1920-55* (Vancouver: UBC Press, 2009), 218.

12 W.H. Cranston to G.E. Moore, 23 March 1964; Norman Emerson to Lloyd Letherby, 24 March 1964; and James Auld to Norman Emerson, 11 April 1964, RG 5-4, OA.

13 William C. Noble, "J. Norman Emerson," *Canadian Journal of Archaeology* 3 (1979): 240–44.

14 *Orillia Packet and Times*, 11 July 1964, clipping in RG 5-4, OA.

15 Norman Emerson to Lloyd Letherby, 24 March 1964, RG 5-4, OA.

16 W.H. Cranston to G.E. Moore, 23 May 1964, RG 5-4, OA.

17 Uncredited newspaper clipping (likely *Orillia Packet and Times*) in RG 5-52, OA.

18 *Barrie Examiner*, 2 April 1968, clipping in RG 5-4, OA.

19 W.H. Cranston to James Auld, 8 April 1968, RG 5-4, AO.

20 *Orillia Packet and Times*, 11 July 1964, clipping in RG 5-4, OA. Although it is unlikely that Robarts had deliberately manoeuvred his alma mater into a position of influence, he did intervene personally to ensure that the university's president sat on the Huronia Historical Development Council. W.H. Cranston to J.P. Robarts, 30 March 1967, F 15, John Parmenter Robarts fonds, series 4-3, OA.

21 W.H. Cranston to Hugh Grant, 16 June 1964; Norman Emerson to James Auld, 25 July 1964; and Norman Emerson to William Davis, 15 April 1964, RG 5-4, OA.

22 Hugh Grant to W.H. Cranston, 2 April 1965; and W.H. Cranston to James Auld, 7 April 1965, RG 5-4, OA. It is unlikely that Cranston's version of events was correct. Emerson left for Calgary to be the accreditor of the University of Calgary's new PhD program in archaeology. However, he continued his work at Cahiagué until 1968. William C. Noble, "J. Norman Emerson: Contributions to Canadian Archaeology," in *Bringing*

Back the Past: Historical Perspectives on Canadian Archaeology, ed. Donald Mitchell (Ottawa: Canadian Museum of Civilization, 1998), 50.

23 James Auld to Norman Emerson, 16 July 1964; and W.H. Cranston to James Auld, 17 July 1964, RG 5-4, OA.

24 James Auld to Norman Emerson, 4 February 1966; and Norman Emerson to James Auld, 14 March 1966, RG 5-4, OA.

25 W.H. Cranston to James Auld, 29 June 1964; and W.H. Cranston to James Auld, 21 March 1966, RG 5-4, OA.

26 Norman Emerson, "Cahiagué" (Public Lecture Series, University of Toronto Archaeological Field School, Orillia, 1961). See also Noble, "J. Norman Emerson," in Mitchell, *Bringing Back the Past,* 45–48.

27 J. Norman Emerson to Peter H. Bennett, 8 September 1969, RG 47-64, OA. Emerson's reports are *The Cahiagué Village Palisade: A Report Submitted to the Archaeological and Historic Sites Board of the Province of Ontario* (Toronto: Archaeological and Historic Sites Board, n.d.); and "The Cahiagué Excavations, 1966: An Interim Report Submitted to the Department of Northern Affairs and National Resources, Canadian Historic Sites Division" (manuscript, National Historic Sites Service, Department of Indian Affairs and Northern Development, n.d.).

28 John H. Rick to D.F. McOuat, 25 June 1969; D.F. McOuat to James Auld, 12 August 1969; and Peter H. Bennett to Norman Emerson, 17 February 1969, RG 47-64, OA. Compare with J.G. Cruickshank and Conrad Heidenreich, "Pedological Investigations at the Huron Indian Village of Cahiagué," *Canadian Geographer/Geographe Canadien* 13, 1 (March 1969): 34; and George Irving Quimby, *Indian Culture and European Trade Goods: The Archaeology of the Historic Period in the Western Great Lakes Region* (Madison: University of Wisconsin Press, 1966), 103.

29 W.J. Cranston to James Auld, 5 August 1970, RG 47-64, OA.

30 *Orillia Packet and Times,* 19 February 1969, clipping in RG 47-64, OA.

31 John Sloan to J.R. McGinn, 17 May 1973; J.W. Keenan to Gordon Smith, 5 July 1973; and Allen Edwin Tyyksä to R.G. Bowles, 2 October 1974, RG 47-64, OA.

32 "Cahiagué and the Systems Plan," March 1974, RG 47-64, OA.

33 Leo Bernier to W.H. Cranston, 20 September 1974, RG 47-64, OA.

34 *Debates of the Legislative Assembly of Ontario* (14 May 1968), 2933.

35 "Tourist Camp Like Indians? That's One Promotion Scheme," *Toronto Financial Post,* 23 February 1963, 48.

36 R.L. Way, "Preliminary Report RE Historic Resources, Brantford Indian Reserve," 17 October 1968, RG 5-30, box 67, file 1.4, OA.

37 James W. St. G. Walker, "The Canadian Indian in Historical Writing," *Canadian Historical Association Historical Papers* 5 (1971): 21–51.

38 See, for instance, Conrad Heidenreich, *Huronia: A History and Geography of the Huron Indians* (Toronto: McClelland and Stewart, 1971); Cornelius Jaenen, *Friend and Foe: Aspects of French-Amerindian Cultural Contact in the Sixteenth and Seventeenth Centuries* (New York: Columbia University Press, 1976); Bruce Trigger, *Children of Aataentsic: A History of the Huron People to 1660* (Montreal and Kingston: McGill-Queen's University Press, 1976); and Calvin Martin, *Keepers of the Game: Indian-Animal Relationships and the Fur Trade* (Berkeley: University of California Press, 1978).

39 Ruth B. Phillips, *Museum Pieces: Toward the Indigenization of Canadian Museums* (Montreal and Kingston: McGill-Queen's University Press, 2011), 28–47.

40 Archie F. Key, *Beyond Four Walls: The Origins and Development of Canadian Museums* (Toronto: McClelland and Stewart, 1973), 242.

41 Prince Edward Island Heritage Foundation, "A Day in the Country," (likely 1972) RG 34, Series 15, PEI 1973 Centennial Commission fonds, Prince Edward Island Provincial Archives, Charlottetown.

42 Ronald F. Williamson, "Replication or Interpretation of the Iroquoia Longhouse," in *The Reconstructed Past: Reconstructions in the Public Interpretation of Archaeology and History,* ed. John Jameson (Walnut Creek, CA: AltaMira, 2004), 162.

43 Laura Peers, *Playing Ourselves: Interpreting Native Histories at Historic Reconstructions* (Lanham, MD: AltaMira, 2007), 5. See also Robert Coutts, *Lower Fort Garry: An Operational History, 1911-1992* (Ottawa: Parks Canada, 1993), 3.

44 Karen Wall, "'A Sliver of the True Fort': Imagining Fort Edmonton, 1911–2011," *Journal of Heritage Tourism* 6, 2 (May 2011): 114–15.

45 Fort Edmonton Park Historical Foundation, *Fort Edmonton: The Reconstruction Story, 1969-1974* (Edmonton: Fort Edmonton Reconstruction Project, 1974), 13.

46 Historic Sites Branch, *Historic Fort William* (Toronto: Ministry of Culture and Recreation, 1976).

47 Historic Sites Branch, *Old Fort William – Rendezvous* (Toronto: Ministry of Culture, Tourism, and Recreation, 1979).

48 Historic Sites Branch, *Venture into the Past* (Toronto: Ministry of Culture and Recreation, [1976?]).

49 Parks Branch, *Fort Steele Historic Park, 1976 Fact Sheet* (Victoria: Ministry of Recreation and Conservation, 1976).

50 Michael Collins, *Fort Steele Historic Park Visitor Use Survey* (Victoria: Department of Recreation and Travel Industry, 1976), 57. Perhaps anticipating these preferences, the Province chose Dunrobin over building a "typical Indian village" at Fort Steele. See Ben Bradley, "By the Road: Fordism, Automobility, and Landscape Experience in the British Columbia Interior, 1920-1970" (PhD diss., History, Queen's University, 2012), 613.

51 Parks Branch, *Fort Steele Provincial Historic Park* (Victoria: Ministry of Lands, Parks, and Housing, 1979).

52 Eric Krause to George MacBeath, 27 January 1978, F3-2, Fortress of Louisbourg, RS 310, Historic Sites Branch Records, subseries G, Provincial Archives of New Brunswick, Fredericton.

53 Peers, *Playing Ourselves,* 28, 44. Peers offers the most complete discussion of recent Aboriginal interpretive programming at living history sites in North America.

54 Ibid., 133.

55 Key, *Beyond Four Walls,* 311.

56 Leslie Allan Dawn, "'Ksan: Museum, Cultural and Artistic Activity among the Gitksan Indians of the Upper Skeena, 1920-1973" (master's thesis, Art History, University of Victoria, 1981), 16.

57 Douglas Cole, "The Invented Indian/The Imagined Emily," *BC Studies* 125–26 (2000): 147–62.

58 On the suppression of the potlatch, see Tina Loo, "Dan Cranmer's Potlatch: Law as Coercion, Symbol, and Rhetoric in British Columbia, 1884-1951," *Canadian Historical Review* 73, 2 (June 1992): 125–65.

59 Laurence Nowry, *Man of Mana: Marius Barbeau* (Toronto: NC Press, 1995), 195.

60 Heather Marshall Koulas, "Native Indian Cultural Centres: A Planning Analysis" (master's thesis, Community and Regional Planning, University of British Columbia, 1987), 41–42.

61 Christy Vodden and Ian Dyck, *A World Inside: A 150-Year History of the Canadian Museum of Civilization* (Gatineau: Canadian Museum of Civilization, 2005), 37.

62 David Darling and Douglas Cole, "Totem Pole Restoration on the Skeena, 1925-30: An Early Exercise in Heritage Conservation," *BC Studies* 47 (Autumn 1980): 31–32.

63 *Annual Report of the National Museum of Canada for 1926* (Ottawa: F.A. Acland, 1926), 5. See also Sandra Dyck, "These Things Are Our Totems: Marius Barbeau and the Indigenization of Canadian Art and Culture in the 1920s" (master's thesis, Art History, Carleton University, 1995), 109–10.

64 Andrew Nurse, "'But Now Things Have Changed': Marius Barbeau and the Politics of Amerindian Identity," *Ethnohistory* (Columbus, Ohio) 48, 3 (Summer 2001): 444.

65 Marius Barbeau, *Totem Poles of the Gitksan* (Ottawa: National Museum of Man, 1929), 187–91, 178–85.

66 Nowry, *Man of Mana*, 195.

67 Wilson Duff, "Contributions of Marius Barbeau to West Coast Ethnology," *Anthropologica* 6, 1 (1964): 63–96.

68 Michael Dawson, *Selling British Columbia: Tourism and Consumer Culture, 1890-1970* (Vancouver: UBC Press, 2004), 165–67.

69 W.H. Birmingham to W.A.C. Bennett, 12 April 1962, GR 1661, box 7, BC Archives, Victoria.

70 Marius Barbeau, *The Downfall of Temlaham* (Toronto: Macmillan, 1928). See Andrew Nurse, "Tradition and Modernity: The Cultural Work of Marius Barbeau" (PhD diss., History, Queen's University, 1997), 496–97.

71 Dawn, "'Ksan," 89–90.

72 Edward Applewaithe to Jean Lesage, 2 July 1956, RG 84, vol. 1420, HS10-151, LAC.

73 Edward Applewaithe to E.A. Côté, 9 August 1956; and A.J.H. Richardson to W.N. Sage, 14 May 1957, RG 84, vol. 1420, HS10-151, LAC.

74 M.H. Sargent to Edward Applewaithe, 4 February 1957, RG 84, vol. 1420, HS10-151, LAC.

75 Dawn, "'Ksan," 92–95.

76 See, for instance, K.R. Mylrea to L.J. Wallace, 17 May 1962; and Wilson Duff, "Memorandum, 7 February 1963," GR 1661, box 7, BC Archives.

77 *Victoria Colonist*, 25 January 1954, 11; *Victoria Daily Times*, 29 January 1954, 9.

78 'Ksan Community Association, "The Story of 'Ksan," in National Museum of Man, *'Ksan: Breath of Our Grandfathers* (Ottawa: National Museum of Man, 1972), 13.

79 Royal BC Museum, *'Ksan: An Authentic Indian Village, Hazelton, British Columbia* (Victoria: K.M. Macdonald, 1977), n.p.

80 Paige Raibmon, "Theatres of Contact: The Kwakwaka'wakw Meet Colonialism in British Columbia and at the Chicago World's Fair," *Canadian Historical Review* 81, 2 (2000): 157–90.

81 George MacDonald, "Introduction," in National Museum of Man, *'Ksan: Breath of Our Grandfathers*, 9–10.

82 Royal BC Museum, *'Ksan*, n.p.

83 See Bill Ellis, *'Ksan: First Annual Collection, 1978 Original Graphics* (Vancouver: Children of the Raven, 1978).

84 Michael Frisch, *A Shared Authority: Essays on the Craft and Meaning of Oral and Public History* (Albany: State University of New York Press, 1990).

Conclusion
1 Ronald Way, "Historical Restorations," *Canadian Historical Association Annual Report* 29 (1950): 59.

2 *The Spirit Sings* was an exhibit at the Glenbow Museum in Calgary, held in conjunction with the 1988 Calgary Olympics. Intended to showcase Aboriginal artifacts held in foreign repositories, it quickly became embroiled in heated political debates over Aboriginal rights and museum practices, profoundly affecting the subsequent work of Canadian museologists.

3 Christine Cameron, "Heritage Conservation Today" (paper presented to "Heritage: Next Generations Conference," Ontario Heritage Foundation, 14 February 1997), cited in Ronald F. Williamson, "Replication or Interpretation of the Iroquoia Long-house," in *The Reconstructed Past: Reconstructions in the Public Interpretation of Archaeology and History*, ed. John Jameson (Walnut Creek, CA: AltaMira, 2004), 148.

4 Laura Peers, *Playing Ourselves: Interpreting Native Histories at Historic Reconstructions* (Lanham, MD: AltaMira, 2007), 27–28.

5 Tony Bennett, *The Birth of the Museum: History, Theory, Politics* (New York: Routledge, 1995), 45.

6 Graeme Davison, *The Use and Abuse of Australian History* (St. Leonards: Allen and Unwin, 2000), 172–73.

7 Robert J. Morris, "The Capitalist, the Professor and the Soldier: The Re-making of Edinburgh Castle, 1850–1900," *Planning Perspectives* 22, 1 (January 2007): 55–78.

8 Vera E. Burns, "Heritage Park," *Canadian Collector* 11, 4 (January-February 1976): 63.

9 Friends of Sainte-Marie, *Site Map: Sainte-Marie among the Hurons* (Midland: Huronia Historical Parks, n.d.).

10 John E. Tunbridge and G.J. Ashworth, *Dissonant Heritage: The Management of the Past as a Resource in Conflict* (New York: John Wiley and Sons, 1996).

11 David Lowenthal, *The Heritage Crusade and the Spoils of History* (Cambridge: Cambridge University Press, 1998), 154, 166.

12 Peers, *Playing Ourselves*, 170–74.

13 Peter Davis, *Ecomuseums: A Sense of Place*, 2nd ed. (London: Continuum International, 2011), 182–86.

14 John E. Tunbridge, "Heritage Momentum or Maelstrom? The Case of Ottawa's Byward Market," *International Journal of Heritage Studies* 6, 3 (2000): 269–91.

Index